Pastels FOR DUMMIES®

by Sherry Stone & Anita Giddings

WILEY

Wiley Publishing, Inc.

Pastels For Dummies®

Published by
Wiley Publishing, Inc.
111 River St.
Hoboken, NJ 07030-5774
www.wiley.com

Copyright © 2010 by Wiley Publishing, Inc., Indianapolis, Indiana

Published by Wiley Publishing, Inc., Indianapolis, Indiana

Published simultaneously in Canada

For general information on our other products and services, please contact our Customer Care Department within the U.S. at 877-762-2974, outside the U.S. at 317-572-3993, or fax 317-572-4002.

For technical support, please visit www.wiley.com/techsupport.

Wiley also publishes its books in a variety of electronic formats. Some content that appears in print may not be available in electronic books.

Library of Congress Control Number: 2009941928

ISBN: 978-0-470-50842-8

Manufactured in the United States of America

10 9 8 7 6 5 4 3 2 1

WILEY

About the Authors

Sherry Stone is a Senior Lecturer in Foundation Studies at Indiana University Herron School of Art and Design. She has taught beginning courses in art and design for more than 20 years. Stone co-authored *Oil Painting For Dummies* (Wiley) with Anita Giddings. This is the second book they've written together.

Anita Giddings is an artist and educator living in Indianapolis, Indiana. She holds a Bachelor of Fine Arts degree from IU Herron School of Art and a Master of Fine Arts degree from Indiana State University. Giddings is currently a faculty member of IU Herron School of Art and Design at Indiana University-Purdue University Indianapolis.

Dedication

For my father, who helped make this possible. —SS

For my mother for all her support over the years, and for my students. —AG

Authors' Acknowledgments

We would like to thank Chad Sievers, Mike Baker, and Megan Knoll at Wiley Publishing for their expertise, help, and patience in this project. We are also indebted to the rest of the staff at Wiley for their efforts to make us look good and get this book to press. In addition, we extend our thanks to Sari Gaby, our technical editor.

We also thank our colleagues in the faculty and staff at Herron School of Art and Design, Indiana University-Purdue University Indianapolis. We would especially like to thank Dean Valerie Eickmeier and William Potter at Herron for giving us the time and space to complete this book.

We wish to express our gratitude to Susan Watt Grade, Carolyn Springer, Carol White, Kyle Miller, and Christine Plantenga for the loan of their artwork. We also thank Carolyn Springer and Mary Ann Davis for allowing us to photograph their studios. Our thanks also go to Corrine Hull and Elizabeth Kenney for daring to be photographed as they worked, and to Debbie Masten and others who modeled for drawings throughout the book. We wish to thank artist Diane Steele for her assistance in writing and for personal support. We also thank Mike McCune of Multimedia Art Supplies and Colleen Richeson Maxey of Jack Richeson & Co. for their support in this project.

Our endless thanks go to our own teachers over the years who guided us. We also express our gratitude to our families, friends, and students for putting up with us during this project, and to everyone at Herron School of Art and Design who acted as our sounding board and gave us advice over the past few months.

Publisher's Acknowledgments

We're proud of this book; please send us your comments at http://dummies.custhelp.com. For other comments, please contact our Customer Care Department within the U.S. at 877-762-2974, outside the U.S. at 317-572-3993, or fax 317-572-4002.

Some of the people who helped bring this book to market include the following:

Acquisitions, Editorial, and Media Development

Project Editor: Chad R. Sievers

Senior Acquisitions Editor: Mike Baker

Copy Editor: Megan Knoll

Assistant Editor: Erin Calligan Mooney

Editorial Program Coordinator: Joe Niesen

Technical Editor: Sari Gaby

Editorial Manager: Michelle Hacker

Editorial Assistant: Jennette ElNaggar

Art Coordinator: Alicia B. South

Cover Photos: Sherry Stone and Anita Giddings

Cartoons: Rich Tennant (www.the5thwave.com)

Composition Services

Project Coordinator: Kristie Rees

Layout and Graphics: Carl Byers, Samantha Cherolis, Melissa K. Jester

Special Art: Sherry Stone, Anita Giddings

Proofreader: Shannon Ramsey

Indexer: Potomac Indexing, LLC

Special Help: Elizabeth Staton

Publishing and Editorial for Consumer Dummies

Diane Graves Steele, Vice President and Publisher, Consumer Dummies

Kristin Ferguson-Wagstaffe, Product Development Director, Consumer Dummies

Ensley Eikenburg, Associate Publisher, Travel

Kelly Regan, Editorial Director, Travel

Publishing for Technology Dummies

Andy Cummings, Vice President and Publisher, Dummies Technology/General User

Composition Services

Debbie Stailey, Director of Composition Services

Contents at a Glance

Table of Contents

Part III: Heading to the Next Level: Intermediate Techniques... 171

Introduction

Nothing cries color like pastel. Maybe you came to pastel because you love Degas's ballet dancers, Mary Cassatt's simple domestic scenes, or Toulouse-Lautrec's dance hall scenes. Regardless, when you pick up pastels, you join the legions of artists over time who have been seduced by the medium's color and rewarded by its endless possibilities. A box of pastels can produce anything from a few simple sketches to elaborate artworks that beg to be called paintings. Pastels are limited only by the potential you see in them to create art.

In this book, we help you get started with pastel. If you have a little experience, we can help you fill in the gaps or give you the tools to take your artwork farther. As we help you build your skills, we also help you develop your voice as an artist. You can find many good books on pastel, but what sets this book apart is that it's geared to help you work at your own level, even if you have little experience with art.

This book follows our philosophy as artists and teachers. We bring to these pages the concepts and techniques we use every day in our classrooms.

About This Book

We designed this book with you in mind. We've taught hoards of students over the years and know how difficult learning on your own can be, but we believe you can discover how to make beautiful pastel drawings. In this book, we arm you with everything we think you need to know to establish a good foundation for making pastel drawings and to continue to develop as an artist for years to come. We don't teach you tricks — we lay out a time-honored process that helps you become the artist you were meant to be, not the shadow of someone else.

The format for this book is easy to follow. We start with pastel basics so that you can get a handle on the technical aspects of pastel and paper and set yourself up to work efficiently. Because drawing and modeling forms is so important to pastel, we provide some easy-to-follow instructions for mark-making and give you a basic primer in drawing and color. After applying those skills in simple still life, we explore ways that you can express yourself and experiment with different approaches to pastel images. Finally, we help you get started working in genre painting — landscape, portrait, and figure — so that you can have a broad range of skills to build on as you move forward with your pastel artwork.

Throughout this book, you find sketchbook exercises and step-by-step instructions for projects. Never fear if you're a rank beginner — we don't assume you already know how to draw well. We provide beginning strategies for drawing and include step-by-step sketchbook exercises so that you can practice your new skills. On the other hand, if you come to pastel with a little drawing under your belt, you can tackle complex subjects and new ways to make art.

We limit the discussion in this book to chalk pastels because of their versatility and ease of use. Chalk pastels can look like both drawings and paintings, and they're friendly to anyone just beginning to draw. Even though oil pastels have the advantage of generating less dust, we advise you to save them for later. They're more difficult to control if you're still working on your drawing skills.

Color is an important part of working with pastel. To help you develop fluency, we include chapters that give you a good foundation in color. Additionally, a running conversation about the role color plays in an artwork weaves through this book. We also refuse to let you get away without talking about designing your artwork well and how to avoid rookie mistakes.

As you work your way through the book, be patient with yourself. Give yourself permission to make mistakes and think of them as learning opportunities. Forget the word *talent.* Hard work, a willingness to learn, and being objective as you evaluate your work are worth much more. If you work regularly, you discover something new with every pastel work you do. If you have a troublesome drawing, don't get bogged down by it; just move on and churn out more work.

Conventions Used in This Book

To help you navigate this book, we use a few conventions:

- ✔ We use *italics* for emphasis and to highlight new ideas and terms that we define within the reading.

- ✔ We use **boldface text** to indicate a set of numbered steps (you follow these steps for many of the projects). We also use boldface to highlight keywords or phrases in bulleted text.

- ✔ Web addresses appear in `monofont`.

- ✔ The main drawing projects in the book have their own project headings so that you can easily identify them as you flip through the chapters. Every project tells you what you need, when you need it. Before you start any project, read all the way through the steps to make sure that you have the supplies you need.

What You're Not to Read

This book is set up so that you can find the information easily. This book is full of essential material, but you can skip over the sidebars if you're short on time. These shaded gray boxes house information that's interesting or technical but not necessarily need-to-know; skip 'em for now and come back later if you need to.

Foolish Assumptions

In writing this book, we have made some assumptions about you:

✔ You have done a little drawing in your life but want to improve those skills.

✔ You're interested in and appreciate art. You may have a little knowledge of art history, but only artists commonly known by people on the street.

✔ You like pastels and may have tried them but are looking for ways to avoid muddying them and want to go beyond merely "coloring" with them.

How This Book Is Organized

We've organized this book so that you can drop into the conversation at any point and flip from one area of the book to another following your nose. At the same time, if you prefer to work sequentially, the organization supports that approach as well.

Part I: Getting Started

In this part, we bring you up to speed on the basics of pastels and help you gather materials and set up a space to work. We give you an overview of the different kinds of color drawing materials and how they're different from pastels. We also discuss what working with pastels is like.

Part II: The Lowdown on Beginning Techniques

We discuss the basics of working with pastels in a comprehensive way in this part. It walks you through the basic skills you need to address each step of the process and then begins with an overview of the process of making a pastel drawing. We help you choose papers and apply pastels in different ways, as well as give you the skinny on when and how to use spray fixatives. We provide primers for basic color and drawing and give you concrete techniques for using value to develop the drawing so that it looks realistic. Finally, we pull it all together in a full-blown still life.

Part III: Heading to the Next Level: Intermediate Techniques

Part III is all about taking the skills in the earlier parts and finding your voice as an artist. It begins by walking you through some techniques for subjects that many people find difficult, such as glass and metal. Then we look at expressive ways to work with pastels. We finish with a wild dive into abstraction and give a nod to conceptual approaches to pastel and art-making. Buckle your seatbelts, because you may never look at pastel the same way again after this part!

Part IV: Drawing Places and People

In Part IV, we bring you right up to speed in portrait and drawing people, with easy to understand steps for drawing realistic people even if you have little or no experience. If landscape is your thing, we address how to approach landscape, including drawing on-site.

Part V: The Part of Tens

This part is chock-full of ideas for projects for those days when your brain just can't think of anything fresh to draw. Part V also provides essential advice for handling and storing your artwork, something you may not consider until you find yourself with a pastel drawing in hand and no safe place to put it.

Icons Used in This Book

The icons you see in the margins direct you to some really cool information:

This icon saves you time and energy by letting you know an easier method for doing something.

You know you're looking at important information whenever you see this icon. It may serve to remind you of something already covered elsewhere in the book, and at other times it lets you know to remember this informative tidbit for later.

This icon addresses potential dangers to you or your artwork so you can avoid potential headaches.

This icon points out practical sketchbook exercises you can practice in your own sketchbook to help you develop your skills.

Where to Go from Here

We wrote this book so that you don't need to read it sequentially. If you're just starting out, we suggest that you start with Part II, which gives you an intensive course in the basics. If you have been working with pastel for a while, some of the information in Part II may fill in the gaps of your experience, but you may also be ready to dive into Parts III and IV for some more advanced fun. You can also feel free to check out the Table of Contents or Index to find a topic that piques your interest.

The bottom line: Have fun. Laugh at the awkward drawings you do, practice and experiment, and relish your successes, regardless of how small they are.

Part I
Getting Started

The 5th Wave By Rich Tennant

"I've always found this shade of blue to be good for skies, backgrounds, and chapped lips."

In this part . . .

Pastels are more than pretty sticks of color — they're one of the most flexible art mediums around. Artists have used them in one form or another for hundreds of years, and you too can do almost anything with them.

Chapter 1 provides an overview of working with pastels and why artists love them so much. In Chapter 2, we introduce you to the various kinds of pastels available and give you some insight into how they're made; Chapter 3 digs into the other materials you may need. Working with pastels isn't just about materials, however; you also need a place to draw, and Chapter 4 gives you the lowdown on setting up a workspace.

Chapter 1

The Lowdown on Pastel Basics

*T*o make an artwork is to tap into the pursuit of creative expression that everyone has inside. Many people gain a true appreciation for the arts by making art. For some, the creative outlet is music or writing, but for others the drive to create a visual artwork is the outlet of choice. Many people's first experiences making pictures involved a crayon. The colors offered many ways to express the world around them. Sky and trees, mom and dad, brother and sister — each one was a different color.

And here you are as an adult now, feeling the same creative urge. Making pictures is a wonderful thing to pick up again; wax crayons are fine and can offer some satisfaction for color, but they don't offer a lot of possibilities for application. On the other hand, nothing beats pastels for ease of use and glorious color. You may have already had some experience with pastels because they're a popular art material for children and adults, but whether you've been working with pastels for a while or are just starting out, pastels are just plain fun. You can take classes that concentrate on pastel techniques, or just pick the sticks up and figure it out on your own with the help of our book.

Working with pastels is quite intuitive. A piece of pastel is just a powdery, sophisticated crayon, after all. Like any material, they can be a little tricky to work with, however, and the different brands of pastels and pastel-related materials vary tremendously. That's why we wrote this book: to give you a firm grounding in the many ways you can use pastels as an art material and offer some insider information about the various approaches to making images with pastels. In this chapter, we give you an overview of the book, walk you through the process of drawing with pastels, and point you to the right chapters for more details.

You and Toulouse: Why Artists Love Pastels

Pastels are a favorite of artists because they offer the rich color of oil painting but the ease of use of a drawing material. These qualities have made pastels popular through the centuries, with such diverse artists as Rosalba Carriera, Henri de Toulouse-Lautrec, and R.B. Kitaj. As a matter of fact, whether the artworks produced with pastel are considered drawings or paintings is up for debate. For now, we can say that the results are beautiful, whatever you may call them, and they're an important part of an artist's materials and tools.

Pastels have actually been in use for many centuries. Making art with some sort of chalk dates back at least to the early Renaissance, where you can easily find drawings made by Leonardo da Vinci and his contemporaries in red, black, and white chalk. Over the centuries, the manufacturers of pastels have increased the number of colors available, and mass-production has standardized their quality to the great benefit of today's artist.

Now drawing with pastels is easier than ever. If you're new to the world of pastels, you may not realize what they have to offer you, so the following sections highlight some reasons why pastels are a popular *medium,* which is another word for *art material.* You may fall in love with pastels for the same reasons, or some of your own. We cover the various ways of working with pastels in Chapters 6, 9, and 10.

Pastels do have a few drawbacks. The sticks are fragile and break easily with too much pressure or if you drop them. The surface of the drawing is also fragile and can be easily smudged. Sometimes a novice is tempted to over-blend the applied pastel, which can muddy and dull the colors. Plus, the pastels can produce a lot of dust as you work. These characteristics can be frustrating for a beginner, but they're easy to deal with. We cover handling these and other problems in Chapter 6.

A love affair with color

Color is the foremost reason to use pastels. Pastels grab you when you first open your box and see all the luscious colors at a glance — and that doesn't even account for the variety of colors of paper you can choose from. The color of the paper becomes a part of the final effect of your artwork, deepening the range of colors possible. And because the pastels go on dry, the sparkling color stays true. Each applied color visually enhances the other colors to create a complex mosaic of color. We devote Chapter 11 to color theory.

If you need further proof of pastel's color prowess, consider its popularity with the Impressionists, who were known for creating artwork made up of color and light. Their interest in fresh, spontaneous marks and the juxtaposition of saturated color made pastel an ideal art medium for Edouard Manet, Edgar Degas, and Mary Cassatt, among others.

The variety of stick pastels

Pastels are a part of a larger group of art materials that come in a stick. They all have different qualities and uses. Here we offer an overview to help you understand a bit of the history and variety of colored drawing materials that are applied in a stick form.

Depending on your preference and style, you can use a wide variety of pigment in a stick to create a masterpiece. Some of the varieties you may encounter when drawing with color include the following:

- ✔ **Chalk pastels:** We focus on this type of pastels in this book; in fact, when we refer to *pastels,* we mean these powdery wonders. Calling them chalk pastels also helps differentiate them from other types of materials, such as oil pastels, wax crayons, and colored pencils. Of course, many artists never refer to pastels as chalk, but the similarities between pastels and colored chalk can't be ignored. Both are dry drawing materials with powdery colored pigments. The difference is in the degree of intense saturated color and their intended use. Pastels intended for fine art are made of pigment and binder, usually gum tragacanth. They may also include some filler materials to modify the degree of hardness or to make the pastel more workable. Chalk is meant for blackboards and sidewalk drawings; we don't recommend using a set of Rembrandt brand pastels to make a hopscotch grid.

- ✔ **Conté crayons:** These old drawing materials have a more velvety texture than chalk pastels because they contain a clay binder. Years ago, conté crayons only came in traditional colors of white, reddish brown, brown, and black, but now they're available in many more colors, some of which are similar to chalk pastels.

- ✔ **Wax crayons and oil pastels:** Unlike chalk pastels, neither of these materials would ever be mistaken for a dry drawing material. These both have a lot in common; the difference is the degree of softness of the crayon. Where a child's wax crayon feels, well, waxy, an oil pastel has a greasy feel. You can blend and layer these materials like you can chalk pastels, but the appearance isn't as soft.

- ✔ **Other, newer items:** You may find other new items on the market: oil sticks that feel more like paint than a crayon and pastels in a pan that you apply with a sponge. Experiment to see what varieties speak to you.

Check out Chapter 2, where we discuss the different types of chalk pastels available in more detail.

The ease and intuitiveness of making art

Another great reason to use pastels is that they're super easy. You don't have to spend a lot of time preparing like you do with oil or acrylic painting. You just pick up and begin drawing! Although the working methods are similar to painting, other factors make pastels easier to use and different from traditional painting:

- ✔ They allow you, the artist, to quickly get down ideas and make initial sketches for work in other media.

- They're more portable than paints — no palette or brushes to carry along — and they travel very well when you properly store them in a secure case.

- They lend themselves to a variety of application methods. As with other drawing materials, you hold pastels in your fingers instead of applying from the end of a brush. This flexibility lets you apply pastel in a bunch of different ways — from the point of a pencil to the delicate powder of soft pastels.

- They allow you to do things that paint doesn't, such as work spontaneously without waiting for the work to dry and experiment with color easily by mixing right on the paper rather than on a palette.

Check out Chapters 8 and 9 for more on what you can do with your pastels.

Part of the joy of working with pastels is that you can do it very intuitively. Drawing with pastels isn't overly complex. In fact, essentially you really have only a few steps to create a drawing. Here are the basic steps to apply pastels to create an artwork. We cover these steps in detail later in the book.

1. **Lay out the general sketch of your image.**

2. **Apply the pastel colors to block in the value patterns in the scene.**

 The *value patterns* are the areas of light and dark colors. This process creates the *underdrawing,* which establishes the color and where the light source is coming from in your scene.

3. **After you complete the underdrawing, you can apply a light spray of workable fixative (see Chapter 3 for more on fixative) to set the image.**

 Fixative also helps you beef up the *tooth* (texture) so you can put down additional layers of color.

4. **Alternate the pattern of applying pastel and sealing it with workable fixative until you complete the image.**

 We cover the ins and outs of layering color, applying fixative, and working with different papers in Chapters 7 and 8.

Perusing Pastels and Paraphernalia

Pastels are easy to work with, but they do require some special equipment and supplies to make the most of their features. They're similar to painting in their color, but they go on dry and powdery like charcoal. You have to pay attention to the different hardness of the pastels and the type of paper you apply them to. You also have to take care of the artworks after you're done, which involves some specialized materials and equipment. We cover a lot of these particular materials and equipment in Chapter 3, but the following sections give you a preview.

Pastels

When you walk into an art supply store, you may be intimidated by all the different types of pastels available. Like we mention earlier in this chapter,

we help reduce your anxiety a bit and focus just on chalk pastels in this book. You can find three general types of chalk pastels:

- **Hard pastels or semi-hard pastels:** They usually come in square sticks. They're used in the initial stages of a drawing to lay down basic shapes and colors.
- **Soft pastels:** They're fragile and delicate. They put down a lot of color quickly and are used later in a project.
- **Pastel pencils:** They're hard or semi-hard pastel in a pencil. They can be sharpened to a point and are used for the initial drawing of an image and for final linear marks.

Pastel sets range from simple collections to big sets in fancy boxes. Pastels come in preselected sets of 12, 24, 30, or up to hundreds. You can also buy the pastels individually, but that's way too many decisions if you're new to the material. Your best choice for a beginning selection is a set that offers a broad assortment of colors. We advise you to buy a set of 24 hard pastels (Prismacolor's Nupastel line is perfect for this), a set of 30 to 60 half sticks of soft pastels, such as Rembrandt brand, and a set of 12 pastel pencils (CarbOthello is a good brand). We cover this topic in more detail in Chapter 2.

Papers and boards

The paper or pastel board that you use for your work is also a big deal. The names of the various papers may sound like a lot of insider lingo, but we give you the information to make good choices.

Pastels require papers that have a rough surface. If your paper is too slick, the pastels are going to just fall off as dust. For the pastels to properly adhere to the paper, it must have a rough texture or *tooth*. Sometimes the roughness feels like the texture of a soft paper towel, and other times it feels more like sandpaper (see Figure 1-1 for an example).

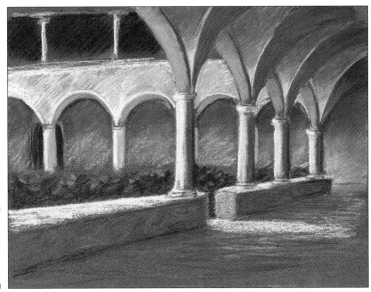

Figure 1-1:
A drawing on sand-paper.

Paper choice is a key decision in making a drawing. As you draw a pastel stick across the surface of a sheet of paper, pigment becomes imbedded in the fibers. Depending on the types of paper you're working on, the pastels reveal the texture of the surface, whether that's a waffle pattern, a soft film of powder, or a rough and gritty buildup of color. For starting out, you can't go wrong with buying charcoal paper. The texture holds onto the pastel particles and the papers are offered in a variety of colors.

You can work on white paper, but a deep paper color adds to the overall effect of your finished piece. Little bits of paper color show through the pastel and contribute to the overall color of the work. You can select a color that harmonizes with the subject, such as blue for a scene with water, or you can select a contrasting color, such as red for a green landscape. Check out Figure 1-2, which uses a different paper color.

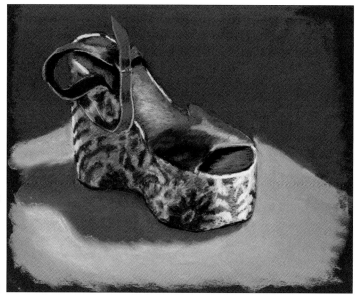

Figure 1-2:
A drawing on blue pastel paper.

Pastel boards are rigid pieces of cardboard, foam core, or hardboard with a surface suitable for pastels. Sometimes the surface is pastel paper that is adhered to the board and sometimes the board has had a gritty surface applied to it, making it ideal for pastel artworks. Pastel boards provide a more stable surface for your artworks and aren't as likely to be damaged as paper. You can read more about picking papers and boards for pastels in Chapter 7.

Basic equipment

Aside from your pastels and paper, you need a bit of other equipment. You can get by with minimal supplies, but at some point, you may want to invest in a few extras to make the process easier, keep your materials undamaged, and explore additional options for application. Pastel artists have drawing boards to support the paper; artists' tape or clips to secure the paper; and sprays to set the drawing. All these items allow you to work on a steady surface, build

up charming layers of colors, and keep your equipment clean and undamaged. Many artists also use tools for blending such as soft sponges, blending stumps (also called *tortillons*), cotton swabs or paper towels twisted into points. You can't help but use your fingers from time to time, though.

Keeping your pastels organized is an important consideration as well. If you have a large number of pastels, storing them in a box keeps the sticks cleaner, unbroken, and more organized. A piece of terry cloth allows you to lay out your sticks and keep them from moving around. We cover all the details about supplies in Chapter 3.

What you need to get started: Your basic list

Pastels vary quite a bit in hardness and texture from one brand to another. We advise that you start with a few sets of different hardnesses and then decide which suits your individual working style. Three different sets cover most of your needs as you begin: hard or semi-hard pastels, soft pastels, and pastel pencils, in a general assortment of colors. You can complete most of the projects and exercises in this book with the following supplies:

- Set of 60 half sticks of Rembrandt brand soft pastels in assorted colors
- Set of 24 Prismacolor Nupastel hard pastels in assorted colors
- Set of 12 CarbOthello pastel pencils in assorted colors
- Workable spray fixative (which we discuss in Chapter 3)
- 23-x-26-inch or similar-sized drawing board
- Pastel or charcoal paper
- A sketchbook with at least 30 pages (50- to 100-pound paper — see Chapter 7 for more on paper weight)

In the beginning, assorted color sets are more useful than the specialized sets you can get for landscape or portrait work. Later, you can purchase individual sticks of colors as you need them or special sets for different subjects. For example, you may find that you always run out of yellow or that you need several different types of violet. These preferences reflect your own working style, and you want to be able to respond to it easily without running out to the store again. You can find more information about pastels in Chapter 2.

Where to Work: A Room (or Table) of Your Own

When you're ready to start drawing with your pastels, you need a designated space where you can spread out your supplies and start sketching. Having a room devoted to your art making is ideal, but don't let not having a dedicated studio space stand in your way. Working with pastels doesn't require a lot of space — all you need is a work surface for the drawing, a place to lay out your pastels, and a table and light for your setup.

If you don't have a dedicated studio space, you can create a work surface in a shared space, such as an office or kitchen. Pastels are very portable, and the equipment is easy to stow away when you aren't working with it. Plus, cleanup is a snap. A table or desk works fine for a temporary space to work.

Working in shared spaces with pastel presents few problems. Pastel is a dry medium, and pastels have no smell. They may attract small hands if you have children, so find a secure place to store your work and materials if you're working in an area with curious young fans.

Pastels work very well on the road as well. Your supplies and equipment are portable and you can take your equipment where you want to work. *Plein air* work — making art out in the open air — requires a bit of planning, much like camping. You need to be able to work comfortably and to see your subject clearly. In Chapter 16, you can read about how to plan and create pastel land-scapes on-site.

Although pastels are safe materials to use and don't require any volatile chemicals for cleanup (unless you consider soap and water volatile), you still need to consider two safety issues when setting up your workspace:

- **Pastel dust:** Pastels create a lot of dust, and breathing in the dust and pigments isn't healthy for anyone. For those with breathing problems, allergies, or asthma, the dust can be irritating. Resisting the temptation to shake or blow on the drawing to remove excess pastel is the best way to avoid getting dust in the air.

- **Ventilation for using spray fixative:** *Spray fixative* is a sealer that allows you to add more tooth to layers of pastels for continued work or to apply a final finish spray to fix the pastel artwork and make it less prone to smudging. Using fixative is an optional step, but be sure to use it with proper ventilation. Spraying fixative in an open garage or porch or outside in decent weather works fine. You can read more about safety issues in Chapter 6.

Starting a Sketchbook

Keeping a sketchbook is a time-honored activity most artists participate in. As a beginner, you can use your sketchbook in two ways:

- **Skill building:** You practice drawing objects and people in quick sketches so that you don't struggle with them when you make your pastel drawings. Spending as little as 15 minutes a day drawing objects in your sketchbook *from observation* (based only on what you see, not on what you think the object should look like) can make a huge difference in your skill level.

- **Idea generating:** Sketchbooks are also receptacles for ideas, which is what seasoned artists use them for. You can sketch and write about your ideas, but you can also cut and paste articles and pictures into it. After you have used your sketchbook for a while, it becomes a rich journal, reflecting and recording your thoughts and attitudes about your life and view of the world.

Your sketchbook can be spiral bound or hardback, but choose one with good-quality paper that works well with your regular graphite pencil as well as with pastels. Everyone has his or her own preferences for size and shape. Some artists prefer small sketchbooks that fit in their back pocket or purse, and others carry around larger versions. After a bit of experimentation, you develop your own preferences based on your own life and work methods.

Your sketchbook is a volume of blank pages just waiting for you to fill them up. Throughout this book, you can find exercises to help you do just that. They provide directed practice that supports the longer projects and helps you build your skills. The following are a couple of sketchbook exercises to get you started and acquainted with your new friend.

Start your sketchbook with drawings of simple objects from around the house. These drawings are quick, no more than 20 to 30 minutes each. Use regular pencil (or pastel pencils if you have them already) and draw each of the following objects on a separate page: a ball, a book, and a cup. Be sure to work from the actual objects and not from what they look like in your mind. (See the following section for more on working from observation.) Refer to Figure 1-3.

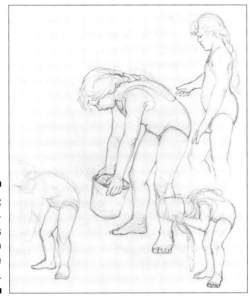

Figure 1-3: A sketchbook allows you to practice drawings.

A sketchbook is for notes as well as drawings. Make two columns on a page in your sketchbook. In one, write what you think your strengths are as you begin making pastel drawings. In the other, write what you think you may struggle with.

Finally, include a specific goal for your work in pastels. That may just be to find a pastime that you enjoy, or it may be something loftier like exhibiting your work in a local gallery. Making a note of this goal helps you plan your journey as you work.

Embracing a Drawing Philosophy

Many artists started drawing by copying cartoons as children. They drew images from their imaginations and later, when they wanted to make their work look more "real," they graduated to working from photographs. Interestingly, few ever did what they really needed to do, which was draw from the real objects.

Drawing from observation is a critical philosophy for developing skills in drawing because it increases the kind and quality of images you can make. If you don't push yourself to widen your boundaries, you stagnate.

When you draw from observation, you translate the three-dimensional image you see into a two-dimensional image on your paper. You look at the image, determine how to turn it into two-dimensions, and then rely on hand–eye coordination to draw the image the way you want. When you draw from photographs, however, you look at a two-dimensional image and then draw a two-dimensional image on paper. The translation has already been done for you. That may sound easier, but you don't get the experience of critically thinking about how to recreate the dimensions, so in the long run, you're making your drawing harder. The camera is also very selective and incomplete in the information it records. Your eyes are much more reliable and complete as a tool, so committing to using them as part of your training is an important prong in your philosophy for drawing.

Another important point in your drawing philosophy is making a habit of working from *general to specific.* When you work general to specific, you find the big, general shapes and go through a process of breaking the shapes down to the more specific forms. It also leaves you the flexibility to adjust your methods as problems arise in the early stages. (Check out Chapter 6 for more info.)

You can apply this process in many ways in your typical pastel drawing. You begin your initial drawing with big, general forms and then go through a process of refining and defining them. You block in your colors generally and then go through a process of refining and developing them. Every part and stage of the drawing goes through this process. Working on small areas at the expense of the rest of the drawing makes those areas too precious and limits your ability to make decisions about your work. Though you should be willing to sacrifice any part of the drawing for the good of the whole, the decisions you make while working the layering process helps keep those tough choices to a minimum.

Chapter 2

Getting to Know Your Pastels

Walk down the drawing aisles in any art supply store and you see dozens of different kinds and brands of color media. Fat round sticks, skinny square sticks, and pencils of every color imaginable — this experience can be like Christmas morning for some people. Behind the dazzling array of colors, you can discover materials that behave in vastly different ways. To help you get better acquainted with the wide variety available to you, this chapter sorts out the characteristics of the various kinds of pastels you encounter and helps you recognize how these pastels differ from other color media.

When you're just starting out, grab a set of inexpensive pastels to help you decide whether you want to pursue this medium. If you do decide to continue working with pastels, knowing a little technical information about them can help you make decisions about which to buy. Find more information on start-up supplies in Chapter 3.

Identifying the Basic Ingredients

The ingredients in pastels determine how they behave and give them characteristics that set them apart from other materials. At the same time, they can be easily confused with other materials used for drawing. They are similar because all art materials are made from essentially the same materials: *pigments* and *binder*. Other ingredients are also added to adjust the value or brilliance of a color, to make the material safer or more economical, or to improve the way a pastel or other drawing material handles. Although the pigments of chalk pastels, oil pastels, colored pencils, and other color drawing media are similar, the binders are different, so these media behave in distinctive ways. The various kinds of color sticks and pencils look alike if you don't know what you're looking at. The following sections help you understand what goes into pastels so that you can understand why they behave as they do and why you can expect different results from pastels than you get from the colored pencils or oil pastels you've been using.

Understanding pigments

One of the two main ingredients in pastels is pigment. *Pigments* are the particles of color you apply to paper to create the image. Understanding pigments is important because each pigment behaves differently. You can begin by looking at how pastel manufacturers use pigments to create a palette for their product lines.

An easy way to keep track of color pigments is to know that color pigments in pastel product lines fall into three categories:

> ✔ **A spectrum of bright hues, with light and dark versions of each:** These color pigments have clarity and look like the hues on the color wheel. The light and dark versions are soft and muted in varying degrees.

> ✔ **Black, white, and grayscale colors:** Some product lines have sets of warm grays and cool grays.

> ✔ **Traditional earth colors, such as yellow ochre and raw or burnt siennas and umbers:** Earth colors may appear to be mixed colors, but what you see is the unadulterated version of the color.

Beyond this basic breakdown, you can discover a lot about pastel pigments from the way the manufacturers name and number their pastels. If the pastels have wrappers, they likely contain information such as the color name, chemical makeup, and lightfastness or permanence rating (see the following sections for more on these qualities). If you order pastels online or by catalog, you see color samples with the names and numbers assigned to each. In the art supply store, the pastels display may show the color numbers, but the store also has brochures that list the color names and numbers for your convenience. The following sections give you more insight on pigments and how they affect the finished product.

Figuring out what the different pigment color names and numbers really mean

In professional- and student-grade lines of pastels, the names of the colors usually refer to one of the following:

> ✔ **The chemical name of the pigment:** These names come from the particular chemicals used in the pigment, such as phthalocyanine or quinacridone. A chemical name may read "phthalocyanine green" or "quinacridone violet."

> ✔ **The traditional names given to specific chemical compositions of the colors:** These monikers are simply the names commonly associated with a particular chemical makeup, such as "ultramarine blue" or "Hookers green."

Chemical and traditional color names are consistent from one manufacturer to another, with only slight variations in color.

After you know the color names, you know what to expect when you look at the pigment. Sometimes, however, pastel manufacturers mix pigments to increase their range of palette colors. The names of mixed pigments can tell you something about the nature of the pigment being used. Here are a few specific terms to look out for:

- ✔ **Hue:** If this word follows a pigment name, the manufacturer is indicating that it's a mixed color that approximates the color of the pigment being named. So, if you pick up a pastel named "cadmium red hue," you hold a pastel made of a mix of pigments that looks like cadmium red but doesn't contain cadmium pigments.

- ✔ **Permanent:** Some pigments are beautiful but fade easily. If *permanent* follows the name, you're looking at a mix that approximates the color of the pigment named but won't fade like the imitated pigment.

- ✔ **Shade:** If this word follows a pigment name, the manufacturer has added black to the color. But you can't assume that white has been added to the color if the word *light* follows a pigment name.

- ✔ **Pure:** In this case, the word *pure* indicates an original pigment free of black or white, but this purity doesn't mean these colors are necessarily the brightest versions of colors on the color wheel.

If you trust the manufacturer, you can usually trust its mixed colors. However, if you find an entire line of pastels with color names that sound like they came from a kid's crayon box, the quality may not be as high as you like.

Some manufacturers, such as Rembrandt and Winsor and Newton, help you identify different pigment mixes through numeric systems that indicate whether a pastel color is pure or a light or dark mix. The numbers are different for every system, but a simple example is a scale numbering one to ten, with five assigned the brightest version of the color, the lower numbers assigned to the darker, duller colors, and the higher numbers assigned to the lighter colors.

There's more than one way to make a pigment

For thousands of years, artists used *pigments* (the particles of color you apply to paper to create your image) manufactured from natural sources, but over the last few hundred years, many man-made pigments have been developed by using chemical processes. As a rule, the relatively new man-made pigments are brighter than those made from natural sources. In fact, the developments of bright new pigments and of tubes that made paints portable influenced the rise of Impressionism.

Many of the same pigments are used in pastels, oils, watercolors, printing inks, and other art media. For example, the phthalocyanine blue pigment you find in pastels is the same pigment you find in oils or acrylics, but it may be more finely ground for one medium than it is for another. On the other hand, if you like cadmium reds or yellows in oils or acrylics, you won't find them in pastels. Some common artist paints contain heavy metals, such as cobalt or cadmium, that have been rendered nontoxic in paint. Because of the increased risk of exposure with pastels through handling the product or inhaling the dust, pastels substitute other pigments for these metals to approximate the colors of those pigments.

Some of the most interesting pastels are handmade from mixed pigments by small pastel producers. Instead of mixing pigments according to a systematic color plan, these producers are interested in making beautiful or unusual colors. The manufacturers are often artists who become interested in making their own pastels because they can't find the colors they want from established manufacturers. Handmade pastels are beautiful and exotic, but for beginners they're a little like handing over the keys of a sports car to a teenager — they may be an expensive learning curve.

Choosing lightfast pigments that last over time

One of the most important factors to consider when choosing pastels is the lightfastness of the pigments. *Lightfastness* refers to how quickly the color of a pigment fades over time. All pigments fade, but they fade at different rates. A color is considered *lightfast* if it fades slowly. A color that fades quickly has a *fugitive* pigment. Sunlight is the enemy of all colors, so some fading is inevitable in sunlight regardless of how lightfast your pigment is.

Artists talk about lightfastness in terms of *stability*. A color is generally considered to have good stability if it can survive unchanged for 75 years under museum lighting conditions. Excellent stability indicates that the color is unchanged for 100 years or more under museum lighting conditions. Art materials manufacturers generally use pigments that are rated good or excellent, but when you venture into off-brand pastels, kids' art materials, or non-traditional materials, lightfastness can be questionable. You want to select pastels that have good-to-excellent lightfastness to preserve your work for many years to come.

You've probably noticed faded posters or magazine photographs. All that is left is a blue ghost of the former gloriously colorful image. Left in the sun, the printed colors magenta, yellow, and black fade fairly quickly until all that remains of the image is the blue printed image. The blue, or cyan, is the most lightfast ink used in the printing process, so it lasts the longest. That blue, incidentally, is the phthalocyanine blue pigment.

You can easily test to determine whether any material is lightfast. Simply make a sample, cover part of it with anything impervious to sunlight, and leave it in the sun for a few days. If you notice that the uncovered portion is paler than before and has even changed hue, you're looking at a fugitive material.

Grasping how binders bind

Binders are the substances that hold the particles of pigment together. They affect the medium's behavior and the clarity of its color. The type of binder determines the kind of art material you're using. Binders in pastels determine how hard or soft your pastels are and how smoothly they glide across your paper. They also affect your ability to layer them and thus help determine what you can do with the image.

Pastels and other color drawing materials are made with the following types of binders in varying degrees:

- ✔ **Wax:** Wax binders adhere particles of pigment to each other and to a surface like paint binders do.

- ✔ **Gum:** No blowing bubbles with this type of gum. This gum glues the particles of pigment together.

- ✔ **Clay:** Clay acts like a binder because of the shape of its particles. Think about how a handful of clay holds together when you mash it.

Gum and clay binders don't bind the pigments to the surface of the paper, however; they hold the pigments together as a stick so that they can be handled. With both of these binders, the pigment is released by drawing the pastel across the surface of a sheet of paper or board. The pigment particles are captured in the fibers of the surface until the spaces between the fibers are filled and can accept no more pigment.

Choosing *toothy,* or rough, papers for your pastel work is important because if the paper doesn't have enough *tooth* to hold the pastel, the pigment lies on the surface or falls off. Gum and clay binders don't adhere pigment to the surface, so working on an appropriate paper becomes critical to the process. Find out more about choosing papers for pastel in Chapter 7.

Noting other ingredients in your pastels

Manufacturers may add other ingredients to pastels for a variety of reasons. Here are a couple of ingredients you may find:

- ✔ **Chalk and clay:** These ingredients are commonly used to affect how the pastel handles. For example, the more clay that's in the mix, the harder the pastel. (See the following section for more on hard and soft pastels.) These ingredients can also thin unnecessary concentrations of pigment or make the pastel product more economical, as is often the case in student-grade pastels. (Flip to Chapter 3 to get the lowdown on the two grades of pastels.)

- ✔ **Pumice:** This gritty material often found in sandpaper causes the pastel stick to rough up or lift the fibers of the paper as you draw it across the surface. In the early stages of the drawing, pumice increases the amount of tooth and pigment on the surface of the paper. Pumice is added to certain specially made pastels for special techniques and should be saved for more advanced work.

Eyeing the Different Types of Pastels

When you walk into an art supply store or shop online for pastels, you may be amazed at the large array of products you can choose from. They come in a variety of sizes and are made from a variety of materials. Before you can fully appreciate what pastels can do for you, you need a firm grasp of the different kinds, as well as products that look like pastels but behave very differently. So that you can make an informed choice and understand what you find on the pastel aisle, the following sections break down the various kinds of products you may find.

Chalk pastels

Chalk pastels are known for their luminous colors and light-scattering surfaces. They're one of the most versatile media because they're essentially

sticks of pigment. They allow broad experimentation and can look like drawings, oil paintings, or even watercolors.

Chalk pastels come in two basic forms: hard and soft. All chalk pastels are made of pigment, kaolin clay or chalk, and a gum binder such as gum arabic, gum tragacanth, or methylcellulose. Chalk pastels' classification as hard or soft depends on the amount of clay in the mixture.

You don't have to choose one type of pastel over the other, however. Hard pastels are an economical choice, so we recommend that you use both hard and soft pastels in tandem, saving the soft pastels for areas where you want brighter, richer color.

For this book, we focus the projects and discussions on chalk pastels. You can use chalk pastels for a wide range of techniques and drawing styles, unlike oil pastels, which can be difficult for beginners to handle and limited in their versatility.

Hard pastel sticks and pencils

Hard pastel sticks are generally slim, rectangular sticks that usually measure about ¼-inch square by 3 inches in length, such as you see in Figure 2-1. They can withstand vigorous sketching without breaking because of their high clay content. They're great for making initial sketches, but you can also break off pieces and use them on their sides to block in color and develop a large portion of a pastel drawing. Because they hold an edge or a point well, they're good for detail work as well.

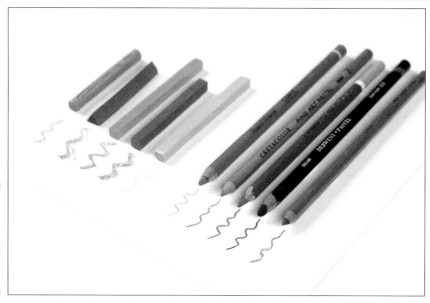

Figure 2-1:
A selection of hard pastels and pencils.

Sharpening your hard pastel pencils

Sharpening pastel pencils can be a challenge — they're notorious for breaking and crumbling just when you thought you had a good point. Dropped pencils may have a broken pastel core and become difficult to sharpen to a point. Here are some suggestions for sharpening your pastel pencils:

✔ Almost all pastel pencils are too soft to sharpen in a wall-mounted or electric pencil sharpener, so don't throw your money away by grinding your pencils down to nothing.

✔ Hand-held sharpeners are only appropriate for the hardest pastel pencils. Investing in a sharpener with replaceable blades is a good idea if you plan to sharpen your pencils in this way; keep the blades fresh by changing them often. Make sure the blades are always sharp. If you notice your points breaking off while you sharpen them, either your blade is too dull or the pastel core is too soft to sharpen with a hand-held sharpener.

✔ You can sharpen soft pastel pencils to a nice point with a sharp utility knife. First, carve the wood away from the pastel core, pointing the pencil and the knife blade away from you as you work. After you have a section of pastel exposed, shape the tip by whittling it with the utility knife, using the same movement you make when you peel a potato with a potato peeler. If you want a sharper point, shape it on a bit of sandpaper. The following figure shows you how to hold your pencil and knife as you sharpen a pencil.

If you like to build up layers of linear hatching (discussed in Chapter 9), hard pastel sticks are a good choice. Because they're larger than pencils, they can cover a lot of territory quickly, but they're small enough to use when working on more intricate areas of drawings.

Because they contain more clay than soft pastels and generally are smaller, hard pastels are less expensive than soft pastels. The higher clay content also makes them less brilliant (because they have less pigment).

All *pastel pencils* are hard pastels encased in wood, but you can't assume they're all the same density. Each brand of pastel pencils has a different level of hardness depending on the amount of clay included in the ingredients. Less expensive pastel pencils may be almost as hard as a graphite pencil, and other pencils are relatively soft. Though less expensive than softer pencils, harder pastel pencils aren't necessarily a bad choice for your work depending on what you need them for. If you're looking to maintain a point for detail or want to use a pastel pencil as you would a graphite pencil, a hard pencil may be a good choice. A softer pencil may work better for initial sketches or blending and layering with other pastels.

Soft pastels

When people think of pastel, they usually think of *soft pastels*. Many soft pastel sticks are approximately 3 inches long and vary in thickness (a ½-inch diameter is common). Many have paper wrappers that help hold them together as you work. Some manufacturers offer half sticks of colors that are an economical choice because you get a wide range of colors for a reasonable price.

Because these pastels are made for broad strokes, using soft pastel sticks comes close to a form of painting, but you can also break off pieces or use their edges to do detail work. They're particularly good for both hatching and massing colors. They're also good choices for blocking in initial drawings, but if you are budget conscious, you may want to consider using the hard pastels discussed in the preceding section for these early stages.

A relatively new type of soft pastels is PanPastels, which come in pans similar to those for watercolor. You apply them with a variety of sponge-tipped tools developed for the pastels by the manufacturer. Using them is more like painting than drawing because they are capable of fine transitions of blended color and the strokes have a soft appearance. In essence, you apply and blend the pastel color simultaneously.

As close to working with pure pigment as you can get, soft pastels contain pigment combined with small amounts of kaolin or china clay or chalk and held together with a little gum. Some soft pastels have so little gum in them that they barely hold together as sticks, but others have so much clay in them that they almost qualify as hard pastels. The softest pastels are expensive, break easily, and can be a little frustrating for a beginner, but they provide sublime beauty after you get the hang of them. Their shimmering color comes from light bouncing off pigment unrestricted by lots of binders. See Figure 2-2 for a selection of different brands of soft pastels.

Depending on the hardness of the pastel sticks, you can hatch layers of color, or more often, break off sections and lay in color by using the sides of the pastel. (Flip to Chapter 9 for more on the kinds of marks you can make with pastels.) You can use the edges as-is or shape them into points for detail work, or you can shave the sticks with a razor blade and press the dust into the fibers of the paper to achieve a soft, dusted appearance.

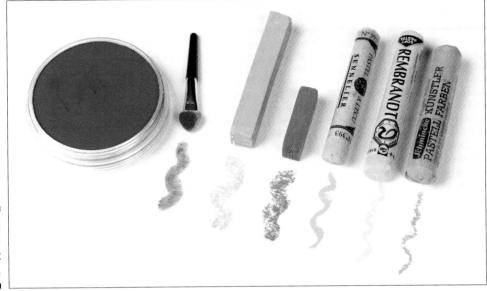

Figure 2-2:
A selection
of soft
pastels.

Oil pastels and oil sticks

Oil pastels are a relatively new medium first developed for Japanese schoolchildren in the late 1920s, which may explain why they handle more like children's crayons than chalk pastels do (see the preceding section). Oil pastels and *oil sticks*, larger versions of the oil pastels, are sometimes considered a wet medium. They consist of a thick paste of pigment, oil, and oil-soluble wax; you can draw on canvases and treat oil pastel as a painting material, or you can use it as a drawing material on paper. The binder captures pigment in much the same way pigment is suspended in paint, and even used as a drawing material, oil pastels' effects can be quite similar to paint. As drawing materials, oil pastels have a certain appeal over chalk pastels because they don't create dust and adhere more easily to less-toothy papers. Figure 2-3 shows you the difference between chalk pastel and oil pastel.

Built up in layers, oil pastels look much like *impasto*, thickly applied oil paint. Unlike oil paints, oil pastels never dry, so you need to handle and store any artwork you make with this medium very carefully. Because oil pastels are a waxy medium, artworks made from them are prone to developing a white haze called *bloom* across the surface unless you apply a special oil pastel fixative. Like oil paints, oil pastels on paper are prone to *oiling out* as the paper absorbs the oil out of the pigment. This condition causes a different kind of bloom and, in the worst cases, can cause the surface of the art to crack as the pastel becomes more inflexible than the paper it lays on. Another concern that arises from using oil pastels is that they aren't acid free and will eventually break down any paper they come in contact with. Priming the drawing surface with *gesso,* an art primer that acts as a barrier to the oil, prevents both of these problems.

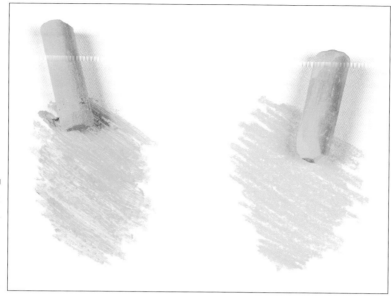

Figure 2-3:
Chalk pastel and oil pastel are different.

Oil pastel is a tempting choice because it doesn't create dust, and its texture is interesting. However, when you're first starting out with pastels, we strongly suggest you stay away from oil pastels. Save them for a time when you're ready to experiment and don't have to worry so much about your drawing skills at the same time. Although oil pastels make a popular choice for children's art classrooms, chalk is more flexible to use, so you struggle less with chalk as you build your drawing skills.

Chapter 3

Assembling Your Materials

In This Chapter

▶ Determining what you need before you go shopping

▶ Finding stores and online retailers

▶ Knowing which materials you need and which are helpful extras

▶ Storing and protecting your pastels and other supplies

*B*efore you can start working on your own pastels, you need to have the right materials and supplies. What better way than to go shopping (all you shopaholics rejoice)! Even if you feel well informed, you may still be a bit intimidated when you face all the different brands of pastel sets, papers, and attractive miscellaneous materials in front of you at the store. You're probably wondering what supplies you *really* need to get started.

The good news is that you don't need to buy a ton of stuff to get going. Pastels are basically drawing materials, so you can start modestly and then work your way up to more sophisticated supplies. Although you can find large sets of pastels that are very soft and quite expensive, starting simply allows you to experiment before you invest in pricier pastel sets. Of course, how much you invest in your pastel-drawing endeavor is up to you. In this chapter, we give you an overview of the materials you need and guidance on how to equip yourself to get started.

Preparing Yourself for Your Shopping Experience

To ensure that you purchase the appropriate materials for your future pastel endeavors, you need a game plan. Spending a little time considering all the decisions you need to make before you spend some money can help you make better choices when purchasing your materials.

This section gives you an overview of what you need to do before you set out on your shopping excursion. Here we discuss how to set a budget so that you don't initially overspend, as well as other important considerations about supplies and retailers that you need to know to be well informed about your needs and options. With this information, you can create your shopping list and hit the stores.

Setting a budget

Many grades of pastels and papers are available for you, so establishing a budget is important in order to avoid going overboard and buying supplies you don't need. A budget prevents you from overspending and buying equipment that you may not need.

We don't give specific prices for the items described in this chapter because a lot depends on the stores and availability of supplies in your area. Furthermore, prices can range quite significantly on some items. Where we can, we describe how you can make your own supplies and tools or what you may already have that can serve the purpose and save some moolah.

To set a budget, get an idea of what the basic supplies cost and decide on what you can afford. No matter what, make sure you determine how much you want to spend and stick to it before you go shopping. If you're just starting out, you can work happily for quite a while with a small, student-grade set of 24 pastels, a set of pastel pencils, and a pad of pastel paper. That should run you under $100. If you're a bit more experienced at working with pastels or if you would like to indulge yourself a bit, you may decide to invest in a larger set of better-quality pastels and papers, tools, art boxes, and portfolios, which can run you about $300.

Keeping quality in mind

In addition to price, the quality and the working characteristics of the materials are important considerations in your pastels selection. Purchasing materials and equipment of questionable quality can be a problem: Poor-quality papers, cheap drawing boards, and pastels that are too hard can make your learning experience more difficult. We suggest starting with simple but good-quality materials and then buying higher-quality materials after you're more familiar with the process.

The makeup of pastels in a particular line not only affects their color and working characteristics but also determines their quality and price. Many levels of quality in pastels are available, and you can decide individually what best fits your budget for your supplies. Knowing how manufacturers categorize the art materials can make the selection easier; the following gives you a quick overview:

- **Student-grade art supplies:** These supplies are the least expensive because the manufacturer substitutes some traditional materials with less-expensive components; for example, sometimes student-grade pastels contain a less-intense color *pigment* (powdered coloring material) or more *binder* (the substance that holds the powdered pigment together in a workable consistency), which can negatively affect their performance. However, many of these products are still very good quality due to the discovery of new pigments, binders, and methods of production that can keep costs down.

- **Professional-grade art supplies:** These pastels, papers, and tools are more expensive because they utilize materials and components that produce a rich and luxurious look in the artwork. Often, professional-grade pastels have a particularly soft texture or intensity of color that you just can't perfectly reproduce with student-grade materials.

After you start working with pastels, you develop your own tastes in supplies. Experimenting to find the pastels and materials that work best for you eliminates frustration and helps you achieve more satisfying results in the long run. Just make sure you purchase materials that are in line with your experience level. For example, starting with student-grade pastels can be helpful — you can try out pastels in an uninhibited manner without fear of cost. Some very beautiful pastels are quite soft and delicate but would be a little difficult for a beginner to use; they're fragile and can crumble in your fingers if you aren't familiar with using them. Not the kind of situation that encourages experimentation! On the other hand, after you've built your skills, you may decide that student-grade materials aren't worth their economy and move up to professional-grade.

Making a shopping list

Before you set out for the store, you want to make a list to take with you for the same reasons you make a list to go to the grocery store: You can get carried away if you haven't planned out your shopping in advance. Making a list keeps you focused and prevents impulse buying or becoming overwhelmed; if you go to the store with a list of the materials you need, you're less likely to get sidetracked by supplies outside your skill level and budget. Keep in mind, though, that you need to be a tad flexible with your list because you may find different brands and types of materials than you expect depending on where you shop.

Chapter 1 provides a starter supply list that includes the essentials you need to get started. As you read this chapter and become more familiar with the different supplies available, you can make decisions about how you need to modify the list according to your preferences or to accommodate your budget.

Knowing where to shop

When you're ready to actually start buying materials, you have plenty of choices. So where do you start your search? This section highlights your main options, including art supply stores (your best choice), online stores, and other types of stores that sell art supplies.

You can find art supplies in many places today. Although we suggest you start with specialty art supply stores, these shops can be more expensive, and not every town or city has one. In order to locate one of these stores, first look in a phonebook and see what's available in your area. Do some research to determine whether these stores can help you get the items on your shopping list.

Buying from art suppliers

When purchasing art supplies, we suggest you first start with art supply stores. The main advantage of shopping at a specialty art store is a better selection of materials and a more knowledgeable staff than you'd get in the art supply sections of other kinds of stores. Although the prices may be higher, the owners and salespeople in these stores typically know what they're talking about, and they can advise you on a range of questions you may have, including knowing the differences between certain brands, understanding various papers and fixatives, and squeezing the most supplies out of a small budget.

In addition, art supply stores often let you experiment with different materials to see which ones you like better. They offer information and advice, and sometimes classes or workshops. They can be a great place to get a little education on any number of art-related pursuits. Here are some art retail stores that you may find in your area along with the Web address to locate a store near you.

- **Michaels:** www.michaels.com/art/online/home
- **Prizm Art Supplies:** www.prizmart.com/
- **United Art and Education:** www.unitednow.com/home.asp

Buying supplies online

Buying supplies online is easy, and the companies that produce the major brands are very informative about the various grades (student- versus professional-grade) of their pastels. You may be a bit concerned about buying supplies that you haven't been able to see or test firsthand, especially if you're a first-time buyer, but don't worry; the great thing about pastels is that they're pretty straightforward in terms of their qualities and use, so you can buy online without fear that you have bitten off more than you can chew (not that you should be chewing on your pastels). To make an informed decision in the absence of a helpful salesperson, you can often find technical information about degrees of softness or hardness, types of colors in each set, composition, and techniques for use right on the manufacturers' Web sites.

Buying from online art supply stores is also a great way to have access to a wide range of supplies and papers. Many times, more brands are available online than locally. The only downsides are paying for shipping and waiting for your materials to arrive. However, online stores are often able to discount their prices because they don't have the overhead that a retail outlet does, so the end cost including shipping may still be very similar to the cost of purchasing locally. Here are some well-known and reputable online retailers to get you started:

- **ASW:** www.aswexpress.com/
- **Cheap Joe's:** www.cheapjoes.com/
- **Daniel Smith:** www.danielsmith.com/
- **Dick Blick:** www.dickblick.com/
- **Fine Arts Store:** www.fineartstore.com
- **Pearl Paint:** www.pearlpaint.com/

Considering other places you can buy supplies

If you don't have access to an art supply store or any online shops, the following are other brick-and-mortar options where you can also find pastel drawing supplies:

- **General merchandise stores:** You may find art supplies in a store that has stationery, household items, clothing, and such. Unless the retailer has a special interest in art, the selection is probably limited.

- **Craft shops:** Along with department stores, they have great prices but may not have much of a selection of pastels or papers.

✔ **Fabric stores:** These stores often have art and craft supplies as well as fabrics. The selection is similar to craft shops.

✔ **Big-box discount stores:** Discount stores have less invested in the individual purchaser, so you have to do more on your own. Every once in a while, you find a store associate who is able to help you with information, but these places specialize in volume retail, not service.

✔ **Educational supply stores:** These stores are similar to fabric and craft shops in their selection of supplies. You find a good selection of student grade art materials and maybe some better quality items as well.

Eyeing the Essential Materials You Need

Getting set up for any hobby can be overwhelming, and pastel drawing is no exception. Maybe you've got visions of art supplies dancing in your head because you saw some TV artist brandishing all sorts of fancy implements. How do you know what you need? Why, you read this section, which identifies the indispensible supplies you need to start your pastel drawing experience.

A basic pastel starter set

Every newbie to pastel drawing needs a set of pastels. Pastels are offered in large sets because, unlike paint, you can't mix the exact color to match the color you see in your image. Although pastels are available in sets ranging from a dozen to hundreds of colors, we suggest you begin with a basic pastel starter set, which typically includes a general assortment of 30 to 60 colors. Get one set of soft pastels and one set of semi-hard or hard pastels and a set of pastel pencils, as we describe in Chapter 1. By buying preselected sets, you save money and get a wider selection of colors. The general assortment of colors gives you more colors for your palette and are more useful in the long run. You can move on to genre-specific sets (such as landscape) later. Plus, you eliminate the guesswork of trying to pick the right materials on your own.

But if you want more freedom in choosing your start-up supplies, you can build your own set. We recommend that you start with the basic sets of hard and soft pastels on our supply list, and then build your own set piece by piece by adding to these sets. We recommend Rembrandt's General Selection of 60 half sticks. The half sticks of colors are very cost effective because you get a greater assortment of colors. To decide what extra colors you need, just note what you seem to use the most of. Maybe it's more blues or more reds; each person has individual tastes. See Chapter 1 for a full list of our recommendations for your supplies.

If you've been doing pastels for a while, we suggest that you purchase a set of assorted colors and then supplement the set with your own preferred colors that you can purchase individually. Even for beginners, you start to develop preferences for certain colors as your work becomes more sophisticated, and you find a need for a wider palette of colors.

Something to draw on: Supports for pastels

In addition to the set of pastels (see the preceding section), you also need something to draw on. The cool news: A wide range of papers and pastel boards is available for pastels, including pastel papers, charcoal papers, sanded papers, and specially prepared cardboards and hardboards. When choosing a support to use for pastel, read the manufacturer's product description to see whether pastel is a suitable medium for that material. You can find this information on the cover of a pad of paper, in the display at the art supply store, in the catalog description, or online on the manufacturer's or distributor's Web site.

The following list gives you a brief description of various kinds of paper and boards available so you can decide what you need. You can find much more information about papers in Chapter 7.

- ✔ **Charcoal papers:** Charcoal paper is the most common support used for pastels; when you're just beginning your pastel drawing endeavors, we suggest you start with this type. *Charcoal* is a soft drawing material similar to pastels. Papers made for work in the charcoal medium also work very well for pastel. Charcoal papers do tend to be more textural than papers made specifically for pastel, however, so you may or may not like the heavy texture. We recommend that you try it to see how you like it. Charcoal papers are widely available in pads and as individual sheets; some well-known manufacturers are Strathmore and Canson, and they come in a wide variety of colors.

- ✔ **Art papers:** *Art paper* is a term for papers specially made for drawing, printmaking, and other media. Sometimes referred to as *rag papers,* they're acid-free, archival papers meant to last well into the future, which means they don't yellow, turn brittle, and decay like papers made from wood pulp (such as newsprint). Arches Cover, Rives BFK, and Stonehenge are common, high-quality art papers that are worth trying. Generally you can find these types in white or off-white colors and some have black also.

- ✔ **Boards for pastels:** In addition to papers, commercially prepared boards are available for pastel. The manufacturer mounts pastel or sanded paper (see the following bullet) onto rigid composite cardboard supports. These boards are convenient and easy to use, but they're not all acid-free, so make sure you know what you're getting. Another interesting type of board made for pastel is a specially primed Masonite or hardboard panel. These boards are convenient and the surfaces are very nice to work on, but the boards tend to be a little pricey, so you may want to stay away from them until you become a bit more experienced with pastels. All come in a variety of colors.

- ✔ **Specially prepared supports:** *Sanded papers* have a mixture of sand, marble dust, or other grit applied to the surface that firmly captures and fixes the pastel pigment to the surface. You can add many layers of pastel to the surface, sometimes with little need for spray fixative (check out the following section, "Looking at Other Equipment and Supplies," for more on spray fixative). They come as heavy sheets of paper or mounted onto foam core or cardboard. They're available in white and a variety of colors.

Many beginners experiment with this type of surface by using sandpaper from the hardware store. This experimentation is good, but keep in mind that commercial sandpaper quickly ages and turns brittle. If you want to try this, get 400- or 600-grit sandpaper for your experiment.

✔ **Canvas and unorthodox supports:** You can use other surfaces for pastel as long as they're properly prepared. You can paint specially made primers onto a wide variety of surfaces, such as Masonite panels, rigid canvas panels (but not stretched canvas), metal, and wood, to make them receptive to pastel. Some artists prefer this process because it allows them to customize the surface for a particular project by *toning* it (adding color to the primer before priming the surface).

Looking at Other Equipment and Supplies

To get started drawing with pastels, you really only need a basic set of pastels and a pad of suitable paper (discussed in "Eyeing the Essential Materials You Need" earlier in this chapter). However, you may come across some other supplies you find you need to really begin your artistic endeavor. This section covers supplies that can be helpful right when you get started, as well as supplies that you can hold off purchasing until you get an idea of your own working methods and preferences. You see a lot of intriguing stuff in art supply stores — everything from tools that look like da Vinci would have used them to high-tech easels that collapse down to the size of a shoebox. This section gives you the lowdown on the rest of the equipment and supplies you should consider.

Checking out other practical stuff you may want

Some supplies are a little more practical and can help you as you begin your pastel drawing hobby. This section covers other tools and supplies you may need or find useful depending on your developing working style, space constraints, and so on.

Drawing board

A smooth, rigid *drawing board* can support your pastel paper when you're drawing. Some very high-quality commercial drawing boards with handles and clips are available; get these at your art supply store. You can pick up a piece of board and binder, also called *bulldog,* clips very inexpensively at your local hardware or lumber supply store. The best surface is quarter-inch-thick Masonite (also known as *hardboard*) because it's inexpensive, widely available, and adequately rigid.

Whatever kind of board you get, choose the size carefully; the bigger and heavier a board is, the more unwieldy it is to use. Look for a board that's at least 23 x 26 inches, which allows for a relatively large drawing — most pastel papers are smaller than 19 x 26 inches. However, you can find some papers as large as 20 x 30 inches; if you decide you want to work that large, you need to look at a bigger board.

Larger drawing boards are available, but you have to consider how you plan to use the board in making the decision to buy a larger board. Do you want to work exclusively in your home? Draw outside? Take it to a class? The size of

the board affects how easily you can transport it, so think about how much you anticipate needing to lug it around. Large boards work best when you know you want to make large drawings or when you know you won't have to take the board on the road.

Easel

An *easel* is basically a stable frame to support your drawing board or drawing surface. An easel can be useful, but it's a bit of a personal choice. Some artists prefer to work only on an easel, and others prefer working flat on a table. For small works, some artists merely prop a drawing board against the edge of a table or chair and support the board in their laps, similar to using a drawing horse if you've taken a drawing course.

Some options for easels are *tabletop easels* (for when you have less space to work), *floor easels* (for larger working space), or *Julian* or *French* easels (for outdoor work). If you do decide to purchase a floor easel, get a heavy one so it doesn't walk away from you when you press against it as you work. Also note that display easels aren't stable enough for art making. For information about how to use your easel, see Chapter 4.

Portfolio

A *portfolio* is a large case used to transport or store your papers and pastel works. The best type of portfolio opens like a book, with zippers or ties on three sides. These cases are usually made of vinyl-covered cardboard, and sometimes leather. We don't recommend the envelope-style portfolios that only open on one side, because your papers and artwork may become damaged as you slide them in and out of the portfolio. We also don't recommend fabric portfolios because they don't support your paper without damaging it — it's like putting your artwork in a sack.

If you have a limited budget, you can make a book-style portfolio out of two acid-free boards. It won't be pretty and it won't last forever, but it will get you started. Gather up two acid-free mat boards or foam core boards the size of the biggest paper you plan to use, duct tape, acid-free artists' tape, 30 inches of string or ribbon, one or two sheets of acid-free paper, an awl, and a pair of scissors, and follow these steps. Figure 3-1 shows a finished portfolio.

1. **Set the boards side by side, butting the long sides together.**

2. **Attach a long piece of duct tape down the seam between the two boards and then run an additional piece of tape on each side of the first piece of tape, overlapping it slightly.**

3. **Close the boards so that the tape is on the inside and place the seam side (not the open side) facing you.**

4. **Attach three pieces of duct tape perpendicular across the seam (one at the top, one at the middle, and one at the bottom) for strength, and, leaving the portfolio closed, attach another piece of duct tape the length of the seam just as you did the inside.**

5. **Open the portfolio and line the inside taped area with folded acid-free paper to act as a barrier, taping it in place with acid-free artists' tape.**

 The duct tape isn't acid-free, so you need this extra layer of protection for your projects.

6. **Close the portfolio and use an awl to punch three holes through both boards on the top, bottom, and open side an inch away from the edges.**

7. **Thread about 10 inches of ribbon or string through each side's holes and tie to close.**

Figure 3-1:
You can make your own portfolio to store your artwork.

Blenders

Almost all pastel work requires blending at some point, which means you'll need at least one *blender.* You can blend pastels a variety of different ways: Soft brushes, tissues, cotton swabs, and even paper towels are effective impromptu tools you can employ for blending your pastels. Blending stumps, however, are special drawing tools used to blend the pastels in a controlled manner. *Blending stumps* — also called *tortillion* (tawr-tee-*on*) — are made of paper rolled up like cigars; they look like paper pencils sharpened on both ends. You can pick up a set in a variety of different sizes pretty inexpensively. Check out Chapter 9 for examples of how to blend with these tools.

Fixatives

Fixatives are sprays that help seal or set the pastels onto the paper surface. They're inexpensive and available in two types: workable and final. We discuss them in the following sections.

Spraying your drawing with any kind of fixative is optional — it's not required to protect your drawing. In fact, some artists feel that the spray changes the colors of the pastel and don't use it at all but rather just work on toothy pastel papers or sanded papers. If you choose to not spray your drawing, the surface is more fragile, but protecting your drawings is still possible; Chapter 21 details

other ways you can protect your artwork. Also be aware that the drawing can still smudge after spraying; fixative makes the pastel drawing less prone to damage, not impervious to it.

Although safe to use properly, you should avoid breathing the fumes of any spray fixatives. Only use the spray fixatives outside or in a well-ventilated area such as a spray booth. Don't spray them anywhere they can be inhaled or ingested. If you have concerns about using these optional products, you can use pastels without spray fixatives.

Always use a fixative made for pastels and charcoal drawing for your artwork. Years ago, young art students commonly applied hairspray to their drawings to fix them. Hairspray is composed of some of the same materials, so it does work for the short term, but it ultimately damages the drawing — the hairspray yellows over time and ruins the drawing.

Head to Chapter 6 for details on how to apply spray fixative, and also read the product instructions before you use a fixative the first time.

Workable fixative

When you plan to continue to apply additional layers of pastel over the drawing, you need to pull out your workable fixative. *Workable fixative* is a thin solution of matte spray varnish that binds the pastel you've laid down to the surface and sets up a new *toothy* (slightly rough) surface for more drawing. If you try to make a mark but lay down little color, or if pastel dust doesn't adhere to the surface well, break out the workable fixative. You can choose to spray the entire drawing or isolated parts of the drawing; let the fixative dry and work back into the drawing. Some artists work with many, many layers in their work, applying workable fixative every few layers to keep a fresh tooth in the paper.

Final fixative

Some artists also apply a final fixative to their finished work to protect it from damage. *Final fixative* creates a more durable surface than workable fixative does. Don't use final fixative if you suspect any chance that you may want to work on the drawing again.

Many artists forgo final fixative because they dislike the appearance of fixed pastel. Fixative causes the colors to darken, and sometimes the pastels appear to shrink on the paper, leaving dots of paper showing through and questionable textures. You can have the best of both approaches — maintaining a good tooth in the paper and keeping the final pastel looking fresh — by spraying workable fixative periodically as you draw but then leaving the final layer of pastel alone.

Supplies for health and cleanliness concerns

Pastels are quite safe to work with. They're non-toxic and require no volatile chemicals or solvents, and you can simply wash with soap and water to clean up. You may want to consider using the following supplies to address any breathing or neat-freak issues you may have:

 ✔ **Dust mask:** Those with respiratory problems such as asthma may find that pastels aggravate and irritate the lungs and cause breathing problems. If dust gives you fits, wear a dust mask while you're working with soft drawing

materials such as pastels and charcoal. Don't feel silly — many artists wear dust masks every time they work with these soft materials. You can find dust masks reasonably priced at any hardware supply store.

As long as you handle pastels appropriately, you generate little dust and shouldn't have any problems with them. But realistically, avoiding creating dust is nearly impossible. If you press too hard or work too vigorously, dust accumulates on the surface of the drawing. Don't blow the dust off the paper! Just hold the paper over a trash can and tap the paper to gently knock the loose dust from the surface. You can also set your easel so that it leans slightly forward, just a degree or two, as opposed to back, so that excess dust falls to the floor as you work.

✔ **Gloves:** Some artists use gloves to keep the dust completely off their hands and make cleanup faster. They're available in either latex or synthetic rubber, though both can be somewhat cumbersome and some people are allergic to the latex.

✔ **Barrier cream:** *Barrier creams* leave a fine film over your hands that prevents your skin from becoming stained with the pastels. Most aren't as good as gloves, but they aren't as bulky as gloves, either. Their main advantage for pastel is the ease of washing up after working — simply wash away with soap and water. You don't have to worry about pastel under your fingernails or in the creases of your skin, and you generate less waste than you would with disposable gloves.

✔ **Apron, old shirt, and so forth:** Protect your clothes from pastel dust. You can safely wash pastel-covered clothes in a washing machine (assuming they're machine-washable to begin with), but trailing around the house or preparing food with pastel particles falling off of you is probably not a good idea. Wear separate clothes for pastel work and household chores (or lounging) to avoid getting dust everywhere.

Sighting sticks and viewfinders

The two main tools you use for sighting and measuring are a sighting stick to help find relative sizes and proportions and a viewfinder to help you focus on your composition and analyze the arrangement of the elements of the work. *Sighting* is used to find correct placement of items in a scene and to find correct angles of some features. *Measuring* is used to gauge the relative scale and proportion of items in a scene.

Sighting sticks are tools used for visually measuring heights, widths, and angles of objects and sighting the relationships of objects or parts to each other. You can use a kabob skewer, pencil, chopstick, or any thin, straight stick about eight inches long. A sighting stick is easy to find around the house, and this section shows you how to make a couple of kinds of viewfinders. Flip to Chapter 5 for instructions on using sighting sticks and viewfinders.

A *viewfinder* allows you to find the best view and decide whether you want a vertical or horizontal format for the image, just like a viewfinder on a camera does. Viewfinders come in a couple of different varieties:

✔ **Window:** A *window viewfinder* is the simplest type; it's just a piece of cardstock with a rectangular opening. The opening corresponds to the standard proportions of a piece of pastel paper. To quickly make your

own, just cut a rectangular window in an index card or similar piece of cardboard. You can modify the window with threads taped in place to create crosshairs that help you visualize your image and transfer the forms to your drawing. Figure 3-2 illustrates this kind of viewfinder.

✔ **Adjustable:** This type of viewfinder, as the name implies, has an opening that can be adjusted for when you want to make a square image or a long rectangular image. If you want to make your own adjustable viewfinder, just follow these steps and check out Figure 3-3 for an example.

1. **Cut two *L* shapes out of a piece of 8½-x-11-inch or so sheet of cardstock, cardboard, or mat board.**

2. **On the interior edges of each *L*, copy the marks of a ruler, starting in the innermost corner with zero.**

3. **Clip the two *L* shapes together with large paper clips or butterfly clips to form a square or rectangle the same proportions as the height and width of your drawing paper.**

 You can also use masking tape to temporarily fix the two L's together.

Figure 3-2:
A window viewfinder.

Figure 3-3:
An adjustable viewfinder.

The main advantage to using an adjustable viewfinder is that you can adjust the opening to fit the proportions of your paper so that you have a square opening for a square piece of paper or have a long, rectangular opening for a long, rectangular piece of paper. Having a viewfinder that has the same proportions as your paper makes reproducing the image you see easier.

Identifying other miscellaneous supplies

You can find lots of doodads and other toys for artists in art stores; some of these products are more useful than others. Here are a few you may want to consider:

- **Tape:** Architects' or artists' tapes, found in art supply stores, are acid-free, so you can safely put them on the surface of your paper. Painters' tape, found in any hardware store, is less expensive but not acid-free, so don't use it on your paper if you don't want yellow marks to show up in a few years. But painters' tape can be very useful when you are doing practice and preparation sketches to work from for your other artworks, so do pick up a roll.

- **Tracing paper:** *Tracing paper* (thin, frosted, see-through paper) is used to sketch, to transfer sketches to your pastel paper, and to make compositional studies. A 9-x-12-inch pad is good to have on hand. See Chapters 12 and 16 for more on compositional studies.

 Tracing paper is also a viable slip sheet alternative to glassine paper. Just be sure you buy sheets that are large enough to cover your artwork. (We discuss slip sheets later in this list.)

- **Sketchbook:** A 50- to 100-page sketchbook is a good way to keep all your drawings corralled in one place. Your best bet is a spiral-bound book; hardcover ones are a good, durable option, but they don't quite lay flat as you work. Be sure the paper is acid-free and suitable for soft drawing materials (charcoal and pastel).

- **Slip sheets:** *Slip sheets* protect pastel works from smudging. Artists use glassine paper as slip sheets as a rule, but it may be difficult to find locally in some areas. Check online (see "Buying supplies online" earlier in this chapter for resources) and in art supply store catalogs.

- **Pastel box:** Sturdy plastic or wooden pastel boxes are useful for storing and transporting your pastels. Pastels come in cardboard boxes that fall apart eventually, spilling and breaking all your delicate pastels. The pastels can also become dirty, picking up dust from each other. A pastel box keeps them clean and safe because it has separate divided slots for each stick and often has padding to help protect the pastels.

- **A color wheel dial:** These fancy color wheels are more elaborate versions of the one in Chapter 11. They can help you better identify colors and work out color chord palettes when you're starting a piece.

- **Artist's bridge:** An *artist's bridge* is a long panel of Lucite or other material that you place over the top of your work so that you can rest your wrist and steady your hand as you work without smudging the pastels. These work well on flat surfaces but there are some that attach to your drawing board as well.

Storing Your Supplies

After you have all of your supplies, you want to make sure that you store them to protect them from damage and to get the most use from all your materials. Some of the items come with their own storage containers and some you can purchase separately. Store your supplies in the following ways:

- ✔ **Your pastels:** You can keep them in the boxes they come in for quite a while. Pastel sticks and pencils come in boxes that are designed specifically for the size and shape of the stick and often times have foam padding to keep the pastels from rolling around and breaking. If you have pastels in their original cardboard boxes and need to replace the worn-out box or you want to have something nicer, almost every art store has nice pastel boxes for your materials. You can arrange the sticks by color (all the reds together) or by value (light colors together and separate from middle value colors or dark colors). The choice is up to you. They're going to get out of order anyway and you'll end up rearranging them according to your current project.

- ✔ **Your paper:** For individual pieces of paper, keep it flat in a sturdy portfolio or something else that keeps the paper from getting creased, crumpled, or otherwise damaged. The homemade portfolio we describe earlier in this chapter can hold several pieces of paper until you have a chance to use them. You may even have two portfolios, one for clean paper and one for completed drawings. See Chapter 21 on how to care for your finished drawings.

- ✔ **Small items:** For your viewfinder and sighting stick, blending stumps, spray fixative, tape, and all other small items, a small tool box works fine. You can find art boxes at the art supply store, but they cost twice what they're worth. Many times a small plastic tool box from the hardware store works fine.

- ✔ **Flat items:** For your drawing board, pads of paper, and other flat items, a vinyl portfolio is good. It closes with a zipper to keep everything secure and is heavy-duty enough to hold these weighty items without falling apart or damaging the goods.

- ✔ **Cumbersome items:** A shelf or a closet works to store your easel, apron, and other cumbersome items. You can put the portfolios, the art box, and everything else on the shelf or in the closet. Make sure this area is a *conditioned* area, meaning someplace that is basically room temperature and dry. Keep your spray fixative in an area where the temperature is between 40 and 90 degrees.

Chapter 4

Preparing to Work

In This Chapter
▶ Putting together a pastel workspace
▶ Adopting the right attitude for pastel success

Have you ever been involved in a project and found that it was a bigger commitment than you anticipated? Or had big dreams for a project, but were disappointed by the results? We know we have. Sometimes in our enthusiasm for the project and eagerness to get started, we set ourselves up for failure. How can you prepare yourself to get a firm grasp of drawing pastels so that the endeavor doesn't become a disappointment to you? Easy. Just make sure you're prepared, both physically and mentally. In this chapter, we give you pointers that get you ready to become familiar with this medium.

Setting Up Your Own Workspace

After you have the necessary materials and equipment (see Chapter 3 if you don't have them), you need to determine where you plan on working. You need to consider what kind of space works best and how to set up the workspace to fit your needs. For example, if you want to make pastel landscapes, the answer may seem obvious: You work outside. Don't assume so quickly, however, that you don't need indoor space to work. Even the most proficient pastel landscape artist does some work in the studio. The following sections spell out some important considerations for you as you figure out the workspace that meets your needs and then how to go about creating it.

Choosing between a dedicated space and a dual-use space

You have two options for setting up a workspace: a dedicated space and a dual-use space. Having a space dedicated to pastel work is ideal. You can think without distractions, work, and make a mess to your heart's content. But what if an art-only space is an indulgence you can't afford? You may only have a corner in a shared area of the house to work. Here are some issues to consider about each option:

 ✔ **A dedicated space:** A *dedicated space* (like in Figure 4-1) is devoted only to your pastel work. One argument for a dedicated space is that pastels generate dust. Even though pastels are generally considered to be non-toxic, dust is bad for your lungs (and the lungs of your family and pets). A dedicated

space helps you keep dust corralled in one separated area. (Flip to "Creating a healthy, dust-free workspace" later in this chapter for more on dealing with the dust issue to create a healthy environment in your studio.)

A dedicated space can also keep you focused on the task at hand. Are you one of those people who can't work in a beehive of activity and need peace and quiet? If so, you may need to carve out a space where you can get away from the bustle if at all possible.

✔ **A dual-use space:** A *dual-use space* is a work area that isn't set aside just for your artistic endeavors; it may have an alternate life as your family room, basement — you get the idea. If your mind is always on the activity in other parts of the house, a dual-use space in the middle of the action may be the best option for you.

Although having a dedicated space may be ideal, for most people just starting out, a dual-use space is going to be the norm. After you get a feel for how you work and how involved you're becoming in the medium, you may be able to find the room to eke out a dedicated space.

Figure 4-1:
A dedicated space belonging to a landscape artist.

Photo contributed by Mary Ann Davis

Working with the space you have

When putting your workspace together, your first priority is to make sure you have enough room to move around without tripping over something. You especially need enough space behind you so that you can back up to view your work in progress. The bigger your art is, the more space you need. In an ideal situation, using a traditional setup with an easel, plan for at least an eight-foot square of space. However, we realize that you may not live in an ideal situation, so this section provides some suggestions to help you.

If you're lucky enough to have a large space available for your pastel work, congratulations — you can pretty much use whatever kind of setup you want, so check out the following section "Choosing equipment for your dedicated space" for more on furniture and other considerations. If you're not fortunate enough to have ample space for a large art studio — perhaps you live in a smaller apartment or house and simply don't have the space — you can still create a workable art workspace. You can turn a closet into a studio if you have to (though tiny studios may mean that you make tiny art). Here are some ways you can work when only a small space is available. These tips are also helpful if you're just starting out and can't afford an easel.

- ✔ **Use a wall for an easel.** This option is best because it takes up no space, and you can easily step back to evaluate your work. Nailing Masonite or Formica to the wall creates a smooth surface under your paper so that you can easily tape the paper to the wall.

- ✔ **Work flat on a long folding table.** You can lay out your materials and even a still life setup conveniently and work flat on the table.

- ✔ **Sit to work with your drawing board propped against the table.** Attach your paper to a drawing board and sit with the bottom edge of the board in your lap and the backside of the board propped against the table. This setup isn't exactly ideal — if you're really digging into the drawing, a certain amount of pastel dust can drift down the face of your drawing and into your lap — but it's certainly better than not drawing at all! Just think of doing laundry as a small price to pay for your art.

Choosing equipment for your dedicated space

When you're ready to set up your own space devoted solely to making artwork, you want to take time to choose the equipment that lets you be creative and productive. Whether your studio is a spare bedroom, the basement, or a corner of the garage, you have basic needs to address as you design a space to work. This section points out important furniture and trappings that you as an artist need to include in your workspace as you design it to maximize every square inch you have.

Choosing between an easel and a table

Like painting and drawing, working with pastel is essentially an activity done on a flat surface, regardless of whether the surface is horizontal, vertical, or tilted. The first important choice you make is whether to work on an easel or a table. Here are some options to consider as you make that choice.

- ✔ **Easel:** An *easel* (refer to Figure 4-2a) allows you to work with your drawing upright and to step back as you're working. A sturdy metal or wooden easel made for studio work is the best choice. If space isn't an issue, working on an easel is a good idea because you can stand back from your work and get a clearer view of it. (If space is a problem, check out the "Working with the space you have" section earlier in this chapter for alternatives to using an easel.)

TIP

Don't try to work on a display easel, because it's too lightweight to stay in place while you're working. Choose a heavier-weight easel that gives you more flexibility in how you can position it. Positioning the angle of the easel slightly forward, rather than angled back as you normally would, allows excess pastel dust to fall to the floor rather than down the face of your drawing.

Figure 4-2:
Using an easel (a) versus using a table (b).

✔ **Drawing table:** A *drawing table* is a good way to go if an easel isn't practical for your situation. The top adjusts to a variety of angles as an easel would, and the surface acts as a well-sized drawing board. They're available in a variety of sizes and table heights, including those that adjust to different heights and allow you to stand to draw.

REMEMBER

Standing to work is always best, so if you're working at a regular table (see Figure 4-2b), finding a table the right height is important because you'll be bending over your work. If you're tall, you may want to visit garage sales and secondhand stores for a taller table, perhaps even giving an old dining room table new life in the studio.

Thinking about lighting

When you set up your workspace, you want to make sure you can see what you're doing when you draw with pastels. Lighting is important to your ability to work as well as to the appearance of your pastel art. You have a multitude of different types of lighting to choose from depending on your preferences and the goals you set for your drawing. Your choices are as follows:

✔ **The sun:** The most natural light source, the sun bathes a scene in bright, even light and intensifies color. Remember, though, that the sun is always moving; the intensity changes drastically from midday to evening, as well as the latitude of your position on earth and the time of year. Sunlight

that comes from an angle, as in the morning or late afternoon, or at high latitudes isn't as bright as when the sun is directly overhead. Some artists prefer *north light,* the indirect light from a window facing north. It casts even light, gently illuminating the color of objects.

✔ **Candles, lanterns, and other types of fire:** These types are also natural light sources. The color is warm and the effect is striking, but the light flickers and changes drastically as the fuel is used up.

✔ **Artificial light sources:** In general, these light sources are the most convenient to use and offer the most possibilities for control. The main types are

- **Fluorescent light:** This light is best for large areas such as classrooms or offices. This light casts few shadows and, although great for work environments, looks rather clinical. The light is cool and appears bluish or greenish. The color transfers to your scene — just like it does to your skin in a department-store dressing room — and isn't the best for making artwork.

- **Incandescent light:** This light is warmer in color (slightly yellow) and provides a focused hot spot of light for individual uses such as reading. This type of light is also easy to direct to a focused point and produces cast shadows — drama! But you still have a yellowish light that can affect your work.

- **Full-spectrum lights:** One solution to the dilemma of dealing with color in artificial lighting is full-spectrum lights. This type of light is intended to mimic sunlight and has a good balance of color, but it is a bit pricey. Reveal bulbs from GE are a low-cost alternative. These bulbs appear to be color-balanced and produce a similar effect as full-spectrum lighting. A great solution for now, although recent regulations will soon make all incandescent bulbs obsolete. Fortunately, new low-energy incandescent bulbs are in development right now. These bulbs are color balanced and energy efficient and meet the new federal guidelines, but they're not widely available and are still quite expensive.

When designing your workspace, keep the following pointers in mind about the lighting you use:

✔ **Double-check the positioning of your lighting to make sure that you can draw without casting a shadow on your work.** Shadows may skew how you see your colors on the paper.

✔ **To achieve strong contrasts of light and dark, set up two lights: one to light your work and a separate light for your model or still life setup.** Try to use a color-corrected light or a Reveal bulb for your work so that the colors appear true as you work on the drawing. Use an adjustable, moveable light for lighting your model or still life setup. An inexpensive light that clips to your easel can work, but a better solution is an *adjustable light stand* that allows you to raise, lower, and direct the light. You can find them reasonably priced.

Collecting miscellaneous furnishings

Besides the most basic needs, a few other items are good investments to pick up when you get the chance. To save a little money, we suggest you obtain these items secondhand when possible.

✔ **Comfortable chair (or two) for resting:** Don't leave yourself without a comfortable chair to sit in while you ruminate, read art magazines and books, or contemplate your next move. A studio is a workspace, but you may also use it for reflecting or for visiting with a friend or gallery director. (The glasses of wine are optional.) If you plan to work with models, offering them a comfortable chair is the polite and considerate thing to do.

✔ **Stool or chair for working:** If standing at the easel gets a bit tiresome, you can work from a stool or chair that still gives you a good angle on your work. Just make sure that you don't get stuck to it! Be sure to stand and step back from your work to assess it often.

✔ **Shelving or cabinets:** All artists accumulate art supplies, and they need to put them somewhere. On the cheap end, you can pick up metal shelving units at your local hardware or discount store, or you can upgrade and buy cabinets.

✔ **Floor covering:** If you're standing on concrete while you work, look into laying down a pad or carpet in your work area. Standing on concrete for hours is tiring and hard on your feet, legs, and back. Interlocking sections of padding (such as that used in playrooms and exercise areas) are relatively inexpensive. Carpet samples and remnants also work well.

You also need tables for materials and still life setups. (See Chapter 12 for more on creating still lifes.) Here are some options for different types of tables:

✔ **Folding tables:** Most of the time, folding tables are a good choice. You don't need the long ones; two short six-footers can suffice. Folding tables are cheap and functional, but if you're tall, an uncomfortably low table may hurt your back.

✔ **Taboret:** A *taboret* is a table artists use to spread out their palette, paint, and other materials while they're working. Anything can be a taboret (some dictionaries define it as a footstool), so don't spend extra for the fancy name. One good choice is a rolling cart, such as you may find in a library, business, or kitchen.

✔ **Other optional tables:** If you want to draw your still life setups at different heights, you may want extra tables in various heights.

Creating a healthy, dust-free workspace

Pastel is one of the safest art media to work with, but taking reasonable precautions against dust is always advisable — both for yourself and anyone who shares your home or studio. Working with pastels in shared spaces is totally feasible, but you must take responsibility to maintain a healthy environment. Be considerate of the people you live with. Here are some ways you can minimize dust in your workspace.

✔ **First and foremost, *never, never, never* blow on your pastel drawing!** Even though the pigments and binders are safe, breathing the dust is unhealthy.

✔ **Work in a well-ventilated area.** Doing so keeps your dust exposure to a minimum.

- ✔ **Vacuum the work area often.** Vacuuming reduces the amount of dust that can get kicked up into the air.

- ✔ **Use papers with good tooth.** A paper with good *tooth* (rough surface) holds the pastel pigment in your paper instead of letting it drift around in the air.

- ✔ **Periodically spray the drawing with workable fixative as you build up the layers.** The spray cuts down on the amount of dust in the environment. You can still maintain the celebrated chalky pastel surface by refraining from spraying the final layers.

If you're physically affected *in any way* by pastel dust — hoarseness, raspy throat, pigment colored residue in your nose, or stinging or scratchy eyes — you need to reevaluate your working methods and don a dust mask while you work. Read more in Chapter 3 about equipment for health and safety concerns.

One more important safety tip: Don't spray fixatives in your living space. Breathing the spray is unhealthy and can spoil your furniture, floors, and carpet. Spray the drawings outside or in a specially constructed spray booth.

Getting in the Right Mindset for the Pastel Process

As an adult, you may sometimes forget what being a novice at something is like. At least we've felt that way. When you're very young, your mind is more open because everything is new and you're always learning. After you're good at something — a job, a subject, an activity, *life* — you may find that you suddenly want to be proficient at new tasks immediately. Many folks lose their patience for the learning process, which often requires them to be bad at something — sometimes for a long time. If you're a beginner to drawing with pastels, we want to offer some sage advice: Recover that childlike approach to learning and open your mind and eyes as you work. The pastel process is more than just physically drawing artwork; it's also a mental and psychological process that requires you to balance your analytical side with your intuitive side. You analyze what you are doing and respond to it, but you also must trust yourself to get it down without questioning every mark you make. Here are some ways that you can mentally approach drawing with pastels.

Keeping it simple

Start with simple, geometrically shaped objects such as spheres, boxes, and cylinders. Mugs, balls, wine bottles, pots and pans, and other basic items from the kitchen are a good start. As you become more familiar with how to manipulate the pastel and begin to understand light and the basic structures of things, you move up to more complex objects and arrangements. Soon, you find yourself doing respectable portraits and landscapes, and the work you do to master the basics pays off. You find yourself drawing with understanding, and your pastel drawings are built on solid ground rather than feet of clay.

Giving yourself permission to make mistakes

Whenever you begin something new, you're bound to make mistakes, and that's okay. No one likes to make mistakes, but fearlessly making mistakes (and lots of them) actually helps you move forward and become a better artist. Give yourself permission to make mistakes, and more importantly, learn from those mistakes. The process of mastering any art medium is trial and error, not trial and perfect.

Making a commitment

Some people actually think visual artists don't need to practice; all they need is talent. If only painting and drawing pastels were so easy! Working with pastels — and every other art medium — is a physical activity, and just like other physical activities, those skills need to be developed and used regularly. Translation: You have to make a commitment to work regularly with your pastels. You want to build on what you've discovered in the past sessions, retain the hand–eye coordination you worked so hard for, and generally keep improving, and that takes conscious, continued effort.

Committing also means investing in proper materials and equipment, especially papers. Trying to work on inexpensive paper like newsprint or on papers you have around the house, such as computer paper, isn't going to adequately help you progress. Committing means setting up a reasonable, accessible place to work as well. As we discuss earlier in this chapter, you can work in shared spaces, but make sure that you give yourself plenty of space to work.

Being objective and gaining perspective

When you're beginning to work with pastels, you want to stay objective about your work. You're physically and mentally close to your work as you create it. To really *see* your work, you must stand back from it. Putting it away for a while and then looking at it with fresh eyes is also helpful.

Don't be too emotionally connected with your pastel drawings. Some people can be very sensitive about their artwork, and they feel their art is an extension of themselves. Don't let yourself get so attached that you can't see the problems yourself and have no ears to hear honest criticism from someone else. You can't correct what you don't acknowledge.

One of the best ways to keep your objectivity is to solicit comments from people whose opinions you respect. Having other artists look at your work is the best practice, but you may be surprised at how good an eye many other people have. A person doesn't need to be an artist to tell you whether something looks like it's falling over.

Part II
The Lowdown on Beginning Techniques

The 5th Wave By Rich Tennant

"I painted still lifes for a long time, but I'm slowly getting into figure drawing."

In this part . . .

Very little in life is so ripe with possibility as a new set of pastels and a blank sheet of paper! Of course, we like to think those possibilities always have positive results, but for most folks, beautiful artwork doesn't just flow out and land on the paper. You have to get a handle on the technical stuff and do the grunt work necessary to make the art look like it just flowed out onto the paper, and that's where this jam-packed part comes in.

Chapters 5 and 6 help you get the hang of some important drawing concepts and highlight the stages for creating a work with pastels respectively. In Chapter 7, we delve into the world of pastel papers to guide you to just the right sheet for your project; Chapters 8 and 9 explore the myriad of ways you can lay down pastel on the paper to create a variety of shapes and effects. To help make your drawings more realistic, we show you how to use shadow and form to model your objects in Chapter 10. Color is such an intrinsic part of working with pastel that we devote Chapter 11 to a discussion of all things color, and Chapter 12 rounds out the part by letting you flex your skills with still lifes.

Chapter 5

Building Basic Drawing Skills

The good news: Pastel is a friendly medium for novice artists new to drawing. Even if your skills are limited, pastels allow you to grow your drawing ability.

Many drawing methods can help improve your abilities if you're willing to practice them. Some beginners think that continuing to work the way they always have improves their work, but improvement (not to mention versatility) also comes from trying different approaches. Plus, artists use different kinds of drawing for different purposes, so even though a particular method may not be your cup of tea, you may find it to be a useful tool in certain situations.

In this chapter, we describe the basic methods and strategies for drawing that we refer to throughout this book. Consider this chapter your 101 on drawing with pastels. Most of these methods help you lay out a strong initial sketch, but we hope you use them as tools to improve your skills as well.

Using the Tools of the Trade

Artists have two tools that assist them in seeing and transferring their chosen scene to paper: a *viewfinder* (a cardboard frame that isolates your scene) and a *sighting stick* (a slim, straight stick used for finding angles and measuring lengths). They may seem to be a bit of an art cliché — like wearing a beret — but they really are useful tools that we strongly encourage you to add to your arsenal of strategies for tackling drawing. The following sections help you utilize these tools.

Finding your scene with a viewfinder

You use a viewfinder to find and isolate a scene so that you can draw it. It helps you focus on the scene by blocking out the visual clutter in the area around the section you want to draw. If you mark the inside edges of the

viewfinder into sections, it's easier to transfer exactly what you see. An index card with a 1½-x-2-inch window cut out works very well for an 18-x-24 or 9-x-12-inch sheet of paper. If you want more flexibility, you can configure two *L* shapes cut from cardstock or mat board for any rectangular format. You can find instructions for making a viewfinder in Chapter 3.

If you're using a viewfinder made from an index card, you can divide the window into quarters by taping a horizontal thread and a vertical thread across the center sections of the window. Then lightly draw a horizontal line and a vertical line from the center edges of the paper. Transfer what you see in each quarter to the paper, paying close attention to where the lines of the initial drawing are positioned along the edges. You can see a diagram of an index card with threads attached in Figure 5-1.

Figure 5-1:
An index card with threads attached.

To use your viewfinder, follow these steps:

1. **Hold the viewfinder so that any ruler marks you made face you and look through the window viewing area at your subject.**

2. **Move the viewfinder around the arrangement trying different views until you find the scene you want to draw.**

 Treat the viewfinder like you do the viewfinder in your camera when you're finding the right shot to take, turning and moving it different directions to fit in the pieces of your arrangement you want in your scene.

3. **Compare the markings on your viewfinder with the objects in your scene and find two points that you can keep lined up as you work.**

 For example, the top of a bottle may line up with the halfway point on the edge of the viewfinder, and maybe the handle of a spoon is positioned at one corner. This tactic helps you maintain the same view or return to it if you move your arm or leave the drawing before you have finished blocking it in.

While you're at it, mark an *X* on the floor where you stand or sit with easy release masking tape so you can always set up in the same place. You can't get an accurate lineup of your key points if you start from a different position during every session.

4. **Lightly mark these key viewfinder points on the edges of your rough sketch and your drawing.**

 These marks can help you transfer and maintain the general positions and proportions of your objects as you see them in the viewfinder. Figure 5-2 shows you how to find key points in the viewfinder.

Figure 5-2: Finding the position of objects within the window of a viewfinder.

Sighting and measuring with a sighting stick

To sight and measure objects for your drawing, you need a sighting stick. The best sighting stick is a straight kabob skewer, but you can also use a slim eight-inch dowel rod, a narrow paintbrush, or a pencil. The narrower and straighter the tool is, the better.

Here are a few tips for using a sighting stick:

✔ When measuring the objects you're drawing, hold the sighting stick in your hand at arm's length in front of you, ideally with your arm perfectly straight. If that's a little rough on your elbow, you can relax your arm slightly — just make sure you hold the stick at the same distance every time.

✔ As you're sighting and measuring objects, close one eye so that you only have to deal with one view of your subject.

✔ To find the height of an object, hold the sighting stick vertically so that the end of the stick lines up with the top of the object. Position your thumbnail in line with the bottom edge of the object. You compare this measurement with the widths and heights of all of the other objects in your arrangement to establish correct proportions.

✔ Finding the angles for the bottom and top edges of a box is a little tricky. First, find the *leading edge*, the closest vertical edge of the box. To find the angles of the top or bottom of the box, hold the sighting stick horizontally and line it up perpendicularly with the top or bottom of the leading edge and estimate the angles. You can see how to use a sighting stick to sight and draw a box later in the chapter.

Compare the angles of the edges of the box with the degrees of angles you know. For example, when the sighting stick and the leading edge are perpendicular to each other, they make a 90-degree angle. Half of that angle is 45 degrees. From there, you can estimate how much more or less than a 45-degree angle the angle of the edge is and then draw the angle.

"Constructing drawings transparently" later in this chapter gives you step-by-step instructions for sighting and measuring boxes and cylinders.

Mastering Basic Drawing Strategies

When you were a young child, you probably made line drawings and then colored them in with crayons. If you aren't exposed to other ways of working, this method carries over into your adult drawing, including the work you do in pastel. The method isn't wrong, but it *is* time consuming and doesn't allow you much flexibility in the drawing process. Other methods can do a better job of helping you capture the images more realistically and make your work look more three-dimensional. Mastering them broadens your palette and makes your work more sophisticated, much like moving from the peanut butter and jelly sandwich you liked as a child to developing a taste for sushi. The following sections walk you through these basic drawing techniques you can utilize with your pastels.

Getting started with basic shapes

When you're first getting acquainted with your pastels, the best way to get a handle on them is to just sit down and experiment. In this section, you can practice drawing and shading simple objects — a sphere, a box, and a cylinder. Later in this chapter in the "Constructing drawings transparently" section, we delve into more detail to draw these shapes. For now, though, just experiment. For more detailed instructions on how to draw the shapes, flip to Chapter 10 which gives you more instruction on modeling your forms to create realistic shapes.

Drawing a sphere

A sphere is an easy shape to sketch and draw when you're just starting with pastels. To draw and model one, follow these steps:

1. **In your sketchbook, draw a circle for your sphere with a dark pastel pencil.**

2. **Making very light lines, copy the shapes of the shadows you see in the sphere in Figure 5-3.**

3. **Look at the light and dark values in Figure 5-3 and model your sphere with similar values, making sure the deepest areas of the shadows are as dark as you can make them.**

 Make sure to maintain the light areas that represent reflected light at the bottom of the sphere.

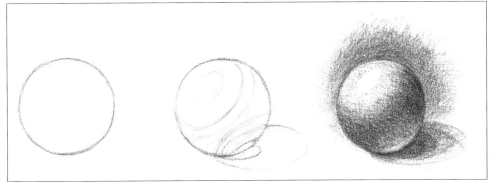

Figure 5-3:
A modeled
sphere.

Drawing a box

A box is another simple shape to sketch and draw when you're beginning your pastel adventure. Here's how you can draw and model one:

1. **Using light lines, draw a box such as you see in Figure 5-4.**

 Avoid using heavy lines on the edges of the box because it will look like you did it in a coloring book, flat and outlined. A well-modeled box focuses on the values of the *planes* (surfaces) instead of relying on lines to define the changes in the surfaces.

2. **Lightly draw the shape of the shadow cast by the box to mimic Figure 5-4.**

3. **Look at the light and dark values and copy the values as closely as you can.**

 Notice how every side of the box is a different value. See the white line along the edge of the box where the top and lighter side meet? Also, notice the variations in the darks used for the cast shadow. Make sure the grays you use on each surface of the box aren't too evenly modeled across each plane; it's more realistic to allow the grays to vary a bit across each plane. Making each plane a different value is the "general" part of beginning your modeling, but looking at the nuances within those values is how you look at the "specific" to develop your drawing.

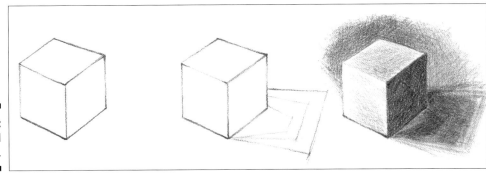

Figure 5-4:
A modeled
box.

Drawing a cylinder

A cylinder is another shape you can practice sketching and drawing when just starting out with pastels. These steps show you how to draw and model one:

1. **Lightly draw a cylinder similar to the one in Figure 5-5.**

 Make sure the bottom of the cylinder doesn't look flat. (If you have trouble, see "Sighting and drawing a cylindrical object" later in this chapter for tips on how to draw a cylinder.)

2. **Look at the shadows cast by the cylinder in Figure 5-5 and lightly draw the shapes of shadows cast by your cylinder.**

3. **Look at the shapes of the values in the cylinder and model your cylinder in a similar fashion.**

 Notice how the values are shaped like vertical bands around the cylinder and take stock of which bands are dark and light. The dark side of the cylinder isn't modeled strictly with dark values; it has a light edge. If you use horizontal strokes to model your cylinder, make sure that the strokes fit within the vertical bands so that your cylinder looks smooth.

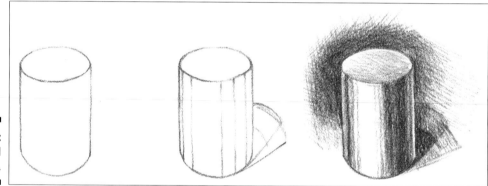

Figure 5-5: A modeled cylinder.

Getting the gist with gesture drawing

Gesture or *action drawing* is a very forgiving, intuitive drawing method in which you quickly sketch the movement and essence of a form without concentrating on the details. Each one should take less than five minutes — really, more like two minutes for an 8 to 10 inch drawing. You don't need to be perfect, and you can correct your work as you draw; think of it as trying to get the gist of a form. You typically use gesture drawings for laying in initial drawings and making rough sketches, but they're also great for building drawing skills. The more gesture drawings you make, the faster you develop skill. Chapter 19 shows you how you can incorporate gesture drawing into your work.

Gesture drawings can be any size. To use gesture drawing in your pastels, keep the following steps in mind:

1. **Find the general directions of the form.**

 To find the direction, look for the general movement in the form. Think of it as the flow of energy through the form; for example, if water was running through it, what would the shape of the stream look like? The

first line you make determines the finished size of the object, so pay attention to how long that first line is. You can see these initial marks in the first gesture drawing in Figure 5-6.

2. **Add mass in fluid, continuous lines that move in and out of the form instead of sticking with the contours.**

Don't pick up your pencil while you work, and absolutely do not erase! Leave the changes that you make in your drawing so you can see the history of the drawing on the paper.

As the drawing develops, you add more information about your subject. In fact, make a rule that the lines must continually say something new about the form. Each change in the line can show something about the shapes of the objects and help refine their shapes. Speed is an essential part of making gesture drawings, but if you find yourself making marks in the same area without adding new information, stop for a second to look and then begin again. Making the same marks over and over is redundant; you just aren't going anywhere.

In Figure 5-6, you can see gesture drawings in different stages of development.

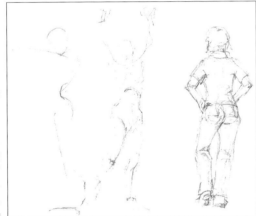

Figure 5-6:
Gesture drawings in different stages of development.

When you feel more comfortable with this process, you can strive to create *sensitive lines* as you work. These lines have beautiful line quality but are elegantly packed with information about the form. They concisely follow the form of an object, but the changes in line weights also connect to the form's shape and the lighting on the object. Heavier weights in the line communicate stress, energy, heaviness, and dark shadows, and lightly weighted areas of the line may communicate lit areas, lift, bulging forms, and so forth.

Constructing drawings transparently

Transparent construction is an analytical method of drawing that helps you draw objects three-dimensionally and create realistic space relationships between objects. A common error in drawing is making objects appear to occupy the same space, and we discuss how this tendency can cause problems in your compositions in Chapter 11. If you draw them transparently, you

can identify and correct or avoid these errors because you can see the space each object occupies.

You can use the following instructions for sighting and drawing a transparent box and cylinder. Although they may differ in degree of complexity, you can draw most geometric shapes by creating boxes, cylinders, or combinations of both, with these processes. Transparent construction also works for other kinds of objects, too. In Figure 5-7, you can see how constructing a shoe transparently makes understanding and depicting it three-dimensionally easy so that you don't continue to struggle with the form when you begin applying pastels to your initial drawing.

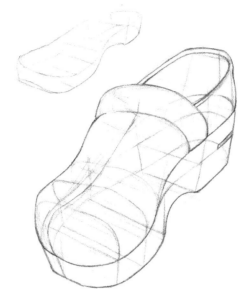

Figure 5-7:
Using transparent construction to draw a shoe.

Sighting and drawing a box

Use this procedure to sight and draw problem-free boxes. Follow along in Figure 5-8.

1. **Draw a line that represents the leading edge of your box.**

 This first line you draw determines how big your box becomes. Head to "Sighting and measuring with a sighting stick" earlier in this chapter for more on leading edges.

2. **Begin sighting and drawing the left side of the box.**

 Hold your sighting stick horizontally at the bottom of the leading edge of the box and estimate the angle of the bottom of the left side of the box as in Figure 5-8a. Draw a longer line than you need that represents the angle. The length isn't important at this point because you find the width of the box in a separate step.

3. **Hold the sighting stick horizontally at the top of the leading edge of the box to estimate the angle of the top left front edge of the box and draw a line that represents that angle.**

4. **Add the left edge of the box.**

 Hold the sighting stick vertically along the leading edge so that the end of the stick lines up with the top of the box. Position your thumbnail on the stick in line with the bottom edge of the box; that's the measurement you use to compare other distances on the box. Now, turn your sighting stick horizontally and compare this length with the distance between the leading edge and the vertical edge on the left side of the box. Ask yourself what proportion of that length the distance between the two edges is (half? Two-thirds?). Decide what portion of the distance it is and draw a vertical line to represent the left edge of the box, allowing it to cross the two diagonals you drew in Steps 2 and 3. That line completes the left side of the box.

5. **Repeat Steps 2 through 4 for the right side of the box.**

6. **Draw the back edges of the top of the box.**

 Hold your sighting stick horizontally at the top of the leading edge and estimate the diagonal angle from the closest front top corner to the farthest back top corner. Draw it very lightly. Hold your sighting stick in the same position and estimate the distance from the front corner to the back corner and mark it on the diagonal line.

 Make sure you don't set the corners too far apart from each other, because that makes the top of your box look flipped up.

7. **Draw the back two edges of the top of the box by connecting the side corners with the back corner you identified in Step 6.**

8. **Draw the back and bottom of the box.**

 Drop a vertical line about the same length as the leading edge from the back top corner of the box. Then draw a line from the bottom left corner to the bottom of the back vertical, staying parallel to the back top left edge. Finally, draw a line from the bottom right corner to the back vertical, staying parallel to the back top right edge. Figure 5-8b shows you the whole sequence.

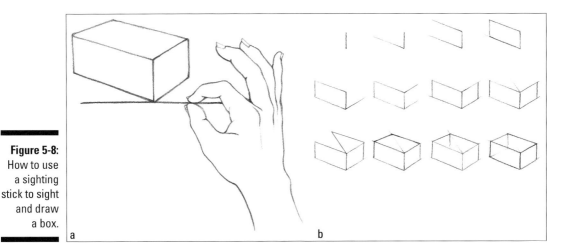

Figure 5-8:
How to use a sighting stick to sight and draw a box.

a b

If you need to find the middle of a side of the box — to place a window or door on a house, for example — simply draw an *X* by running diagonal lines from one corner to another and then run a vertical through it as you see in Figure 5-9. If you run the line higher, you can use it to find the peak of a roof.

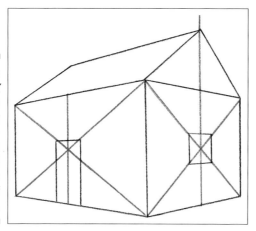

Figure 5-9: Use an *X* to place centrally located windows and doors and establish the peak of a roof.

Sighting and drawing a cylindrical object

The following steps (and Figure 5-10) show you how to sight and draw a cylindrical object:

1. **Draw the silhouette of the object as if it were a flat shape.**

 Draw lightly until you know the shape is correct. For example, a tin can would be a simple rectangle.

2. **Draw a middle line vertically down the center of the object so that the right and left sides are equal.**

3. **Draw a horizontal line at every point that the sides of the object change direction.**

 These horizontal lines act as the *major axes* for the ellipses you draw in Step 4. For example, the shape of the wine bottle in our example changes direction at the neck, so we draw a horizontal line at that point and another horizontal line where the line transitions to the main body of the bottle.

4. **On each of these lines, draw an ellipse.**

 If you're looking down on the object, make sure that the ellipses at the top of the object are narrower than the ellipses at the bottom. You can sight them by holding your sighting stick at the point of the major axis and mentally measuring how much below that line the ellipse hits.

 Make sure you draw a true ellipse, not a football, almond, or racetrack shape. Getting the shape right can help you avoid making flat-bottomed cylinders, which is one of the rookie mistakes you can see how to avoid in Chapter 12.

You can also draw a cylinder by using a box shape, as you see in Figure 5-11. Not all cylinders are conveniently standing upright for you, and this method is particularly helpful if the cylinder is lying on its side. You must make certain that the rectangles for the front and back of the box appear to be

foreshortened (shorter than they actually are) squares for this technique to work. You may need to tinker with the widths of the rectangles to get the proportions right.

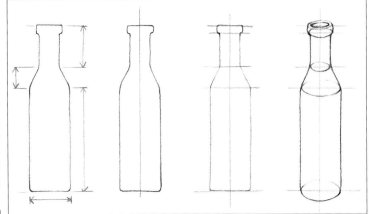

Figure 5-10: The process for sighting and measuring a cylinder.

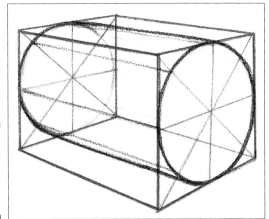

Figure 5-11: Using a box to draw a cylinder on its side.

Making linear perspective easy

Linear perspective is one of the most useful tools in your bag of drawing tricks, but many people avoid it because they think it's too much like math. Linear perspective defined Renaissance art and much of realistic Western art up until the last century because it gave artists the opportunity to create infinite depth, like a window onto another world, rather than be limited to flat space. *Linear perspective* is built on the premise that all things appear to diminish in size as they recede into the distance. You need to understand only the following three concepts to have a working understanding of how to use linear perspective:

- ✔ **Eye level line:** The *eye level line* (also known as the *horizon line*) represents the level of your eyes when you look straight ahead. Even if you look up or down, your eye level line is determined by looking straight ahead. If you were Superman and used your laser vision to burn a level

line around the room at your eye height, you'd have a perfect horizontal eye level line. Every composition has only one eye level line, and it's always perfectly horizontal.

In this context, the horizon line isn't the place where the sky and the earth meet; it's just another term for eye level line.

✔ **Vanishing points:** You've probably seen railroad tracks that converge at a single point in the distance. This point is the *vanishing point.* Vertical objects, such as walls and rows of windows, trees, and fence posts, also appear to diminish in size as they appear farther away, and the lines that mark their tops and bottoms eventually converge at a point just like the lines of the railroad tracks do.

Almost all *vanishing points* are situated on the eye level line. It doesn't matter whether you draw objects that are sitting on the floor or hanging from the ceiling; they all utilize vanishing points situated on that one eye level line.

✔ **Convergence lines:** The *convergence lines* for an object are the guidelines that run through and from the object to the vanishing points. The lines that mark the tops and bottoms of walls, for example, are convergence lines that continue past the end of the wall to the vanishing point for the wall. They're invaluable for keeping windows, rooflines, doorways, and many other architectural details in line.

The funny thing about linear perspective is that it assumes that you're standing in one spot with one eye shut. Hold up your hand and look at it with one eye. Now close that eye and open the other. See how the position of your hand appeared to change? Linear perspective is great for capturing a single point of view and moment in time, but it can be confusing because the view changes if you move.

Whether you're drawing an intimate still life or a building, most of the subjects you draw rely on two methods of using linear perspective: one-point and two-point. Deciding which to use for an object is easy:

✔ If the back wall of a room or the flat plane of a box or building is facing you, use one-point perspective.

✔ If you're looking at the edge of a box or the corner of a room, use two-point perspective.

The following sections describe both options in more detail.

One-point perspective

In *one-point perspective,* all the lines that describe the sides of a box or the side walls of a room converge at a single vanishing point. The lines for the rectangle that faces you — the back wall of the room or the front of the box — are perfectly horizontal and vertical. In the following sections, we show you how to draw both a box and a room in one-point perspective.

Drawing a box in one-point perspective

To draw a box in one-point perspective, follow these steps. Check out Figure 5-12 for an example.

1. **Draw a horizontal eye level line from one edge of the paper to the other.**

2. **Draw the rectangle to represent the front of the box below the eye level line.**

 This image depicts a box as though you're looking down on it.

3. **Draw convergence lines from the corners of the rectangle to a vanishing point on the eye level line.**

 In one-point perspective, the vanishing point represents where you are in relation to the box (to the side of it, in front of it, and so on). In Figure 5-12, we're positioned in front of the box, so we put the vanishing point directly above the rectangle.

4. **Draw a horizontal line to represent the top back side of the box.**

5. **Drop verticals down from the back corners to the convergence lines that originate with the bottom of the front rectangle.**

6. **Draw a horizontal line to unite the two bottom back corners.**

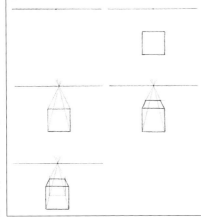

Figure 5-12: Drawing a box in one-point perspective.

Drawing an interior in one-point perspective

The following instructions and Figure 5-13 help you draw a room in one-point perspective.

1. **Draw a rectangle that represents the shape of the back wall of the room.**

2. **Draw a horizontal eye level line from one edge of the paper to the other.**

 It should run through the rectangle at a height relative to your own eyes.

3. **Draw lines from the vanishing point through the corners of the rectangle and out to represent the side walls of the room.**

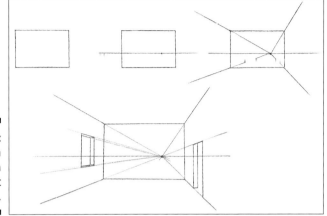

Two-point perspective

In *two-point perspective,* you have a vertical leading edge of a box facing you and the lines that define the sides of the box recede and converge at vanishing points on each side of the box. The following sections show you how to draw both a box and a room in this perspective.

Drawing a box in two-point perspective

To draw a box in two-point perspective, follow these steps.

1. **Draw an eye level line.**

2. **Draw the vertical leading edge of the box below the eye level line.**

 This view depicts a box as if you're looking down on it as in Figure 5-14a.

3. **Draw the convergence lines for the sides of the box.**

 Run them from the top and bottom of the leading edge to vanishing points marked *vp1* and *vp2* (or whatever you want to label them).

4. **Draw verticals for the edges of the left and right sides of the box as in Figure 5-14b.**

5. **To draw the top of the box, draw convergence lines from the right top corner to vp1 on the left and from the left top corner to vp2 on the right as in Figure 5-14c.**

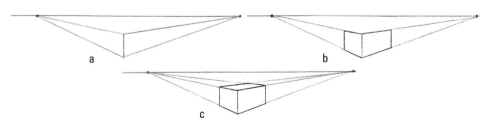

Figure 5-14:
Drawing
a box in
two-point
perspective.

Use a similar procedure if you're looking up at a box or straight on. You can see examples in Figure 5-15.

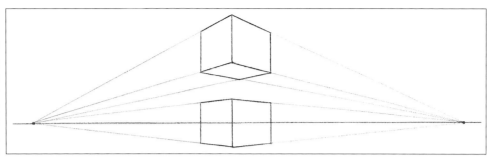

Figure 5-15:
Looking up at a box or straight on in two-point perspective.

Drawing interior walls in two-point perspective

Drawing the walls of a room in two-point perspective is like drawing the inside of a box but not the outside. Consult the steps that follow and Figure 5-16 to see how this technique works.

1. **Draw a vertical line for the interior corner of the room.**

2. **Draw the eye level line.**

 Make sure the eye level line runs across the vertical at a height relative to your own.

3. **Add the vanishing points (marked *vp1* and *vp2*, or however you want to designate them).**

 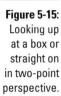

 For your first interior, put your vanishing points on the eye level line at the edges of the paper to avoid creating a distortion that looks like a fish eye lens view. Afterward, you can try placing the vanishing points at different positions on the eye level line to see how they change the point of view in the room.

4. **To draw the wall on the left side of the room, run convergence lines from vp2 on the right to the top and bottom of the vertical and beyond to depict the wall on the left.**

5. **To draw the wall on the right side of the room, run convergence lines from vp1 on the left to the top and bottom of the vertical and beyond to depict the wall on the right.**

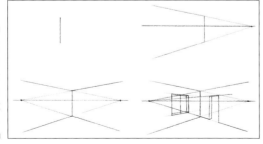

Figure 5-16:
Drawing interior walls in two-point perspective.

Applying linear perspective to useful situations

After you get the hang of linear perspective, you can use it for many more objects than just boxes and walls. Figure 5-17 shows you how linear

perspective can help you draw accurate staircases (a) and windowed walls (b); you may even find more helpful uses for it.

Figure 5-17: Using linear perspective to help you in some useful situations.

a b

Knowing when to try more advanced techniques

As you work on developing your skills, you may begin to feel fairly confident in your abilities and want to try something a bit more difficult. In order to know you're ready for more advanced techniques, make sure you're continually evaluating your work honestly. To evaluate yourself, use the inventory checklist that we provide in the earlier section "Setting realistic goals and evaluating your progress."

If you're evaluating your work honestly, you can move up to more advanced work when you believe that your skills in an area are relatively competent. If you think you're doing great work, you need to raise the bar if you want to continue to progress. Maintaining a low level of dissatisfaction with your work is good, but balance that with a healthy eye for what you're doing right and can use to challenge yourself further.

What exactly constitutes more advanced work? It includes more complexity or variety in subject matter and compositions, larger projects, and added difficulty. For example, still life is easier than a human figure or portrait. To some degree, after you're accustomed to working with pastels you can follow your whim, working with subject matter that interests you. If you get in over your head, you know it immediately, but continue to try to pull the work together even if it looks like a big mess. You may surprise yourself by succeeding at this extra challenge, but even if the work turns out badly, you can learn from the experience and know to back off a bit with the next project.

Combining Photographs Using Linear Perspective

Although working from life is your best option, we realize that it's not always practical. Many kinds of subjects are temporary or have some temporal aspect that limits your access to the original state you want to capture. (Check out

Chapter 16, where we discuss using photos with landscapes.) Therefore, you can use photography in an attempt to capture that moment in time, the details of the subject, and its surroundings in hope that you can preserve the initial image that inspired you. Taking many photographs is important for gathering as much of that information as possible so that you can combine those images to create a realistic scene you can't capture in a single photo. The goal is to put the photographs together as a cohesive, uninterrupted scene, and most folks take photographs from many different points of view and expect them to meld together as a unit when they copy them. Unfortunately, it doesn't work that way.

When you combine photographs taken from multiple points of view to make a single scene, use your knowledge of linear perspective (discussed in "Making linear perspective easy" earlier in the chapter) to construct the scene from scratch while consulting your photographs. Maintaining a single point of view is the biggest challenge, and the best way to conquer it is to establish a consistent eye level line throughout the work. All the objects in the scene, whether it's an interior or exterior, have convergence lines and vanishing points that relate to that eye level line, so after you lay it in, you have a reference for all the other objects.

Acting Like an Artist

If you consider pastel to be a pastime or a hobby, you may not see yourself as an artist. The value of thinking of yourself as an artist is that you start acting like an artist (rather than someone who just dabbles in art), and the quality of your work rises to match the level of effort you put into it. Here are some habits artists do that help improve their work — incorporate them into your own pastels studies.

Working from what you see, not just from your imagination

Artists who make realistic images have a strong background in drawing from observation — what they see. If you work only from your imagination when you make images with your pastels, you become proficient at doing one kind of work and never improve your skills as a whole. Even though works in that strong category may look professional, you may struggle when you try to switch to something else.

Drawing from what you see and observe is important to your growth as a pastel artist because

- ✔ **It helps you build the skills necessary to accurately transfer what you see to paper, which has the added advantage of increasing the inventory of objects, lines, forms, and other shapes that you can draw when working from your imagination.** It helps you understand how to manage the space in your composition, to see how light affects the value pattern, to see how color changes across a form, and many other aspects.

✔ **It allows you to communicate with other people.** Drawing objects as they actually appear helps you to convey them and their meanings accurately to viewers much like common sign shapes communicate that you should stop your car at the next corner. Drawing from observation helps you build your visual language skills (discussed in the following section), giving yourself more sophisticated material and flexibility in the kinds of images you can make.

Building visual language skills

Visual language skills, also called *visual vocabulary,* are the inventory of kinds of shapes, lines, patterns, techniques, and strategies for working that you accumulate as you study how to make images. They become part of the visual language you use to communicate with your viewers.

Ways you can build your own visual language skills include the following:

✔ Draw both still lifes and live subjects from observation, not from your imagination (see the preceding section).

✔ Make rough sketches to study composition and color.

✔ Visit museums to look at artwork by contemporary and old masters.

✔ Visit galleries to look at artwork by local, regional, and national artists.

✔ Study arts and crafts from other cultures.

✔ Be aware of trends in popular culture, including cultural images used as metaphors and symbols (such as the use of pink ribbons to represent the fight against breast cancer).

To build your visual language skills, make sure you view artwork (in any medium, not just pastels) in person instead of looking at reproductions in books or on the Internet. Standing in front of a piece gives you the opportunity to see how it was made, which is impossible to tell from a reproduction. Books and the Internet just can't show you the details, such as how large an artwork is or what its surface is like, and the colors are almost always wrong.

Making thumbnail sketches

Making thumbnail sketches and rough sketches is an essential part of the creative process whether you're planning a composition or a sculpture project. Generally speaking, *thumbnail sketches* are small drawings done in preparation for other work. The term *thumbnail* may imply that the sketches are tiny, but most artists actually draw them in a size somewhere between a credit card and a postcard.

You can also use thumbnail sketches to document artworks by other artists that you see in galleries and museums. Making a rough drawing as you're observing the artwork can help you remember what a work really looks like later on when your memory may forget certain details.

Chapter 6

Diving Into the Drawing Process

*W*hether you're a true beginner to pastels or have some familiarity with them, working intuitively and diving right into the artwork seems to be the best way to start. You're probably familiar with the idea of an artist launching into a work of art with intense passion, overcome with the spirit of creation. You may even have the idea that planning an artwork somehow interrupts the creative act and makes your artwork less true or less passionate. Not true — you need many years of experience (and a well-equipped studio) to be able to fly into an artwork with success. Thinking ahead and setting the stage for success benefits you and your artwork.

In Chapter 4, we discuss how to prepare your physical environment for working in pastel. In this chapter, we get down to real business and make some drawings, as well as show you the basics.

The concept of working from general to specific is an important factor in making any artwork, so this chapter gives you an overview of that process. Later chapters show you how to use the technique in specific situations.

Getting Ready to Draw: Planning and Preparing

Before you actually sit down and start drawing your pastel masterpiece, you want to be sure all the elements are in place, including choosing your subject, setting it up with a good point of view, and arranging the lighting effectively. Be sure to take your time with each one. You may even want to start with a setup of simple still life items — we suggest one to three objects. (Chapter 12 gives you more info on working with still life subjects.) This section points out the preliminary steps you need to take to prepare to draw before actually drawing your final product.

Choosing your subjects: Start easy

Your pastel drawing is only as good as what you choose to draw. You can avoid many problems and frustrations right off the bat by choosing your subjects well. *Subject* is just the art term for the item you're drawing. Subjects can be simple objects like oranges and books or something complex like rivers, trees, and people. You choose your subject based on your skill level and where your interests take you.

Even though you may have grand visions of drawing some intricate and detailed object, we suggest you start with simple subjects. Leave the more difficult subjects on the back burner for a bit until you get more adept at drawing with pastels. Begin with easy still life objects with simple geometric forms; these forms give you a good foundation for drawing more complex subjects, such as the human figure, later. With these simple subjects, you can discover how to *model* objects (create a realistic-looking figure) without having to struggle with getting their shapes at the same time.

Starting with simple arrangements and small drawings is also important. These small-scale drawings give you a chance to make your mistakes, gain some successes, and move on. Struggling through a large drawing with few successes can be time consuming and disappointing. (Check out the following section for more on arranging.)

Arranging your subjects with a viewfinder

Setting up your subjects in an arrangement is an important step you have to take before you can start drawing because a bad arrangement isn't going to miraculously transform into a masterpiece when you put it on paper. When you arrange your subject, you want to make sure you use a simple background and a variety of forms and can see all the items clearly. Cluttered scenes or objects lined up in rows just aren't that interesting to look at or draw.

A viewfinder is a simple tool that can make your arranging job much easier. *Viewfinders* are valuable tools that help you zero in on what image you want to draw. You can purchase a viewfinder, find one online, or make your own by following the directions in Chapter 3.

After you have your viewfinder ready, look through its window at your subject like you'd look though the viewfinder of an old camera. The viewfinder frame allows you to visualize your current setup as a possible composition for your artwork by isolating the image so you can judge its overall effect. Try several arrangements of your items and use your viewfinder to look at the subject from several points of view (for example, from the left, right, top, bottom, and so on) to see what strikes your fancy. You may rearrange a few more times as you draw thumbnail sketches (as we discuss later in the section).

The shape of the viewfinder's opening must correspond to the shape of your drawing. Here are two ways to check:

> ✔ **Stand back from your paper and look through the viewfinder.** Make sure the edges of the paper visually touch the edges of the window in your viewfinder.

✔ **Lay the viewfinder on the corner of your paper.** Lay a ruler or other straightedge diagonally across the paper so that the corners are connected. If the straightedge passes exactly through the corner of your viewfinder, it'll work.

Setting your lighting

After you settle on an arrangement (see the preceding section), play around with the lighting of your scene. Usually, the best light source position casts light across the objects rather from up above or directly in front of the subject because it casts interesting shadows. For landscapes or outdoor scenes, early morning or late afternoon light gives you the most interesting pattern of light and shadows. For a still life or interior scene, the *raking* light (light falling across an object from one side) from an open window, a clamp light, or a desk lamp gives you a clear light source and creates some dramatic shadows. Check out Chapter 4 for an in-depth discussion on the types of lighting available to you.

Making thumbnail sketches

After you arrange your subject and have the lighting just right, you have to experiment to determine whether the scene holds your interest and has potential for success. By making some initial experimental sketches (often called *thumbnail sketches*) in your sketchbook, you can try out several possible compositions, points of view, and subjects. Each of these sketches is small (3 x 4 inches or so), and very quickly done. You see little detail in the sketches — only enough information to show the item's position, relative size, and relationship to any other items in the scene. These preparatory sketches allow you to get to know your subject and its qualities and practice drawing it. You can use an ordinary pencil, pastel pencil, or whatever's at hand.

In Figures 6-1a and 6-1b, we show a couple of options for sketches of an apple and a glass. Notice how loose and informal they appear — they're just thumbnails.

Figure 6-1: Thumbnail sketches of various arrangements of a subject.

a

b

Figure 6-2 shows you how we changed the arrangement and point of view from the illustration in Figure 6-1. The new version shows the inside of the glass, making it more interesting to draw and giving the drawing more dimension.

Figure 6-2:
A thumbnail sketch with a more interesting object position and point of view.

Making thumbnail sketches to plan out your work is an essential step of working with pastels, but it doesn't require a lot of time — maybe 10 to 15 minutes for a simple setup. Planning difficult or complex setups, however, may benefit from making fairly elaborate, more complete drawings in charcoal that may take one to two hours to complete.

After making a few thumbnail sketches, you can also experiment with the forms by putting a frame around your scene to try out different formats. Turn the viewfinder vertically or horizontally and play with how close the edges are to the subject. Going back and forth between arranging and sketching is all part of trying out the arrangement and lighting and seeing how they fit in your piece. Each arrangement has a different effect, and you just have to try them out to see what works.

Choosing and situating your drawing surface

You have many choices of materials to draw on with your pastels, but we suggest that you initially stick with a straightforward option, such as a 9-x-12-inch medium-texture pastel paper in a simple color like white or off-white. Using a white paper with a medium texture (often called *tooth*) for your initial projects helps you get the hang of working with pastel. Heavily textured papers and those with strong colors are more difficult for beginners to deal with, and smooth textured papers are not suited for pastels and can trip you up in your first efforts. Avoid multipurpose papers; other than for simple sketching, they aren't ideal for pastels because they don't have the right amount of tooth. As you gain more experience, you can select more specialized papers with rougher textures, strong colors and/or larger sizes. Check out Chapter 7 for more on available papers.

The color and texture of the paper influences the overall effect of your work. Because of the rough texture, the color of the paper may show through the pastel as you work and still be visible in places after you complete the drawing. To exploit this tendency as your skills progress, you can experiment with gray or black paper for a striking effect, or be adventurous with color by drawing something unexpected, like a red apple on blue paper.

You need to attach whatever paper you use to a drawing board to keep it steady and secure. Use artists' tape to attach your pastel paper to the board. (If you are working on a rigid board, such as a hardboard panel prepared for pastels, you can attach it directly to the easel at the correct position.)

The position of your drawing surface is very important as you work because you must have your paper surface roughly parallel to your face. The top of your paper should be the same distance from your eyes as the bottom of the paper (as in Figure 6-3) so that you don't get a stretched image with elongated forms. Do keep in mind that whether you have your drawing set up at eye level or slightly below affects the tilt of your surface, as does the natural tilt of your head.

Figure 6-3:
How to position your work surface.

Putting Pastels to Paper: Beginning the Pastel Drawing

After you finish your preparations (see the preceding section), including making some initial thumbnail sketches, you're ready to actually start drawing with your pastels. Are you excited yet? We're excited for you, and in this section we guide you through the initial steps of the formal drawing.

We can't stress enough how important preparing for your pastel project is. If you haven't read the preceding section "Getting Ready to Draw: Planning and Preparing," we strongly recommend that you do so before proceeding.

Laying out your drawing: Making the first marks

As you get ready to start on the drawing itself, you need to figure out where to lay your marks, which is a lot easier if you gathered information with your thumbnail sketches. That said, work from direct observation as you lay out your drawing and not from your thumbnail sketches. You can use the sketches as references, but you want to work from the original source for your artwork to keep your image true.

Begin with light, loose marks by using your pastel pencils, which are a bit harder than pastel sticks and great for drawing out the general shapes of the forms. Find and lightly sketch in the *center lines* (a guideline that bisects a form) and the angles and ellipses for each object, using bundles of light lines rather than heavy or firmly drawn outlines. This strategy helps you establish the general position of your forms before you commit yourself to one set position, size, or scale.

Don't worry about details at this point; just note the general position of the major forms for now. These initial marks set the composition and help you determine your point of view. Be sure to lay out all the items you see in your scene — whether they're minor forms in the background, clouds off in the distance of a landscape, or shadows on a wall — because they all play a part in the effect of your composition, as the example in Figure 6-4 shows.

If some of the lines are incorrect, don't erase them — erasing damages the texture of the surface. Just go over the lines with a slightly different color to correct them. This process is called the *underdrawing* (discussed in Chapter 8), and it serves as the framework for the structure and the bones of the finished piece.

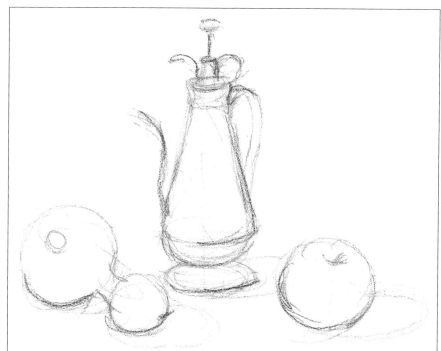

Figure 6-4: The first marks for a pastel drawing.

Checking for accuracy

When you have all the items laid out, you're ready to check for accuracy. To verify that the initial marks look good and that you have laid the drawing out correctly, use these methods:

- ✓ **Back up and look at the image you have drawn from about six feet away.** This method is the best way to check for accuracy because it allows you to see the overall arrangement of the forms but not any of the minor bits of information. Check all forms to be sure they're plumb and parallel with the edges of the paper. If not, you want to straighten them out if you're going for realism. Now look at both the actual object and your drawing through your viewfinder to see whether the images match.

- ✓ **Stand with your drawing in front of a large mirror so you can see the drawing in reverse.** Viewing your drawing in a mirror gives you a fresh vantage point and may help you notice mistakes.

- ✓ **Turn your drawing upside down to check for lopsided forms.** Flipping your composition upside down helps you concentrate and identify big shapes and notice any potential errors.

- ✓ **Sight and measure it.** With this method, you use a skewer or pencil as your sighting stick to compare angles and the relative sizes of forms. Check out Chapter 5 for more on sighting and measuring.

To make the corrections, either draw over the misplaced form in another, slightly different color or scrape off the powder with a razor.

Adding Color: The Layering Process

After you lay out your drawing (see the preceding section), you're ready to start the process that pops into most people's minds when they think of pastels: applying the color. Applying color in pastel drawing is unlike other color media (such as oil or acrylic paint) in that you mix the color right on the work rather than on a separate palette. In order to achieve variety within colors and degrees of lightness and darkness in your pastels, you layer color on the artwork. This section explains the basics of the layering process and provides some pointers to help you become more acquainted with this stage in the drawing process.

Exploring the basics to layering

When you reach this stage, you want to softly layer the pastels to create rich, complex colors. We suggest you use pastel pencils first and then move to medium-hardness pastels, such as the Nupastel line from Prismacolor, and finally soft pastels, such as those from the Rembrandt brand. This progression creates a hard-medium-soft application pattern for the pastels and helps you put down the material more easily. If you start out with soft pastels, the texture of the paper fills up quickly and you can't work as easily with later layers. If you're only working with one type of pastel, make it a medium-hardness variety such as Nupastel.

You have several methods of layering pastels to choose from. The two main methods are

- ✔ **Massing:** In this method, you lay the piece of pastel on its side and gently stroke a thin, even layer of color over the surface of each form, developing the scene by working on the focal point of the setup first, followed by the secondary forms, and finally the background or other less-prominent areas. You then return to the focal point area and apply a second layer of the same or perhaps a slightly different color, repeating the process across the drawing until all the areas are appropriately (but not necessarily evenly) developed.

- ✔ **Hatching:** You can also layer the color by applying parallel lines of color in a crosshatched manner to create a dense field of color. The lines don't need to be straight; you can try curving lines or some variation all your own. As with massing, work all of the areas to one level of development before returning to any one area for a second layer.

You can stick to an individual method or mix them up, but resist the urge to color in the forms in a solid manner — this technique fills the texture of the paper too quickly, which limits the number of layers you can apply. You can read more about specific methods of applying pastels in Chapters 8 and 9.

Working from general to specific

You continue to work from general to specific as you begin to layer your drawing. This phrase *general to specific,* meaning you nail down the basic elements before adding the details, is a mantra for artists working from observation (drawing from an actual object or setup). The previous discussions in this chapter follow this plan, starting with the general layout and layering of color and progressing slowly through increasing levels of refinement and detail, and the process continues in the same fashion until the drawing is done.

Don't dive into the details in one area while you have others still at the under-drawing stage. Bring the whole image up in layers at the same time, leaving final touches and detail work for the end. When you're ready to add specific details, pastel pencil is a good choice. Pastel pencils are harder, and you can sharpen them to a point for more control. This hardness can work against you if you have a number of layers of pastel, however. A pencil that's too hard for the layers may only dig a channel though them. If that happens, use the corner of a semi-hard pastel or sharpen an edge of your soft pastel and use that to lay in the details.

Using workable fixatives to allow more layers

As you apply layers of pastels, the powder begins to build up to the point when the drawing can't take any new layers of color. You can use workable fixatives to set the layers so that you can apply new, fresh marks. (Check out Chapter 3 for a general explanation of fixatives and their uses.) *Workable fixatives* give a

coating of sealer to protect the artwork and create a more durable surface for adding more layers of pastel; you can apply fixative several times during the development of the drawing. Although not all artists use fixatives because they think the sprays change the color and look of the drawing too much, fixatives are very useful in the application of many layers of color and can be an integral part of the layering process.

So how do you know when your piece would benefit from a coat of workable fixative? Getting a handle on exactly when to spray your artwork takes practice and experience, but as a general rule, you shouldn't see a lot of dust regardless of whether you're massing or hatching your strokes. Lots of dust either means you're pressing too hard or you've built up so much powder that the new strokes have nothing to hang on to — the new marks are just dusting off and grinding the previous layers into a muddy mix of colors. If this situation happens to you, you may want to spray.

To apply the fixative, make sure you're in a well-ventilated area, such as a porch, garage, or outside on a dry, calm day. Remember that you're spraying a varnish and that the overspray adheres to everything around your drawing, so protect your surroundings accordingly. Also be aware of safety precautions using this product and read the directions on the can. Don't inhale or ingest the spray, and don't use it near an open flame. The spraying process itself is super easy:

1. **Secure your drawing to a board and set it on a stable surface.**

2. **Following the directions on the can, apply light, even sprays from about 12 inches away from the surface of the work and let dry for 10 to 20 minutes before applying more pastel.**

 For a 9-x-12-inch drawing, three light swipes of spray should be enough to do the job. Always apply less than you think you need — spray fixative changes the color of the pastel surface, making it darker. Err on the side of applying too little.

 How much spray to use isn't easy to describe in writing. One analogy is to apply it like you would a natural amount of hairspray (but not enough to secure a bouffant). Use this suggestion as an analogy only — never use hairspray on artwork!

3. **After the fixative has dried (10 to 20 minutes), you can continue to apply pastel.**

Although fixatives do settle the pastel layers, they don't completely protect the drawing. Even final fixatives can't do that. The surface is still somewhat fragile and can be damaged if mishandled, so flip to Chapter 21 for details on protecting your work in a more permanent fashion.

Bringing the image up in layers

You can apply more layers of color over your drawing, varying the shades, type of stroke, and direction of your stroke to create a rich complex network of color. At this stage, you should be working with the softer pastels, which are terrifically soft so that the powder lies on the top of all the hard layers very nicely. Brands like Rembrandt, Sennelier, and Schminke go on in a very

creamy fashion and are fantastic to work with. Apply a variety of color to every part of the drawing, staying with the sequence of development (the focal point, secondary areas, and background).

The layering process is where your own interpretation comes in! For example, a tangerine isn't only orange but also yellow, red, violet, and even blue as Figure 6-5 shows. The strokes can be soft or pointy; they can be applied in diagonal hatch marks; or they can indicate the direction of the texture of the forms. Continue to apply a variety of color to every part of the drawing, staying with that sequence of development (focal point, secondary areas, and background).

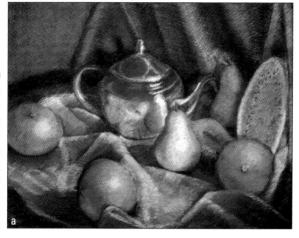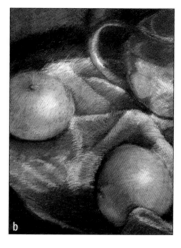

Figure 6-5: A still life drawing in pastel and a detail showing a tangerine with a range of colors.

 Be a bit daring in your color choices, and remember that the viewer's eye blends the color, so you don't need to rub or smear the colors at this point. Fight the urge to work exclusively in one area; instead, continually think about the whole composition. The best strategy you can use to consider the whole composition and think in layers is to constantly step back from your work to see how it's progressing as a whole. It gets your nose away from your work and makes you mentally step back from it.

 In general, you should try to use the hard-medium-soft method of working that we outline earlier in the chapter. But this succession can fall by the wayside as you find yourself picking up a pastel of the "wrong" hardness because the color is so right. Don't worry about this deviation — we often find ourselves doing the same.

Finding light and dark areas

As you're drawing with pastels, you also want to keep an eye out for light and dark areas. Light illuminates an object and creates the sense of depth in the scene. It also helps you create the illusion of three-dimensional form because the change in the color you see from one side of the objects to the other is created by the play of light and dark across the forms. The shapes of the light and dark areas you see are called the *value pattern*. As you examine those light and dark areas, take some time to think of the lights and darks as color differences and choose colors that achieve the effect of light and dark for the

most interesting results. For example, light areas may be a paler version of the color and dark areas may be a deeper color.

 If you're working with a still life or a small interior scene, you can analyze the effect of the light. The first characteristic to notice is which direction your light is coming from. Put your hand or another object in the light to cast a shadow over the setup and notice what happens to the lighted areas and shadows; the cast shadow of your hand shows you the direction of the light and helps you correctly establish the pattern of light and dark. Look at each item in your scene and note how the light flows across one form to another, and then make sure you accurately represent this flow in your drawing.

 Stay away from black and white and select colors that look light or dark instead. As you see in Figure 6-5, the tangerine has dark orange marks on one side and light orange on the other, but other colors are in play as well. Pale yellow creates the highlighted area, and red-violet and blue create the value in the darkest part. All these colors still meld with the other tangerine-y colors. You can be creative as you work, exploring more options for color to exaggerate the degree of light or to create an area of emphasis.

Making corrections

Even the most advanced artists make mistakes. When you do (and you will), don't be discouraged. Just be ready and willing to make necessary corrections. If you find an area that needs changes, you have two main choices: to draw over the area, adding new colors or edges to make the corrections, or to scrape off the area with a razor blade. You can also use a kneaded eraser to lift small amounts of color, but the colors may be muddied in the process. (**Note:** Making lots of corrections can roughen soft papers, so don't be afraid to make them, but do be judicious.)

 Here's how to make corrections with a single-edged razor blade. You may want to practice this procedure in your sketchbook before you attack a drawing with a sharp object!

1. **Ensure that the drawing is firmly supported on a table or drawing board.**

2. **Scrape with the broad side of a razor and then erase.**

 Remove only a little material at a time. If the pastel is very thick, you may have to use the tip of the razor, but don't dig down too firmly or into the surface of the paper itself. The idea is to take off the pastel in layers, just the way you put it on.

3. **Work in one direction and then another to remove a little pastel at a time.**

 You may not be able to remove all the color; you just want to lessen the color. Avoid scraping the surface of the paper too much and changing the texture of that area; you want the texture to be as similar as possible to the original surface of the paper.

4. **Go over the area with fresh marks of pastel to make the correction.**

 You may have to camouflage your correction with a mixture of color to achieve the results you want.

Deciding when your drawing is finished

Knowing when the work is complete is a part of the development of the drawing, but determining whether an artwork is finished is an issue that many artists struggle with. Sometimes the decision comes easily and naturally, but it can perplex even the most experienced artist because it's something of a moving target. You have a mental image of your drawing as your goal in the beginning of the work, but as you work, you stop to check your progress (using the methods we describe in "Laying out your drawing: Making the first marks" earlier in this chapter) and discover hints of color in unexpected places, edges to emphasize, and highlights to intensify, and your ideal goal shifts.

So how do you know when your drawing is finished? The entire area of the drawing doesn't need many coats to look finished, but you want it to look as if all the areas have been given enough attention. Areas you want to emphasize may need several layers of drawing that develop the nuances of the forms, shadows, highlights, and other patterns. Other areas, such as the background, may only have general shapes and colors laid in.

✔ A drawing that isn't finished looks thin. A *thin* drawing is like watered down soup. It has the strength to draw you to it, but it's too weak to savor. The nuances of the value pattern are under-developed and the use of color is basic. Look carefully and work to understand color so that you can create a still life that entices your viewer to linger over it. Chapter 11 can help you.

✔ Sometimes you can overwork a drawing, however. An *overworked* drawing has lost its fresh appearance. The colors look muddier than they should or the strokes may appear stiff. As you gain a little experience, you learn when to stop. When you start to feel that a drawing is getting away from you, the best thing you can do is take a break and come back with a fresh set of eyes.

 Be careful not to overwork a piece. Many artists believe that a work is complete when you think it's *almost* done, a sort of quit-while-you're-ahead philosophy. This strategy may not work for you, but it can be a working strategy until you develop your own instincts as to when a work is complete to your satisfaction.

Even if you meet your goal, you can look over your completed work and still have a sense of disquiet about the drawing as a whole. At this point, you may need to take another step back and look at the overall effect of your work. This last bit of checking is important because you aren't only looking for errors but also verifying that all areas of the work have something to hold the viewers' interests. Go over the drawing visually and examine the effects of each small section (2 x 2 inches or so at a time). We're not saying you need to have excitement in all areas; some areas may be relatively quiet. But they all should tell the viewer something about the scene. Make sure you have a variety of marks, colors, and lights and darks — variety is an important part of a work's success.

Project: Draw a Pear

This project captures a green pear in natural light from a window. Our project uses a set of 12 CarbOthello pastel pencils, a set of 12 Prismacolor Nupastel medium-hardness pastels, and a set of 15 Rembrandt soft pastels, as well as Ingres Fabriano paper. You can try any solid color object, but avoid very dark or very light items, such as lemons and eggplants, which don't give you enough variety of color to work with.

1. **Draw some thumbnail sketches with a regular ol' pencil to get to know your subject.**

 We experiment with different pears and different positions to gauge the effect, sketching in the items and checking for accuracy as we go. We also try different marks (such as hatching and tonal marks) on the pear. Figure 6-6 shows the thumbnail sketches for the pear.

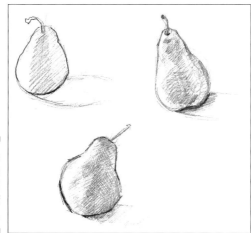

Figure 6-6:
Some thumbnail sketches of the pear.

2. **Decide which thumbnail view you want to use and create the under-drawing on your pastel paper with bundles of lines, adding corrective lines as needed.**

 Don't erase lines that go astray; just redraw the correct line. We start ours in Figure 6-7a with a pale green pastel pencil, finding the general shapes within the pear. Then we make corrections and define the edges in a darker green to help cover the first drawing.

3. **Begin to layer.**

 You can see the first layers of pastel in Figure 6-7b. We use hatching marks to layer Nupastel, establishing the lights and darks within the form, and develop the shadow cast on the table.

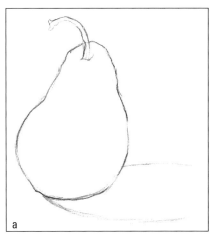 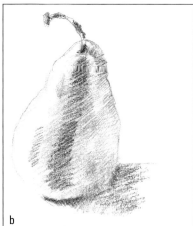

Figure 0 7.
Under-
drawing of
the pear
(a) and a
light layer
of pastel
establishes
the object's
color and
value (b).

a b

4. **Develop the layers of the pear's green with a variety of colors, applying workable fixative between layers if necessary.**

 We work with colors closely related to green to create a more complex range of color. Highlights are bright yellow, and shadows are in blue-green and blue. We also added a golden yellow color to the layers to achieve the particular color of a pear. Using almost all the blues possible helps us create just the right color for the table surface and the shadow of the pear. You can make corrections as necessary, although if this piece is your first try at pastel drawing, we recommend saving corrections for a later piece. Focus on getting this first piece done rather than getting it perfect.

5. **Decide when it's done.**

 Continue to add layers of color and any necessary workable fixative until you're happy with the results. There is no right answer here — use your judgment. Figure 6-8 shows the completed, layered drawing.

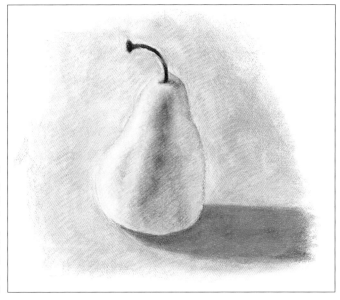

Figure 6-8:
The final
pear
drawing,
with lots of
layers
of color.

Chapter 7

Picking Papers for Pastels

● ●

In This Chapter

▷ Understanding the basic qualities of pastel papers

▷ Sifting through the available paper types

▷ Selecting your paper surfaces (or preparing and toning your own)

▷ Caring for your work through proper paper handling and storage

▷ Observing how paper texture influences the final work

● ●

Paper is everything in pastel, but beginners frequently overlook it in their eagerness to begin working. The surface of your paper determines how textural your pastels look, as well as how detailed an image you can make. The color of your paper can set the overall tone of your work and affect the decisions you make about layering your colors. This chapter aids you in making good decisions about paper so that your choice of paper falls in line with the goals you have for your artwork.

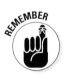

No single paper is best for pastel. The right paper is the paper that complements and cooperates with the goals you have for your work. The only way you can find that paper is to continually try new ones.

Grasping Paper Basics

Even though you may be new to making art, you probably already know something about paper. If you buy paper for your computer printer, you're probably familiar with the weight difference between basic printer paper and cardstock. You've likely seen firsthand that a newspaper left in the sun turns yellow and becomes brittle and that children's colored construction paper fades easily. You can build on these experiences as you think about how to choose papers for your work with pastels.

All papers have a few basic characteristics that help you make decisions about them. The following sections show you the basic nuts and bolts you can consider.

Papers that are labeled as "general-purpose" or as suitable for a long list of materials (including graphite and ink) aren't ideal for pastel. They serve too many roles to do well in any except simple sketching.

Weight

Weight refers to how much a *ream* (500 sheets) of a particular paper at a specific size weighs. Therefore, a ream of 20-pound computer paper you buy at the office supply store weighs 20 pounds if the sheets are the specific size used for measuring weight. At the other end of the spectrum, a ream of 350-pound watercolor paper weighs 350 pounds. Heavyweight papers cost more as a rule, but that doesn't mean they're better suited for what you're doing. Most pastel papers are 100 pound or less, which is relatively light in terms of art papers and means they must be handled more carefully to prevent damage. Most of the time, you choose paper according to your preference for surface, but if you prefer a heavier weight paper, you can choose a mounted pastel paper or an all-purpose paper such as Rives BFK.

Composition

Today, almost all everyday papers are made from wood. Art papers, however, may be made from *cotton rag* (an acid-free cotton product), wood, a combination of cotton rag and wood, or other plant fibers. Papers made from wood (called *sulphite papers*) typically have short fibers, causing the paper to be more prone to damage from handling than cotton rag papers (often just called *rag papers*) that have long fibers. If a paper is made of a combination of both wood and rag, the percentage of the rag content is noted.

Some drawing papers are made from recycled materials, or a percentage of recycled materials. These papers are commonly found in pads and are generally considered better for practice work than for finished artwork.

pH neutrality

pH measures the degree of acidity in a substance (in this case, paper). Acidity breaks down the fibers of paper, causing the paper to disintegrate. If a paper is pH neutral, it qualifies as *acid free.* Choosing acid-free paper for your work is the respectful and responsible thing to do. Even though you may not think your work is that great, always take steps to preserve your work for others who may value it. Rag papers (see the preceding section) and papers commonly known as rice papers are naturally acid free. As long as nothing acidic comes in contact with the paper, it can last for centuries.

However, you can't assume that every art paper is acid free. Newsprint pads are just as prone to breaking down as your newspaper is, so these pads are meant for practice exercises, not final artwork. Most sulphite (wood) papers intended for art are acid-free, but you can't assume they are. Read the product descriptions or ask an art store associate if you aren't sure.

If you find a paper you love that isn't acid-free, you do have some options for prolonging its life. Storing the art away from sunlight is one, but if you want to display it, frame the work behind glass that filters out ultraviolet light.

Looking out for a paper's watermark

Many papers have a *watermark,* a manufacturer's imprint set in the paper as it's made. To find it, hold the paper up to the light and look in the corners. Watermarks are difficult to cover with pastels and other materials and sometimes are so obvious that they interfere with the image. Most artists plan ahead to avoid them, either by working on the opposite side — which is often considered the *right* side of the paper — or by tearing or cutting the paper down. You don't want a watermark to show up in your drawing, but don't let it dictate which side of the paper you draw on either.

Avoid using pine-based solvents such as turpentine to make pastel washes. They can change the pH of the paper, making it acidic and shortening its life. Using water or watercolor is a better choice for washes, but you may have to tape down or stretch the paper first because water causes many papers to swell and warp when they dry. To prevent the warpage, you can dampen the paper and then tape down all four edges with paper mailing tape. When the paper dries, you can use all the water you want on it and the paper stays flat.

Tooth and surface

Tooth refers to how rough the surface of the paper is. Tooth is important because pastel adheres to the paper by becoming embedded in the fibers of the paper; slick papers like standard notebook paper aren't textured enough to hold pastel. Some papers look very textural and therefore have a lot of tooth, but other papers can look smooth but actually be very toothy when you touch them. A good toothy surface should feel fibrous and matte rather than slick.

You may see some papers labeled either "hot press" or "cold press." *Hot press* papers are smooth, and cold press papers are textural. A paper that has a *laid* surface has a regularly occurring texture. Some papers are textured on one side and smooth on the other. Don't assume that you must use the textured side. The smooth side of the Canson-brand Mi-Teintes paper is very nice to work on, even though the textured side is considered the "right" working side.

Lightfastness

Lightfastness (resistance to fading) is another important factor to consider when choosing pastel papers. The paper colors can be very appealing, but some lines of papers are prone to fading. If you're just practicing, fading may not be an issue for you, but for actual works, choose from a line with good lightfastness, such as Canson Mi-Teintes or Fabriano Tiziano. Keep in mind that if your paper fades, your color composition changes in unpredictable ways. If you go to the trouble to choose lightfast pastel colors, choosing papers with *fugitive* (fading) colors makes no sense.

Encountering Different Kinds of Papers

Quite a number of papers are suitable for pastel. Everyone works with pastel different ways, so all you have to do is experiment with a variety of papers until you find the ones that work best for you. Regardless of what paper(s) you choose, always check to see whether a paper is acid-free and lightfast so your work can live on for years to come.

When you're looking for paper, don't let labels stop you from trying them. Pastel is a versatile medium, so paper that works for sketching or thin layers of pastel may not work as well for heavy applications in a paintlike fashion. On the other hand, highly textured papers may be great for those paintlike approaches but inappropriate for fine work. Consider what your goals for your artwork are as you decide what papers to use.

Three categories of papers are good for pastel: drawing papers, printmaking papers, and watercolor papers. The following sections detail each; check out the preceding section for more on the attributes of paper in general.

Drawing papers

The most popular category of paper for pastel includes pastel paper, charcoal paper, and other drawing papers. These types of paper are quite versatile as a rule, but when you're considering them for pastel work, consider how much tooth you're going to need for your work and how much abuse the surface can take.

Colored pastel papers

Anything labeled as pastel paper is good for drawing with pastels. Pastel papers can be very delicate or quite sturdy. Although weight alone doesn't dictate how resilient a paper is, you can make some generalizations. Lightweight, delicate papers can't typically tolerate infinite layering, rubbing, and erasing, so a fresh, direct approach where you draw quickly and stick to one or two layers of drawing is best for those papers. Heavyweight papers can usually take more abuse, but you should test every paper to see whether it can tolerate your methods. With any weight, erasing sometimes can plow up nasty rough spots on a paper.

Also consider how a paper's texture affects the look of your work. The color of the paper shows through the drawing in most textured papers. Many pastel papers are very textured with lots of tooth and work well for an expressive, paint-like approach but are unsuitable for fine detail because the paper is too rough to accept small lines and shapes. Some, such as Canson's Mi-Teintes, are textured on one side and smoother on the other. You can draw on either side, so these papers can be a good choice if you're experimenting with different surfaces. Besides Canson, Fabriano and Strathmore make good pastel papers. Figure 7-1 shows you a selection of pastel papers that are widely available.

Sanded papers

Sanded papers are primed with a solution of binder and grit that holds pastel well. These papers were developed because a number of pastel artists were experimenting with drawing on sandpaper, which was highly effective but deteriorated quickly because of its acid content.

Figure 7-1:
Canson Mi-Teintes, Fabriano Tiziano, and Strathmore pastel papers.

Manufacturers have developed a few good sanded papers. Colourfix (refer to Figure 7-2) is readily available, and some, such as UArt, have a choice of grit. They tend to soak up pastels pretty quickly, but they do hold many layers of drawing without requiring fixative.

Figure 7-2:
A sanded paper for pastel.

Pastel boards

Pastel boards are also quite popular and come in a variety of forms. Here are some common examples that illustrate the range available:

- ✔ **Papers acting as boards:** Some papers are heavy enough to be considered a board. Sennelier LaCarte Pastel Board is an example of a heavyweight, 200-pound sanded pastel paper — it's boardlike but has a surface like sanded pastel paper.

- ✔ **Papers glued to boards:** Canson's Mi-Teintes and Hahnemühle's Velour papers also come in varieties attached to boards. If you like the papers but want a harder surface to work on, these products are good options. You can see an example of Canson Mi-Teintes board in Figure 7-3.

- ✔ **Boards coated to accept pastels:** Unison Gator Foam Premium Pastel Surfaces combine a popular archival backing material with a specially prepared surface made of binder and grit with a tooth similar to sanded paper. Gator board is a very lightweight, acid-free board similar to foam core, but harder.

Figure 7-3. A pastel board similar to sanded pastel paper.

Charcoal papers

Charcoal is often lumped together with pastel as a medium because some of the characteristics are similar. Because charcoal work also requires a toothy surface, most papers manufactured for charcoal are suitable for pastel. Most have laid or textural surfaces, so decide how you feel about texture becoming part of your image. Many fine charcoal papers are available as sheets or in pads. In Figure 7-4a, you can see examples of charcoal papers.

General drawing papers

General-purpose papers come in pads of 50- to 100-pound white sheets. This type of paper is economical, but make sure it can meet your needs. On most pads of papers for general drawing purposes, you find a long list of media the manufacturer claims the paper is well suited for. The longer the list is, the more you should examine your goals for your drawing and whether that paper is likely to be suitable. Papers with very smooth surfaces suitable for ink aren't likely to be suitable for heavy pastel applications.

Furthermore, consider the tooth of the paper and how you work. If you're sketching, doing line work with few layers of hatching (discussed in Chapter 9), or working without manipulating the color very much, a general purpose paper may be fine. If your pastel work is more like painting (such as massing layers of color as we describe in Chapter 9), you should consider investing in a better sheet. Canson and Strathmore (check out Figure 7-4b) both make good general-purpose drawing papers.

Figure 7-4: Charcoal papers (a). You can use general-purpose papers for pastel sketching (b).

a

b

Printmaking and watercolor papers

Printmaking papers are formulated for fine art printing processes such as etching, lithography, and silkscreen, and watercolor papers are made to accept watercolor, but many also make good surfaces for pastels. Most printmaking papers are smooth but have a good tooth for pastel. Some surfaces are more resilient than others to erasing and rubbing, however, so try several papers to see which works best for your working methods. On the other hand, watercolor papers may be rough or smooth. Cold press watercolor paper has varying degrees of roughness, depending on the paper and weight. Hot press watercolor papers are smooth and have a tooth similar to some printmaking papers. Either may work well for pastel. Printmaking and watercolor papers have two advantages over pastel and charcoal papers:

- **They're available in larger sizes and weight ranges.** In fact, some of them are available in long rolls, so your works aren't limited by the size of the paper. They also have a wider range of weights. The heaviest commonly available weight for watercolor paper is 300 to 350 pounds, but weights over 1,000 pounds are available.

- **You can use water on them.** Many pastel and charcoal papers irretrievably warp or disintegrate if you apply water to them, but printmaking and watercolor papers are much more forgiving of these techniques. You can brush water into the pastels to make washes or use water media, such as watercolor, gouache, or acrylic paint on their surfaces for a multimedia effect. *Gouache* is a water-based paint that has a chalky appearance similar to tempera paint. Like watercolor and tempera, you can manipulate it after it dries by brushing water into it.

One potential downside to these papers is that you can't find them available in the colors offered in the pastel paper lines — expect whites, off-whites, creams, tans, grays, and blacks — but don't consider that a limitation. You can tone paper any color you want, so if you like how your pastels behave on one of these papers, don't let its natural color stand in your way. (Check out the "Toning Your Own Paper" section later in this chapter for more info.) The three most common printmaking and watercolor papers include Rives BFK, Arches Cover, and Arches watercolor paper (refer to Figure 7-5 for examples).

Figure 7-5:
You can use printmaking papers as well as watercolor papers for pastel.

Choosing a Surface that Fits Your Goal

When working with paper for your pastel drawing, you also need to consider the paper's surface. Selecting a surface that meets what you want to accomplish is important because it determines the overall look and level of detail you can attain in the work.

Knowing how you want to work with pastel is the first essential factor in choosing your paper. If you want to use line, layers of hatching, and fine detail, common textural pastel and charcoal papers may frustrate and dissatisfy you — you need a smooth surface. If you like texture but don't want the paper to show through the pastel layer, choose a paper with a little texture. If you like to experiment with erasing, rubbing, and throwing everything but the kitchen sink at the paper, use a heavyweight paper with a strong surface.

Another consideration when choosing a surface texture for your paper is what you want to communicate to your viewer. Smooth surfaces can evoke any number of varied interpretations, such as serenity, coolness, mechanization, or elegance. Rough, textured surfaces may suggest expressiveness, luxury, antiquity, or warmth. The following sections can help you choose papers based on surface.

Smooth surfaces

Smooth surfaces actually can support a variety of styles of pastel drawing, including the following:

- ✔ Line drawings and general sketching
- ✔ Layers of linear hatching
- ✔ Delicately modeled work with fine detail
- ✔ Images that mix line and mass
- ✔ Paintlike, expressive images made from massed pastels

However, these surfaces are limited in the number of layers they can accept, even with generous applications of fixative. Therefore, one of the most important considerations you have when choosing a smoother surface is whether it does in fact have enough tooth for your needs. After tooth, you may also want to consider how soft or hard the surface is; if you like to really work the surface by erasing or pressing the pastel stick heavily into the paper, the fibers in softer surfaces are more likely to lift and ball up, roughening the surface of the paper. Test your proposed paper to ensure it can stand up to your style.

Textures on smooth surfaces are *visual textures* made by the hand of the artist instead of being dictated by the physical surface of the paper. Figure 7-6 shows how physical texture (left) and visual texture (right) affect the final artwork differently.

Figure 7-6:
Physical texture refers to the surface of the paper; the artist creates visual texture.

Rough surfaces

Rough surfaces, including laid surfaces, become an integral part of the images that are made on them as pastel is deposited on irregular points of the surface, often leaving the paper to show through in lower points. Although some papers are highly textured, every kind of rough paper has a different degree of physical texture that dictates the overall look of the work — some very rough textures can overtake an image, but others merely affect the surface of the final work. Rough textured papers are better for more extreme styles of pastel drawing, such as

- ✔ Expressive mass sketching with ambiguous forms
- ✔ Atmospheric (soft and ambiguous) approaches to images
- ✔ Heavy layering
- ✔ Experimental techniques on heavier papers

Sanded surfaces are rough, but they're so regular in texture that they appear smooth (although the very fine grits are basically smooth.) The surface can take a number of layers of pastel, and the finished work appears very much like a painting. Chapter 14 covers sanded surfaces in more detail.

Besides the distinctive expressive look of textured papers, the strength of rough surfaces is that the fibers can hold a lot of pastel. If you want to make crisp edges and detail, however, the texture of the paper is going to interfere with your efforts.

You never want to fight your materials. Experiment and find out what their capabilities are and coax and bend them, but trying to make them do something they aren't made to do never turns out well.

Preparing Your Own Surface

Sanded papers and boards cost two to four times as much as other papers you may buy for pastel, so you may want to explore the option to prepare your own surface. Doing so is easy and doesn't take much time — you simply buy or prepare a solution of binder and grit and paint it on a good-quality sheet of paper or board. The following sections describe both options.

Using ready-made solutions

Several good ready-made solutions for pastel surfaces are available at most art supply stores and online. They usually consist of a mix of acrylic medium and various types of grit. Simply paint them on a sheet of paper (such as Rives BFK) that doesn't warp when you apply acrylic paint to it.

You can use these solutions as is, or you can customize a solution by adding acrylic color to the mix. Liquid or low-viscosity acrylics work best, but high-viscosity tube colors thinned with water also work well. Because the acrylic medium you're using dries clear and many tube paint colors are transparent, you may want to consider adding a small amount of *gesso* (a surface primer) or white acrylic paint to control how opaque the surface color is. (For more on acrylic paints and the mediums that go with them, check out Colette Pitcher's *Acrylic Painting For Dummies* [Wiley].) Acrylic solutions are acid-free and therefore don't affect the pH content of the paper, unlike oil painting solutions, which aren't acid-free and can eat the paper.

The following list gives you some prepared solutions that work well for pastels; some have coarser grits than others, so consider how coarse a surface you want as you decide which to try:

- **Golden Pumice Gel:** This product comes in fine, coarse, and extra coarse varieties; coarse and extra coarse may be too textured for many artists. The fine grit makes a rough pastel surface that is very textured, but the coarse grits are similar to very rough sandpaper and needlessly gobble up your pastels. These rough grits are more appropriate for acrylic painting surfaces than pastel.

- **Golden Pastel Ground:** This surface is fine and less gritty than sanded paper. It's also a finer surface than the surface created by the fine pumice gel in the preceding bullet.

- **Golden Micaceous Iron Oxide:** This product's surface looks and behaves very much like dark gray 200-grit sandpaper.

- **Liquitex Natural Sand Texture Gel:** This gel creates a fine sanded surface. Figure 7-7 shows an example of the gel modified with a mix of blue and white paints.

Making your own surface

If you can't find paper with the surface you want or you're the do-it-yourself type, you can create a surface solution for your paper yourself. The whole point of making a homemade solution is to customize the amount of grit applied to the surface, so, before you make an entire batch to paint on several sheets, test different amounts of pumice in the mix. All you need is some gesso and pumice powder (available online or by catalog from Daniel Smith art supplies). Here's a method you can try:

1. **Tear or cut several 3-x-5-inch swatches of a heavyweight paper such as Rives BFK or Arches Cover paper.**

2. **Measure ½ cup of gesso into a bowl and combine with 1 teaspoon of pumice powder.**

3. **Paint a 3-inch swipe of the mixture on one of the swatches, label it "1 teaspoon," and set it aside to dry.**

4. **Add ½ teaspoon of pumice powder to the gesso and mix well.**

5. **Repeat Steps 3 and 4, labeling each swatch with the correct pumice content, until you feel like you've got too coarse a swatch for your needs.**

6. **After the test swatches are thoroughly dry, try your pastels on them to see which solution works best.**

After you have decided the amount of pumice to add to the gesso, you can further customize the solution by adding acrylic color to the mix a little at a time until you get the color saturation you want. Be aware that acrylic dries darker than it appears while wet, so test and dry some areas as you add the color.

Toning Your Own Paper

Textured papers provide tooth for pastels, but pastel can't always get into all the fibers of the surface, which allows the color of the paper to show through. Sometimes this color contributes to the appearance of the image, but it can also be distracting. Toning your own colored paper is one way to make sure the paper becomes an integral part of the work. Toning also gives you a greater selection of color than is commercially available and doesn't damage the paper fibers. Plus, your handmade toned paper is archival (meaning it changes very little with age). This section gives you the lowdown on selecting a color for toning and tackling the actual toning process.

Although a wide range of colored papers is available, lightfastness can be an issue. If you tone your own white paper, however, you have the advantage of using the surface you like, toning it the color you like, and knowing that the color you tone it is just as stable as the rest of the pastels in your palette.

Choosing a color

How do you decide what color to tone your paper? First and foremost, you should always consider the colors of the components in your composition. Don't just choose some random color, because it may create a distraction in your composition. Aside from that guideline, you can use several strategies to choose toning colors:

- ✔ You can tone the entire image in one color or give separate areas in the composition different colors.

- ✔ Toning a composition a cool color can make the entire image cool, just as using a warm color can give the entire composition a warm tone.

- ✔ Using neutral grays and browns can help neutralize colors so that the backgrounds recede and help create depth. Flip to Chapter 10 for more on creating depth with neutralized colors.

Laying down a tone: The how-to

If you have white paper and you want to work on a colored paper, don't run out to the art supply store. Make your own! Laying down a tone is easy, although if you haven't toned paper before, you may want to try this process in your sketchbook first to get a feel for it.

To tone your own paper, just follow these easy steps and check out Figure 7-8.

1. **Tape your paper down to your board with artists' tape and break off a ¾- to 1-inch piece of a medium-hardness pastel in your toning color.**

 Prismacolor's Nupastel line is a good choice.

2. **Lay the pastel on its side so the entire length is in contact with the paper and gently lay parallel strokes across the paper (any direction) over its entire length.**

Don't be too heavy-handed with this stroke — otherwise, you may fill the texture of the paper before you have started the drawing. Just skim the surface of the paper. You don't have to worry if you skipped some places; the blending in the next step fills them in.

3. **Take a piece of tissue or paper towel and gently wipe it over the surface to blend the color evenly over the paper.**

 Voilà! Your own do-it-yourself colored pastel paper, custom made for your next project.

Figure 7-8: You can easily tone your own paper.

You can also lay down a watercolor tone either by washing water into the pastel layer or by beginning your drawing by giving the paper a wash of thinned tube watercolor. Wash the area with a 2- to 3-inch brush, being conscious of how the strokes move across the paper (a rigid stroke looks awkward if any paper shows through). Use a soft watercolor brush loaded well with water and freely move the brush across the surface of the paper. Allow the paper to dry thoroughly before using pastel unless you want to try drawing into the wet surface.

Handling and Storing Paper

Nothing destroys the value of works on paper more than poor handling and storage. Even great drawings start to look shoddy when they're covered in *dings* (those little permanent half-moon creases in the paper where the fibers have broken). Keeping your work in pristine condition not only preserves any value it may have but also shows respect for your work. To protect your paper, keep the following pointers in mind:

- **Buy paper in good condition.** Don't buy dinged, ripped, or creased paper.

- **Always support your paper appropriately.** Hold the paper on opposing edges with both hands. Holding a sheet with one hand only invites trouble because gravity isn't so worried about keeping your paper nice. In addition, always make sure that the entire sheet is fully supported by your drawing board or any other flat surface it lies on.

- **Protect the surface with a slip sheet of *glassine paper*, which looks like very slick waxed paper, or by putting it in its own folder made of acid-free paper.** Do this whether you give your work a final spray of fixative or not — fixative helps, but it doesn't cement the pastel to the paper.

- **Store paper and finished pastels flat.** Holding pastels in one position so they can't move around preserves the paper and image indefinitely. Flat storage fully supports the paper and helps pastel dust stay put instead

of falling down the image as it may if stored vertically. Unfortunately, flat storage can require investment in an expensive set of flat files, which are those shallow, wide drawers often used for blueprints. Because you're just beginning with pastel, you can put off purchasing the flat files and store your work in flat portfolios such as we describe in Chapter 3.

Project: A Simple Still Life on Smooth and Textured Papers

This project helps you see firsthand how your paper choice is an integral part of the image you make. By completing the same image on different papers in this project, you can see how smooth and textured surfaces affect not only the image you make but also the methods you use to make the image. The images in Figure 7-9 demonstrate how smooth and textured papers can affect an image. Just follow along with these steps:

1. **Set up a simple still life of two objects.**

 Keep it simple — this is a short exercise — but consider lighting and cast shadows as you set your arrangement up. If you want help setting up an arrangement, check out Chapter 12.

2. **Choose a colored paper that has a textured side and a smooth side.**

 The Canson Mi-Teintes works fine, but any pastel or charcoal paper with a smooth side and a noticeably textured side works.

3. **Tear or cut the paper down into two sheets of the same size.**

4. **Make the *initial sketch* (rough drawing of general forms) on the textured side of one sheet, and an identical initial sketch on the smooth side of the other sheet.**

 Head to Chapter 6 for more on creating initial sketches.

5. **Use the same set of colors to block in and develop each drawing.**

 Don't try to force them to look the same. Let the surfaces have a voice in each drawing. Chapter 6 also gives you pointers on developing sketches.

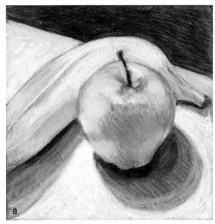 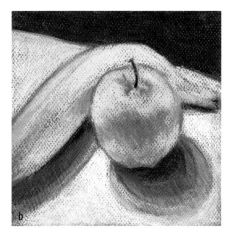

Figure 7-9:
Smooth and textured papers affect the appearance of an image.

a

b

Chapter 8

Exploring What You Can Do with Pastels

In This Chapter

▶ Using line to create pastel shapes

▶ Adding emphasis and value with tonal marks

▶ Combining line drawing and tonal marks for a hybrid effect

*P*astel is quite versatile, and you can use it in many different ways. You can create drawings, paintings, or even a hybrid version that incorporates aspects of both the linear and tonal marks we discuss in this chapter (see Figure 8-1).

Sometimes when you begin an artwork, you aren't really sure how it will turn out. You find yourself picking up pastels and working with them intuitively. The pastel goes down, thick and thin, color and line. The artwork seems to be guiding your hand. That's one of the great things about this medium. You can begin with a quick sketch and maybe leave it at that. The paper shows through in places, and others reveal a network of lines and thin color. The drawing is as immediate as a thought. You can also plunge right into that drawing with all you have, building up layers of color until the work looks more like an oil painting than a drawing. In this chapter, we walk you through several ways of making pastel artworks to show you how you can use the material in a manner that best suits your artistic goals.

Figure 8-1:
A pastel
drawing
with both
linear and
tonal marks.

Establishing a Drawing with Line

Whether you're using pastel pencils or sticks, your initial marks are likely to be lines, whether they're loose bundles or something more precise. The pastels fit comfortably between your fingers, and the action of laying down lines comes as naturally as the first time you picked up a pencil.

Lines are a great way to help you estimate the placement of your subject, find the edges of forms and the positions of shadows, and generally set the tone for the work. They also add beauty and character to the artwork. Dead, dull lines sap the energy out of an image, but lively lines that vary in width and sharpness engage the viewer. You can read more about how to make marks in Chapter 9, but in the meantime, the following sections contain some exercises you can try in your sketchbook to get a better feel for drawing lines.

Thinking about line variation

Drawing with lines really isn't that difficult, especially if you remember to explore line variation. Being able to vary your line choice just means that you have a larger vocabulary of line to use — you aren't just a one trick pony.

Although this exercise is quite simple, it can help you get a feel for the different types of line variations you can make with pastels. You can use pastel pencils, but a soft graphite pencil also works just fine. Just make a page of lines on a page in your sketchbook about ½ inch apart. Make the first a regular line that runs from the top of the page to the bottom. Next, make a line as lightly as you possibly can, and then another as hard as you can. Continue to explore as many different ways of making lines as you can: fast/slow, careful/random, angry/happy, and so on. Your page ends up with pinstripes! Whether you approach the exercise in a loosey-goosey or precise manner, you can expand and develop your artistic vocabulary by pushing yourself to make as many variations as you can.

Underdrawing: Making initial lines

The first lines on your surface set the stylistic tone for the work and act as a framework for the drawing. This initial structure or framework lets you build recognizable forms and try out many options for arranging your compositions. This process is called the *underdrawing*, and it's helpful because you can solve basic problems early in the drawing process by experimenting with the shape, position, and scale of the forms before committing yourself too much. Spend more time with this initial stage of the drawing and be sure to find the inherent structure of each form so that you don't get halfway through your drawing to find that things are in the wrong shape or size.

That doesn't mean that this set of marks is unimportant or should be completely covered over or obliterated. As you gain confidence in your marks and choices of colors, you can afford to be daring and make your work more

dramatic by making your structural lines more forceful or by using contrasting colors (see "Creating emphasis with color" later in this section). You can see the underdrawing still showing through a second layer of color in Figure 8-2, a drawing that has just been started.

Figure 8-2: Underdrawing with first layer of added color.

Finding contours

Another opportunity to explore lines is in the contours or edges of the forms. Although the underdrawing (see the preceding section) consists of bundles of lines that allow you to experiment with the general position of objects, the *contour* tells you more specific information about the forms. (Does this progression sound familiar? It refers to the general to specific process that we discuss in Chapter 6 and throughout the book.) You use the underdrawing to help you find the placement of the contours.

To find the contours of your drawing, keep the following characteristics of contours and edges in mind:

- ✔ **Crisp versus soft edges:** Take a moment to really look at edges that are crisp and precise versus those that disappear into the shadow. First find an item with an interesting shape — a mechanical object like an old telephone is a good choice. Place it in a darkened area, where it's half in shadows and half in light. A closet shelf with the door set ajar so that only a little light can enter works fine. Notice how edges that you can see clearly attract your eye, perhaps because of contrasting lightness or contrasting color. In a drawing, these would be the crisp edges. Those edges in the shaded areas appear softer because of the soft edge of a shadow or because the values and colors are closer together and don't

have as much contrast. These edges are more difficult to see, but don't avoid them — your artwork needs all types of edges.

✔ **Angular versus wandering contours:** The lines in geometric, machine-made objects are often straight and angular or curve in a regular, machine-made sort of way. For natural forms such as plants, animals, and forms in a landscape, the lines seem to wander randomly. To capture the random nature of these forms takes a bit of doing because humans seek order in all things. Find a viney houseplant in a clay pot and imagine drawing the vines, leaves, and edges of the pot. As your eye follows the edges of the leaves, the line wanders in and out, across and down, all along the random edges. When a vine comes to the edge of the pot, the line continues in the perfect arc of the ellipse or down the side of the pot in a straight line.

Work on finding contours in your drawing by tackling this project in your sketchbook. These random lines can be a part of your underdrawing, or they can be a final bit of information you add to the drawing last.

1. **Choose a subject with a natural form, position it against a white piece of paper, and light it well so you can easily see the contours.**

 Anything with a natural, free-form shape works fine. We've chosen a flower, but you can try leaves, your hand, potato chips, two or three bananas, or a shoe.

2. **Hold a pastel pencil loosely 3 to 4 inches from the tip and drag it over the paper in the general shape of your subject.**

 The line will be a bit free-form, but it will be random as in Figure 8-3. If your subject is something *really* free-form, like a cloud or vine, twist the pencil in your fingers for even less control.

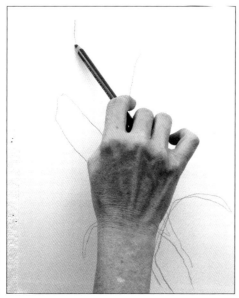

Figure 8-3:
Making random lines to find contours.

Looking through objects

One of the best ways to develop a strong structure in your underdrawing is to think of the forms as transparent. This strategy, called *transparent construction,* is a great way to develop the structure of the forms because it helps you visualize hidden portions of your objects and is invaluable for creating images of complex manmade objects and anything made from glass. Transparent construction is very similar to your underdrawing marks — it exists as bundles of lines, too. Chapter 5 explains how you can you implement this process in your drawings.

Figure 8-4 shows an example of how transparent construction looks; note how you can see through the box and cylinder shapes.

Taking your time with this stage in the drawing allows the work to develop gradually. Practice making transparent objects in your sketchbook. Make drawings of boxes, teapots or coffee pots, lamps, and chairs; geometric forms work best. As always, stop and check for accuracy as you work. See Chapter 6 for tips in checking your work.

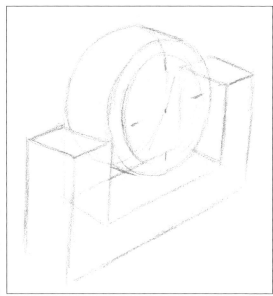

Figure 8-4:
Transparent
drawing of a
clock.

Creating emphasis with color

As the previous sections discuss, how wide or heavy you draw the line can give your line variety. So can color. By adding colors with different *temperatures* (such as the warmth of a red or the coolness of a blue), you can alter the way the lines appear in your artwork.

Bright colors and warm colors attract attention and move forward in a composition, and cool colors and duller, gray colors recede. This effect creates

the illusion of depth in your pastel drawing, and you can use these ideas as you choose colors to create line drawings with your pastel pencils. Chapter 11 discusses the details of color more in-depth.

Project: Still life on black

You can apply all the concepts we discuss in the previous sections to this project. Here you can make an underdrawing of structural lines and then develop it with some contour lines in a variety of warm and cool colors (we choose orange and blue here). All you need is some black Fabriano paper and hard pastel pencils in blue and orange. These colors are bright and show up on the black paper well, which helps clearly separate the lines. We use a tea kettle as our subject because it has both geometric and organic shapes. For your subject, you can use any item that is made up of similar shapes, such as a coffee mug or a small lamp. Figure 8-5 shows you the finished product.

1. **Make the underdrawing in pastel pencil.**

 We lightly lay out the structure in Figure 8-5's drawing in bundles of lines. We draw each ellipse first clockwise and then counterclockwise to achieve even shapes. You can use either of your colors here; we start with blue.

2. **Use the same pencil to define the form's contours.**

 Apply the lines more slowly than the underdrawing lines to describe more precisely what you see. In Figure 8-5, the more intentional lines on top of the structure lines describe the contours of the teakettle.

3. **Add more contour lines with the other pastel pencil.**

 These contrasting lines in the other color give an indication of the direction of the light source and help you see corrections to the shapes. Continue to build the form using transparent construction.

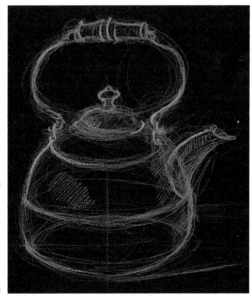

Figure 8-5: Using warm and cool colors for a simple line sketch.

Creating Tonal Drawings

Another way of working with pastel is to build the image out of broad sweeps of color without line. This method of *tonal drawing* emphasizes edges less and builds the forms with masses of color in an almost sculptural manner. With this method, you still work from general to specific, but your first marks are large masses of color, and then you break up these large masses with other bits of color. The following sections give you a thorough overview of incorporating tonal drawings into your artwork.

Grasping tones

In order to use tonal drawing in your next pastel masterpiece, you need a firm grip on the process. The good news is the process isn't difficult. Soft pastels are best for this method, but you can start with semi-hard pastels and then add soft. (Flip to Chapter 2 for more on different kinds of pastels.)

You can practice a tonal drawing in your sketchbook with a handful of pastels as a dry run to solve problems before starting a large drawing. (Check out Chapter 12 for more on problem-solving.) That way you start the main tonal drawing with confidence. Make a page of practice tonal marks first; they're very different from linear marks. Stick to these steps to create masses of tone:

1. **Choose an unpopular color — one that sits neglected in your box — and break off a ¾-inch length.**

 A semi-hard pastel (such as Prismacolor's Nupastel) works fine.

2. **Hold the pastel on its side against the paper and drag it down the page in a curving line that goes back and forth, like skiing down a hill.**

 Make several of these strokes to get the hang of making tonal marks. Figure 8-6 shows an example.

Figure 8-6: Using the pastel to create masses of color.

3. **After you've got a handle on the basic tonal mark, draw a ball by laying down a sphere-shaped mass of color.**

 To make the form look three-dimensional, add a light color on one side to indicate a lighted area and a dark color on the other to make the shaded area.

4. **Now try using the edge of the pastel to indicate the edge of a form.**

 You can press the edge of the pastel more precisely to indicate the edge of your ball, as if you're skirting around the inside of the ball. Practice this a little; it requires a bit of finesse.

As you add more and more layers to your drawing, the pastel builds to the point where the paper surface can't take any additional layers of pastel and you have to use spray fixative to give the drawing more *tooth* (surface texture for catching pastel). We cover spray fixative in more detail in Chapter 6.

You can find powdered pastels on the market that work well for this approach. They're called *PanPastels,* and you apply them with a sponge. PanPastels have a low degree of dust and work extremely well in laying down large masses of color.

Finding the shapes of light and dark areas

As you're laying down your color, you may immediately wonder where to actually put the color. When you look at your real-life scene, you can see the different areas of light and dark, but they all seem to blend together in a very subtle way. It's beautiful to look at, but how do you do it? The following sections show you just that.

Defining the pattern of lights and darks

First, you have to notice the pattern of light and shadows that the direction of the light source creates on your object(s). Keeping this pattern true and consistent is the key to creating a believable artwork.

Visualize the patterns you see as shapes of light and dark and try to imagine that you're creating your own paint-by-number artwork. Pretend that you only have three values of a color — light, medium, and dark — and that the edges of the shapes of the values are defined rather than blended. Don't worry about blending at this early stage; just leave the pattern well defined. Stroke-wise, you can use tonal marks, or hatching and crosshatching, which we discuss in Chapter 9.

You can use your viewfinder to help focus your attention and see the patterns more clearly. Head to Chapter 3 for more on viewfinders and instructions for making your own.

As always, you want to work from the general to the specific, developing the largest areas first and working through to the smallest areas last. Start by filling in the shapes of the large, dark areas, followed by the next darker, smaller

shapes within those areas. Continue finding successively smaller, darker areas until you have a good range of darks throughout the drawing. Do the same with the light areas, finding large, light areas and then moving on to smaller, lighter areas.

Adding highlights and shadows

After you start to develop the forms with lights and darks, you need to pay more attention to how the value is distributed within the image. Take a moment to really look at the scene before you. The light areas aren't all the same — those that are closest to the light source are brighter and lighter than those that are farther away. The point of intense light where the light is the brightest (usually a very small area) is the *highlight,* and the *shadow* area is the part of the object that doesn't receive any direct light at all. Capturing these nuances in the pattern of lights and darks is what makes your drawing that much more convincing.

One way to check your values is to blur your eyes to take away the details and reduce the scene to just the areas of light and dark. Look at your scene and find where the darkest and lightest areas are and then do the same on your drawing. You can then make the necessary adjustments to the size, shape, and intensity of the colors.

Considering light and dark areas in a composition

The areas of light and dark you work so hard to create aren't just artistic magic tricks used to make objects appear three-dimensional; they're also quite important to your overall composition. They work together in your artwork to create drama and direct the viewer's eye around the composition, as well as help connect all of the areas of the composition. Patches of contrasting light and dark attract the eye; they emphasize a focal point. Similar areas of value play down an area, making it subtle.

Try these strategies to make sure you have composed the values well in your piece. Take a step back and look at your work. Examine it from six feet or more away (or if you don't have space for that, look at your work in a mirror) and ask yourself these questions:

- ✔ Are the dark areas all bunched up into one part of the artwork or distributed throughout the composition?
- ✔ Do I have lights and darks in the secondary areas and background?

If you find areas that need more intense light or a deeper value, add the appropriate color. No matter what stage you're at in a drawing, you always have time to make adjustments.

Artwork with extremes of light and dark are dynamic and can almost be chaotic, and those with a subtle range of value — avoiding the extremes — look quiet and calming. But watch out — your image may end up looking boring. Figure 8-7 shows a balance of lights and darks; see Chapter 12 for more information on this balancing act.

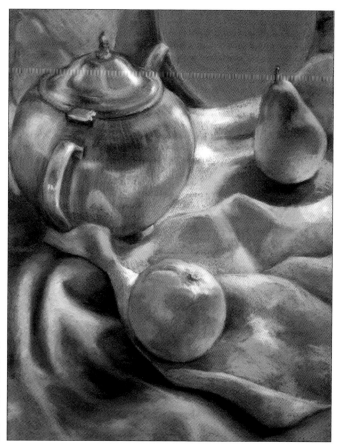

Figure 8-7:
A pastel still life with a balance of value.

Project: Eggs on colored paper

This project allows you to try some of the tonal methods we discuss in this chapter. In this project we select two eggs to draw on a medium blue paper with a variety of pastels. Eggs are great for analyzing values — they're round forms, but they're more interesting than the standard white ball. Blue paper is a good choice because the eggs stand out against the color, but it's not too dark. Take a stab at this project and follow these steps.

1. **Apply underdrawing marks for the initial drawing by sketching the oval form of the egg and find each egg's center line with pastel pencil as in Figure 8-8a.**

 Eggs have a small and large end. To make this shape, draw two circles, one large and one small, and then connect them with curving lines along each side of each egg.

2. **Using semi-hard pastels, lay out the main areas of value by establishing light and dark sides of the eggs and the shape of the cast shadows like in Figure 8-8b.**

 Keep the tonal areas distinct, with light color in light and dark colors in dark. The colors can overlap to form an area of middle tones where the two meet. Ask yourself which egg is closest to the light source and adjust the amount of light and dark on each egg — they likely aren't the same.

Figure 8-8:
An initial sketch of the eggs with pastel pencil (a) and adding the big areas of value (b).

3. **Find the highlight, light, and shadow on each egg and use semi-hard and soft pastels to fine-tune these large areas with gradations of value (refer to Figure 8-9).**

Don't neglect the setting for your subjects. The tabletop in Figure 8-9 has bright areas of light that correspond to the eggs.

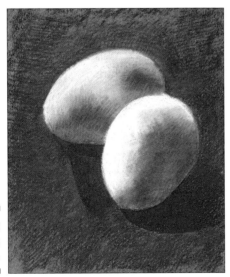

Figure 8-9:
Fine-tuning the values.

4. **Add the final touches by finding the reflected light and adding it with carefully applied soft pastel (check out Figure 8-10).**

The reflected light is the light you see *within* the shadowed side of the eggs. This bit of light hits the table and reflects onto the underside of the egg. It's quite subtle and not as bright as the highlight or lighted side of the egg. Then adjust the edges of the forms with pastel pencil by drawing a line around the edges of the eggs. The color of the line you apply should match the color already on the egg, so use light colors for the light side and dark for the dark.

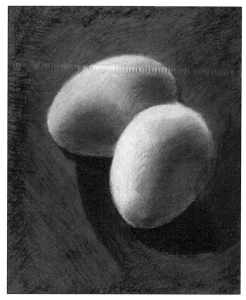

Figure 8-10:
Final
touches
with soft
pastel and
pastel
pencil.

You say painting, we say drawing

Throughout this book, we refer to the act of making an artwork with pastel as drawing. But pastel can also be used in a manner that is very similar to painting. This painting-or-drawing question can cause tempers to flare, so we want to dig into the debate a little.

Pastel use can resemble painting in many ways. You can apply the material to a support and use it in a rich, dense film of layered color, as with painting. You can wash the pastel with alcohol or other materials to completely cover the support with pastel color, building up the layers of pastel until the appearance can be difficult to discern from painting.

Many artists who work with painting media such as watercolor or oil also use pastel to make studies for traditional paintings. You can even add pastel on top of acrylic or watercolor paintings. You can read more about using pastel with other media in Chapter 14. Plus, many artists refer to their pastel artworks as paintings, and galleries and museums often follow suit — the pastel portraits by Rosalba Carriera in the Accademia Museum in Venice are labeled as paintings.

So why do many people (including your authors) call it drawing? For us, it's a matter of habit, custom, and training. We were educated to refer to dry materials on paper as drawings. Pastel is similar to other drawing materials; it doesn't require drying, and you apply it as dry material in the form of a stick or pencil — not a liquid from a brush or palette knife. You don't mix the colors on a palette, and the material goes on to its support in a manner that is indistinguishable from charcoal or other soft drawing materials. Even museums often categorize pastel artworks as drawings, like the Holbein pastel portrait in the Uffizi Museum in Florence, Italy.

Some people find a happy medium on this issue by making the distinction based on the way the artist uses the pastel. For them, pastel applied as a thick layer of color without any paper visible constitutes a painting. Pastel used to make a thin scrim of lines and color (similar to colored pencil or charcoal) with bits of the paper peeking through is a drawing.

Ultimately, the painting-versus-drawing question is in the eye of the beholder. Whether the artwork is successful or not has nothing to do with whether you call it a drawing or a painting. When we look at a beautiful Degas work in pastel, we aren't trying to decide whether it's a painting or a drawing — we're admiring a beautiful piece of art.

Bringing Lines and Tones Together

Although you may find that you prefer to work with either lines or tones (discussed earlier in this chapter), you can use both in the same artwork. Doing so allows you to use linear marks in some areas and still apply the pastel in thick layer in others. You can decide the direction of your artwork. Artists have used pastel in this manner from the very beginning. That's the wonderful thing about this medium; it's adaptable to a range of working methods. This section gives you a few pointers you can apply to a drawing with both lines and tones (such as the project in the following section).

As you build your drawing, some areas of the drawing may naturally be left less developed than others. You can apply more tonal marks or linear marks to add complexity and definition to areas that you want the viewer to focus on.

When you incorporate both lines and tones into your drawing, remember to apply the pastel in the hard-medium-soft pattern that we describe in Chapter 6. Start the work with hard or semi-hard pastel and then switch to soft for the last layers of color. The layers of soft pastel are delicate and fragile and can be damaged with too forceful a stroke or the application of a harder pastel.

Project: Going Bananas

This project allows you to apply all the concepts we discuss in this chapter. You can incorporate all the methods of putting down pastel — with lines and with tones. All you need are a banana, pastel pencils, semi-hard pastels, soft pastels, and a piece of 11-x-7-inch Rives BFK paper. The image is life sized.

We draw the banana by using the linear marks described in "Establishing a Drawing with Line" earlier in the chapter and develop it with a mix of soft, tonal marks as well as hatching and crosshatching (discussed in Chapter 9). The paper is completely covered with a thick layer of pastel in a paintlike approach. We leave the lines of the hatching on the surface of the drawing so the image is made up of some areas that appear tonal and some that have apparent lines of the hatching.

For your own project, plan to do a series of at least three compositions so that you can experiment with the techniques and building up layers of drawing. You can use these same steps for each drawing — you're just reworking the composition each time.

1. **Set up your composition, using a single banana on a simple ground, such as a sheet of white computer paper.**

 Pay attention to your lighting and the shapes of the shadows cast so that you clearly see a light side and a dark side of the banana and get a clear cast shadow.

2. **Use your viewfinder to help you find the best page-filling compositions.**

 Line up the banana so that it fills the viewfinder's opening but doesn't touch the edges. If the banana is horizontal, a horizontal orientation is

best for your viewfinder; you can also try a vertical orientation with a diagonal banana. Check out more on composition in Chapter 12.

3. **Lay out your initial sketches with pastel pencil and block in the basic colors with hard pastel.**

 Use structural underdrawing and then apply some color with tonal or hatched marks.

4. **Blend the colors into the paper and then begin developing the forms, first with hard and then soft pastels.**

 Apply more color with the hard pastels until you have color in all parts of the drawing. Next, apply soft pastels, building color and complexity by varying the colors to match the values in each area. Figure 8-11 shows an example of the final drawing. See Chapter 10 for help in laying down colors for shadows and making your bananas look three-dimensional.

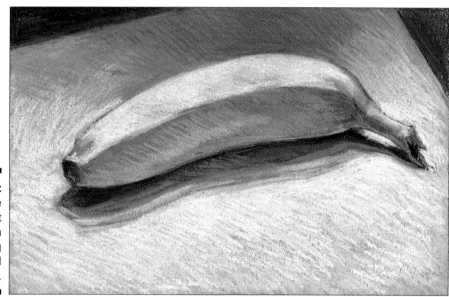

Figure 8-11:
A complete drawing that uses both line drawing and tonal drawing.

Chapter 9

Making Your Mark

In This Chapter

▸ Using mark-making to express a certain feeling

▸ Utilizing hatching and massing to build form

▸ Blending colors to create effects

▸ Creating textures with experimental techniques

Are you able to recognize your mother's handwriting? What sets her handwriting apart from another person's? When you look at a sample of her writing, you may recognize the shape of the letters first, noticing whether they tend to be rounded or linear. Next, you observe other features of her handwriting, including whether a line is wide or thin, sharp or blurred, and heavy-handed or lightweight. If you think about it, these are many of the same words you may use to describe the strokes you use in pastel drawing.

Many people worry unnecessarily about developing their own distinctive "style." Don't get worked up about your mark. Many factors (including pencil pressure, stroke speed, pencil sharpness, and dominant hand) impact the way you draw a stroke. Your style comes out naturally as you progress. Everyone is unique and the way you mark on a piece of paper is unique as well. Just as your signature has unique characteristics, your mark-making in your pastel drawing also has distinctive attributes. Your artwork is already recognizable as your own, as much as another drawing is recognizable as a work by Raphael. Your natural way of working changes over time as you develop as an artist, but it'll always be yours alone.

This chapter gives you an overview of creating your own style, or your mark, as well as the different marks you can draw and how you can use them in your drawings to bring out your own unique look and feel.

Understanding How Marks Create Mood

You can create mood in your drawing by thinking about what you want to communicate in your drawing and making marks that convey that feeling. Ultimately, the marks you make in your pastels form a *mood* (sensation conveyed to the viewer) or *expression*. A pastel drawing that looks very expressive appears to have an emotional quality to the work. For example, Van Gogh used linear brush strokes in the sky in "Starry Night" to convey the spectacular starlight he found in the sky, which belied the tranquility an evening scene might normally convey.

No one hesitates to use the word *masculine* to describe a set of bold, angular lines or the word *feminine* to describe a set of fine, delicate lines. Where does *that* come from? They're just lines on a piece of paper! The answer is that humans use their knowledge of the world to describe and make sense of everything they see, including a pastel drawing. The idea of an observer interpreting a set of lines as masculine or feminine is directly related to how his perceptions of those characteristics developed through observation or even social conditioning.

Because everyone has different life and cultural experiences, people read what they see differently. Therefore, an artist may intend to convey one message, but viewers may interpret it in many different ways depending on their experiences, which is absolutely okay. Artwork that touches many people, however, may have tuned in on an experience everyone has shared, which may explain why Mary Cassatt's scenes of mothers and children continue to strike a note with people today.

Figure 9-1 shows some lines that we scribbled. Take a look at them; do words like angry, calm, whimsical, lyrical, aggressive, or happy pop into your head? You're using your own filter to interpret the mood of our drawing.

Figure 9-1:
Marks can
express
different
moods.

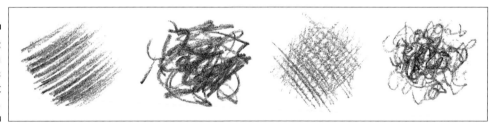

In this exercise, you push yourself to experiment with many different kinds of lines and then explore what kinds of moods and emotions those lines trigger for you and for others.

1. **Choose one of your pastel pencils.**

 A dark pencil works best because it has the most potential for variation of value. Use the same pencil throughout, because color can also affect the mood of a drawing; you want the only variable in this experiment to be the line.

2. **In your sketchbook, draw a series of lines to create as wide a variety of lines as possible.**

 Make as many different kinds of lines as you can — at least 20 separate lines trying something different with each one. Use heavy and light pressure, a sharpened pencil and a dull pencil, and so on. Make scribbled lines, looped lines, angular lines, delicate lines, lines that start and stop abruptly, and so forth. You're not trying to evoke a certain mood at this point; you just want to get a wide array of lines on the paper.

 Space them in rows or a grid. Leave room beneath each for a short list of descriptive words.

3. **After you have exhausted all of your possibilities for lines, examine each set and write a few words that describe each.**

 Look at each line and reflect upon what the line suggests to you. For example, maybe a wavy line looks like tranquility because it suggests water.

4. **Show the sets of lines to another person and ask him or her to describe them.**

 Showing the lines to someone else allows you to see how another person interprets what they see — they may see your lines very differently than you do. Strokes that indicate anger to you may seem energetic and ecstatic to a different person. If your intent and the viewer's interpretation differ, don't worry. It's fine. Just avoid making them incongruent and confusing.

Creating Marks for Realistic 3-D Objects

An important consideration in your mark-making is how to create the illusion of three-dimensional form. The most important part of creating realistic objects is *value* (the patterns of lights and darks), but the big question is always how to lay that value on the paper. You can read more about using value to create realistic looking objects in Chapter 10, but here we provide some strategies for putting pastel to paper so that you can concentrate on value when you're ready.

The two basic strategies for laying down pastel to create realistic objects are making lines and generating mass. *Line* involves using the end or a sharp edge of a pastel stick or pencil. Some pastel drawings are simply made of long, beautiful, fluid contour lines. Others utilize dense webs of shorter lines called hatching (which we discuss in the following section). *Mass* involves laying a short piece of pastel on its side and making broad strokes that feel like coloring. Everyone has a preference for one or the other, but artists often use both in tandem with each other according to their individual working methods. The following sections show you some basic how-to processes you can use to incorporate these two strategies into your drawing.

Hatching

Hatching is a system of laying down strokes to develop areas of color. You can use different hatching strokes to define the surface contour of an object, to develop shadows, or simply to put some color down. The possible downside of using hatching in your pastel is that you have to layer it very densely to cover the color of the paper if you don't want the color to show through. Thinly layered pastel drawing integrates more easily with colored paper than white paper, which is why many artists tone white paper by giving it a thin layer of pastel color before they start. Hatched pastel on white paper does have a certain appearance that many artists find appealing, however, so follow your own preference.

Making the strokes is a repetitive action that comes from the wrist, but that doesn't mean they have to be boring. You can vary them not only by using

the methods we discuss in the previous section but also by changing the direction, density, and speed of the strokes. Using the following hatching strokes creates pastel drawings that appear exceedingly textural, but the energy in each affects the expressive quality of your work differently.

Uniform strokes

One of the most common types of hatching strokes is the uniform stroke. Drawings made with *uniform strokes* appear structured and controlled, yet textural. You make uniform strokes by drawing short parallel lines that run the same direction.

To create a uniform stroke, just follow these easy steps:

1. **Determine the shape of the area you want to hatch.**

2. **When you make your initial drawing, you can lightly sketch in the shapes of the light, medium, and dark areas of an object, like a paint by number.**

3. **Draw parallel lines the same direction to fill each shape you drew.**

 Use light lines for the light areas, heavier lines for the medium value areas, and dense lines for the dark areas. Change the pressure on the pastel to make the lines lighter or darker. Or you can use light, medium value, and dark colors without changing the pressure on the pastel.

Many times, you draw the lines on diagonals that relate to whether you're right- or left-handed, but you occasionally make compositions made up of vertical or horizontal strokes. Here are some ways you can use uniform strokes; check out Figure 9-2 for more examples.

- ✔ Draw the lines the same direction throughout the composition to create a structured appearance.

- ✔ Draw parallel lines that follow the surface contours of the objects, like the engravings of the faces of the people depicted on your money, to emulate the topography of the surface of the forms. That may mean that you draw the parallel lines a different direction for each object in your composition.

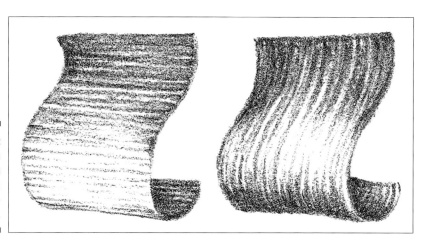

Figure 9-2:
Uniform strokes allow you to use controlled lines.

Crosshatching

Crosshatching, as the name implies, utilizes lines that cross each other. You can try these two basic approaches to crosshatching:

- ✔ **Diagonal hatches:** The most expressive, dynamic way to draw crosshatch is to use diagonal marks. They maintain the visual movement of your subject matter better. A good crosshatch looks like grass clippings, but a better crosshatch follows the surface contour of an object more closely. Some lines may run the length of the object, with lines crossing on the diagonal, for example.

- ✔ **Perpendicular hatches:** If you want structured drawings that have little movement but appear solid, use marks that are perpendicular. Usually, the lines run the length of the object with perpendicular lines running across the width, almost like a drawing made out of a wire grid.

You can practice these by following steps similar to those for uniform hatching in the preceding section. Figure 9-3 illustrates these strokes.

Figure 9-3: Cross- hatching allows you to make expressive marks.

Agitated strokes

Agitated strokes are scribbled strokes that have a lot of energy. You approach them with the same energy a child uses to color a large area in his coloring book. This kind of stroke is related to crosshatching, but the lines go in every direction and may move outside the form of an object, giving the appearance of controlled chaos. Agitated strokes create a tremendously expressive drawing.

To create agitated strokes, just follow the same steps you use for crosshatching but make the marks from the wrist using quick, scribbled movements. Figure 9-4 shows you agitated strokes.

Figure 9-4:
Agitated strokes allow you to show strong emotions.

Massing color

Massing color is a method of drawing that emulates the look of a painting. It's a versatile technique for creating mood because it can look very soft and smoky on one hand, or crisp and precise on the other. Massing pastel entails using the broad side of the pastel to make soft, broad strokes that look like paint. As a matter of fact, you find yourself working and thinking like a painter, even though you're using pastels. Massing is an easy way to make your work look three-dimensional because you can vary the pressure of the strokes to make quick dark and light areas. The following sections point out two ways you can mass color.

Using the sides of your pastels

For massing, you use the sides of your pastels, laying in color much like you lay down paint with a brush. Break off half-inch sections of the colors you want to use and then lay in the colors with broad strokes. As you make your marks to lay in the colors, vary the pressure so the marks define the light and dark shapes. For example, light pressure for the shapes of the light areas and hard pressure for the shapes of the dark areas. When you need to define more refined areas, move to the edges of the pastels. (See Figure 9-5 for an example of massing color.) This method is great because it helps you think general to specific. Getting too bogged down in details is difficult if you have to do it with the broad side of a house!

Figure 9-5:
Mass color with the side of your pastel.

Layering colors

Layering colors is a system of blocking in the major colors and then refining the patterns of colors and values layer by layer. You block initially by massing in the major areas of color throughout the entire composition. Don't get stuck in one area, refining it at the expense of the rest of the composition. In the next layer, you observe and lay in the next smaller shapes within the shapes you already laid in. You continue developing these patterns until the smallest patterns are defined in the areas you want to emphasize. You can read more about how to develop these patterns in Chapter 10.

Considering Blending Techniques

Most people think of pastel as a medium with lots of visual texture — if you look closely, you can see that what looks like texture is actually specific marks. However, you can also manipulate your pastel drawing's appearance by blending the pastel. Even though this method appears smooth and without marks, it's still a form of marking to achieve a desired pastel effect, such as to set a toned foundation for the drawing or create delicate changes in values.

Here are some reasons artists blend pastels:

✔ To make realistic soft value gradations, such as you might see in skin.

✔ To tone specific areas so that you can mark over the areas without white areas showing through.

✔ To soften textures that are too rough for the surface you are emulating or to soften edges to make objects appear to be farther away.

✔ To blend colors, especially when massing colors in the first layers of the drawing.

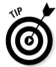

Blending colors isn't difficult. Follow these easy steps to get the hang of it:

1. **Lay down color in the areas you want to blend.**

 Do this as you would if you were massing color as described in the "Massing color" section of this chapter.

2. **Softly rub the color into the paper with your blending tool of choice.**

 If you're blending colors together, start rubbing the lighter color with circular motions into the darker color. You can see how to blend colors for the lower levels of the drawing in Figure 11-13b in Chapter 11.

For the best control in blending specific areas, artists use *stumps* and *tortillions*. These are small rolled paper sticks that look like paper pencils. Stumps are sharpened on both ends, and tortillions are sharp on one end and blunt on the other. You can also use a chamois cloth, although it does tend to remove some of the pastel. Blending isn't a science, however. For large areas, simple paper towels or cotton socks can work. (We recommend using clean socks, for obvious reasons.) You can see how to blend pastel with different kinds of utensils in Figure 9-6. This figure shows blending with a tortillion, cotton tip, chamois, and a small piece of paper towel.

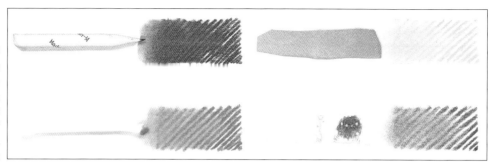

Figure 9-6:
Blending
pastels with
various
kinds of
tools.

Whipping Up Some Creative Textures

Pastels offer a wide range of possibilities for different textural effects, especially if you're willing to mess around with them a little. Every material offers potential for new ways of working. Although some of this experimentation may be more for people who are a tad more familiar with pastels, after you get a good grasp of the basics you can play around with the following techniques and see what you can do. Use them as a jumping off point for your own experiments.

✔ **Rubbing through with a kneaded eraser:** A kneaded eraser picks up some pastel (after all, its job is erasing), but if you don't knead the pastel into the eraser to clean it as you normally would, the eraser can act as a rubbing tool that pushes the pigment into the paper and blends the pastel together in a paintlike fashion as in Figure 9-7.

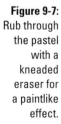
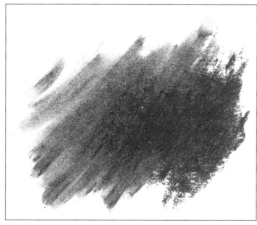

Figure 9-7:
Rub through
the pastel
with a
kneaded
eraser for
a paintlike
effect.

✔ **Scrubbing with a brush:** Scrubbing with a brush can be an effective way to blend pastel because the brush pushes the pigments into the fibers of the paper. If you work on a smoother pastel or art paper, you can achieve a soft, feathered look to the pastel drawing like in Figure 9-8.

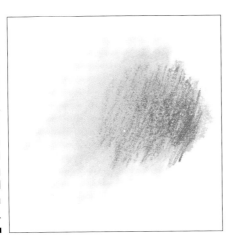

Figure 9-8:
Create a feathered look by using smooth paper and scrubbing the pastel with a brush.

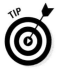

✔ **Blending with water or isopropyl alcohol:** For a soft, watercolor-like appearance, you can wet the pastel pigment with a brush dampened with water or isopropyl alcohol. This technique takes some experimentation to be able to predict how the color will react. Thin layers of pastel work better than many layers because each layer blends into the other and the layers can muddy if you aren't careful. You can also layer more dry pastel on top of the treated pastel if you want.

Isopropyl alcohol works better than water on some papers, which can warp if you use water. If trying water techniques is interesting to you, you may want to consider using watercolor paper. Check out Figure 9-9 for an example.

Figure 9-9:
Brush water or isopropyl alcohol through pastel for an effect similar to watercolor.

✔ **Brushing through with acrylic matte medium:** After you make your drawing, brush *acrylic matte medium* (a variation of the binder for acrylic paints) into the pastel to create various painted looks. Matte medium appears milky while it's wet but dries clear. Matte medium thinned with water may appear similar to watercolor, but it dries with a little bit of sheen. A heavier, concentrated application gives you a more heavily painted look. You can use any kind of brush or stroke with this method.

Be aware that chalk pastel may not adhere well to a thick coating of dry matte medium, but you can draw into it while it's wet. (You can, however, apply oil pastel to the dry matte surface.) Thin coats of matte medium on paper may allow for more work into the surface. Figure 9-10 shows you a sample.

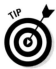

Avoid using gloss medium for this technique because the glossy appearance is so different from the matte appearance of the pastel.

Figure 9-10:
Brush acrylic matte medium into pastel to make it look like thinned acrylic or oil paint.

Brushing through with gesso: *Gesso* is a matte white primer for art surfaces. Brushing gesso into a pastel drawing has the effect of adding a chalky white to the color and may streak it, which is often very interesting. Because gesso can provide a *toothy* surface (surface that will grab pastel), you can draw into the surface after it dries, especially if your gesso coat is thin like in Figure 9-11.

Figure 9-11:
Brush gesso into pastel for a chalky and possibly streaky look.

Project: Nine Parts, One Experimental Masterpiece

This project is fun and gives you a chance to try out some new techniques. Here you can practice creating mood in your drawing by experimenting with some of the techniques we discuss in this chapter. See Figure 9-12 for

an example of one version of this project. This project is a sampler of techniques drawn on squares of paper. The small compositions are then composed into a larger square composition configured as a 3 x 3 grid.

1. **Choose a subject that has different kinds of parts.**

 You need nine different sections for this project, so having lots of part options is helpful. For example, if you plan to draw a face, you can use views of the eyes, nose, and mouth depicting various expressions. Cars, animals, plants, and machinery are other good choices.

2. **Make rough sketches in your sketchbook; in square frames, draw the parts you want and work out any compositional problems.**

 Make sure your image fills the square well. A small drawing looks lost and disappointing.

3. **Using a ruler for a straightedge, measure and tear pastel paper into nine 6-inch squares.**

 You may cut the paper if you want, but tearing gives you an attractive *deckled* (ragged) edge. To tear paper to size,

 A. Measure and mark the size you want on the backside of the paper and then line the ruler up with your marks, leaving the paper you want to remove outside the edge of the ruler.

 B. Press the ruler firmly against the paper with one hand, grasp the corner of the paper with your other hand, and pull it toward you slowly, tearing the paper.

 To make a clean tear, be sure to press down on the ruler next to where the paper is tearing, moving your hand down the ruler as you tear the paper.

 C. Run your thumbnail down the edges of the paper to press down any raised edges to give them a finished, well-crafted appearance.

4. **Lightly lay in the initial drawings based on the work you did in your rough sketches in Step 2.**

 Transfer your drawing by using a light colored pastel pencil. Keep your rough drawing in front of you while you draw so that you can copy it accurately.

5. **Complete your drawings by trying a different set of strokes or experimental technique for each.**

 Before you start, make a list of techniques you want to try and gather materials. Begin working on each composition. Make sure you cover the entire surface of each paper with pastel. Use a similar color palette for all of the compositions so that when you compose them into the large composition, the overall palette works.

6. **After you finish all nine drawings, arrange them in a 3 x 3 grid and mount them on a stiff white board to display.**

 Try a variety of different grid arrangements to find the most attractive composition.

Figure 9-12:
A completed nine-part work that uses experimental techniques.

Chapter 10

Making Your Work Look Real with Shadows and Solid Forms

In This Chapter

▶ Understanding how light position affects shadows

▶ Modeling realistic shadows

▶ Using edges and broken strokes to create form

*H*ave you ever seen a painting or drawing that looked so real it just took your breath away? The image comes together so well and so convincingly that you feel that you can reach out and touch the real thing. Since the Renaissance, artists' quest to depict the world in a convincing manner has played a key role in art making. In this chapter, we show you a few things you can do now to make your objects look real and how you can construct your own version of reality.

Illuminating News: Creating Shadows

No matter what you want to make a picture of, lighting is all-important. Just the right point of light can focus the viewer's attention and add drama or subtlety to your work. Lighting reveals and conceals forms and colors. Correctly seeing and depicting the play of value (both lights and darks) across an object is what makes it look three-dimensional. This modeling or shading is a primary goal for most artists to make their work look real and convincing. Whether you're setting up the light yourself or dealing with natural light in a landscape, knowing how to work with light has a big effect on your art. This section explains how lighting affects your subjects, how to set up your own lighting, and how to use different colors of pastel to make light and shade.

You may take lighting for granted, but when working with pastels, your light sources can play a big role in what your drawing looks like. Setting up the right light for your scene is one of the first things to consider when you begin to work. Check out Chapter 4 for some insight on the different types of lighting available to you and how to know which light source is right for you.

Grasping how a light's position affects a cast shadow

Your light's position has a big effect on *cast shadows* (the shadow your objects cast on surfaces under and near them). Whether the light is directly overhead, to the side, in front of, or behind your scene determines whether the shadows are long or short, angled or straight, or nonexistent. For example, you can easily observe when the late afternoon sun casts dramatic shadows over a landscape. The direction of the light source is at a low angle and casts long shadows, giving you stronger areas of light and dark in your landscape. These cast shadows not only create patterns of light and dark, they occupy space in your drawing and function almost as another object in the scene.

When you set up your scene, you are setting up your subject *and* the lighting at the same time. Consider what part of your scene you want the viewer to focus on and make sure that part has a strong, clear light. Strong light on a form focuses the viewers' attention on that object, giving it center stage. Angled light, coming in from the left or right, gives you the clearest pattern of light and shade, and *raking* light (light that falls across the object) illuminates the texture and the surface of your subject. Setting the light for your scene has as many options as the subject itself, so try out several to see what works for you. To illustrate this point, try this lighting experiment and see what happens. Set a cup up on a table with a plain background. First position the light so that it casts a direct beam on the cup from one side at an angle. Next, try it from directly above and then from directly in front of the cup. See how the cast shadow looks different with each position of the light? You can try out lots of positions to find the best arrangement of light and shadow for your scene. Figure 10-1 shows the effect light has on casting shadows.

Figure 10-1: A cup with shadows from three different light directions.

As you probably notice, the position of the light also has an impact on the emotional content or mood of your artwork. Each shift in light direction or intensity changes the overall look of the work. For example, think of the effect of a flashlight under your chin when you tell a spooky story at a campout. It's a silly, kitschy example, but you get the idea.

Modeling the lights and darks

After you have your subject lit, you need to break down the various areas of light and dark/shadow for your drawing. This *modeling* process is important because if you can see, analyze, and portray light accurately, it makes the

objects look as if they exist in three dimensions. (***Note:*** Modeling is the same as the concept you may know as *shading;* we refer to it as modeling in this book.) You may have seen this process before as a diagram of a ball with finite zones of value labeled as highlight, light, shadow, cast shadow, and so on. If you haven't, not to worry. Stick to the following steps and walk through the process. For each step, work on the subject, secondary areas, and background in that order before moving on to the next step.

1. **Set up an object and adjust the setting and lights so that you have definite areas of light and shadow.**

 The best arrangement is to have the light above and to the left or right at about a 45-degree angle from the object. Depending on the strength of the light, position the light close to the subject so you have clear areas of light and shade. We use a plain cup on a cloth against a blue wall, and our light is a clamp light with a strong bulb. You can use any item that you know you can draw with confidence, but keep it simple. In other words, no Easter eggs on plaid cloth.

2. **Start with an underdrawing, using structure lines and transparent construction to lay out the drawing and including the placement of the cast shadow's edges (as we do in Figure 10-2).**

 Sketch in your object in life size, making sure you have enough room for the cast shadow. You can find more instruction on structure lines and transparent construction in Chapter 5.

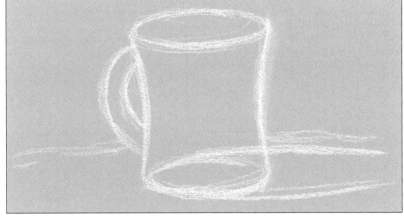

Figure 10-2: Structure line drawing with shadows drawn in.

3. **Draw the light and shaded areas on the object.**

 To do so, follow these steps:

 A. Using tonal marks, lightly block in the values with a medium-dark and a medium-light color.

 At first glance you see that the cup has a light side and a dark side. These are the big general areas of value and color. Use a pastel stick on its side to lay down a soft tonal film of light and dark color. (Chapter 8 gives you more info on tonal marks.) As you look more closely at the object, you see that these areas have some variation of light and dark. Find some slightly different colors of light and dark to add variation to each side.

B. Add the appropriate color to the subject and the background as in Figure 10-3.

For our scene, we add two shades of blue for the background, cloth, and cast shadow under the cup in the foreground. For your scene, select the color that matches what you see.

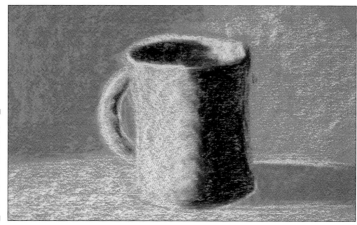

Figure 10-3:
Blocking in the general values in medium tones.

4. **Break the big dark and light areas into smaller zones of value.**

Start by adding variations to the colors of the subject. When you're first starting out, you see the subtle gradations of value and may want to blend. Resist the urge! Keep the areas distinct for this exercise. To break the areas into smaller zones, follow these steps; we start with the dark values, but you can choose to work on either the light or dark areas first:

A. Find the smaller zones where the value is the darkest and add them to the object as in Figure 10-4.

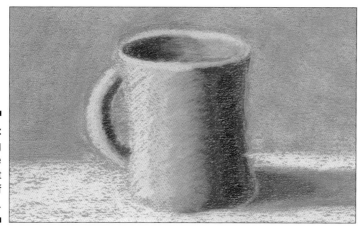

Figure 10-4:
Breaking down the darkest areas of value.

B. Continue with all the other areas, adding a deeper value of dark to each big general area.

Remember to add more pastel to the cast shadow as well. As you work you may want to apply spray fixative between layers to set the color and allow you to add more layers.

C. Switch your focus to the bright spot of light (the highlight) you see on the light side of the object.

You may have more than one spot of highlight. Use the lightest color possible to make the highlights — perhaps white or a very light version of the color of your subject. Add the highlight in very short marks of color. You can see our highlight in Figure 10-5.

D. On the dark side of the object, add the reflected light applying small marks of pastel in a slightly lighter color than the shadow as in Figure 10-5.

The *reflected light* (the light reflecting from the surface of your table to the shaded side of the object) isn't quite as light as the lighted side of the cup. Try out layering colors to achieve the right color. It may be the same as the middle values or be a slightly different color. Because the reflected light is literally light that is reflecting from the surface of the table, it can pick up some of the table color and bounce it up onto your subject.

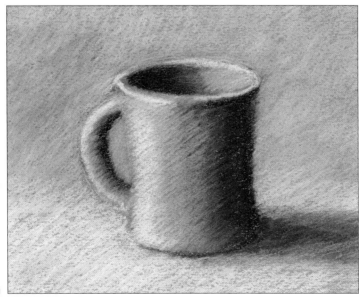

Figure 10-5: Adding highlights and reflected light.

5. **Repeat Step 4 for each area of the drawing until all the values and colors are correct.**

When you break down the light and dark, you see lots of variety in light, shade, highlights, and cast shadows. By focusing your attention, you can see other things, too. For example, the cast shadow is very dark directly under the cup and less dark in the other parts of the shadow. The different areas of light and shadow have subtle half-tones where the light and dark mix together. You can continue to develop these areas.

Seeing how colors make shadows

Colors help give your shadows life, but to use color well, you must go beyond merely adding white and black to your colors to make them lighter or darker. Both of these neutral colors make other colors look dull and less intense. If you can't use black or white, how are you supposed to create shadows? Your choice of colors may stump you initially, but the following list shows you some ways you can go about adding color to create shadows without sacrificing brightness and intensity:

✔ **Select colors that are close to the actual color of the object.** The intrinsic color of a form is called its *local color,* which means an orange's local color is "orange." To create shadows for that orange, you select the colors that are close to orange. Even if you have a pastel that is an exact match for your orange, use two or three different colors to create depth and richness. Remember to keep track of your light source and apply light colors to the light side, dark to dark. Figure 10-6 shows an example.

Figure 10-6:
Using variations of the local color.

✔ **Choose colors that are *analogous* to the local color on the color wheel.** *Analogous colors* are next to each other on the color wheel; you can refer to Chapter 11 to see a color wheel. Picking colors this way creates the brilliant, vivid colors you see in sunlight. For analogous colors to orange, you can use red-orange and red for darker areas and yellow-orange and yellow for the lighter areas. See our examples in Figure 10-7.

✔ **Use complementary colors.** *Complementary colors* are directly opposite of each other on the color wheel. This technique creates more muted colors similar to those you see in artificial light or in interiors. The complement of orange is blue, so in Figure 10-8 we use bits of blue for the darker side of the shadow.

Figure 10-7:
Using analogous colors to make a shadow.

You have to be a bit careful when adding complementary colors; the colors can muddy. If you find you've added a little too much of the complementary color, you can add some of the local color back into the complement to balance it. In Figure 10-8 we add some orange and red-orange to balance the blue.

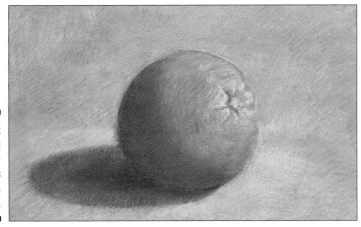

Figure 10-8:
Using complementary colors to make a shadow.

✔ **Select colors based on value, regardless of the actual color.** This approach offers more variety of color and creates a complex, fragmented pattern of color and light. Just set out some light colors (such as pinks, pale yellows, and light blues) in one group and dark colors (such as violets, deep reds, and dark blues) in another. If the colors start to mix too much or don't look right, spray some workable fixative to set the colors so you can apply more layers. Allow it to dry for a few minutes and continue to build layers. Figure 10-9 shows our version of using colors based on value.

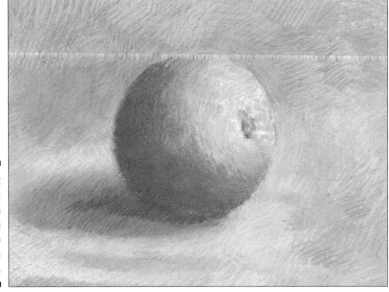

Figure 10-9:
Selecting colors based on value to make a shadow.

Adding Dimension to Your Scene

After your object has a variety of color and value, you want to start to add more color to make the form appear more substantial and three-dimensional so that it appears real. Creating the illusion of a three-dimensional form helps your pastel drawing come alive. This section shows you a couple of different ways you can do this.

Take this step *gradually*. Resist the urge to fill in the area with solid color. If you do, you may end up filling all the texture of the paper and be unable to add any more layers. And remember, the beauty of pastels is their capacity to build up color in layers. Also keep in mind that you don't have to completely cover the drawing surface. Small bits of paper showing through can be an important part of the drawing.

Working with a broken stroke

One method of developing dimension in your forms is to lay down individual strokes or marks of pastel that visually describe the surface of the object. These bits of color give the illusion of a surface and mimic the texture of the object. The color can appear to be a multicolored mosaic that describes the play of light and shade across the object's surface and therefore gives it dimension. Make small marks, dots, and dashes across the form. You can stick with analogous, complementary, and/or value-based colors as we describe in the preceding section.

Broken stroke works best on small-scale drawings and with lots of patience — be sure to take your time. Make your marks relatively small, like embroidery stitches. The size of the mark should never be more than a quarter of the shortest length or width of the form. Broken stroke can get tedious because you're repeatedly using the small hand muscles, so take a break occasionally as you work.

Broken stroke is somewhat easier to do with a medium-hardness pastel or a pastel pencil; they're harder and make a definite mark. Repeated marking dulls the point of the pencil or the edge of a square pastel, so develop the habit of turning the pencil in your fingers or switching to a new sharp corner of a square pastel to keep the marks definite.

If you have trouble working with broken stroke, hatching and crosshatching are a very good way to get started. The marks are just a bit shorter and they don't have to cross each other in a fixed pattern; they are more random. For example, take a look at the marks of color in some of Van Gogh's self portraits. Whether he was using oil paint or pastel, you can see that he used many different types of marks to build a network of broken strokes. Some marks appear to be hatching and crosshatching (which we cover in Chapter 9), and some seem to follow no pattern. He used a broken stroke to build up color with individual marks giving the work vibrancy.

Practice broken stroke in your sketchbook, trying out a few different ways to select your colors as we describe earlier in the chapter. Using similar colors gives you a subtle effect; if you use a wide range of colors, playing free and easy with your choices, you have a livelier image. You can make just a patch of color or draw an image of a simple subject. Putting blue on a red apple, for example, may seem weird, but sometimes you really can see it there.

Thinking about edges

Another way to make your work look real is to pay attention to the edges of your subject. You can work with two types of edges:

✔ **Closed edges:** *Closed edges* are crisp edges that clearly enclose the subject. They show up when an object is clearly lighted and the edge is a contrasting color to its surroundings.

✔ **Open edges:** *Open edges* are fuzzy, indistinct edges that don't seem to stop at a definite point. These edges appear on forms that are in the shadows or where the edges are a similar color or value as their surroundings.

You can easily create closed edges with the point of a pastel pencil or the corner of a hard pastel and open edges by either blending the edge or by laying down fragments of color along the edge.

You may have both types of edge in a work, playing one off another to keep the viewers' eyes traveling around the image. The closed edges with contrast attract the eye first; they indicate a focal point and where items are clearly lighted. The open edges are harder to see; you find them in the shadows or to indicate distance. They add interesting variety to the work without making it too busy. Figure 10-10 shows an example of both crisp and blended edges.

The way you depict the edges of a form also has an impact on the mood of your drawing. Closed edges give your work an appearance of cool detachment; they look clear and rational. The eye is attracted to closed edges because of the contrast and the abrupt jump from one color or value to another. You can emphasize this effect with contrasting colors and a big difference in value. Open edges blend into their surroundings, creating mystery and carrying a quiet message. They don't attract the eye initially but play a more subtle role in your drawing.

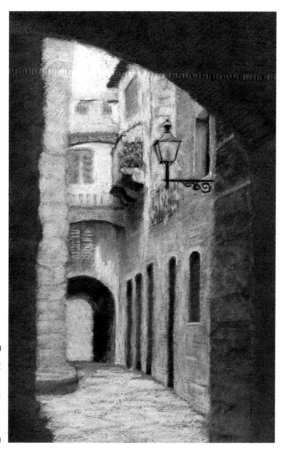

Figure 10-10:
Drawing
with crisp
and blended
edges.

Project: You Say Tomato . . .

This project lets you get down to business and see what you can do with all the information about shadows and form that we discuss in this chapter. In this project, we draw two tomatoes on a yellow cloth. We use pastel pencils and medium-hardness pastels on a piece of Rives BFK paper.

Make sure you get the right lighting. Experiment with lighting from what you have available around your house. A clamp light or desk light with a shade works best. Remember to adjust the direction of the light and maybe turn off any overhead lights so you're in full control of your lighting. Use your viewfinder to preview your scene and ensure that the lighting and objects make an attractive setup. (Head to Chapter 5 for more on using a viewfinder.)

To create this project, follow these steps:

1. **Use pastel pencil to create a structural underdrawing.**

 Sketch in all the shapes you see, including shadows, using light strokes and bundles of lines.

2. **Lay in large areas of color and value with tonal marks.**

 Select two colors for the tomatoes (a light and dark color) and two colors for the cloth (a light and dark). Find the colors that are closest to the value and color that you see in each of these big areas. You can see both the underdrawing and value marks in Figure 10-11, which is okay; you're not looking to cover the sketch entirely just yet. (Check out Chapter 8 for more on tonal marks.)

Figure 10-11: An under-drawing of the project with large value areas laid in.

a

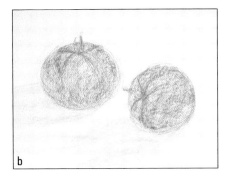

b

3. **Break down the big value areas with more colors of pastel as in Figure 10-12.**

 Select a color for the darkest part of the shaded side of the tomatoes and for the darkest part of the yellow cloth and apply them over the first layer of value to indicate the small bit of dark you see; do the same for the light areas. Don't cover the area completely; you're still laying in general areas of color. We choose a color close to the actual color of the objects (their local color).

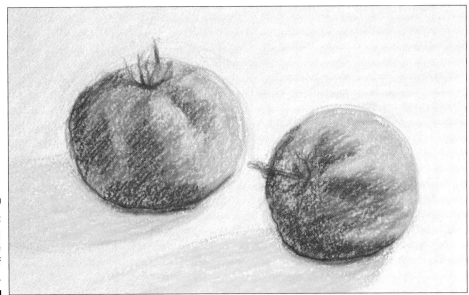

Figure 10-12: Breaking down the big areas of value.

4. **Continue to break down the light and dark areas with broken strokes as in Figure 10-13.**

 Hatching and crosshatching are one way to get started with broken stroke. Apply color variations to all areas — don't get stuck on just one spot. The dark red of the tomato doesn't just become redder; we add some violet as well. The light side is light red with orange and yellow. For the cloth, we use a pale blue-green for the cast shadow. Check out Chapter 9 for more on making these types of marks.

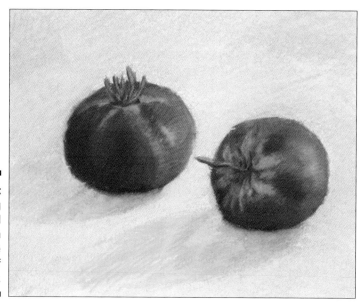

Figure 10-13: Adding hatched marks with a wide variety of color.

5. **Apply workable spray fixative and continue developing the values.**

 The fixative helps you build up lots of layers without muddying your colors or losing the ability to add more pastels. We add some green to the shaded side of the tomatoes because green is the complement of red, but you can try all sorts of methods, including those we discuss in "Seeing how colors make shadows" earlier in this chapter. Continue to develop the forms and values until it's finished. You know it's finished when all the objects appear three-dimensional and you have a variety of color on all forms.

Chapter 11

Pastels, Color, and the Big Picture

*F*rom start to finish, pastel is about color. Whether you're a beginner or have been around pastels for a while, you probably look at, caress, and even drool over sets of luscious pastels and dream of the beautiful art they can make. However, when you get them home, you may not be quite sure how to make them live up to their promises. We've been there before, so don't worry. In this chapter, we release their (and our) secrets and hand you the tools you need to make the colors sing in your pastel drawings.

A Simple Color Primer in Pastels

If you don't understand a few basic things about color when you work with pastels, you're essentially in a boat without a paddle, at the mercy of whatever current comes along. You're headed the right direction, but you may not arrive at your destination. The following sections provide you with some basics to help you paddle toward that wonderful artwork.

Describing colors

Everyone thinks of *color* as being red, blue, green, and so forth, but color is much more than the name you give it. You can find many versions of blue, for example, but what makes one blue different from another? The answer is that colors have three properties:

▶ **Hue:** *Hue* is the name you give a color, but it also describes its position on the color wheel.

▶ **Value:** *Value* explains how light or dark the color is.

✔ **Intensity:** *Intensity* refers to how bright or dull the color is. When you talk about intensity, you may refer to its *temperature* (whether it's warm or cool), or refer to its *saturation,* which describes the purity of a color's hue (how free it is of white, black, or hues from the opposite side of the wheel). A color's brightest version is its *pure hue.*

Any discussion you have about color involves those three properties. In the next sections, we cover these properties in more detail and explain how each of them affects the decisions you make about color.

Getting acquainted with the color wheel: Hue

Hues are organized into what is commonly known as a *color wheel,* which acts as a map of the relationships colors have with each other. But you may not realize just how much the color wheel has to offer your artwork. If you understand the relationships among colors, you can apply them to make colors work for you.

Think of the color wheel as a slice of rainbow looped around and tied into a circle. It represents the spectrum of hues that make up the white light from the sun. Every color you see, dark or dull, has a basic hue whose position you can plot on the color wheel. The color wheel you see in Figure 11-1 is based on the work of Johannes Itten and Josef Albers.

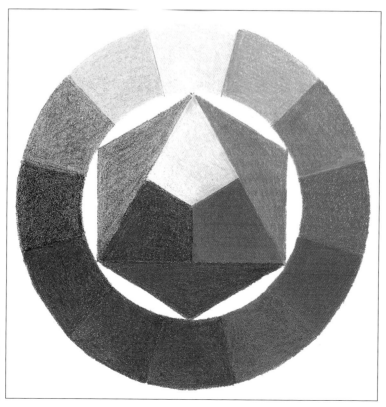

Figure 11-1:
A simple
color wheel.

To correctly name a color, you call it by its hue name rather than subjective names such as cornflower, teal, or peach. What color is "peach," anyway? If you look at a peach, you can see a range of hues that include red-orange, orange, and yellow-orange. Everyone has a different idea of what the color "peach" is, but hue names are very specific.

Here's a quick overview of what you can find in the color wheel:

- **Primary hues:** These hues are red, blue, and yellow. Theoretically, you can make all other colors from those three hues.

- **Secondary hues:** They're orange, green, and violet. (In the Albers/Itten system, *violet* is the same hue as *purple* would be in another system.) Theoretically, secondary hues are the result of mixing two primary hues together.

- **Tertiary hues:** These hues are red-orange, yellow-orange, yellow-green, blue-green, blue-violet, and red-violet. Theoretically, these hues are made from a primary hue and a secondary hue.

- **Complementary hues:** They're the hues directly opposite each other on the color wheel. Examples are red and green, violet and yellow, and blue and orange.

Some color wheels also include the *intermediate hues,* hues that fall in between the hues shown on the wheel, such as red red-orange or green blue-green. Some wheels also feature *achromatic* entries (such as black, white, and gray) that have no hue.

You may notice that we talk about "theoretically" creating colors. That's because in practice, you can only get the brightest versions of some colors, such as violet and red-violet, by buying pure pigment; mixing creates the desired color, but only in muddy, dull versions.

Grasping value and intensity

Colors have two other properties in addition to hue: value and intensity. The following explains a bit about each property and why you need to know about them:

- **Value:** If you look at the color wheel in Figure 11-1, you can see that the brightest versions of some hues, such as blue or blue-violet are naturally dark, and others, such as yellow or yellow-orange, are naturally light. In Chapter 2, we discuss how some pastel manufacturers formulate and organize the colors of their pastels around systems of adding white and black to pure pigments to make them lighter or darker. If you look at Figure 11-2, you can see colors sorted into sets of light and dark values.

Figure 11-2: Colors grouped by dark values and light values.

✔ **Intensity:** *Intensity* indicates how bright or dull a color is. If you look at Figure 11-3, you can see colors sorted into bright and dull colors. *Bright colors* appear clear and vibrant; *dull colors* are milky or hazy in appearance. You can also think of intensity in terms of saturation and temperature:

- *Saturation* affects the clarity of a color by indicating how pure the color is. Highly saturated colors are vibrant, and colors with lower saturations appear muted.

- *Temperature* refers to how warm or cool a color is. *Warm* colors are more intense than *cool* colors. Warm colors, such as yellow, orange, and red, can be associated with fire, and cool colors, such as blue, violet, and blue-green, are those you may associate with winter.

Figure 11-3:
Colors grouped by bright and dull intensity.

All the colors in your pastel box are modified to vary their values and intensities. You normally choose colors based primarily on their hues and values, but later in this chapter we also talk about the importance of considering intensity.

To train your eyes to see the difference between value and intensity, try this sorting exercise in your sketchbook.

1. **Divide a clean page in your sketchbook into three sections.**

2. **Label the page "Value Study" and the sections "dark value," "middle value," and "light value."**

3. **Set out your pastels and pastel pencils and divide them into pools of dark-value, middle-value, or light-value colors.**

4. **Tear out another piece of sketchbook paper and use it as scrap to test a ½-inch spot of color of one pastel.**

5. **Examine the spot of color, decide whether you have it classified in the right pool, and then mark a ½-inch spot in the appropriate section in your sketchbook.**

6. **Repeat Steps 4 and 5 for each pastel and pencil (you can reuse the same sheet of scrap paper).**

7. **On a separate page in your sketchbook, set the page up as you did in Step 1 but label it "Intensity Study" and the sections "bright," "medium," and "dull."**

8. **Repeat Steps 3 through 6, sorting by bright, medium, and dull intensity.**

Grouping your pastels by intensity is easier to do if you sort the brightest colors first and then the dullest. Judge the ones you aren't sure about by comparing them to the other pools.

Looking at Real Color and Invented Color

Understanding the difference between real color and invented color is important when drawing with pastels. The *real color* is the color an object appears to be. The proper term for these colors is *local color*. *Invented color* is the color you choose to make an object regardless of the color it appears to be. For example, the sky's real color is blue and the grass is green. However, you can invent your own colors and make the sky purple and the grass yellow — whatever your heart desires. Being able to make things any color you like is fun. When you want to change a real color and invent your own color, you can alter the hue, value, or intensity, which the following sections discuss.

Understanding what you see

Before you can invent your own colors, you need to first comprehend what you're looking at. After you're able to identify the colors you see, you can predict how colors change as you work with them. Remembering how colors affect each other can help you choose the right pastels as you're working.

You may remember sitting in science class in fifth grade and studying how light and color work together. When you look at a red baseball cap, the white light of the sun hits the baseball cap, which absorbs the entire spectrum of light except the red rays. The red range of the spectrum is reflected to your eyes, and you see a red baseball cap. White objects reflect all the rays, and black objects absorb all the rays. The color (or lack thereof) reflected to your eye is an object's local color. If a baseball cap is red, its local color is red.

Color can be very deceptive, however; you may think you see one color and then find the color is very different. Look at the spots of color in Figure 11-4. They all look like different colors, but they're actually all the color you see to the far right — the colors surrounding them just affect the way you see them.

Figure 11-4:
All the colors in the centers are the same color as the color on the right.

The best way to find an object's true color is to isolate the color. Many artists find true local colors by punching a hole in an index card and holding the hole over the object whose color they're trying to determine. The card blocks out the surrounding colors that may skew it.

As you experiment and invent your own colors, keep the following characteristics in mind. They can help you make wise choices. Refer to Figure 11-4 as you work through this list.

- **Value changes:** A color surrounded by a darker color appears lighter, and a color surrounded by a lighter color appears darker. Look at the first set of colors and how different the values of the violet centers seem. One appears dark and the other appears light because the different values of the backgrounds affect how the colors appear in the following ways:

- **Hue changes:** All hues are made of one or two primary hues. (See "Getting acquainted with the color wheel: Hue" earlier in this chapter for more on primary hues.) If a color is surrounded by one of the primary hues it's made of, its hue looks more like the other primary color in its mix. In the second set of colors, the hues of the violet centers now look more like red-violet and blue-violet because the blue background pulls blue out of the violet, making it look redder, and the red background pulls red out of the violet, making the violet look bluer. Colors made from primary hues don't change noticeably when surrounded by other hues because they are made from only one hue. On a similar note, complementary hues don't change each other's hues because they don't share any of the same hues. For example, blue and orange are complements, with blue on one side and orange (with its primaries red and yellow) on the other.

- **Intensity changes:** Colors made from complementary hues make each other look brighter, and colors made from the same hue (or hues analogous to that hue) make each other look duller. If you look at the third set of colors, you see one combination of a violet center with a yellow background; because yellow is violet's complement, the combination looks vibrant. The other combination in the third set has a violet center and a lighter violet background. Because both colors have the same hue, they make each other look duller. The overriding rule for intensity, however, is that a color surrounded by any brighter color appears duller, and a color surrounded by any duller color appears brighter.

Considering the importance of value

The secret to choosing invented colors successfully is to develop a *value pattern* (the arrangement of lights and darks in your composition) that works well in the composition. A drawing with values doesn't need hue to succeed (as is evidenced by amazing graphite and charcoal drawings), but hues need value to work well in most compositions. Value pattern is more important than the hues you choose or their intensities because we respond to the value pattern in an artwork before we respond to hue or intensity. If the values you choose are good for the composition, you can choose any hues you want.

If you make a pastel still life where all the colors are the same value, they blend together. It may be interesting, but the composition is flat — it has no depth. People respond to value so strongly that keeping the value pattern foremost in your mind as you work is always a good decision. In Chapter 8, you can read more about how to focus on value as you develop your work.

Applying artistic license

Artistic license gives you permission to chuck all the rules and be creative. Notice we didn't say, "chuck all the rules and do anything you want." Of course, you _can_ do that, but eventually you find that anarchy doesn't provide a good foundation for making pastel drawings. One way to start exploring artistic license is to make the parts of your pastel compositions any color you like, regardless of their true local colors. You can assign colors based on metaphor and symbolism, or you can change colors that don't work well in the original setup. For example, maybe you like the shapes of your objects, but one of the objects looks too dark with the others. You can pick colors based on any reason you like — or no reason at all!

In order for a drawing with artistic license to succeed, you still need to think about how the colors relate to each other and how the overall composition is working. Feel free to experiment, but continually step back and assess how your work is doing. You can make a wild composition, teetering on the edge of chaos, but in the end, it should still look resolved.

Creating Harmony: Color Chords

One way to figure out which colors to use in your pastel work is to think like a musician does and put together colors that work together just as a set of musical notes creates harmony in a song. These _color chords_ or _palettes_ (sets of hues that have a logical placement on the color wheel) are commonly used, but you can also invent your own. For example, you can say that your color chord consists of all the tertiary hues on the color wheel. Most of the time, however, the commonly used color chords in the following list are sufficient.

When we talk about color chords and their positions on the color wheel, we are only referring to the hues themselves. The color chord is basically a starting point in the process of making color choices. Value and intensity are still important decisions to make.

- **Monochromatic:** This composition features many values and intensities of one hue, such as the light blues, dark blues, medium blues, and so on in Figure 11-5.

Figure 11-5: A monochromatic color chord.

✔ **Analogous:** This set contains a set of two to five hues that are next to each other on the color wheel. For example, all the reds and oranges are an analogous chord as in Figure 11-6.

Figure 11-6:
An analogous color chord.

✔ **Complementary:** This popular chord is made up of two hues directly across the color wheel from each other. Therefore, a complementary palette may be made up of various values and intensities of reds and greens, as you see in Figure 11-7.

Figure 11-7:
A complementary color chord.

✔ **Warm/cool:** This chord is an expanded version of the complementary chord that allows you to incorporate more hues, but you don't necessarily need to use exact complements. Simply pick a few warm and cool hues (like in Figure 11-8) and you're in business.

Figure 11-8:
A warm/
cool color
chord.

- **Triadic:** With a *triadic chord,* you choose three hues that are equally spaced on the color wheel. Think of it as placing an equilateral triangle on the wheel and picking the colors the points touch. The three primary hues and the three secondary hues are each triadic chords (check out Figure 11-9).

Figure 11-9:
A triadic
color chord.

The following sections highlight how you can use these different colors to bring about different looks for your pastel works; check out "Incorporating Contrast Creates Interest" later in this chapter to see how value and color temperature can craft focal points

Using light and dark colors

Manipulating value can also create mood in your work. Every pastel drawing you make can have a different value pattern. The following list gives you a few examples of ways value compositions can influence mood; you can decide for yourself which system best communicates the mood you want.

- **Full-range:** *Full-range* value compositions are the everyday compositions, the whole kit and caboodle. You use all the values available — dark, middle, and light. The compositions are neutral in mood, taking on the mood of the subject matter.

- **High-key:** *High-key* compositions are very light in color — most of the values in the work are lighter than middle gray. They indicate that the subject matter is washed in light. High-key compositions can communicate a sunny day or a lighthearted mood.

- **Low-key:** *Low-key* compositions are dark, indicating low or little lighting. In this kind of composition, most of the values are darker than middle gray. They can indicate a darker mood, possibly gloomy or simply nocturnal.

- **High-contrast:** *High-contrast* compositions have extreme lights and extreme darks and communicate dramatic moods. Today, high-contrast compositions are often associated with photography, but they're also at play in other media, like in the work of the Baroque artist Caravaggio. We encourage this type of value composition in your work because exaggerating forms and shadows helps you focus on seeing the patterns more clearly. You can read more about finding dark and light shapes in Chapter 8.

Using cool and warm colors

You can also exploit the interactions of cool and warm colors to create a combination that influences the composition. Because analogous colors make each other appear duller, a composition full of warm reds and oranges can actually make the colors appear more muted than each color would appear on its own. Sprinkle in a few cool colors, however, and *voilà!* The composition suddenly sparkles with bright color. (Head to "Understanding what you see" earlier in this chapter for more on how colors are affected by the colors around them.)

You can use warm/cool combinations two ways in your compositions. Figure 11-10 shows a composition made of warm and cool colors.

- **Arrange warm and cool areas of a composition so they interact with each other.** This strategy is the most important because it allows you to establish focal points and develop depth in the composition, as well as create aesthetically pleasing color combinations.

- **Use colors made from a set of complementary hues to model objects.** When you model an object, you use a system of marks to make the object look three-dimensional. You can make the body of the object one color and hatch through the shaded areas and cast shadows with the other.

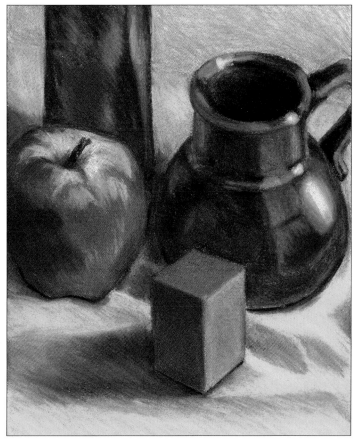

Figure 11-10:
A composition made of warm and cool colors.

Project: Using analogous colors in objects

You can use analogous colors in objects to expand the variety of hues you use when you model an object so that it looks three-dimensional. For this exercise, you need a green pepper, your pastels and pastel pencils, and two sheets of approximately 9-x-12-inch blue or blue-gray paper. (You can tone a sheet of paper to the proper color by following the instructions in Chapter 7 if you prefer.) As you're working, remember to follow the *general-to-specific* method of development, in which you block in big shapes of color first and then slowly refine the colors in layers, adding the highlights last. (Check out Chapter 6 for an overview of this method.)

The colors for this project are analogous to green on the color wheel. You have a green pepper, blue support, and a variety of blue-violet, blue, blue-green, green, and yellow-green colors.

1. **Arrange the green pepper on one sheet of paper and light it so that the shadows are interesting.**

2. **On the second sheet of paper, lightly sketch the green pepper with a dark blue pastel pencil.**

3. **Block in the shapes of the shadows and the darkest values with the same pencil.**

 When you block shadows, first draw outlines of the shapes of the values that you see (like in Figure 11-11a). Think of it as a loose paint by number. Next, use the side of a darker blue pastel to fill in the shapes of the darker value (like in Figure 11-11b). Don't worry about refining them.

Figure 11-11: Draw the shapes of the shaded areas in line (a) and block in the darker values (b).

4. **Block in the shapes of the middle values with a blue-green pastel.**

 Use the side of your pastel to fill in the shapes of the middle value areas as in Figure 11-12a. Notice how the blue-green pastel looks green on the blue paper (flip to "Understanding what you see" earlier in this chapter for an explanation of this effect).

Figure 11-12: Fill in the shapes of the middle values (a) and then fill in the light values (b).

5. **Block in the shapes of the lightest values with a green pastel.**

 Use the side of the pastel to fill in the shapes of the light areas, as you can see in Figure 11-12b.

 Notice in Figure 11-12b that we don't use white as we work lighter; we choose warmer colors. You can save white or colors with a lot of white in them for areas where nearly all the available light is reflected, such as highlights.

6. **Blend the three colors into the paper with a stump or bit of paper towel wrapped around your finger.**

 Softly rub the color into the paper without losing the boundaries between the colors as you can see in Figure 11-13a. (A *stump* looks like a pencil made from paper fibers and sharpened on both ends and is used for blending drawing materials on the surface of the paper.)

Figure 11-13: Blend the blocked in colors into the paper (a) and then hatch with the same colors (b).

7. **Hatch across the blended color with the same color pastel you blended.**

 Make sure you overlap the hatching into the adjacent areas (as in Figure 11-13b). You can also begin to work a lighter blue into the cast shadow to develop it more.

8. **Develop the forms by laying a fine hatch into the very darkest shapes with a dark blue or blue-violet pastel like in Figure 11-14a.**

 Don't use black, which muddies your colors. Don't forget the area directly underneath the green pepper. (Check out Chapter 9 for more info on hatching.)

9. **Hatch across the lightest areas with a light green pastel.**

 For highlights, hatch a bit of white, pale yellow, or yellow-green. If you want to lighten part of the background, you can add a loose hatch with a medium to light blue. Continue to develop the forms and the background with a fine hatch until it's finished like in Figure 11-14b.

Figure 12-14: Develop the darkest areas with a fine dark blue (a) and light green hatch (b).

Incorporating Contrast Creates Interest

When using pastel (or any other art form), you can include *contrasting colors* (colors that are starkly different from each other) to create focal points and direct the viewer's eye around your composition. Colors that are similar in value, hue, or intensity act as a backdrop to the other colors. You can see an example of this effect in school buses and army vehicles. School buses are painted bright yellow so that other drivers can see them clearly at a distance. An asphalt-gray school bus would blend in with the road. On the other hand, army transports are often the color of their surroundings precisely because they need to blend in.

Here are some ways you can use your pastels to create contrast:

 ✔ **Put light and dark colors together.** Doing so catches the eye as in Figure 11-15; colors that are close in value are nondescript and blend together. Check out "Using light and dark colors" earlier in this chapter for the lowdown on creating compositions with lights and darks.

Figure 11-15: Light and dark colors create contrast.

 ✔ **Juxtapose warm and cool colors.** This strategy creates a different kind of contrast like in Figure 11-16. Warm colors are more intense than cool colors, and putting them next to each other intensifies that effect. The section "Using cool and warm colors" earlier in this chapter explains how you can combine these color temperatures in your compositions.

Figure 11-16:
Warm and
cool colors
create
contrast.

Adding Depth with Color

In addition to using your colors to direct your viewer's attention (see the preceding section), you can also use them to give your images depth. Being able to establish great distances is necessary if your goal is to make great landscape pastels, but the same principles can help you make some objects in a still life setup or some petals of a flower look farther away than others.

Look out a window where you can see off into the distance. If you examine the areas closest to you, you can see every kind of color: dark, light, bright, and dull. You also see lots of details — maybe the bark on a tree, the veins in a leaf, and the blades of grass. Now look at similar objects off in the distance. The details are gone. Dark colors are lighter, and bright colors now look a little hazy. If you look even farther away, perhaps you only see basic shapes of buildings or hills and they appear to be a blue-gray. This effect of the atmosphere on the amount of light that can reach your eyes over distance is called *atmospheric perspective*, and it's a set of principles that artists use to show depth in a composition.

Figure 11-17 applies some of the principles of atmospheric perspective that we discuss in the following sections so that some objects look close and others look farther away. After you understand how atmospheric perspective works, you can use its principles to choose pastels for your drawing. The following sections have some guidelines you can use when creating depth with nearby and far-off objects.

Figure 11-17:
Atmospheric
perspective
makes some
objects look
close and
others far
away.

Making objects appear near

With atmospheric perspective, close objects are detailed and have clear edges and a full range of values from black to gray to white. Their local colors are true and unmodified. Here are some suggestions you can use to help you add depth to help you make objects appear close by.

- **Use bright versions of colors.** Don't choose grays and black unless you must because they look dead in the composition and the grays tend to recede. Try to substitute blues and violets for grays when you can.

- **Develop as wide a range of values as you can.** Use dark colors, light colors, and all the values of colors in between.

- **When modeling a form, avoid using white to lighten a color unless the color demands it.** Save white for strongly lit areas. Instead, go warmer

as you go lighter. For example, if an object's color is red, using pink pastels or reds lightened with white actually flattens the object because the areas around the edges are brighter than the center. A better way to create depth is to transition to warmer, analogous colors. In Figure 11-18, the red object transitions through red-orange and maybe orange and yellow-orange to create a more three-dimensional look.

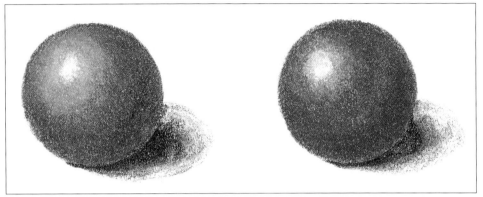

Figure 11-18: Transition from dark to light by using warmer colors.

Making objects appear farther away

Because of atmospheric perspective, far-off objects lose detail, and their edges become soft. The colors become duller and bluer, and the range of values you can see shortens so that you get no blacks and whites and fewer darks and lights. These suggestions can help you make objects appear far off.

- ✔ **Use duller colors for objects, even if they're directly behind the objects in the foreground.** This tactic ensures that the foreground items draw the focus.

- ✔ **Don't use whites for far objects.** White tones go slightly darker when they're farther away from you, so light grays, blues, and violets create more realistic distant white objects. Think about clouds. Fair-weather clouds on a clear day have brilliant whites as they pass overhead, but the clouds closer to the horizon have no whites. Their sunlit areas may be pale blues, pinks, or violets.

- ✔ **Avoid black and very dark colors.** Black and dark colors become lighter the farther away from you they are. Use lighter versions of the colors instead, like a dark, grayish violet rather than black.

- ✔ **Use colors with similar values and intensities for objects in the background.** They can be different hues, but the values should be relatively close and the intensities duller. Figure 11-19 shows an example.

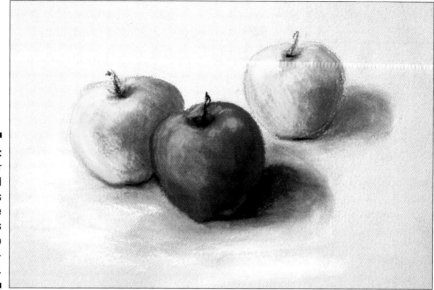

Figure 11-19:
Use similar values and intensities to make objects recede into the background.

Project: Exploring How Color Chords Affect a Composition

In this project you consider how analogous and complementary colors can affect an entire composition by exploring how one composition appears in different color combinations based on monochromatic, analogous, and complementary color chords. In this project, we create one image three different ways to show you how colors affect the way you respond to an image. In Figure 11-20, you can see the three versions of this project.

1. **Choose an image and draw or trace it onto three 9-x-12-inch sheets of white paper.**

 Rives BFK is a good choice, but any white pastel paper is fine.

2. **Decide the colors you want to use for each color chord.**

 For the monochromatic drawing, you need several different values of one hue. The analogous drawing requires three to five hues in different values and intensities, and the complementary drawing uses various intensities and values of complementary hues.

3. **If you want to tone the papers in keeping with each drawing's chord, label the back side of each sheet with one of the chords and then tone each paper with a color appropriate to the chord.**

 Keep in mind that you don't have to tone the entire sheet. You can even wait until after you lay in the initial drawing and then tone different sections of the image different colors. Check out Chapter 7 for directions on how to tone white paper.

4. **Sketch the initial drawing onto each sheet with a dark color.**

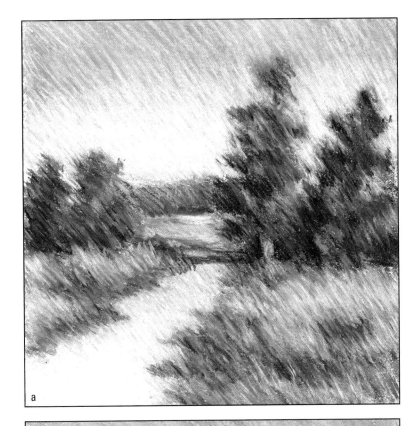

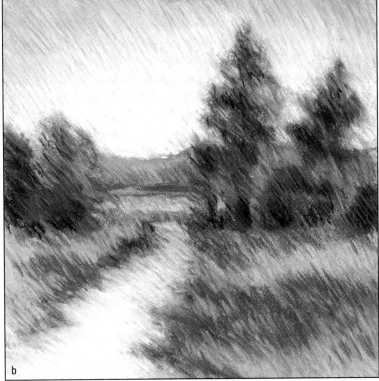

Figure 11-20:
Three
compositions
with three
different
color
chords.

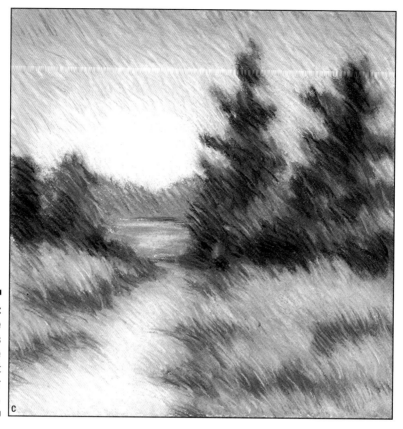

Figure 11-20:
Three
compositions
with three
different
color
chords.

5. **Using the monochromatic chord, follow the process we describe in the pepper projects in "Creating Harmony: Color Chords" earlier in this chapter: Lay in darkest values first, then the medium values, and finally the lightest values.**

Starting with the monochromatic chord helps you set the value pattern for all the drawings, making it easier to do the other two.

6. **Blend the dark, medium, and light values into the paper, and then develop the drawing with a hatch until it's finished.**

Because this drawing is monochromatic, be sure to stick to one hue.

7. **Repeat Steps 5 and 6 for the analogous and complementary chords.**

For the analogous chord, you can use the same methods in the "Project: Using analogous colors in objects" section earlier in the chapter, incorporating the depth-creating suggestions we discuss in the preceding section. When you're ready for the complementary image, remember that bright and warm colors create focal points and move forward, and duller and cooler colors appear to move back.

Chapter 12

Starting with Still Life

. .

In This Chapter

▶ Making interesting compositions

▶ Drawing a pastel still life step by step

▶ Eliminating and correcting drawing problems

▶ Creating a still life self-portrait

. .

*1*f you've ever played a piece of music in a band or orchestra, you know that each person in the group has his own skills to master and parts to play. When you make a piece of art, however, you alone are responsible for playing all the parts. You need to know how to make the necessary decisions and how to use the correct techniques to work with pastels. (The other chapters in Part II give you an overview of these decisions and techniques.)

Making art has a certain rhythm to it. No matter what medium you use, whether it's oil paints, watercolors, or pastel, making art becomes a series of steps you take to reach your final creation. The same goes for creating still lifes. Thinking about ideas for your still life is part of the process, but you also need a firm grasp of the basic steps for creating your still life pastel. This section helps you get on the right track by walking you through the step-by-step process of drawing a still life.

Still life is a very old subject for art making. You can find still life images in the frescoes decorating the walls of homes in the ruins in Pompeii. Generally speaking, a *still life* is an arrangement of objects, sometimes including plants, fruits, or vegetables. Minimal setups of a few simple objects can exude elegance. On the other hand, big, complex arrangements that extend beyond the tabletop become theatrical and dramatic with the right lighting.

Figuring out how to draw still life objects provides a foundation for everything else you may want to depict — even the human figure. Still life allows you to start with simple forms and move on to more complex forms when you're ready. Everything is easier to draw when you start with still life. You may even decide you prefer working with still life objects. They don't move around while you're trying to draw them!

In this chapter, we help you put all of these parts together in a still life drawing, as well as look at ways you can avoid making rookie mistakes.

Starting Your Pastel off the Paper

If you like to cook, you know the importance of thorough preparation. You don't want to stop in the middle of whipping up your favorite recipe to run out to the grocery store for a missing ingredient or risk burning the dish because you didn't allow enough cooking time and had to speed things up by cranking the heat too high.

So even though you may be eager to jump in and start working on your still life, take some time to prepare. You need to think about a few things before you begin working on your paper so that your still life gets started in the right direction. In order to be fully prepared, set up a strong arrangement, light your still life, and, make sure you have a clean, organized workspace. (Chapter 4 discusses how to set up your work area.) Keep the tips in the following sections in mind.

Arranging an interesting still life grouping

Your pastel drawing is only as interesting as your still life setup, and that starts with how you arrange your objects. Arranging them is important because no amount of beautiful modeling with your pastels is going to save a boring composition based on a poorly designed setup. Think about a time when one painting caught your eye in a museum full of artwork. What was it about that painting that pulled you from across the room? We can assure you that it wasn't the way the artist painted the highlight on a teapot. In fact, it wasn't any of the details of the work at all; it was something about the overall color or value pattern in the work that caught your eye.

Keep the following general points in mind:

- **For this still life arrangement, limit your arrangement to either three or five objects.** Using an odd number of objects usually creates more interesting small arrangements.

- **Mix up the kinds of shapes.** Try boxes, cylinders, spheres, and linear shapes like paintbrushes or pencils. Stay away from complex objects and organically shaped objects (like potatoes) for now.

- **Arrange them on a plain piece of fabric or a sheet of paper.** You want to clearly see the definition of the cast shadows.

- **For now, stay away from wood grain, metals, and glass.** We want you to concentrate on developing your overall composition instead of getting bogged down in the surface details of your objects.

In Figure 12-1, you see a photograph of our simple arrangement. We choose a cylindrically shaped mug, a box, and a pear, which is a combination of a sphere and a cone with the top lopped off. We arrange them asymmetrically on a piece of plain blue paper.

When drawing your still life, make sure you're aware of how the total composition looks from the time you begin setting up your arrangement until it's finished. This section focuses on several strategies you can use to ensure your compositions are engaging and interesting.

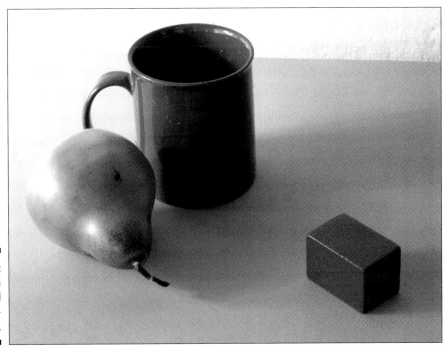

Figure 12-1:
Begin with
a simple still
life arrange-
ment.

Thinking about the background

All of your objects have shape, but did you ever consider that the background has shape, too? The objects in your composition are called the *positive space* and the background is called the *negative space*. The attention you give to the background is as important as your objects. As you arrange your still life objects, look at the space around them and try to see it as a flat shape. In Figure 12-2, you can see how the negative space appears as a shape.

Figure 12-2:
The nega-
tive space in
a composi-
tion appears
as shape to
the viewer.

Use your viewfinder to help you isolate the composition so that you can see the shape of the background space. If all the objects are too close together or too far apart, the shape of the space around them is boring, which makes your entire composition dull.

Try considering the amount of space the objects occupy in the composition versus the amount of background. As a general rule, making objects at least half of your composition is a good idea, especially if you tend to make your objects too small. Of course, every rule has its exceptions. This one works better when the arrangement is composed of several objects. It may not work as well for small arrangements.

Thinking about the whole page

Clustering objects in the center of large page makes them seem lost and insignificant, even if you have an interesting arrangement. Luckily, this problem usually shows up when you first start drawing, so you can fix it easily before you go too far. You want to make sure you use the whole page; keep these tips in mind to help you:

✔ **When arranging your composition, spread some of your objects out instead of placing them so close they touch.** But don't space them evenly; that can be boring, too.

✔ **Use your viewfinder so that you can see how much of your still life setup will appear on the paper.** Head to the "Using a viewfinder" section later in this chapter for more on viewfinders.

✔ **Strive to draw the scene you see in the viewfinder, looking carefully at how the objects relate to the viewfinder's interior edges.** These edges correspond to the edges of your paper.

✔ **Look for areas that seem inactive, especially along the sides of the composition.** Break up these areas by adding objects or rearranging the ones you have.

Areas where your eye can travel the entire length of the page without a break are called *gutters*. You generally should break these areas up as shown in Figure 12-3.

Figure 12-3:
Break up gutters in your compositions.

✔ **Try making asymmetric compositions with a few objects arranged to one side and offset by fewer, less significant objects on the other.** This type of composition encourages you to spread your objects out as Figure 12-4 illustrates.

Figure 12-4:
Try
asymmetric
composi-
tions.

✔ **Avoid making compositions shaped like pyramids unless you have a symbolic or conceptual reason for doing so.** Otherwise, the upper right and left areas of the composition are empty. Check out Figure 12-5.

Figure 12-5:
Steer clear
of pyramidal
composi-
tions unless
you have
a good
reason.

✔ **Don't arrange tall objects on the sides and leave empty space in the middle.** Doing so leaves a void in the area your viewer is most likely to look first. See Figure 12-6.

Figure 12-6:
Placing tall
objects on
the sides
creates a
void in the
middle.

Lighting your arrangement well

Good lighting can make the difference between a bland, boring still life and a dynamic arrangement. It brightens the colors and creates strong darks and lights.

When arranging the lighting for your still life, experiment with different lighting directions, levels, and distances. Look at the shapes of the shadows, as well as the highlights or hot spots on the objects.

Figure 12-7 shows how we set up a workspace and the lighting for our simple still life arrangement. The position of the easel and materials is correct for a right-handed person. If you're left-handed, swing the easel and table to the left side of the still life arrangement. Notice the height and the direction of the light. You can set yours up similarly with an inexpensive desk lamp.

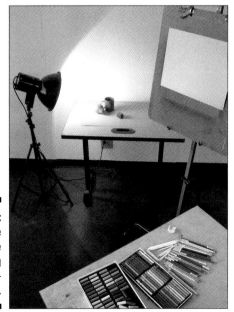

Figure 12-7:
A still life
workspace
and lighting
arrange-
ment.

Using a viewfinder

After you arrange your still life and lighting, you're ready to start drawing. Here's where a *viewfinder* (similar to the one in your camera) comes in handy. You look at your still life through the viewing area and determine which part of the arrangement you want to draw. In the process, you also crop out unwanted areas of your still life and eliminate distractions. Doing so helps you predict what the pastel will look like. Most importantly, the viewfinder assists you in transferring exactly what you see onto the page. Chapter 5 has more in-depth info about how to use a viewfinder.

The viewing area of the viewfinder should be a size that relates to the height and width of your pastel drawing. Because papers used for pastels are such varied sizes, we recommend that you make an adjustable viewfinder. (Don't worry: We tell you just how to do that in Chapter 3.)

Making a rough sketch

Taking a little extra time to make a separate *rough sketch* in your sketchbook before you start working on your good paper can be helpful, especially for beginners to pastel. This sketch allows you to work out any problems in the composition before you get too deep into the drawing. Look at Figure 12-8 to see an example of a rough sketch.

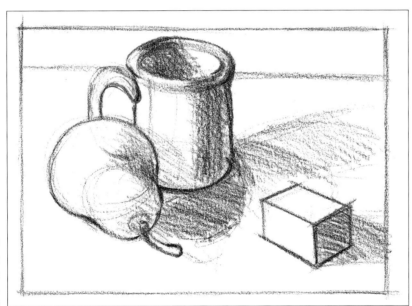

Figure 12-8:
A rough
sketch.

Rough sketches are just that — rough. You draw very quickly — the primary goal is to capture the general sizes and shapes of the objects so that you can see how the composition will appear. Don't labor over the drawings or refine them at all.

Sighting and measuring to refine your drawing

As you begin your large drawing, you need to make a more precise initial drawing. A viewfinder helps you find the general shapes and positions (see "Using a viewfinder" earlier in this section), but sighting and measuring techniques help you refine them. For detailed instructions on how to sight and measure, check out Chapter 5.

Use a sighting stick to find accurate heights and widths of your objects. You can also use it to find the angles of the tops and bottoms of boxes and the relationships of the objects to each other. Keep your sighting stick at a consistent distance from your face and keep one eye closed as you make your measurements and judge angles.

You must close one eye because each eye sees a different image. The human brain synthesizes these images so that you can see three-dimensionally and perceive depth. This ability may confuse you when you try to make visual measurements, but you can eliminate the confusion by shutting one eye. Try this: Hold your hand out in front of you and close one eye. Now, open that eye and close the other. See how different the two points of view are?

Drawing Your Pastel Still Life

Now you're ready to start your pastel still life! Follow the steps we outline for you here and remember to work in layers. Resist the temptation to work too much in one area at the expense of the rest of the drawing. Most of all, have fun! If you follow that advice, you can make a great still life.

Laying out the initial drawing

When you lay out your initial drawing, you're blocking in the basic shapes, sizes, and positions of the objects in your composition. This process actually goes beyond the idea of blocking in because you are considering the entire composition as you work. You have two basic approaches to laying out your initial drawing:

- ✔ **Massing:** In this method, you use the side of a pastel to block in the general forms of your objects. The edges of the forms are soft and not defined.

- ✔ **Linear:** In the linear method, you use a pastel pencil to block in the shapes of your objects. This method allows you to find precise shapes more quickly than the massing method.

The first marks you make on the paper determine how large the objects appear in your composition. Most people start off drawing their images too small and then are surprised when their drawings look lost on the paper. Be sure to think carefully about how big your first object should be on the page.

As you can see in the example in Figure 12-9, you draw the objects with a light pastel pencil first and then correct and refine them with a darker pencil. You lightly draw in the shapes of the shadows.

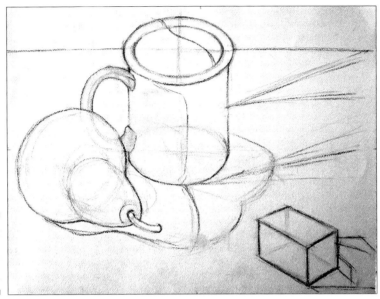

Figure 12-9:
A completed
initial
drawing.

Blocking in the basic values

After you finish the initial drawing with pastel pencils, you have to block in the basic colors with the hard pastel sticks. *Blocking* is drawing the basic shapes of the objects, shadows, and other components of your composition, primarily in a geometric way. You can block the parts of the initial drawing using line, as we just described, but you can also block in the basic shapes of the values in your objects and composition by using the sides of your pastels. For detailed instructions on blocking in the values of an object, check out Chapter 6. Here's how you block in your *values* (light and dark areas) for this still life:

1. **Choose hard pastel sticks in the colors that most closely match the values you need.**

 You want to start with a color close to the value you need because after you lay a color of a very different value down, you may have trouble layering enough color over it to achieve the value of light or dark you need. To make your use of color more interesting, consider starting with colors slightly warmer or cooler than you need and plan to layer the actual colors of the areas into them.

2. **Break off ½-inch pieces of the pastels you select and use them on their sides to block in the shapes of the light and dark areas of the objects and the rest of the composition.**

 Work in layers. Concentrate on covering the whole composition with general color rather than trying to *model* (shape) the objects one piece at a time. Work from general to specific. At this stage, stick with the general

REMEMBER

shapes, not the specific details. Chapter 6 gives you the lowdown on building up layers to make an object look three-dimensional.

Focus on filling in the shapes of the dark and light areas with colors rather than flooding an entire object with its local color. If you only use one color on an object, it looks flat rather than three-dimensional.

In Figure 12-10, we block in colors for the objects as well as the entire composition to establish the overall values pattern for the still life. Rather than simply choosing the colors we see for blocking in, we pick some colors for areas (such as the background and shadows) that will blend with the final layer of color and add variety to the color composition. You can consider these areas to be a form of spot toning.

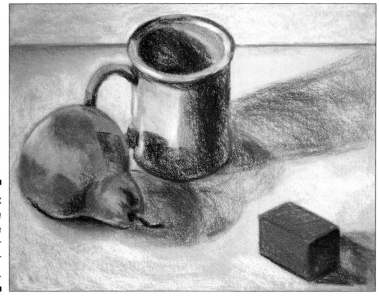

Figure 12-10:
A still life
with the
first layer
of color
blocked in.

Developing and refining the forms

After you establish the basic color composition, you can begin to model and refine the forms of the objects. To develop the form more, continue to use the hard pastels to define the value pattern more clearly. When you are ready to think about the darkest, lightest, and brightest areas of the forms and overall composition, you can switch to the soft pastels and use their rich, brighter colors selectively to give the objects more definition, create focal points, and make some objects appear closer to the viewer. Here are some strategies you can use to guide you as you develop the drawing with both the hard and soft pastels:

✔ **Observe the value pattern as you model the objects and work the areas around them.** The *value pattern* includes the shapes of the light and dark areas. Also look for highlights within the light areas. Chapter 10 discusses in detail how to develop the value pattern in a drawing.

✔ **Use analogous colors to model an object instead of limiting yourself to the object's actual color and shadow.** *Analogous colors* are the colors near each other on the color wheel. Chapter 11 discusses the color wheel and how you can more fluently use color.

✔ **Look for ways to use bright colors to make an object look close and muted colors to make areas seem farther away.** Apply what you see outdoors to your still life drawing. Trees or buildings in the distance look hazy and dull, while nearby trees and buildings have clear, bright colors. This effect is called *atmospheric perspective,* and you can read more about it in Chapter 11.

Figure 12-11 and the following list show you how we've used some of these tips.

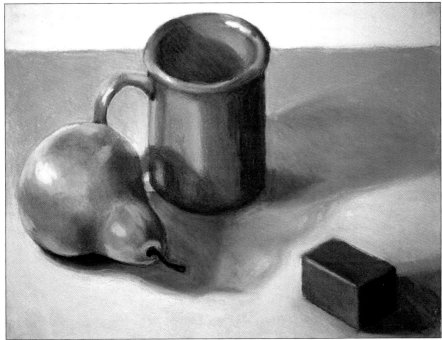

Figure 12-11:
A fully
developed
still life.

✔ Not only is every plane of the red box a different value, but each plane is also modeled with slightly different hues and intensities. The vertical plane on the left side of the box has the strongest lighting, so we modeled it with warm red-oranges. We established a yellow-orange line to show the highlight on the top left edge. The top of the box is redder and darker, and the end of the box is modeled with dark reds and blue-violets.

✔ The shadow cast by the box is a darker version of the blue paper the box is sitting on; however, we also use analogous hues such as violet and blue-green. You also notice a bit of red representing the reflection of the color of the box on the paper.

✔ We model the mug in analogous colors, including blue and blue-violet for the darkest areas of the value pattern and yellow-green and green in the lightest areas. The local color of the mug is blue-green, used in the middle value areas and controls the overall color of the mug. The term *local color* refers to the color the object appears to be — "red" box and "blue-green" mug, for example.

✔ You may notice a warm light orange tone in the background at the top of the composition. It blends with a very light blue to create a duller light color that recedes in the fully developed composition in Figure 12-11.

Preventing Rookie Problems

If you're fairly new to drawing pastels, you're probably like many other beginners who tend to make the same kinds of mistakes in drawing still lifes. The good news is that you can employ some basic strategies to prevent these mistakes. This section describes some structural problems you can look for in your pastel still lifes and some strategies you can use to eliminate them.

Righting leaning shapes

When you draw objects in your still lifes, you can construct them from basic box shapes. A common mistake occurs when your shapes and lines aren't straight and vertical, resulting in leaning shapes that look like they could fall down. Check out the examples in Figure 12-12 to see the difference between well-built and rickety basic box shapes.

 To ensure that you draw straight boxes, always keep an edge of your paper in sight as you draw your line. Test whether your line is plumb by measuring the distance between the edge of the paper and the line with two fingers on one hand. Measure this distance along the entire length of the line. If you're new to drawing, consult Chapter 5 for instructions on how to sight and draw a box.

Figure 12-12:
A rickety box and a well-built box.

Rounding out flat-bottomed cylinders

Another common mistake newbies make when drawing pastels is creating flat-bottomed cylinders. The top of the cylinder looks great because they carefully draw the entire elliptical shape, but the bottom looks squared off. See Figure 12-13 for examples of incorrect and correct cylinders.

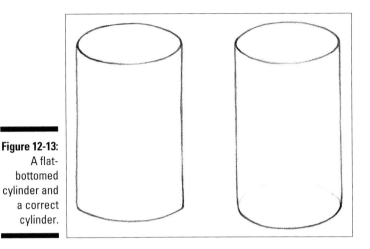

Figure 12-13:
A flat-bottomed cylinder and a correct cylinder.

The secret to drawing good cylindrical shapes is drawing good ellipses. For our purposes, you can think of an ellipse as a circle — like a hoop — that is turned away from you in space. It's a mathematical shape that you can divide in half either horizontally or vertically and still get symmetrical sides. For example, if you divide it in half horizontally, the top half is the same size as the bottom half. Unfortunately, many people can draw the top half of an ellipse very well but flatten the bottom half. Not only does the bottom edge look smaller, but it also shapes the bottom of a cylinder so that it doesn't look round.

To make sure both parts of your ellipse are even, lightly draw the entire ellipse when you're drawing cylindrical shapes and make sure that the bottom half of the ellipse looks just like the top half. After you've drawn a good ellipse, darken the parts that define the shape.

Ellipses have a definite shape. Don't draw them like footballs, racetracks, or almonds. After you know the height and width of the ellipse you need, draw a proper ellipse and your cylinder will look right every time. See Figure 12-14 for examples of true ellipses versus what beginners often draw for ellipses. This figure shows a real ellipse and shapes that look like a football, racetrack, and almond.

Figure 12-14:
A real ellipse (left) and three errors.

Many people have trouble with ellipses — even people who have drawn for many years. Fortunately, training yourself to draw a proper ellipse is simple. You just have to practice drawing the correct shape. You can always look at the top of a cup and practice drawing its shape. In another method, you can practice tracing ellipses many times so that you train your hand and mind to find the shape. This practice helps you create a physical memory of the

movement so that it becomes natural to your drawing. To set up this exercise, use the ellipse tool in the drawing palette of any computer processing program to fill a page with a variety of large ellipses and then print it. Trace the ellipses on the page using only a forward-moving line; don't pick up your pencil as you follow the shapes. Start very slowly, only picking up speed when you feel more confident.

If you're patient and practice, you'll see yourself improve very quickly. It's like practicing the scales on a piano — you develop technical skill so that you can be free to be expressive. After you conquer drawing ellipses, you can draw any cylindrical form. If you're still feeling a little unsure of yourself, however, check out Chapter 5 for easy instructions for drawing cylindrical forms.

Separating intersecting masses

Clustering objects so closely together that they appear to be a part of each other is a common beginner's problem. Here are three ways you can avoid this obstacle:

✓ **Give the objects in your still life some breathing room.** Your composition is much more interesting and the objects easier to draw if they have some space between them, as shown in Figure 12-15.

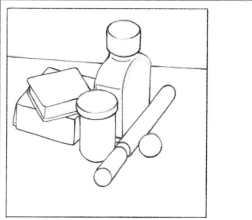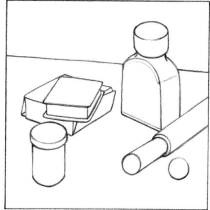

Figure 12-15:
Clustered objects and objects spread out so that they appear separate.

✓ **Offset the edges of your objects distinctly.** Avoid lining objects up so that the edge of one object forms a continuous line with another object. If this situation happens, the objects appear to be part of the same object. Check out Figure 12-16 for an example.

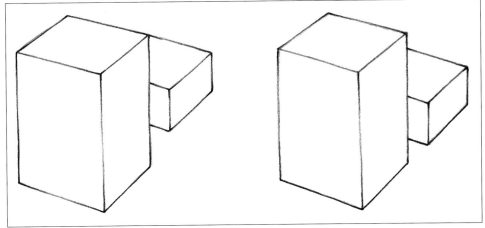

Figure 12-16:
Objects
lined up
appear to be
one object;
offsetting
them
separates
them.

 ➤ **Draw the objects in the initial drawing as though they're transparent.**
Drawing objects as though you can see through them is called *transparent construction*. Any areas where the objects seem to overlap in the same space show up in this early stage, and you can then correct them before the drawing progresses too far. The instructions for drawing boxes and cylinders in Chapter 5 show you how to draw transparently. Refer to Figure 12-17 to see how transparent construction can help you avoid overlapping objects in the same space.

Figure 12-17:
Using
transparent
construction
to identify
and fix
overlapping
objects.

Project: A Still Life Self-Portrait

For this project, you create a still life that acts as a self-portrait. It expresses who you are, but you don't actually use your own image. You use objects and colors that represent who you are as a person for your still life.

Think about what you want to say about yourself in your still life. Pick objects that are symbols or metaphors for those aspects of your life. Add objects that symbolize how you feel about a particular idea or issue. You may also add objects that you use in an activity you enjoy or that imply the activity. For example, if you enjoy cycling, you can put your bicycle gloves in the arrangement or make a print of your tire track and add that to the arrangement instead.

Try to be creative by avoiding common symbols. Make them more personal. If you're a religious person, for example, try to think of a way to express your faith without using the common symbol for your religion. Check out the still life self-portrait in Figure 12-18. The objects in the still life represent the artist's interest in bicycling, dancing, and gardening.

Figure 12-18:
A still life
self-portrait.

If you want to do more research for this project, look up the early paintings of Audrey Flack. Her large, involved canvases were full of metaphors and symbolism. Her still life setups are much too complex for you to tackle now, but they can give you some great ideas.

Part III
Heading to the Next Level: Intermediate Techniques

The 5th Wave By Rich Tennant

PRISONER ART PROGRAM

"Nice technique, Randal. I love the play of light off the sheriff's handcuffs and the warm glow around the homemade shank..."

In this part . . .

When you get your basic skills under your belt, what next? Perhaps you're happy to continue developing your skills by tackling more difficult subject matter, want to use your new pastel skills to make art about something bigger than yourself, or feel the urge to experiment with images and materials.

Whichever kind of artist you are, this part helps you decide where to go from here. In Chapter 13, we show you how to depict surfaces with shine and texture. Chapter 14 guides you toward determining your own artistic point of view, and Chapter 15 encourages you to have a wild fling with abstraction. Sample a little of this and a little of that and before you know it, you've found your own voice as an artist.

Chapter 13

Capturing Shiny or Textured Surfaces

In This Chapter

▶ Creating realistic metallic objects

▶ Depicting transparent glass objects

▶ Getting a feel for drawing textures

Sparkling silver, translucent glass, and rich, natural textures are all surfaces that give an artwork a sense of magic. They twinkle and reflect light, imitate water and ice, and communicate the rich variety of the natural world. Is it any wonder that paintings depicting such complex textures and surfaces became status symbols of the Renaissance?

These tricky surfaces also represent a tour de force for an artist, but don't be intimidated. Although you have a bit to discover about how to accurately depict metal, glass, and textures, you don't have to spend years practicing. You just have to see the objects accurately and carefully build them up by starting with the general layers and working toward the more specific details. (Flip to Chapter 6 for more on working from general to specific.) In this chapter we tackle these challenging subjects and help you gain some confidence so you're ready to handle whatever you encounter.

Adding Some Sparkle: Modeling Metallic Surfaces

Depicting shiny metal objects is a challenge — the surface seems to be made up of many confusing bits of color that appear to move as you move your head. If you look closely, you see a funhouse-mirror reflection of yourself. How on earth are you going to draw that?

That's where this section comes into play. We cover what you need to know to ensure your metallic drawings are sparkling and reflective and not dull and boring.

When depicting metal with pastels, a key step is beginning with a *simple* metal object, such a geometric shape without much detail. Plain silver cups, brass bowls, simple candlesticks, or copper boxes are some good choices; stay away from the bowling trophy for the time being. If you find a metal object

that works for you but has some detail, you can still use it to get started. Just remember to allow yourself to be a rookie and don't worry too much about the details; focus on getting the metallic surface down.

Breaking down a metal's look

Drawing metallic objects with pastels takes a little extra care to ensure that you capture the true glisten and shine. Because metals come in such a wide range of colors and surfaces, the type of metal you're working with greatly affects how you draw it. The following bullets spell out the general types of metals and some of their basic characteristics and what colors to use:

- **Polished steel or chrome:** The surface of shiny metal reflects its surroundings at various degrees depending on its surface and shine. It can be completely, brilliantly polished or have a soft *patina* (a duller, less reflective sheen because of age or use), or a combination of both. You see light gray and blue-gray for polished steel as well as other colors reflected from the surroundings.

- **Brass and copper:** These types of metal have an inherent color of their own. They can be shiny or dull and may reflect their surroundings, too, but with the addition of a little of their own color. You see various degrees of yellow-orange for brass and red-orange for copper. Both can have dull brownish or greenish areas as well.

Although all metals have a base color, shiny surfaces reflect their surroundings and can pick up colors from anything nearby. That doesn't mean they reflect those outside colors exactly; silver-colored metals (especially chrome) pick up colors and shapes like a mirror with little color change, but copper and brass cast everything a yellow-orange or pink. See the following section for more on depicting these reflections.

Your value range extends from the darkest dark, almost black, to brilliant white for silver, chrome, and polished steel. This broad range of value is what makes the metal look shiny, so the shinier the metal, the more extreme the values. For brass or copper, the range of color may extend from a dark greenish-brown to intense spots of very pale yellow. For copper the range is from a dark reddish-brown to spots of pink.

 As you draw an image of a metallic object, go with the colors you see and trust that they'll look like metal. Don't try to use metallic pastel colors or anything sparkly, unless you want a drawing that has a glitzy Vegas look.

Capturing all those reflections

To create the illusion of shiny metal, you must capture the reflections of the objects nearby as well. This task is a matter of looking at how the shapes of the values and colors form patterns that abruptly shift from one shape to another on the surface of the metal object. In Figure 13-1 we provide some detail; you can see how the shapes of the colors in the fabric and the fruit reflect in the metal teapot. Their reflections are directly related to their positions with the teapot.

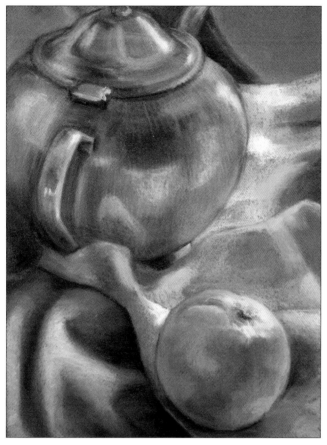

Figure 13-1:
Nearby
objects
and colors
reflect in the
surface of
metal.

To capture the reflections in a metallic drawing, establish the reflective areas as part of your initial sketch and note the following:

- ✔ **Sketch in the shapes you see and lay them in with tonal marks (discussed in Chapter 8).** Work from general to specific and avoid the temptation to work on details. At this point, you're using light, medium, and dark colors that match the object, as we describe in the preceding section. After you lay the colors in, you can use a tissue or drawing sponge to blend them into the paper (but not each other), creating a solid base for your later marks.

- ✔ **Keep the reflected objects distinct.** The key to capturing the shine of a metal surface is to avoid blending the colors into one another, so be careful as you blend the colors into the paper as we discuss in the preceding bullet. If the colors start to muddy and you lose the appearance of shine, spray the drawing with workable fixative (which we cover in Chapter 6) so that you can reapply fresh color and separate them.

- ✔ **As you work, focus intently on what you see.** Don't just draw what you think the metal looks like — take a moment to think about the characteristics of the metal on your object. If it's really shiny, it has distinct areas of light and dark. If it has a patina of age or the surface isn't polished, it has large sections of dull color that may change in value from one area to another.

We describe and illustrate the steps for depicting reflections in the following section.

For some dull reflective surfaces (such as a brushed steel or aluminum) you can use a blue-gray or cool gray Prismacolor colored pencil over the pastel layer to mimic the dull surface of the metal. This type of colored pencil flattens the pastel layer and adds a little color. Just lay in a pattern of color and value to define the surface of your metal object with the colored pencil. You may have to use some workable fixative if your pastel layer is too heavy to allow the pencil to adhere. Figure 13-2 shows an example of the detail for when you make your marks.

Figure 13-2:
Use a gray Prismacolor pencil over the pastels to boost some surfaces' metallic look.

Project: A simple metal object

As we mention earlier in the chapter, we suggest you start with an uncomplicated geometric shape for your first few forays into drawing a metallic surface. In this project, we use a chrome watering can. This shape is basically two cones with a handle and a ribbon of metal running to the spout. Whenever you begin a new subject, start simply and follow these steps:

1. **Set up the initial sketch.**

 Make sure your object is well lighted; ours utilizes a spotlight situated on the right. Simplify the scene; a solid purple cloth minimizes the number of reflections we see on the can. (Check out Chapter 6 for specific info on making an initial sketch.)

 Draw your object life-size or larger; a miniature drawing is the hardest to do.

2. **Lay in the areas of local color like in Figure 13-3.**

 Lay in the color with tonal marks. When soft marks make open fuzzy edges, clean up the edge with a pointed edge of a semi-hard pastel or pastel pencil. Metal has a larger range of lights and darks because of the reflection to the surface, so our chrome watering can is picking up purple from the cloth and a little warm brown from the room. Refer to Chapter 6 for more on laying in color.

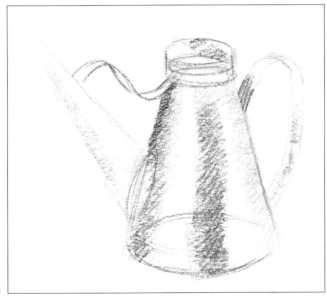

Figure 13-3: The initial sketch of the watering can with some color applied.

3. **Continue to build color and keep values distinct as we do in Figure 13-4.**

 Have all the colors you're using for your item out of your box and close at hand so that you can pick up the color you need — this strategy helps you keep the color distinct. Lay the color down in patches of tonal marks, keeping your marks short and confined to the area of color. As we discuss earlier in the chapter, be careful about blending because you may lose the appearance of shine on the surface.

 For this chrome item, we use several light and dark blues, a violet, a magenta, and several light and dark grayish-browns. To represent the areas that gleam, we lay in linear marks down the length of the can's body and spout and then redraw these lines into more organic shapes that follow the slightly bent surface of the can. Flip to Chapter 6 for

more discussion on building layers of color. Remember to work on the background and cast shadow as you develop the subject.

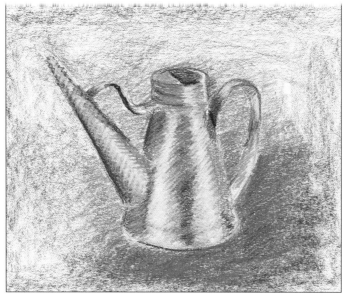

Figure 13-4:
You apply more color and the object begins to take shape.

4. **Make the final touches with soft pastels as in Figure 13-5.**

 Continue to develop the drawing, building colors one on top of the other with soft pastels. The two groups of color we use here (blue and brown) work well for this watering can. If one color, such as the blue, seems too intense for these final stages, you can dull it down with a little of its complementary color. Here we use a dark warm brown (not strictly a complement to blue) because it's the same value as the dark blue. Check out Chapter 11 for more info on complementary colors.

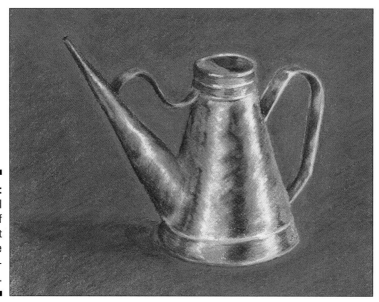

Figure 13-5:
Add the final touches of highlight and resolve the background.

Giving Your Surfaces Transparency: Seeing Through Glass Objects

Glass is another tricky subject to draw with pastels because you can see through the glass. Not only do you have the object itself to deal with, but you also have to contend with the distorted figures that you can see on the other side. Glass objects therefore require a two-pronged attack:

- ✔ Create a transparent underdrawing for the object.

- ✔ Model the object so that it appears dimensional while capturing the distortions of the objects seen through it.

That task sounds formidable, but it's easier than you may think. As in modeling the reflections on metal (covered in the preceding section), you must look closely and capture the patterns of the colors and values you see. Even so, glass is different from metal, so the following sections give you a couple of tips for getting it to look right.

Getting a head start with glass-drawing tips

You want to be as well equipped as possible so you can start your project confident that it's going to turn out well, so before you actually begin sketching your glass subject, keep the following pointers in mind to avoid potential problems:

- ✔ **Remember how glass is made.** The fact that glass starts out as a liquid affects its form's appearance. Molten glass is poured into a mold and then becomes solid as it cools. This pouring and cooling process causes long, fluid distortions in the glass that bend the light reflected off the objects on the other side. Even blown glass has these distortions. If you remember that the distortions in the shapes are fluid and stretched, you can see and capture them more easily.

- ✔ **Use the drawing technique *transparent construction* as you begin sketching.** This technique is normally used for studying the three-dimensional forms of objects and their relationships with each other, but it's invaluable for drawing the shapes of transparent objects. It provides a good structure on which to build your image. Check out Chapter 5 for specific steps on using this technique.

- ✔ **Start simply.** As with metal, picking an easy piece to start with is important when working with glass; you've already got the added challenge of trying a new technique, so don't make things harder on yourself if you don't have to. Plain glass vases or drinking glasses are best. Working with colored glass is a good idea; as a matter of fact, it's a bit easier to work with than clear glass. Avoid glass with wavy patterns, ridges, or molded writing.

Looking closely at shapes and distortions

After you start looking at your glass object, you notice free-form shapes within the glass. As you work to capture these distortions, make sure you keep your point of view steady and focused, because the distortions may appear to bob and change their shape radically as you move. Even parts of the edges of the glass seem to change appearance with the slightest movement. These shapes are made up of the distortions in the glass itself (see the preceding section) and the articles that you can see through the glass. For example, if you have a red apple on the other side of a blue bottle, the apple doesn't appear to be a true red, and it doesn't look round.

To capture the shapes and distortions, sketch in the shapes you see within the glass on top of your structural line drawing. Be aware that the *ellipses* (the circular edges on the top and bottom of the glass) may not be a continuous solid line and that the lines on the edge of the glass may disappear. After you sketch in the shapes you see in the glass, you can start developing them in color. Determine the color of the glass and other colors you see through the glass and choose light, medium, and dark versions of the colors. Apply these colors in unblended shapes to achieve the same abrupt shifts of color that you see. (The following section gives you more guidance on blending when drawing transparent objects.)

Knowing when to blend and not to blend

Whether you have blended areas on your glass depends on how shiny the glass is, so to determine whether or not to blend, you first need to know what type of glass you have. A highly polished drinking glass sparkles with unblended spots of lights and darks, but an old glass jar has dull spots of color and very little shine, so it has a lot of blended areas. Any glass is likely to have areas that are somewhat dull, but remember that blending makes your glass appear more matte and not as transparent.

Take a moment to concentrate on the glass and identify whether you have areas that need blending. Some areas appear dull; the glass is not quite as transparent in these areas, and you can see the surface of the glass itself. You see the dark and light shapes in these duller areas have soft, open, blended edges. On the other hand, the sparkling areas of the glass and the areas that are very transparent have crisp, unblended edges (such as along the rim and on the bottom edges). You see them anywhere the shapes change color abruptly. Don't overdo your blending; the result can look like a piece of ceramic and not glass. See Chapters 8 and 9 for more info on blending.

The last step in the drawing is to find any small points of highlight on the object and leave them unblended. Glass is reflective, so it has spots of highlight on rims, edges, or wherever strong light hits the surface.

Project: Looking through glass

This project lets you try out your glass skills by drawing a glass object with another object behind it. Keeping the scene simple is important because too

many objects can make your glass appear overwhelmingly complex. Be sure that both the glass and the second item have simple forms (see Figure 13-6a). If you have a clear glass, be sure to use a solid-colored cloth. The object and the cloth that you see inside the glass may still change color even though the glass is clear. That's because the density of the glass may make them appear more duller or slightly greenish or bluish. Match your colors to what you see in your own setup.

1. **Draw the layout of the object by using transparent construction.**

 Remember that these lines are an important part of the drawing and may still be somewhat visible at the end. Take your time to make them correct.

 As we discuss in Chapter 6, you can use a mirror to check the accuracy of your image; the mirror reverses the image and makes your mistakes easier to see. For this project, make sure you check for level ellipses and straight verticals.

2. **Find the free-form shapes in the glass and sketch them as in Figure 13-6a.**

 Make sure you keep your point of view steady to accurately capture these elusive shapes. Sketch these forms in as guidelines, even if you see them as dark shapes. You can fine-tune them as you continue your work.

3. **Find the basic color of the glass and begin to build up the colors in the scene as in Figure 13-6b.**

 Choose a variety of light, medium, and dark colors and lay in the colors. You're just blocking in the general colors at this point, so don't blend.

4. **Refine the image and find the highlights and details as in Figure 13-7.**

 Identify the blended and unblended areas in the glass and add them. The blended areas have open edges, and the unblended have closed edges. Notice the details you begin to see within the large areas of color — sharp points of light on rims, edges, or wherever the light hits a shiny surface. You can correct any color that doesn't look quite right by applying spray fixative to set the colors and then reapplying soft pastel to make the corrections.

Figure 13-6: Draw the organic shapes for a bottle (a), and apply the colors to the entire drawing (b).

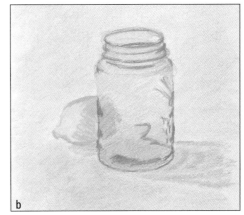

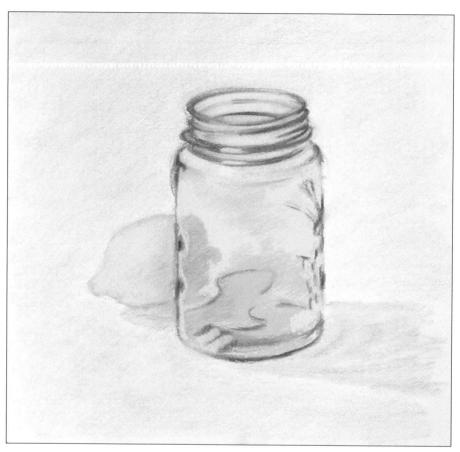

Figure 13-7:
Add high-
lights and
details last.

Creating Textures

Lots of objects have texture: wood, rocks, fur, grass, crumpled paper, and
your own skin, to name a few. The tricky thing about drawing texture is
capturing the pattern of the texture and making it look dimensional at the
same time. Drawing textures can seem like so much work that you may have
trouble deciding where to start.

Seeing the object correctly and thinking clearly about what you have in front
of you is key. If you can draw the actual shape of your subject and then find
how the texture wraps around the form as though it's wearing clothes, you
have it. As you begin to draw textures, follow the process in these sections.

Nailing down form before
moving on to pattern

In order to make textures in your pastel works, you want to begin your drawing
by laying out the actual shape of the item. We suggest you select something

simple and easy to draw based in simple geometric shapes to start. For example, a wooden log is a cylindrical shape. If you're a bit more advanced, you can choose a more complex object. In a pinch, even a dog can be a combination of cylinders and boxy shapes.

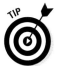

If you do choose something with a more organic, natural shape, the easiest way to start is with a *gesture drawing,* a type of underdrawing made up of curving lines (covered in Chapter 5).

After you draw the item's shape, you need to then tackle the *value patterns* (the various areas of light and dark). This process is important for textured objects because texture can fragment the light, diffusing it across the form so that you lose all the structure. If your object has the same value in all areas, it doesn't look dimensional. Take time to adjust the light so you have clear areas of light and dark. This act helps you break down the complex shapes into understandable zones of value that lay on the form. (Check out Chapter 6 for more on drawing value patterns.)

Identifying an object's texture and letting the strokes work for you

Before you start to add the actual texture, take a moment to examine the texture you see. Texture can usually be broken down into two types that affect how you draw it:

- ✔ **In a similar direction:** Short bits of color that flow across the surface in a similar direction as you see in the fur on a dog. Use small parallel hatch marks that run in the same direction to achieve these.

- ✔ **Random:** Random chunks of light and dark as you see on tree bark. If your texture is random, it still works best to create a pattern that you can repeat throughout the form. Apply hatch marks in a variety of directions to make the chunks.

After you have an idea of the type of texture you have, you can use strokes to bring that texture to life. When applying texture, you apply marks in the direction of the texture. Initially you draw a series of light guidelines to help you follow the direction of the texture as it follows the contours of the form. The guidelines can be lines or a grid, appearing almost like a topographical map. Check out Figure 13-9 later in this chapter for an example.

After you have these guidelines, you can apply your marks in the same direction. Different textures call for different marking methods, but most common marks are hatching and dashes. Chapters 8 and 9 cover the different kinds of marks you can make; use whatever mimics the texture you're looking for.

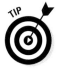

As you're making your texture marks, remember not to let them blend together. Texture is made up of a collection of discreet marks, each with its own color and value, and blending muddles that. Pastel pencils work very well for keeping these marks separate — they keep their points, making the marks easy to apply and allowing you to add linear details and lay in the structure of the texture. Hard pastels work well for texture as well because they have a square shape with corners you can use to make texture marks.

If you have a heavy layer of pastel built up, you may find that the pastel pencil seems to dig a furrow through the soft powder, especially if you're working with some very hard pastel pencils. CarbOthello pencils are relatively soft and should remedy this problem. Applying the color with the pencil at an angle, so that the tip just drags across the surface, may help as well.

Building complexity with color variety

When creating texture, use a variety of colors to make your texture more believable. Even if you're drawing a simple brown dog (like we do in the "Project: A furry subject" section later in this chapter), you can see light and dark browns that show value and vary the shades of brown to emulate the natural color changes on the dog.

Building up a variety of color can be daunting. Initially, you may think you need a lot more colors — you just don't seem to have enough browns for all that fur. But be adventurous. Take a look at Chapters 9 and 10 to see how layering short strokes produces many unexpected colors and creates shades and variety. If you need a darker version of a color, try combining it with blue or violet. If the color doesn't look like you intended, spray it with spray fixative to set the colors and then apply another layer of pastel.

As you layer your colors to build the texture, you can see bits of light in the dark areas and vice versa. Apply these bits as you see them, but be sure not to interfere with the overall patterns of light and dark. Continually check your subject to be sure that the structure of the lights and darks is still true. You may apply so much texture and have so much fun with the marks that your form loses its three-dimensional character because the values have gone awry. If this situation happens, just take some time to reestablish the value pattern. Squinting your eyes as you look at your subject helps you isolate the patterns of light and dark. After you've got a new handle on the pattern, spray workable fixative, allow it to dry, and then reapply texture in the correct pattern.

Project: A furry subject

Although we encourage you to stick with geometric forms as you begin working with texture, you often find texture on natural forms, so here we draw a dog named Eva. If you don't have a pet handy, the steps we describe in the project work for other subjects as well.

1. **Start with a gesture drawing (as in Figure 13-8a).**

 After you've got the gesture lines lightly sketched in, they can act as a structural frame for the next step, establishing the contours of the dog. Sketch in the exterior and interior contours — the line around her body and the lines for her legs, ear, shoulder, and so forth — by adding light lines around these forms.

2. **Find the areas of light and dark and break them up like in Figure 13-8b.**

 Determine which direction the light is coming from and add lights and darks to the appropriate area. Lay down the values in distinct areas, keeping track of the light patterns. Apply the color everywhere; it becomes a base for the texture you apply in Step 4.

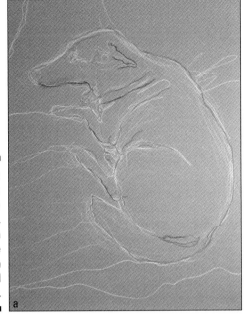 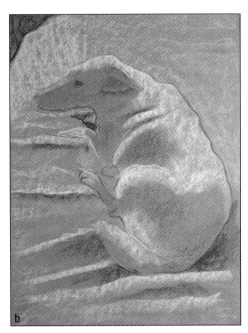

Figure 13-8: Make a gesture drawing (a), and then break up the form with lights and darks (b).

3. **Find the direction of the texture (see Figure 13-9).**

 These guidelines indicate the topography of the dog. They run down the length of her back, down the side of her hips, and undulate across her shoulder and sides. For your project you may have to use a wide variety of colors for the texture guidelines to match the various value patterns.

Figure 13-9: Texture guidelines and some texture marks.

4. **Apply the texture to finish the portrait as in Figure 13-10.**

Figure 13-10:
The applied texture leads to the finished portrait.

Take a good look at your subject; how does the texture look? Eva has short, straight fur, so we use short, straight marks that follow the direction of the guidelines and have a variety of color. Check out the previous section for more info. This process is labor intensive and your hand may get tired, so take your time with texture and stop occasionally for a break. You may find it helpful to use a tool called an *artists' bridge* (a transparent plastic shelf that rests over your drawing) to support your hand as you work.

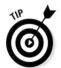

Don't start at one end and work your way to the other. You run the risk of losing track of your value patterns and texture. Instead, do a little bit everywhere.

Chapter 14

Finding Your Artistic Voice

In This Chapter

▶ Balancing technical skill and artistic expression

▶ Identifying your unique perspective

▶ Using interesting materials to jump start your imagination

*I*f you're new to making art, getting your drawings to look as real as possible is often your first concern, which means spending a lot of time practicing. But as you acquire a knack for realism, you may become interested in working on your own individual ideas as well. This stage can come very naturally, and in fact, many artists excel at original and inventive work from the very start. Sometimes you may be stumped for inspiration, and making contact with your inner muse becomes difficult. Although almost everyone displays creativity in childhood (through imaginary friends, complex invented games, and so on), school, jobs, and real life often push that creativity aside.

Now is the time to recapture your creativity and move on to the next step in the development of your artwork. Finding your artistic voice means getting in touch with what *you* uniquely have to say with your artwork. This chapter helps you take those steps to being creative, whimsical, and original with your pastels.

Juggling Technique and Ideas

The majority of this book helps you develop and improve your technical skills (also known as *technique*). However, building your ideas about what you see is important as well because ideas are what give your work direction and individual focus. If you can only duplicate what you see, you're limited to functioning like a camera, and a world full of cameras would create a lot of similar-looking (though technically proficient) art. So what sets your work apart from others? *Ideas* (also known as *content*) are how you add individual meaning to your art.

Combining technical skills and imaginative ideas is what makes a work memorable. A technically great piece can fall flat if the idea behind it's uninteresting (or nonexistent), and a really innovative idea loses its effect if you can't execute it properly. The great art of the ages demonstrated not only skill but also insightful ideas. This section takes a closer look at how ideas can augment technical mastery and how you can incorporate them into your artwork to express yourself.

Elevating technique by focusing on ideas

If your work is only an exercise in technical skill, it looks dry and limited. Adding meaning to your art requires you to think about what you're seeing, arrive at your own interpretation of it, and then communicate that vision to the viewer. Ideas keep art fresh and engaging; because ideas are open to interpretation, your viewer actually participates in your work to a certain extent.

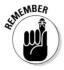

If you have an appreciation for traditional art, you may not be keen on innovation. Always keep in mind that all of today's art was new and shocking at one time. Whether you look at the art of the Renaissance, the landscape painters of the 19th century, or the more recent Impressionists, know that all broke the conventions of their times.

Project: Putting yourself in the picture

To practice putting yourself in your work, think of what sets you apart from others. Your hobbies and interests give you a perspective on life that is all your own. This project gives you a way to use your own experiences to create collages that incorporate your history and tastes through a selection of photos. It doesn't necessarily improve your technical skills, but it helps build your creative skills.

In our project, we start with a collection of photos from a vacation to Lake Michigan. We had the standard shots of people and attractive scenes in the dunes to choose from, but we concentrate on a series of photos of the sunset over the lake. The beautiful colors and sense of space give the same inspiration we seek in our pastel drawings. To select your photos, think of your favorite places, colors, and textures and choose photos that are a good match for your skills. Plain landscapes are easier, and people, waterfalls, or complex city scenes are more difficult. To create your project, you need at least 10 to 20 photos, an 8-x-10-inch piece of mat or chipboard, scissors or a craft/utility knife, and glue (a glue stick works fine).

1. **Select some photos to work with.**

 Be sure whatever photos you choose are ones that you don't mind cutting up.

2. **Try out possible collage arrangements by laying out two or three photos one on top of the other or side by side.**

3. **After you have some possible combinations, cut the photos down using your scissors or knife so that you can combine them in a collage.**

 You can cut out shapes of particular things or cut two photos in half to combine together for a new image. As you cut down the photos, lay them out with each other in their selected arrangement. Keep trying out new combinations as you work.

 Do your cutting on a self-healing cutting board or a heavy piece of cardboard, such as the back of your sketchbook, to protect your cutting surface.

4. **Glue the pieces of your arrangements down to your mat or chipboard as in Figure 14-1.**

Try to place the pieces of photo together as close as you can so the mat or chipboard doesn't show through.

Figure 14-1:
Our collage
of photos.

5. **Repeat Steps 1 through 4, making unconventional choices such as selecting photos only for color and texture or using a photo upside down or sideways.**

 In our example in Figure 14-2, half of the collage is right side up and half is upside down. Keep making collages until you have four or five. You may have to pull out more photos.

Figure 14-2:
A photo
collage
with half
the image
upside
down.

6. **Select a collage to reproduce in pastel.**

Simply make a drawing of the collage like you'd make a drawing from any photo. (Chapter 16 gives you guidance on drawing with photo sources.)

If this project works to jump start your ideas, you can make dozens so that you have some original images to work from as sources for your next pastel project. Your collages are going to be relatively small, so you may have to increase the size of the image in pastels to make it workable; miniatures are difficult in pastels because the pastel sticks are large and can't easily make small marks. Figure 14-3 shows you a pastel inspired by one of our collages.

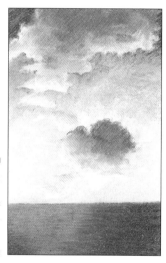

Figure 14-3:
A pastel
from one of
our
collages.

Finding Ways to Amp Up Your Unique Artistic Voice

Gaining depth with skills *and* ideas feeds your work, as we discuss in the preceding section. But how do you do that? Skill is the result of practice, experience, and absorbing a bit from others, and the same is true for cultivating your ideas. Just like perfecting your technique takes time and patience with plenty of practice, developing your ideas also takes work. This section focuses on a few strategies that can help you dig deeper into how you want to express yourself artistically.

Exploring your own point of view

The best way for you to develop your ideas is to take a closer look at yourself to see what your point of view is.

To examine your own point of view, look at what makes your art unique from other artists. You can spend your time imitating the work of other artists, but why make images of 19th-century ballet dancers or roaming buffalo if you live in a 21st-century suburb of Chicago? Think of what interests you aside from art. Is it gardening? Genealogy? Hiking? If that's the case, your subject matter may be botanical drawings, portraits of family members, or scenes from your nature walks. Sit down with your sketchbook and think about these questions on paper to identify your unique voice.

When you think you've got a pretty good handle on your point of view, look at other artists' work to generate some ideas and help further define your own perspective. Sometimes inspiration *can* come from the influence of another artist, which is different from simply copying or imitating another's work. Start by selecting one artist based on subject matter, time period, or materials used, and research that individual to find out all you can about his or her working habits, writings, studies, readings, and personal influences. You can discover a lot about color, composition, or how to tackle a particular subject by understanding how your inspiration approached it.

As you do all this inspirational research, you may find that your own ideas start flowing. Keep your sketchbook handy and use it to record any ideas that come to mind.

Make a point to look at a lot of art in museums and galleries and try to attend lectures by artists and art historians. You may find taking a class or doing some individual study with books and videos about an artist or group of artists useful. Finding out more about art expands your ideas of what's possible in your own work. You can see how artists have handled a particular medium or subject matter for clues to your own dilemmas. Think about what confuses you or what you disagree with in art — sometimes inspiration can come from wanting to do the opposite of what someone else has done.

Expanding your ideas means getting out of your comfort zone and doing something different. For example, if you always do landscapes, study how they were done historically. Find out what's going on with landscape in art today and experiment with an unusual twist in your landscape drawings. Knowing yourself, your interests and tastes, and exactly where you stand on current issues can keep art new for you and keep you from getting yourself in a rut.

Working on odd surfaces

Finding your own voice in your work can be the product of working with ideas, but it can also come from the materials themselves. Using unconventional art materials can be very inspiring, and an easy way to mix things up is to try drawing on different surfaces. Although working with pastels is fairly straightforward, after you've gained some experience with traditional papers and pastels you can experiment to see how far you can push the surfaces to inspire your work.

We suggest you take any of the projects in this book and repeat the steps on a surface that you've never used before. Try either Wallis or Richeson's Unison sanded papers and boards and compare the results. They come in a variety of sizes, and you can always cut a large piece down to the right size for your project. Keep in mind that any sanded paper is going to eat up your pastels, so use hard or semi-hard pastels.

Playing around with sanded papers is a bit of an investment when you aren't sure how to proceed, because they're about $10 to $15 per sheet, and not all stores have them. An alternative, less expensive method to try is experimenting with regular sandpaper from the hardware store. Get 400-grit black sandpaper; its standard size is about 9 x 11 inches, so you can only try a small project (but that may be good if you're just starting to experiment). Figure 14-4 shows you a work drawn on this kind of sandpaper.

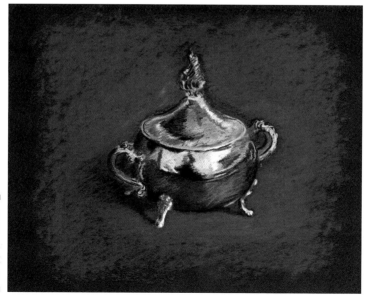

Figure 14-4:
Pastel
artwork
on 400-grit
sandpaper.

Experimenting with materials

Experimenting with pastel in combination with other art materials can open up a whole new world of expression. Pastel is a very flexible medium and can

be combined with other art materials. So sit down with a variety of materials, mess around with them, and see how you can come up with some unique work that sets your perspective apart. Here are a few techniques to try:

- ✓ **Draw with pastel over a watercolor painting.** This technique creates a powdery effect on the watery-looking surface.

- ✓ **Apply denatured alcohol to a pastel piece.** This method gives you a similar effect as a watercolor because the alcohol liquefies the pastel and allows you to spread the color over the paper surface in a wash of color. In Figure 14-5, you can see how an artist has prepared a sheet of paper with pastel primer and is brushing denatured alcohol into a pastel drawing to create a watercolor effect.

- ✓ **Add a thin layer of pastels to a sanded paper (see the preceding section) and then apply odorless mineral spirits such as Gamsol or Turpenoid.** The effect is similar to using alcohol (see the preceding bullet).

- ✓ **Wet your pastels before drawing.** By dipping your pastel stick in water, the pastel marks go down thick and pasty instead of dry and powdery.

- ✓ **Sketch with pastels over a pen and ink drawing.** This technique adds color to a black and white work. You can add little touches of color or add a lot to change the look of the work.

Figure 14-5:
An experiment with materials.

Photo courtesy of Carolyn Springer

You can palso try painting *pastel primer* (like in Figure 14-6) onto paper or cardstock to give it a *toothy* (lots of texture) surface similar to sanded paper; it makes many unconventional surfaces receptive to pastels. You can find this primer in any well-supplied art store. You can apply pastel primer to a hardboard panel, a rigid canvas panel, or other rigid surfaces. You can even add color to the primer with acrylic paints to create a toned surface.

Image courtesy of Jamie Combs

Figure 14-6:
Working expressively on a surface primed for pastel.

Examining other ways you can tap into your own creativity

Setting yourself a task to work creatively doesn't just mean sitting around waiting for the inspirational spark — fostering creativity takes time and attention. The rest of this chapter includes some general ideas to help you generate your own ideas and get your creativity humming; the following list provides some more ways artists try to find new and interesting ideas:

- ✔ **Make your sketchbook a real working diary, like in Figure 14-7.** Keep notes on your work, the materials and the supports you use, the subjects you're drawn to, and the projects you've completed. Give yourself a critique at the end of a project assessing your success and how satisfied you are with the results. Record the amount of time you spend on a project and your best work habits. These notes allow you to duplicate the circumstances of successful works if you ever find yourself in a dry spell.

- ✔ **Collect any printed material of an exhibition you attend and attach it to the sketchbook with your notes.** Your sketchbook is also a great place to keep a record of art you see and ideas for future projects.

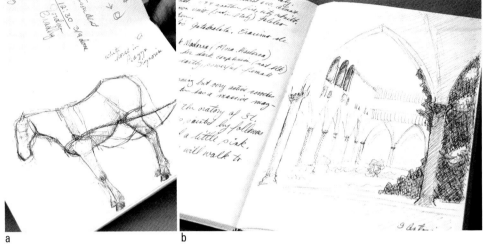

Figure 14-7:
Notes in your sketchbook can help you evaluate yourself.

a b

✔ **Take a subject that you've worked with a lot and turn it completely around.** Try it from a new angle or limit the color palette to only one group of colors, such as only blues or only reds.

✔ **Try something truly expressive.** *Expressionism* refers to art that puts a premium on expressing emotions. Artists often try to communicate their emotional message through the distortion of form, color, or space like the examples in Figures 14-6 and 14-8. See Chapter 15 for more on abstraction.

Figure 14-8:
An expressionist artwork with distorted space.

Image courtesy of Susan Watt Grade

> ✔ **Rework old artwork.** If you've abandoned a work and judged it a lost cause, resurrect it with some pastel CPR. Try adjusting the color, lighting, and mood with pastels applied in hatching, line, or thin layers of color. Add or delete elements, change the focal point — whatever it takes. Add in materials from another medium. If your experiment fails, you've risked nothing and gained valuable experience. If you succeed, you may have hit upon a novel technique or created a fine mixed-media work.

Project: An Expressionistic Work with Distortion

One popular method for finding your artistic voice is expressionism. Expressionism is more a way of working with the elements of art than a historic style such as Cubism. Instead of reproducing the look of a color, *expressionism* tries to communicate a mood or emotion through color and other elements of art.

You can think of expressionism as the distortion of the elements of art to communicate emotions. The elements of art include color, form, space, value, line, and texture. Distorting the elements communicates a strong message to viewers because it doesn't represent the reality they're used to — without their traditional realistic interpretations to rely on, they'll (hopefully) pick up on the emotion you're trying to convey

Distortion can be a little tricky to pull off because you don't have anything to look at to tell you how to do it, so this project leads you through the steps to create an image with distorted form. The goal of expressionism is to go beyond strict representation but still have a recognizable image, and this project can help you develop your ability to express the indefinable in your artwork. It's a self-portrait, but instead of using a mirror, you use an object that distorts your reflection. For this project you need a reflective object such as a toaster, electric percolator, or other shiny steel or chrome object (we use a shiny electric coffee percolator); your pastels; and paper. Follow these steps to create your own piece of expressionism:

1. **Set up your lighting, reflective object, and anything else in your scene.**

 Make sure the light casts a strong light on your face. You may have to place the reflective object somewhat above your eye level to get the best view — you want to be able to see yourself, your features, and a definite pattern of light and dark on your face.

2. **Sketch the shapes you see in the reflection.**

 Don't worry about capturing a likeness of yourself. The reflective object stretches and distorts your face and features and any other reflected items. If you have trouble getting started, you can do a sketch first in your sketchbook as we do in Figure 14-9.

Figure 14-9:
A pencil sketch of a distorted self-portrait in a sketch-book.

3. **After you're satisfied with your shapes, lay in tonal marks for the color and values as Figure 14-10 illustrates.**

 Make these marks lightly so you can be flexible in case you want to make changes as the work progresses and you notice mistakes that escaped you earlier. Figure 14-10 shows you how distorted the purple table cloth is in the foreground of our project.

Figure 14-10:
Our dis-torted self-portrait with shapes blocked in.

4. Continue to apply pastel to the image to develop the colors.

You can develop the image with tonal marks and a combination of hatching marks as we do ours. If the paper becomes too dense with dust, apply spray fixative to give it more *tooth* (surface texture) and then continue to add layers. You can see our finished project in Figure 14-11.

Figure 14-11: The completed expressionist project.

Chapter 15

Trying Abstraction

*W*orking with pastel isn't limited to realistic subject matter — you can use it to make artwork that doesn't look realistic as well. Honing your skills by working from observation is great, but sometimes you just want to take a break from all that and do some work that comes from other inspiration. Adding an element of abstraction to your repertoire is a good way to continue developing your pastel skills while adding to your vocabulary as an artist. If you're interested in creating abstract pieces of art, this chapter can help you get started.

Defining Abstraction

When you normally think of abstraction, you may think of artwork that doesn't have subject matter you recognize. Although this picture is one type of abstraction, many artworks have realistic subject matter and still appear abstract. So, what exactly makes an image appear abstract? Generally, *abstraction* is an idea or concept conveyed in the form of an artwork. An abstract drawing usually has a couple of the following characteristics:

▶ **The subject is simplified and pared down, sometimes to a basic symbol.** What makes realistic subjects abstract is that the artist simplifies them to suggest the subject rather than include lots of minute, realistic details. For example, much of Picasso's work has both abstract elements and realistic elements. You see a woman or a bull, but they're abstract portrayals of those subjects because he only portrays their general characteristics.

▶ **The subject is repeated.** In this form, the artist isolates a characteristic of the subject and repeats it many times. The subject becomes unrecognizable because of the patterns of shape and color that take over in the total image.

▶ **The subject looks relatively flat.** You find little depth in abstract paintings because the artists draw attention to the surface of the work by using flat shapes, emphasizing the *negative space* (background), creating textures on the surface of the work, and so forth. In realistic work, the artist strives to create a window into another world, treating the surface more like a windowpane than an art surface.

The ultimate hyperbole: Stylizing

Some artists stylize their drawings to convey an idea. *Stylizing* an object is a little different from abstracting it. Both pare down forms to simple shapes, but stylizing the form takes the simple shape and exaggerates it. Cartoonists and manga artists do it all the time. Superhero comics convey energy and power. Children's cartoons are often cute and cuddly. Both depict human beings but play with the forms according to the needs of the storyline and audience they want to attract.

You can best use stylizing to convey an idea; just doing it to make the object look pretty or cute is generally discouraged. Picasso stylized many of his bulls by exaggerating the natural shapes of the horns and body to accentuate beautiful forms and lines, but if he had stylized them by giving them big eyes and long, curly lashes, people probably wouldn't be talking about him today.

The next section delves more into these three characteristics and explains how you can create these characteristics in your own drawings.

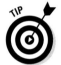

One way to think about whether images are abstract or realistic is to consider them on a continuum or a sliding scale that plots them according to their degrees of realism or abstraction. Very realistic and very abstract artworks appear on opposite ends of the spectrum, with abstract/realistic hybrids falling somewhere in the middle. For example, *Photorealism* (drawings and paintings that look like photographs but aren't) would fall on the realistic side of the scale. A Picasso bull may be plotted in the middle of the scale, because it looks both realistic and abstract, and a Jackson Pollock painting made of layers of paint drips may appear on the abstract side of the scale. Here's another example: In Figure 15-1, you see three versions of an increasingly abstracted bird. The first version is realistic but slightly abstract. In the second, the bird is simplified but still realistic; the final version is a quick, very simplified sketch of the bird

Figure 15-1: Three versions of a bird in different states of abstraction.

Getting Started in the Abstracting Basics

Although drawing newbies may unintentionally make abstract forms as they struggle to match the level of realistic detail in their subjects, creating abstract forms with purpose sets the stage for crafting some pretty interesting work. If you're interested in making a conscious effort to draw abstract artwork, the following sections can get you headed in the right direction.

Simplifying forms

Simplifying forms is at the heart of abstracting real objects. Anytime you simplify something, you keep what's important to its form or identity (the general) and pare away the detail (the specific).

When you simplify forms yourself, you begin by looking at the general shapes, movements, and patterns of the subject. You develop only general forms in the image but then model them so that they appear finished. For example, recent artist Richard Diebenkorn painted images of the area around and looking out of his studio window. The forms are simple and flat, broken up by lines that represent telephone and electric wires and the shapes of roofs outside the window. You see no details, only the colors and textures of the paint. In some of his paintings, you can recognize the objects in the room, but in other paintings, the image is so simple and abstract that you can't recognize anything.

This exercise allows you to get started with simplifying. For this exercise, you need your pastels, paper, and a good size color reproduction of a realistic masterwork (which you can find in many art books). Choose a work that has interesting patterns of values and colors, such as one by one of these artists: Vermeer, Velasquez, Rembrandt, Edward Hopper, William Merritt Chase, or Degas. You can see our example in Figure 15-2.

1. **Set up your workstation and prop up your reference image upside down within easy proximity.**

 Turning the image upside down keeps you from being tempted to copy it too closely.

2. **Identify the patterns of darks and lights you see in the composition and block them in, beginning with the darks and adding the lights and then the middle values.**

 You can use colors similar to the artist's, or you can use other colors you like as long as they have similar values to the originals. Check out Chapter 6 for more on blocking.

3. **Avoiding adding any details, model the composition you began in Step 2 by using the same colors as well as some analogous colors.**

 Analogous colors are those next to each other on the color wheel. You can refer to your book for color ideas, but resist the urge to make your work look as detailed as the masterwork. Chapter 10 gives you more info about modeling (your artwork, that is).

4. **After you've partially developed the work, decide whether to keep the orientation as it is (upside down) or turn it another direction and then finish the drawing.**

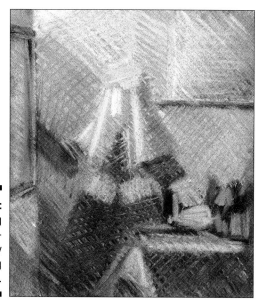

Figure 15-2: Abstracting a masterwork by simplifying it.

Repeating forms

Another way to abstract familiar forms is to find shape themes that run through your subject matter and repeat those forms. You see this repetition in cartoon illustrations of people quite often. A man is depicted with narrow eyes, mouth, nose, face, and maybe even a narrow mustache. Or perhaps a character's facial features and body are all round. The artists didn't pull this tactic out of the air; people's features actually do have similarities in shape. If you boil forms down to their simplest shapes, you can easily see patterns that arise and use them in your images. For example, M.C. Escher was famous for going through a process of simplifying, abstracting, and morphing one series of shapes (such as chess pieces) into another (such as buildings).

For this project, which we call metamorphosis, you change an object into an abstract pattern in five steps. You need your sketchbook, a pencil, pastels, Rives BFK paper (or a sheet of your choice), a ruler, a fine-point marker, and tracing paper. We show our finished project in Figure 15-3; follow these steps to create your own:

1. **Choose an interesting everyday shape that's relatively simple.**

 If it looks like it's going to be a pain to draw, choose something else.

2. **In your sketchbook, make some rough sketches of your object to study its form.**

Draw it realistically from different points of view and look for an abstract form that may make an appealing abstract pattern when repeated. Then experiment with the abstract shapes to see what works best. Head to Chapter 6 for the lowdown on rough sketches.

3. **Make a realistic master drawing of your object on tracing paper.**

 This drawing represents the first step in your metamorphosis. It should be no larger than 3½ inches in any direction. Draw it with a pencil simply but realistically, without the form looking too complicated. When you're happy with the drawing, clarify the pencil lines with a fine-point marker to make them easier to see throughout the project. Draw a rectangle around the image that touches it on all four sides — make sure the corners are square (90 degrees) — and go over those lines with the marker as well.

4. **Measure your rectangle and draw and cut out four rectangles of the same size on tracing paper.**

 These rectangles let you draw similar images for the other four steps of the metamorphosis.

5. **Make an abstract drawing of your object on one of the rectangles.**

 Choose one of the abstract sketches you made in your sketchbook and draw the image with a pencil into one of the rectangles you cut. Make it fill the rectangle, touching the edges when it can. When you're happy with its shape, trace the lines with your marker. This drawing represents the fifth or last step in your metamorphosis, so now you know where the metamorphosis begins and ends.

6. **Draw a shape in another rectangle that you feel represents the halfway point between the realistic and abstract shapes.**

 This rectangle is step three (the middle step) of your metamorphosis. Don't clarify or finalize (with the marker) this drawing until you have the other intermediate steps finished

7. **To create steps two and four of the shift, draw forms that represent shapes halfway between steps one and three and three and five on the remaining rectangles.**

 After you have drawn steps two and four, put all five drawings in a row and butt them up next to each other to check the transitions. Refine drawings two through four in pencil and clarify the lines with the marker when you're happy with them.

8. **On your drawing paper, lightly draw a row of five rectangles.**

 The five steps of your metamorphosis fit into the row of rectangles. Check your measurements and then tear or cut the drawing paper you chose to the size of the row. You're removing any border you may have because pastel dust can dirty it.

9. **On the backs of the master drawings, use your pencil to roughly cover the marker lines you see on the other side.**

You're giving it a layer of graphite similar to carbon paper for tracing. Then place the masters graphite side down in their respective positions in the row and trace them lightly to transfer the shapes.

Don't press too hard when you transfer the images — the lines can etch into the paper and prevent your pastel from covering the paper well.

10. **Begin applying pastel to your drawing, keeping an eye on how your patterns develop as you work.**

 Choose colors for your shapes and backgrounds freely, but be sure to distribute values pleasingly throughout the composition. Avoid putting too many light colors together or too many darks together, and keep away from extreme contrasts.

Figure 15-3:
A metamor-
phosis of
repeated
shapes can
make an
interesting
abstraction.

For an added level of difficulty, continue the metamorphosis by changing the pattern into another set of realistic objects.

Tapping Into Your Abstract Side

Before you can actually draw an abstract drawing, you need to figure out what you're going to draw. The following sections get your creative juices flowing and point out different ways you can explore abstract drawing.

Stream of consciousness: Letting out your inner self on paper

One way you can come up with possible abstract subject matter is to draw from your *stream of consciousness.* In this process, you make images from what you can pull up from the depths of your inner being; it's a meditative activity that absorbs you to the point that you lose track of time and place. Stream of consciousness comes out of the Abstract Expressionist movement from the 1940s and 1950s, which emphasized personal expression and using the paper or canvas as a space for artistic activity. Whatever came out and landed on the surface was considered genuine. For example, Jackson Pollock worked by splattering paint on a canvas laid out on the floor while he danced around it. He considered the painting to be a record of his activity.

Stream-of-consciousness work can be a very spiritual undertaking, but it can also be a dangerous minefield of cultural clichés about color and images, and even what it means to be an artist. Although you may find it difficult to set aside everyday influences and let the muse take over, it's fun and rewarding as long as you don't allow too much of the critic to intervene as you're working.

Doing this work is like brainstorming on paper, but instead of making notes, you make marks and absorb yourself in the visual and physical sensations of the colors and materials, suspending judgment and just letting the work happen. You experiment with colors, different ways of making marks, and adding materials to the pastels so that, like Pollock, the artwork becomes a record of your artistic activity. The work is finished when it feels done; if you have any question about whether it's done, it probably isn't.

Remember that working from your stream of consciousness is about the *process* rather than the *product,* so don't focus too much on what you're producing as you work. Churning out a lot of work and reserving judgment until later is a good way to tap into your intuitive side, but second-guessing yourself as you go interrupts your stream of consciousness.

Be prepared for the fact that you're going to create a lot of really bad work with this process. Your work will improve, however, and soon you'll be having a great time making beautiful work that reflects your own personality.

Making artwork about ideas

You can make abstract images by creating artwork about ideas that take up a cause you feel strongly about. Although realism has historically been an effective way to communicate ideas that draw in viewers and prompt them to think about what a work says, today you have more avenues for communicating ideas.

One abstract communication method is collaging imagery to build compositions. In a *collage,* the surface of your paper acts as a bed upon which you arrange the components of your composition. Picasso and Georges Braque are credited with having invented them, but the ideas behind putting images together in such a way existed in advertising art and other art forms long before. Collage is a great way to communicate ideas because you can mix images creatively to convey exactly what you mean. In traditional collages, you cut out and glue down the images, but you can also work within the spirit of that form by drawing your images directly onto the paper and developing the drawing from there. Even realistic collage drawings can create an overall abstract design. Using collage as a mental process to put your ideas into an image is an effective way to communicate several ideas at the same time. In Figure 15-4, you can see two abstract pastel works that use collage to convey the artists' ideas.

Another advantage of using collage as a design technique is that you can use text in the image. The text is a component of the work, so you design it into your image as you would any other part instead of tacking on the top like you would a science fair poster.

Figure 15-4:
Artists use collage as a mental process for composing art that conveys their ideas.

a b

Images courtesy of Kyle Miller (left) and Carol White (right)

Another way to communicate ideas abstractly is through graffiti art. As annoying as it can be in the wrong place, museums and galleries recognize graffiti as a form of abstract art. Graffiti often conveys some kind of message, and it's a form of expression that lends itself well to pastels and paper. As a combination of image and text, graffiti has strong associations with the acts of handwriting, painting, and drawing. It's a raw, gritty form of expression but a fun way to express yourself (in the proper situation, of course).

Sampling Different Kinds of Abstraction

The previous sections in this chapter discuss a few ways you can add abstract elements to your pastel works, but they're only the tip of the iceberg. The following sections provide three ways you can make pastel abstracts.

Project: Abstracting a realistic scene in two steps

For this project, you transform a realistic drawing you've already made into two increasingly abstract versions. Almost any drawing works, but look for one with interesting shapes and values. In addition to your original drawing, you need two pieces of paper the same size and your pastels. You can see our version in Figure 15-5.

1. **Choose your realistic drawing and set it aside so you can easily refer to it.**

 Make sure the drawing you choose has some visual material (such as shapes and values) to exploit in the next two drawings.

Figure 15-5:
Paring a
realistic
image
down to an
abstract
image.

a

b

c

2. **Begin the second drawing by making an initial drawing that copies the general shapes of your first drawing and then block it in similarly.**

3. **After you block in the second drawing, put your original drawing away and begin developing the second drawing.**

You put the original away so that you're not tempted to totally copy it. As you develop the second drawing, keep the shapes very general by simplifying the forms and not adding details.

4. **Develop the second drawing until you've given all the forms adequate attention.**

 Concentrate on making the colors and marks interesting. It's done when the entire paper is covered with pastel and looks like all the focal points are developed and all problems are resolved. If you look at it and think, "It needs something," it isn't finished. When it's finished, set it up where you can see it and get ready to work on the third drawing.

5. **Start your third drawing by blocking in the forms from the second drawing geometrically.**

 Refer to your second drawing as you do this step. Make the forms very simple and pared down in your third drawing. Use layers of *analogous colors* (discussed in Chapter 11) and various marks from Chapter 9 to develop the drawing.

6. **When the three drawings are finished, set them up in a row and make sure they're all developed to the same degree in terms of layers of colors.**

 Because these drawings all relate to each other, strive for continuity in color and development. If an area in one looks unfinished when you set it with the other two, go back into the drawing and finish it.

Project: Dabbling in Cubism

With this project, you get to mess with your sense of reality and what you think art should look like. This project introduces you to *Cubism* (a type of imagery built on two design devices: multiple points of view and transparency); check out the nearby sidebar for more information on Cubism.

For this project, pick one to three easy objects to draw and consider pairing them with a piece of cloth with a simple design. You also need a sheet of good paper, three sheets of tracing paper, a soft pencil, a 2B graphite stick, a fine-point marker, and access to a copier. Keep the size of the final work to 11 x 17 inches or smaller. You can see our version in Figure 15-6.

1. **Set up your still life and make a simple line drawing of it in pencil on one sheet of tracing paper.**

 Check out Chapter 12 for more on setting up a standard still life. Refine the shapes until you're happy with them and then clarify and darken the lines with your fine-point marker. Set the drawing aside.

2. **Move to a slightly different position and draw the still life again.**

 You can either move yourself or the table, but don't reset the still life. Draw the still life from the new position on the second sheet of tracing paper the same way you did in Step 1.

3. **Repeat Step 2, moving to a third position and drawing the still life on the third sheet of tracing paper.**

Figure 15-6:
A cubist-
inspired
pastel.

4. **Photocopy all three drawings together.**

 To photocopy the drawings,

 A. Stack them with your favorite drawing on top.

 B. Open the copier and place the stack face down on the glass so that what was the top of the stack is now the bottom.

 C. Put a sheet of copy paper on top of them so that they copy better and then make a test copy to check the darkness.

 You may need to adjust the darkness level on the copier if the copy turns out light.

 D. After you get the right darkness, make at least two copies of your drawings.

 The extras are for trying out colors in rough sketches. Be sure to use the photocopy from your actual drawings, not the test copy.

 When you photocopy the drawings on the tracing paper together, you get a composite of all three drawings that synthesizes your drawings into one that has multiple points of view and features transparency. You can use the photocopy you make to transfer the image to your good paper.

Getting a grip on Cubism

Picasso and Georges Braque co-invented Cubism, a type of imagery that incorporates transparency and multiple points of view, but they didn't give it that name. A critic wrote that their work looked like cubes, so the name stuck. Because of that, many people think that Cubism is about making things look very blocky, but its original motivation was to depict the world more realistically.

As farfetched as that goal may seem, Picasso and Braque argued that showing more than one point of view in a scene is actually truer to how people see the world than the scenes that Western artists had portrayed since the Renaissance. By incorporating multiple points of view, they added the element of *time* to artwork — in effect, giving it a fourth dimension. They also incorporated transparency into their works, suggesting that showing everything present in the scene is more real than showing only what is visible. In other words, showing all the fruit in a bowl (even the fruit hidden by the bowl itself) more accurately portrays the fruit bowl than showing only the fruit poking up over the bowl's rim.

5. **Rub the graphite stick over the back side of one of the copies, place the copy image side up on your good paper, and carefully trace all the lines on the copy with a pencil to transfer the image.**

 Remember not to press too hard on the pencil; that etches lines into the drawing paper.

6. **Model the image with your pastels.**

 Flip to Chapter 10 for more on modeling. You can make every section a different color if you want, or you can use variations of one hue on different sections of a particular object. If you're nervous about where to put your colors, use your extra copies to make rough color sketches to try out different colors.

Part IV
Drawing Places and People

In this part . . .

Some artists begin working with pastels because they're interested in specific art genres. They're in good company. Across the centuries, landscape, portrait, and still life images have been the bread and butter for the careers of many artists and the focus of study for many others. These art genres have lasted so long because they are challenging but fun to do and popular with art lovers.

In this part, we get you started in landscapes (Chapter 16), interior and exterior scenes (Chapter 17), and portraits and figures (Chapters 19 and 20). In each chapter, we give you tips on setting up to work with each type of subject matter, discuss basic strategies for approaching the genre, and help you combine them with the skills you already have. Before you know it, you'll be creating vacation pastels rather than photo albums.

Chapter 16

Going the Scenic Route: Sketching the Landscape

*P*astel and landscape are natural companions because pastel beautifully depicts light and atmospheric effects. It gives you the ability to create the dramatic long shadows of late afternoon scenes, as well as the soft nuances of fog or summer haze. Using your pastels to draw landscapes is a fun way to capture real-life picturesque scenes on your paper. This chapter helps you get set up to work outside and looks at several approaches you can use to tackle landscape.

You can use photography to collect images of these effects for resource material for your artwork, but the best way to capture them is by working from actual observation in the field. This activity is known as working *en plein air,* or "in the open air." You can work on-site to make sketches for work you do in the studio, complete the entire pastel drawing in the field, or do a combination of both.

Taking Your Studio Outdoors

The idea of working outdoors *en plein air* has a romantic quality to it that evokes visions of brilliant sunsets, beautiful landscapes, and inspired artwork. Even the term itself has a dreamy tone. Unfortunately, working outside isn't always as idyllic as it sounds. The environment can be just as lovely as it is in your imagination, but it can also be hot, buggy, and miserable and put you so out of sorts that the pastel landing on your paper may bear little resemblance to what you see. Working in an inspiring environment can be fun, though, and a great break from working in the studio. If you set goals for your work and prepare well, you can have a great time and make some wonderful artwork. The following sections help you make the necessary preparations so your venture outdoors is successful.

Preparing to go

Painting outside is more than just grabbing a piece of paper and a box of pastels and taking off. Planning ahead before you step outdoors is essential. Here are some things to consider as you get ready to head out:

- ✔ **Scouting a site:** Always be on the lookout for areas you can transform into pastel. Record them in your sketchbook as you encounter them, taking care to note the locations you've already drawn. If you have several, their locations are easy to forget.

- ✔ **Checking the weather:** Consulting the weatherman may seem like a no-brainer, but rain isn't your only consideration. Consider how humidity, temperature, and the elements (such as cloud cover, haze, fog, and other atmospheric conditions) affect your attitude and what you see.

- ✔ **Timing your work session to catch the right lighting:** Leaving early in the morning and making a day of working is tempting, but consider how the sunlight is going to affect the shadows cast in the scene you want to capture. You want to lay in the major elements of the drawing early, so you need to time your work session so that you can capture the lighting you want for your composition. Maybe morning light isn't best for the image you want.

In addition, you want to ensure you set some clear goals and take the necessary supplies before you venture out. Check out the following sections for more in-depth preparations you need to take before you go outside.

Setting goals for your work before you go

Setting goals for your work simply means having some idea of what you want to accomplish before you start. Do you plan to start and finish the entire drawing on-site? Do you want to make the rough sketches and possibly sketch some of the details outdoors and then take photographs so you can finish the drawing in your studio? Knowing this goal helps you determine what you need to take with you when you go. For example, if you only plan to sketch, just take your pastel pencils, but if you plan to complete an entire drawing, you take the whole supply shebang.

Consider your own working methods as you decide your goals. You may be tempted to set the goal of finishing the entire drawing on-site, but that often isn't possible because of time limitations. On the other hand, if you find that you do your best work in the studio, you can concentrate on collecting resource material — drawings and photographs that provide information — in the field and doing the final work in the studio.

Deciding what to take

Whatever you need when you work in the studio you also need when you work outside. Consider the goals for your work as you decide what to take (see the preceding section), and try to travel as lightly as possible. The following list gives you an idea of the spectrum of items you may need; check out the next section for more on outdoor studio equipment:

✔ Pastels

✔ Two sheets of drawing paper (so that you have a sheet to use and a backup sheet)

✔ One sheet of glassine or tracing paper

✔ Small to medium sketchbook

✔ Any other necessary drawing materials (only what is necessary)

✔ Viewfinder and sighting stick

✔ Artists' tape

✔ Drawing board

✔ *French easel* (which is portable and folds up to incorporate a box for paints and other materials) or supply box

✔ Four or five paper towels

✔ Small digital camera (optional)

✔ Folding chair or blanket

✔ Sun umbrella easel attachment (optional)

✔ Sunscreen

✔ Hat that shades your eyes

✔ Mosquito repellent (seasonal and depending on location)

✔ Water and food

✔ 13- or 30-gallon trash bag for protecting your work from sudden showers

✔ Spray bottle of water for cooling yourself if you get too hot

Your main concern when packing to work on-site is making sure you have the drawing supplies you need and taking care of your comfort and health. If the day is warm, make sure you have water and a means of shading and cooling yourself to avoid heat and dehydration. Dress appropriately and wear sunscreen and insect repellent for insects such as ticks and mosquitoes. Pack a lunch or bring a snack if you're going to be out any length of time. These may seem like obvious considerations for any outdoor activity, but people seem to get so focused on going out to draw that they forget them.

Setting up at your work site

After you arrive at your site, set up so that you have an interesting scene to draw and are comfortable drawing it. (Consult the section "Finding a Good Composition" later in this chapter to help you select a scene.) Consider these few points as you set up your site:

✔ **Set up in the shade, in a place where you can still see your scene.** This setup is best because the sun can make you hot and the glare from your paper is hard on your eyes and can give you a headache.

✔ **Remember lighting changes during the day.** You may start in shade in the morning but find yourself in full sun all afternoon. The sun isn't going to stop moving across the sky so that you can finish your drawing, so keep in mind that everything in the landscape is constantly changing, especially the shapes and directions of shadows. Take a look around and try to find an area that could remain shady all day. Try not to move from a spot after you choose it.

✔ **Consider the safety of the area you have chosen.** People are naturally curious about artists, so you can expect to be approached and asked

questions. If you set up in an area that is fairly isolated, however, consider working where you can blend in with the environment, and always have a cellphone within easy reach in case you end up in an uncomfortable situation.

✔ **Set up your drawing board on an easel or other support so that you can see your scene without peering around the board.** You have some options for supporting it and setting up your work area:

- **Set up on a picnic table and work flatly.** Chapter 4 gives you more guidance on working on a flat surface.

- **Sit on a blanket and prop the top edge of your drawing board on your supply box so that the drawing board sits at an angle.** This system is similar to propping the drawing board against a table as we discuss in Chapter 4.

- **Invest in a French easel and work as you would on an easel in your studio.** French easels are portable, collapsible, and specially designed for *en plein air* work. Some are even designed as backpacks and include a folding stool. If this is your first time going out, you may want to hold off on buying the French easel until you know outdoor work is something you want to continue doing, but they're a good investment if you want to do any kind of landscape work (especially if you're worried that you may have trouble getting back up if you sit down on a blanket!) You can pick up a good one for $50 to $100 or spend up to $250 for a fancy setup that includes a stool and umbrella.

Don't be tempted to use a display easel for outdoor work. It's too unstable, and your drawing board is liable to fall and ruin your work.

After you set up your drawing board, lay out your pastels and other items you need so that you can reach them conveniently. Figure 16-1 shows you one way to set up to work outside.

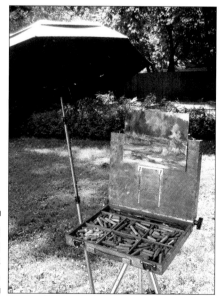

Figure 16-1:
Setting up to work outside.

Image courtesy of Mary Ann Davis

Protecting your work

Another precaution to consider is how to protect your finished drawing as you transport it back to the studio, because the potential for damage is always present. You can't do much about a bird that "critiques" your work with a well-placed shot from overhead, but you can protect your work other ways. Keep the following in mind:

- ✔ **Bring a plastic bag to protect your work in case a rain shower pops up.** Drops of rain (and sweat) can ruin a pastel work. Furthermore, avoid leaning over your work if you're sweating.

- ✔ **Refrain from wiping bugs off your work.** They won't hurt your drawing, but you can damage it if you wipe across your work. Just dump them off or let them walk off.

- ✔ **When you're ready to leave, tape a sheet of glassine or other paper over your drawing and carry it home attached to the drawing board.** If you leave it unprotected, you may accidentally brush the drawing against your leg or plant growth as you walk.

Finding a Good Composition

When you choose an area of the landscape you want to draw, you often can't fit that entire scene into a pastel work. Luckily, you can focus and arrange that scene into a workable composition with the help of your viewfinder. You use a viewfinder like a camera lens to find the section of the landscape you want to draw by eliminating all the environmental clutter outside the picture frame that competes for your attention and pulls your eye outside the area in focus. Check out Chapter 5 for instructions on how to use a viewfinder.

The same principles of design that apply to still life and all genres of two-dimensional art also apply to landscape, so always be conscious of how design fits into your picture when you're setting a landscape composition. Every recognizable object has a geometric form and a direction — vertical, horizontal, or diagonal — and they fit into compositions in surprisingly similar ways. A tall bottle becomes a tall tree, and a box becomes a house or a car. The objects may change, but their general forms and directions don't.

Keep these points in mind when locating a composition specific to drawing landscapes:

- ✔ **Consider what the overall design communicates to your viewer.** Does this scene appear formal or informal? *Formal* compositions look structured and planned, like a fancy garden, and *informal* compositions look unstructured and dynamic, like a nature park.

- ✔ **Look at the patterns of light and dark.** Are the darks well distributed throughout the scene? The darks don't need to be evenly distributed, just distributed in an interesting manner. If you take good care of the distribution of darks, the light areas are taken care of automatically.

✔ **Find the focal points.** The *focal points* are the areas that immediately attract the viewer's eye. You want the viewers to look where you want them to look, not just at some random spot in the composition. Avoid setting the scene up on your paper so that its most interesting aspect is situated at the edge (although that doesn't mean it has to be at the center, either).

✔ **Consider texture.** How are textural areas balanced with areas of little texture? Texture attracts the eye, too. Textural areas can be focal points if they're very textural. On the other hand, too much texture can seem busy. If you like texture, try to create a balance of textured and less-textured areas.

✔ **Think about the distribution of bright colors and warm and cool colors.** If most of your composition is one color, the placement of other colors becomes very important because they draw more attention.

Chapter 12 has some helpful hints about designing compositions, and Chapter 11 can help you with color.

Collecting Resource Materials

Sometimes when you're drawing a landscape, you may not be able to always complete it on-site in one sitting, in which case you may have to finish it back in the studio. In fact, you may not even draw at the site at all in some situations. In these instances, collecting *resource materials* (sketches, photographs, and in some cases, actual specimens from the field that you refer to as you're working) to work from is important. It's a lot like taking notes so that you can write a paper. In Figure 16-2, you can see a collection of resource material. The following sections discuss a couple of different types of resource materials and how you can utilize them.

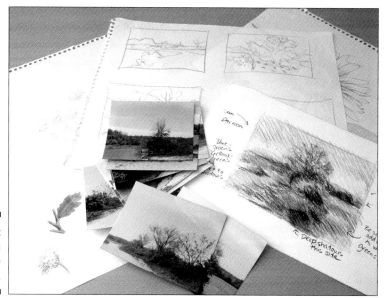

Figure 16-2:
A collection
of resource
material.

If you see that you can't finish a drawing on-site before you must leave, be sure to stop working on it in time to collect your resource material. Avoid having to rely on memory or to flat-out invent areas of your drawing because you aren't able collect the information you need to finish it.

Making rough sketches

Drafting rough sketches is a great resource material. Your eyes can focus in on the areas that you need to record so you can later refer to them and capture the scene. These drawings are for your use only, and the more information you collect, the easier the transition from working in the field to working in the studio becomes.

Before photography, people made drawings to record information. For example, Lewis and Clark didn't have an expedition photographer; they made drawings of plant and animal specimens that they could not collect. You, too, can use sketching to remember information about your landscape scene. When you sketch for information, you draw with the goal of capturing shapes, colors, and other elements that you may need later. These sketches can include a blocked in composition of your scene (discussed in Chapter 8), the outline of a leaf, a sample of a color, or a detail of the way a branch curves. None are meant to be artwork themselves; they're just studies that contribute to the final work. In Figure 16-3, you can see an informational sketch that includes notes; head to the next section for more on annotating your sketches.

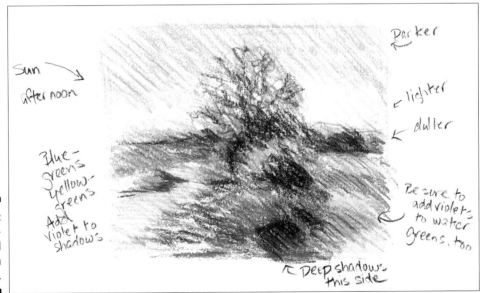

Figure 16-3: An informational sketch with notes.

As you're making your sketches to take back to the studio, don't hesitate to make notes and draw diagrams on them. Notes jog your memory, give instructions, and add information you can't convey in the sketch.

Using photographs

Although some artists frown upon drawing from photographs because it undermines your ability to create the illusion of three-dimensional space, we don't entirely agree. When you don't have original sources at your disposal, photographs are indispensible tools to help you complete your drawing.

Don't be afraid to use photographs in drawing landscapes. Just make sure you're aware of their limitations and how to overcome those obstacles so you can use the photos effectively. The following sections point out how you can use photos when drawing landscapes; you can read more about using photographs in Chapter 5.

Knowing what to photograph

In order to capture the essence of the scene, you want to take a photo not only of the scene as a whole but also of the areas that may be particularly tricky to draw. The temptation may be to take a single photograph from your work area, but that often doesn't give you enough info on specific areas to work from, so also take these shots as well:

- ✔ Close up photographs of areas of your composition in addition to those from the position you were working.

- ✔ Photographs of anything in the environment that may be difficult to draw.

- ✔ Photographs of an object or area from several points of view so that you can understand its form while you're drawing it.

Take your photos of the scene in the lighting or time of day you want to depict. Remember that the light is constantly changing.

Cropping to add drama

If you're working totally from an existing photograph, remember that you aren't required to paint the entire photograph. Just as you use your view-finder to find the best scene to depict, you can *crop* your photograph down so that you work with the most dramatic scene. Essentially, you're paring away the areas that don't add anything to the composition and render it boring. In Figure 16-4, you can see a photograph and a cropped version.

You don't have to have a bunch of fancy-shmancy equipment to crop a photo, although you can certainly go the high-tech route if you like. Here are a couple of low- and high-tech ways that you can crop photographs to make them more effective compositions:

- ✔ **Low-tech:** Cut four strips of paper to frame the image by covering up various portions along the four sides. Use the strips the way you would use your viewfinder.

- ✔ **High-tech:** Scan your photograph into a computer and use a program such as Adobe Photoshop to crop the image. The advantage of using this method is that you can try several different crops and compare them next to each other.

Figure 16-4:
A photograph and a cropped version.

a b

De-cluttering and drawing only what's important

As we mention earlier in this chapter, you don't have to draw every little thing you see in your scene. Your photographs are likely full of things you don't need or want — telephone poles, wayward hikers, or some non-descript weed breaking into an area like an annoying party crasher. Feel free to banish them to simplify and get rid of clutter.

If you're working from *general to specific* (see Chapter 6) — our mantra for beginning students — the clutter in the landscape naturally goes away because you don't develop it as the drawing progresses. You focus on developing the important parts and leave out the background noise. You wouldn't draw it if you were drawing on-site, so you don't need to draw it because it happens to show up in your photograph.

Communicating Mood with Landscapes

Landscapes communicate mood through light. *Mood* is the emotional feeling you want to convey to your viewer. Life experiences influence how your viewers react to artwork you create, and connection to the outdoors is something everyone shares. Therefore, pastel is a particularly effective medium in communicating mood through landscape because of its ability to capture light and color. Think about how sunny and overcast days or sunrises and sunsets affect you differently. Even the light in different seasons reflects distinct moods. You depict light and mood through the colors you choose. These sections provide you with some insight about how to infuse some mood into your landscapes.

Exploring the effects of light: Shape and patterns

You show light in your landscapes by contrasting your lights and darks, paying attention to the direction of your light source (the sun, or possibly the moon) and using bright colors in sunlit areas and duller colors in shadowed areas. Sunny, bright days need saturated colors that contrast well, but overcast days require colors of similar values and intensities.

Using the right colors isn't enough; you must use them in the right places. Capturing the shapes of the patterns of the shadows as well as the light areas is important for depicting light, but it's also important for creating strong compositions. In Chapter 8, you can read about value patterns and how the distribution of dark areas contributes to strong compositions.

This sketchbook exercise shows you how to glean a strong value pattern from the scene you're studying. It's also a good way to explore a variety of scenes before deciding on one for a final drawing. You need only your viewfinder, sketchbook, and a dark blue pastel pencil.

1. **Go to an area that is full of possible scenes for pastel landscapes and walk the area, looking through your viewfinder for possible compositions.**

 An area you've already worked in is fine. When you find a potential composition, make a loose, rough sketch in your sketchbook, as you see in Figure 16-5.

Figure 16-5: A loose, rough landscape sketch.

2. After you sketch the scene as a line drawing, squint at the area and look for the dark shapes of the landscape.

Rough in the shapes and loosely fill in their forms with diagonal lines like in Figure 16-6.

Figure 16-6:
A high contrast rough sketch.

3. Make at least 10 drawings, one per page.

Try finding new variations of the same scene by changing it from a horizontal to a vertical, or by raising or lowering the horizon line in the composition.

Taking different atmospheric approaches

Thinking about atmosphere helps make your work appear more real. Every day isn't clear and sunny; you may want to depict the effects of other weather conditions, so you think about how you can change those clear colors to capture a gloomy day or a threatening sky. You also consider how junk (moisture and dust) in the atmosphere affects the way you see near and far objects.

To show distance and detail in a landscape, you must treat the areas near you differently than the areas far away. This effect is known as _atmospheric perspective_. You can read more about atmospheric perspective in Chapter 11. The atmosphere affects your color palette depending on what your conditions are like:

✔ **Rain, fog, smog, and other atmospheric conditions:** Water and debris in the atmosphere cut the amount of light that reaches your eyes. This reduced light makes colors appear grayer and less clear and shortens the range of values to eliminate deep darks and light lights. The palette of colors appears very similar as a group, lacking any contrast to speak of. Figure 16-7a illustrates an atmospheric landscape drawing on a foggy day.

✔ **Clear day:** On a clear day, you have less dust and moisture in the atmosphere to affect the way you see distance, but it's still there. The areas close to you are distinct, with clear, bright colors, or colors true to their actual appearance. Close areas should also have contrasts of dark and light colors, as well as bright and dull colors like in Figure 16-7b. Areas that are far away get duller colors and little contrast, much like a rainy or foggy scene would.

Figure 16-7:
A landscape on a foggy day (a) and a clear day (b).

a

b

For this sketchbook project, you can practice using color to depict depth by making quick sketches that focus on color choices. You need your viewfinder, sketchbook, and set of pastel pencils. Check out Figure 16-8 for an example.

1. **Begin your sketches by laying in the initial drawing in line with a pastel pencil.**

2. **Block in the patterns for the darks with a dark blue or green hard pastel or pencil.**

3. **Block in basic colors for the composition.**

 Use your blues to lay in the sky first. Create distance by using a bright blue high in the sky and transitioning to lighter, duller blues toward the horizon.

4. **Block in basic colors for the landscape.**

 Use brighter analogous colors (discussed in Chapter 11), such as greens and yellow greens, for areas in the foreground, and transition to cooler greens and blue-greens for areas farther away. Keep the shapes simple and fresh, and quit working before you over-refine the shapes.

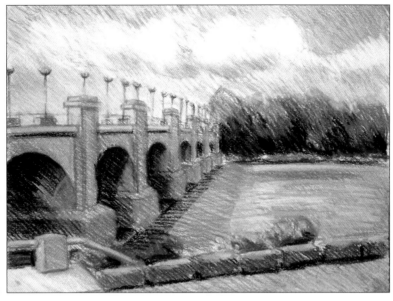

Figure 16-8:
A color rough sketch of a landscape.

Drawing Land and Water

Drawing the parts of a landscape, such as land and water, is simple if you start with basic shapes and then refine the forms according to the parts they play in the composition. Remember to make closer objects and focal points more developed and leave far away areas loose and general. Avoid the temptation to refine any of the far away areas too much. The following sections walk you through the how-to for drawing land and water.

Shaping the flora: Trees and bushes

Trees and bushes are the heart of most landscape art, but they can be intimidating because of their complexity. Many beginners focus on the details — leaves and twigs — when they draw trees and bushes, but that's tedious and prevents you from focusing on your total composition. Try this procedure for drawing trees instead. We show separate examples for line and mass, but the process is the same. You can follow along in your sketchbook.

1. **Block in the basic shape of your tree.**

 Don't touch the details. Refer to Figure 16-9.

2. **Refine the form by breaking down the large shapes into smaller shapes as in Figure 16-10.**

3. **Block in the shapes of the basic darks and lights of the leaf areas and branches like in Figure 16-11.**

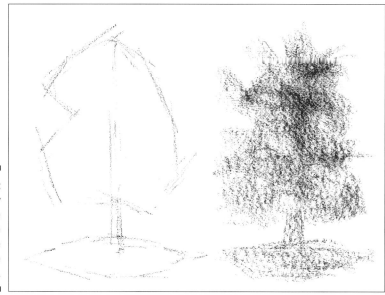

Figure 16-9:
Roughly
draw the
basic shape
of your tree
in either line
or mass.

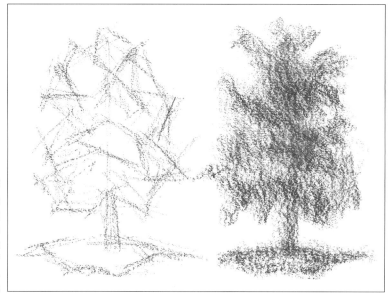

Figure 16-10:
Break
down the
big shapes
into smaller
shapes.

4. **Work on the sky.**

Use the sky as *negative space* (background) to help refine the nuances of the branches and leaves of the tree like in Figure 16-12. Refer to Chapter 12 for more info.

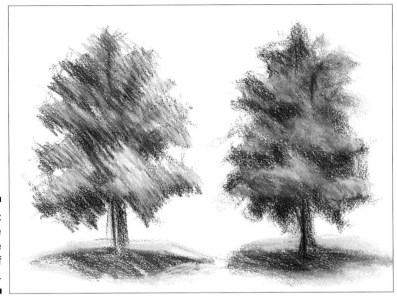

Figure 16-11:
Block in the basic value pattern of the tree.

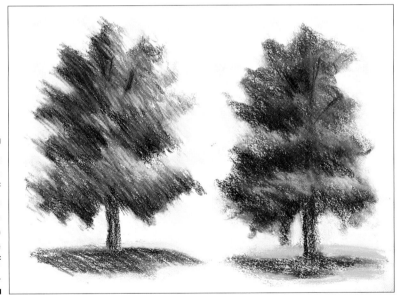

Figure 16-12:
Refine the forms of the tree and use the sky to help shape the nuances of the shape.

5. **Continue refining the light and dark areas to develop the form of the tree.**

 Don't neglect the background as you work. Even though the background may be one color, it still needs to be developed with more layers of similar colors to give it some depth of color. See Figure 16-13. If you constantly consider the *entire* composition, the background naturally becomes a part of the process of development.

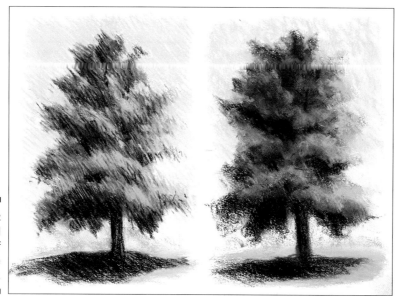

Figure 16-13:
A finished drawing of a tree in line and mass.

Choosing colors for trees and bushes

When laying in colors for trees and bushes, the best choice in all cases is to use a variety of hues, with lighter, warmer hues assigned to sunlit areas and darker, cooler colors assigned to shaded areas. When you choose colors for trees and bushes, use *analogous* colors (colors made from three to five hues near each other on the color wheel). Traditionally, people automatically think of various greens, yellow-greens, and blue-greens, but fall brings in analogous reds, oranges, and yellows as well. You can even find some violets in leaves that turn deep red in the fall. (Check out Chapter 11 for more info on using colors.)

Don't color your trees and bushes by flatly laying in color without variation as you may have done in your coloring book as a child, because it looks two-dimensional and pasted down, without any illusion of dimension. Laying colors on top of one another creates intermediate colors and textures, whether your approach is totally massing color, hatching it, or a combination of both. Experiment to see what works best for you.

When adding color to trees and bushes, you also want to consider what color to use for the shadows. You may automatically think they're a deeper shade of the color they appear to be (their *local color*), but if you look at a dirt path or pavement on a sunny day, you also see violet tones. After you notice them there, you may start seeing them in all sorts of shaded areas, even in green grass. Even if you aren't seeing violet shadows in nature yet, go ahead and experiment with them in your pastel landscapes; the variation of color makes your work more interesting.

Creating textures in the landscape

If you look at your scene, you see a variety of textures — big, coarse textures for trees and bushes; smooth, fine textures for grass; and glass-like or rippled textures for bodies of water. You naturally create textures when you work on rough paper or layer pastels, but keep the following pointers in mind to help you create texture in your landscape:

- **Lay in lines of hatch in different directions.** Make them using short strokes loosely and quickly applied. Check out Chapter 9 for more on how to hatch.

- **Mass layers of color.** Use the side of your pastel and vary the pressure to create dark and light areas. In Figure 16-13, you can see the difference between using hatch and massing to create visual textures. Check out Chapter 9 for more on layering.

- **Combine textured areas with areas of less texture.** Doing so is another way to make your work interesting.

Make conscious decisions about the quality and kind of textures you need or want in certain areas. Sometimes, you may want an overriding texture that a particular kind of hatching or the paper provides. Other times you may want to depict the variety of textures that you see in your scene, or maybe a combination of both.

Depicting water

Water can throw you because its form and appearance are always changing — it certainly doesn't sit still for you while you draw it. Many people try to capture water as it appeared at the moment in time they began drawing it, but that can be very frustrating because the moment passes quickly.

This tendency of water provides a valuable lesson about drawing, however. When you draw, you aren't trying to create a photographic image of your subject in pastel. Instead, you're gathering information from your subject and putting it together in your drawing. Instead of trying to memorize its shape before it moves on, watch it. Look at how it behaves and moves, how it's shaped, how light moves across it, and so forth. Then when you draw it, you understand it. You don't need it to pose for you while you draw. Start with the form you see and elaborate on it based on its characteristics after it moves on.

The key to depicting water is capturing the shapes of the patterns of color, similar to modeling a colored glass bottle. (Check out Chapter 13 for more on modeling glass.) If you think of water in the landscape as having the following two parts, you can more easily understand the shapes you're seeing.

- **Surface-reflected colors:** The surface reflects the sky and condition of the weather that day. The sky on a sunny day may be blue with sparkling whites. A threatening sky is likewise reflected in the water as blue-gray or a sickly gray-green. The shapes of anything near the edge of the water may also be reflected on the surface.

- **Underwater colors:** If the water is deep at the edge or has sediment in it, you see little variation in the underwater color, which can be anything from a murky brown to deep violet, blue, or green. In Figure 16-14, you can see how varied the colors can be in shallow water. Very deep areas of water tend to appear dark blue-violet. If the water is relatively clear, however, you can see the colors of the earth, rocks, and plants beneath the surface. The shapes of the underwater areas can be distorted and bent somewhat by the shape of the surface of the water.

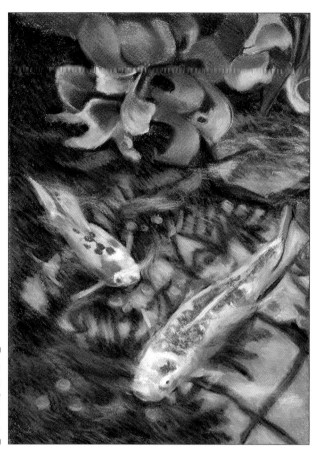

Figure 16-14: The colors in shallow water can be diverse.

If you analyze what color shapes belong to the surface and what belongs to the underwater areas, you can sort it all out and treat it mentally as layers: You lay in the colors of the underwater shapes (which may be slightly distorted) and then add the moving reflected colors of the surface.

Illustrating clouds

Clouds are mischievous forms to draw. They fool you into thinking they'll maintain their shapes long enough for you to draw them, but in reality, they're constantly moving and changing shape. Like water (see the preceding section), they're easier if you study them before you begin drawing. Even though they aren't solid, they have three-dimensional form — a top, bottom, and sides. When the sun shines on them, they're light where the sun hits them, and the bottom and unlit areas are darker. They can also cast shadows on the earth and on parts of themselves. Even though their forms can be relatively complex, they have the same characteristics as trees or anything else you may draw in the landscape. The following sections help you determine which colors work best for clouds and walk you through the steps of drawing clouds.

Picking colors for clouds

Most people think of clouds as being white, but they're more than just white. When figuring out which colors to use when drawing clouds, keep your options

open. They reflect the white light of the sun, but you can find blues, violets, yellows, and just about any other color in clouds. On overcast days, the clouds are a duller blue and blue-violet without much white. When the skies are threatening, you see dark, dull blues and blue-violets, and maybe even greens. The secret to capturing clouds' colors accurately is to work from observation rather than assume what the colors are.

Sketching realistic shapes

The secret to capturing the shapes of realistic clouds is finding the big shapes and then breaking those shapes down into smaller shapes. Continue until you have a well-formed cloud. The following helps you draw a fair-weather cloud.

1. **Use a light blue pastel to lightly mass in big circles for the basic shapes of the clouds.**

 For these clouds, you can use circular shapes as in Figure 16-15a.

Figure 16-15: Use a light blue pastel to lay in large circles for the basic shapes (a) and then break down into more specific shapes with smaller circles (b).

2. **Lightly break those areas down into smaller circles.**

 Don't fill in any areas. Refer to Figure 16-15b.

3. **Lay in the light areas of the clouds with a light blue pastel like in Figure 16-16a.**

Figure 16-16: Mass in the light areas with a light blue pastel (a) and mass in shadowed areas with cool and gray pastels (b).

4. **Add the shadowed areas.**

 The shadowed areas of the cloud need a combination of a light, warm gray and a blue, violet, or blue violet. Lay them in on top of one another and lightly blend them like in Figure 16-16b.

5. **Lay in middle values and lightly blend them in with a dull, light violet (check out Figure 16-17a).**

6. **Work on the background.**

 Use a darker, brighter blue at the top of the format, bringing it to the edges of the cloud to define the form more clearly. Don't create a hard edge; in fact, blend it slightly to give the cloud a wispier edge. Use a blue that's lighter and more violet, such as a medium ultramarine blue, beneath the cloud and blend it into the background blue as in Figure 16-17b.

Figure 16-17:
Lay in the middle values with a dull, light violet pastel (a) and bring up background with dark and light blues, blending the edges (b).

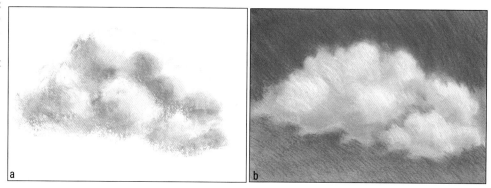

7. **Develop the lightest areas with white and refine the midtones and darks with combinations of the colors you've already used in those areas.**

 Check out Figure 16-18 as an example.

Figure 16-18:
Develop the lightest areas with white and refine the value pattern with the colors you have used.

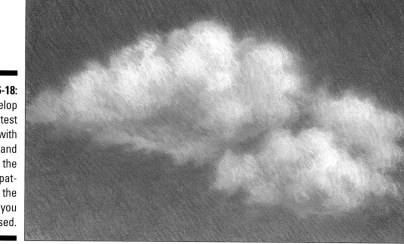

Project: A Full-Blown Landscape

For this project, you bring together everything we discuss in this chapter into your own landscape project. Check out the illustrations (for this drawing, we start with white paper) and follow along with your own image. For this project, you need two sheets of your choice of drawing paper (ours is Rives BFK), pastels and pastel pencils, drawing board, artists' tape, paper towels, viewfinder, and sighting stick. If working on-site, check out the supply and equipment list earlier in this chapter under "Deciding What to Take."

1. **Use your viewfinder to select your image.**

 Be sure that the window of the viewfinder is the same orientation and proportion as your paper.

2. **Lay in the initial drawing lightly and loosely with a blue or green pastel pencil like in Figure 16-19.**

 Flip to Chapter 6 for help creating an initial drawing.

Figure 16-19: Lay in the initial drawing.

3. **Block in the sky.**

 Make it brighter and darker at the top of your composition and lighter and violet-blue (ultramarine) near the horizon (if the horizon isn't blocked in your scene). Lightly blend the pastel into your paper like in Figure 16-20.

4. **Block in the basic dark areas of the landscape.**

 Start with the basic darks to set the overall value pattern for your composition. Refrain from using the darkest values. Like in Figure 16-21, the base hues should be similar to the local colors of the areas in the landscape. Remember to work generally; don't add details.

Figure 16-20:
Block in
the sky.

Figure 16-21:
Block in the
basic darks
of the land-
scape.

5. **Block in the middle values with colors analogous to the darker values.**

 If the darker color is green, for example, choose a green that's a little more yellow for the light area. Look for the variation of hues in the landscape — everything isn't the same shade of green. Refer to Figure 16-22.

6. **Go through the drawing and block in all of your light areas.**

 Use colors analogous to the colors you have already used.

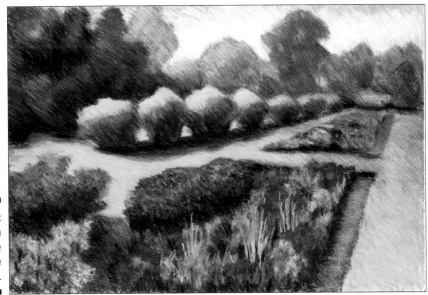

Figure 16-22:
Block in
the middle
values in the
landscape.

7. **Lightly blend the color into the paper throughout the drawing.**

 You are, in effect, spot-toning the paper like in Figure 16-23.

Figure 16-23:
Lightly blend
the colors
into your
paper.

8. **Begin the next layer of color by going back to the darks and refining their shapes without adding details.**

 Blending color into the paper lightens the pastel layer, so you can work back into the area with the original color or begin using darker analogous colors. Do the same for the middle tones and light areas like in Figure 16-24.

Figure 16-24:
Begin layering colors into the blended color to refine the shapes.

9. **Continue building layers of color, saving details for the end (check out Figure 16-25).**

Don't get bogged down in drawing individual leaves. Look for and draw patterns of light and dark and color. Think of it as bringing some areas more into focus than others.

Figure 16-25:
Continue to refine the forms, bringing some areas more into focus than others.

Chapter 17

Sketching Exteriors and Interiors

In This Chapter

▷ Getting a handle on drawing outdoor scenes

▷ Examining the intricacies of indoor scenes

▷ Steering clear of common mistakes

▷ Creating interior and exterior scenes

Your surroundings often spark the inspiration to create a piece of art — a quiet moment gazing at a shaft of sunlight on a wall or an afternoon walking through a small town reveals the beauty in ordinary things. Scenes from in and around homes provide the setting for most of the everyday occurrences, so this chapter walks you through drawing both outside and inside and explains just what you need to know.

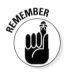

Drawing realistic and convincing structures, homes, and scenes from around buildings is similar to work you do with a still life comprised of geometric objects. You base your initial marks on establishing the structure with light guidelines and check your lines for accuracy in the early stages of the work with sighting. When you draw a still life, you can rely on your own judgment for the angles and the edges that go back in space, but for the larger spaces depicted in interior and exterior scenes, you may need to use linear perspective, a drawing method developed in the Renaissance to depict three-dimensional space. If you don't have any experience with linear perspective, flip to Chapter 5.

Drawing the Outside: Basics for Exteriors

When you find a lovely outside scene and want to get it down on paper, actually getting it done may be daunting. Where do you start, and more importantly, where do you stop? The good news is that drawing outside scenes isn't overly difficult. The following sections provide some insight to make drawing exterior scenes a tad easier.

Working from exterior scenes is similar to doing landscapes (covered in Chapter 16) in that it depicts *deep space* (spaces that extend farther than a typical tabletop scene). It just involves a lot of boxy structures for houses, bridges, and so on.

Getting started: Finding the placement

When drawing an outside scene, the best way to start is to use your viewfinder to limit the scene to one or two features. This strategy also helps focus your attention on the elements that play a large role in the overall scene so you don't overwhelm yourself with the details. Remember that exteriors are large, so instead of thinking of the big picture and the entire outside scene, you can think of the task as making a small portrait of a house or a bridge.

Wander around until you find the best point of view for your scene. Use your viewfinder to try vertical and horizontal compositions. Put your main structure to the left or right and try to balance the main feature with other secondary elements. Setting the main object off to one side rather than letting it dominate the center of the composition helps to create a visual path that invites the viewer to enter the scene. These strategies let you focus on one thing at a time. After you gain experience, you can try multiple structures and deal with more complex compositions.

Sketching in the structure lines

After you know the placement of your subject, you want to sketch in the *structure lines* (the light bundles of preliminary lines). A good way to be sure your lines are true and accurate is to make sure all vertical lines are parallel with the edges of the paper. For the edges that angle away from you, use your sighting stick to find the angle and then reproduce it on the paper. Chapter 3 gives you more info on sighting sticks, but here are some steps to get you started reproducing angles:

1. **Hold your sighting stick at arm's length with your elbow straight and then visually lay the stick along the angle that you want to reproduce and close one eye.**

 Closing one eye limits your depth perception so you can focus on the angle of the stick. Lock your wrist to hold the stick steady as shown in Figure 17-1.

Figure 17-1:
Use your sighting stick to reproduce an isolated angle.

2. **With your elbow and wrist still locked, slowly swing your arm over your work like a mechanical arm**.

 When you hold the stick over your drawing, you can see the angle that you need to draw on your paper.

3. **Draw in the angle you need with light structure lines.**

 You may want to check it again to make sure it's accurate.

You can find more directions for sighting and estimating angles in Chapter 5.

After you draw in the lines, be sure to stop and check your drawing. You have a couple of different ways to do so:

- ✔ **Take a step back and test your composition and accuracy.** You can do this by finding the spatial relationships between forms. Maybe the right edge of the window is lined up with the left edge of the door, for example. Use your sighting stick to make comparisons vertically, horizontally, and with angles to connect the various portions of the composition.

- ✔ **Make sure doors, windows, walls, and so on converge properly at their vanishing point.** *Linear perspective* (discussed in Chapter 5) is a drawing system that helps you work out the appearance of large man-made forms in a landscape or inside a building. Along with sighting, linear perspective is an aid to checking your drawing to make sure that it's accurate before you dive into the heavy-duty development of the image. For example, your perspective guidelines for the doors, windows, and walls converge at the same *vanishing point* within the composition. If they don't converge to the same point, your scene may appear strange, off-kilter, and a little surrealistic.

- ✔ **Sketch in all the large forms (including sky, fields, and large trees) as shapes.** This strategy helps you see how the different parts of your composition fit together. In Figure 17-2, you can see our small building and all the various parts of the scene are sketched in as shapes. Your sketch may look like a puzzle for a 5-year-old, but you can easily check it for accuracy. Ask yourself whether all the pieces fit together like they do in your viewfinder.

Figure 17-2:
The shapes of mountains, buildings, fields, and sky sketched in as shapes.

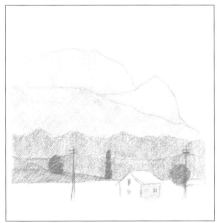

Capturing light and shadow

After you sketch in the structure lines (see the preceding section), you then want to block in the values of light and shadow. Remember to work from *general to specific,* establishing the general scene before adding any details. The advantage to this method is that the image comes up gradually — you can check the entire image for accuracy and avoid big corrections later.

After you block in the light source patterns, go ahead and develop the drawing as you like. You can go for a loose approach where your marks show or something more precise and blended. Use standard, realistic color for your underdrawing (which we cover in Chapter 8) or work more subjectively with this layer. Subjective color choices just mean you base your decisions more on your opinion than on what you really see. Purple shadows and brilliant yellow-green highlights can dramatically flavor your drawing with high color. Later layers can be more realistic and representational with only some of the more daring colors showing through.

Sketching the Inside: Basics for Interiors

If you want to take your pastel work inside, the good news is you have tons of choices. Whether you want to draw a public or private space, the scale of the space has an effect on the feeling of your work. If the space is a home or small room, it's scaled to human proportions and the feeling is intimate. If you're dealing with vast halls and public spaces, the scale is large, less personal, and more similar to what you would see outside. The following sections provide an overview of indoor scenes so you can successfully draw an interior with your pastels.

 In order to get a feel for interior drawing, look at how other artists have utilized interiors in their work. Sometimes the space is just a backdrop, like the intimate spaces that surround the people in Mary Cassatt's artworks. Other times, the drawing focuses on the shape of the architecture, as in Edward Hopper's work.

Looking at the room as a box

Interiors have a lot in common with exteriors. Perspective, lighting, and structural underdrawing are useful, and the forms are based on geometric shapes. (Check out "Drawing the Outside: Basics for Exteriors" earlier in this chapter to read about how these elements influence exterior drawings.) However, interior space feels more intimate and evocative of human interaction than exterior space does. Interiors often have a narrative component, as if a story resides within the arrangement of the chairs and personal items. You may find visualizing the room as a box helpful; the bottom is the floor, the sides are the walls.

In order to get the shapes of interior rooms just right, you can try one of the following methods:

✓ **Do some preliminary drawing in your sketchbook to work out all the angles.** Make some preliminary drawings in your sketchbook to work out angles of all the walls, doors, and windows. Use the sighting methods we discuss in "Sketching in the structure lines" earlier in the chapter to sketch in light angular marks onto your page. You can rework the lines until you find the correct position for the edges of the room.

✓ **Follow a line all around the room, mentally tracing the outlines of the shapes you see.** Here's how it works. Take a moment to get yourself in a fixed point of view; it's important to not move from this spot even the least little bit. Look through your viewfinder at a scene in your home that includes a corner of a room with a wall, a floor, and a window or door. Start with a line where the floor and wall meet and trace it visually along its edge until you encounter another edge — perhaps the corner or a door. Follow that new line line until you encounter another edge and continue the process. Then imagine that the shapes of the floor, walls, and window or door are flat, not dimensional. Try to draw these shapes onto your pastel surface. Check out Figure 17-3 for an example.

Figure 17-3:
Following a
line around
the contours
of a room.

Sketching windows and doors

Most interior spaces have at least one door or window, so knowing how to draw them is important. Drawing windows and doors isn't overly difficult because you build the forms on a box. Using linear perspective ensures that you get them right every time. Use your viewfinder to help you focus your attention so that you can see the forms.

To draw a window, follow these steps:

1. **Draw the sides of the window vertically plumb and parallel to each other.**

2. **Identify the vanishing point of the window's lateral lines and sketch in those lines.**

 Look at the top and bottom edges of the window. Instead of being horizontal, those surfaces appear to be angled. The *vanishing point* is where these lateral lines would meet if you hypothetically extended them past the edge of the window. The top of the window may appear parallel to the ceiling, especially if the window is only a foot or so away from the ceiling, but it's not — the angles are slightly different. Be sure to include all lines that are part of the window: The sash, the window casing, the panes, and so on all have different lateral angles that meet at the vanishing point.

 In your scene, as in ours in Figure 17-4a, the vanishing point may be off the page. If you're working on a drawing board, you can locate the vanishing point on the board itself and use it to create a fan of lines to form the angles of the top and bottom of the window.

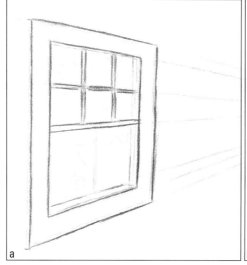

Figure 17-4: The lines on a window (a) and door (b) converging to a vanishing point.

The process for drawing a door is the same: Draw the sides of the door vertical and parallel to the sides of your paper. Next, find the angles for the top and the bottom of the door. They converge at the same vanishing point. If you have the top and bottom edges of the wall (between the wall and floor or ceiling), those lines go to the same vanishing point as the top and bottom line of the door. Figure 17-4b shows you a door example.

Drawing chairs, tables, and other boxy objects

You can use the same method that you use in the previous section to draw windows and doors to make tables and chairs. You can draw most tables and chairs by sketching a box shape; in fact, most parts of an interior scene can be sketched out first with boxes. (Exceptions, such as very curvy Victorian sofas or freeform modern chairs, may best be captured by using methods for plants and other organic forms that we describe in the next section.)

To begin drawing chairs and tables, first create a box the general height, width, and depth of the piece of furniture. Draw it as a transparent box, as we describe in Chapter 5, and lightly sketch in the top, bottom, and sides. After you draw the box, sketch the piece of furniture in the box. Here are some helpful points to remember:

- ✔ Square tables are easy because a square table is already a box with legs at the corners and no sides.

- ✔ For tables with round or oval tops, draw a rectangular top and then draw the oval or ellipse within the rectangle. Draw the round seat of a chair by using the same method.

- ✔ Chairs sit within a box. The feet of the chair point toward the bottom corners of the box like in Figure 17-5a.

- ✔ Chair legs often slant a bit, so they aren't always perfectly vertical. Sketch the vertical guidelines for the leg first and then sketch the angle of the leg.

Figure 17-5: Chairs fit within a box (a), and the arms and legs of a chair aren't always parallel (b).

a

b

✔ Chair arms are often wide apart in the front of the chair and a little closer together toward the back. In that scenario, they aren't parallel to each other, but you can draw them from a set of parallel lines. Sketch in the lines parallel to each other and then use those parallel lines to help you find the angles of the arms, as we do in Figure 17-5b.

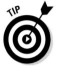

If you have trouble getting your piece of furniture just right, sketch it several times in your sketchbook with a regular pencil. This tactic helps you work out the bugs. You can also aid your visualization of the box by running strips of masking tape on the floor around the outside of the furniture, creating a square or rectangle that gives you a base for building your box.

Sketching plants, fabrics, and other natural shapes

When you draw an interior scene, you inevitably come across some soft, cushy furniture, plants, and other organic shapes. In order to draw these shapes, start with their forms, which nature determines (through either growth for plants or gravity for everything else). Understanding this fact is key to achieving a convincing shape. The best drawing method to capture these natural forms is *gesture drawing,* which we cover in Chapter 5.

Plants can be dense with leaves or minimal and sparse, but either way the energy and movement radiate up from the pot. Use a series of light, sketchy lines to capture the movement and fluid form of a plant by starting with some light lines. These bundles of lines depict the direction of the leaves as well as their overall height and width, as you can see in Figure 17-7. Continue lightly drawing more specific areas, such as the edge of a leaf, the interior stem, or a shape of a group of leaves. Draw in the *negative space* (open spaces) between the leaves to establish the forms. Figure 17-6 shows an example of a plant drawing.

Figure 17-6:
A gesture drawing of a plant.

Gravity defines the energy for soft furniture, pillows, and loose fabric, giving them soft, rounded lateral marks and vertical lines that sag toward the floor. As with plants, use light, sketchy lines to get in the general shape and amend the basic form with the details that you can particularly pick out, such as the corner of a pillow, the sag in a cushion, or the droop of a piece of fabric. You may want to practice these features in your sketchbook before committing them to your drawing.

Creating the right mood with lighting

As you look over your interior scene, consider what the lighting says about it. Lighting illuminates colors and textures, creates a focal point in the scene, and sets the mood. If you don't have a person or animal in the scene, the light becomes the character that makes it animated. Consider all the possibilities of natural and artificial light to focus attention and reveal color. Each arrangement of the lights seems to tell a different story. Here are some that you can try:

- ✔ Pull all the curtains open on a sunny day and blast the room with daylight.
- ✔ Turn off all the lights and darken the room as much as possible except for one table lamp. Set an object with brilliant color under the light.
- ✔ Set a light behind a door or around the corner in a hall for a mysterious, off-camera effect.
- ✔ Arrange the lights in the room so that bright light falls on one wall or door. Make this beam of light the main subject of your pastel drawing.

Each of these arrangements creates a different mood. Spend some time to set the stage for the most evocative scene. Check out Chapter 4 for some general discussion on setting up lighting.

Steering Clear of Newbie Mistakes

Little mistakes in your work can have a big impact — you don't want those minor blunders to interrupt your effect. Everyone makes mistakes, but the following sections help you reduce and eliminate errors common to rookies.

Remedying common mistakes

Most mistakes boil down to two missteps: not checking your work as you go and trying to include every blessed thing in the world. The following list shows things that commonly go wrong in a work with deep space, man-made objects, or lots of details and gives some quick remedies to fix these mistakes.

- ✔ **Everything is in equal focus, even the butterfly a quarter mile away.** Blur areas that are meant to be farther away.
- ✔ **Too many light sources are creating too many unclear value patterns.** Focus and limit your light sources.

✔ **Multiple vanishing points create a funhouse sense of space.** Having a vanishing point that's not in the right position or angled lines of your forms going to several vanishing points throws off your drawing's perspective. Use correct linear perspective (see Chapter 5) to create more accurate drawings.

✔ **The colors on far away objects are unrealistically bright or defined.** When things are farther away, the forms should be fuzzy and the colors less vivid. Apply the principles of *atmospheric perspective* (covered in Chapter 10).

✔ **Objects all face the viewer or all appear in profile.** Vary the positions of your figures and draw from observation to accurately capture the scene.

✔ **Objects are idealized.** To achieve more natural forms and realistically portray your scene, work from observation rather than what you think your objects "should" look like.

Maintaining a single point of view

Trying to maintain a single point of view is a major stumbling block when you're working from a scene depicting deep space, especially when you have a primary subject in the foreground and other secondary items much farther away. When you group all the objects in a scene together, changing your viewpoint doesn't greatly affect them. But place a chair in the middle of the floor with other items 4 to 6 feet behind it and then look at your scene and bob your head — the appearance of the back objects shifts radically. Seeing the objects from different viewpoints and trying to capture them in your pastel drawing is confusing, and the results can be confusing to the viewer, too.

This problem is especially troublesome on large projects, which usually take more than one session to complete and require you to get yourself back into position. If you mark your working position on the floor or ground after you have chosen your point of view, you know where to stand when you return. If you're working outside, take a photo of your scene from your initial position to solve the problem so you always have the original to return to.

Project: An Interior Scene

For this project, you capture a scene inside your home. Take a tour around your house with your viewfinder and select a scene that is relatively simple, editing out knickknacks and details so you can concentrate on the form of the room. Make the lighting the interesting feature.

1. **Lay out your drawing with structure lines.**

 Sketch in the vertical, horizontal, and angled edges with structure lines. Don't be afraid to redraw a line to correct the shape of a form — your objects may look like you've drawn them with bundles of lines by the time you're done. To get the angles right, use your sighting stick at arm's length to sight along table edges, walls, windows, or doors and then take a step back to check what you've drawn with your sighting stick and viewfinder. You can also use linear perspective for your underdrawing. Check out Figure 17-7a for an example.

Figure 17-7:
Initial sketch of a hall with a door (a) and the values added to the hall (b).

a

b

2. **Squint your eyes and look for the areas of light and dark.**

 Lay in these big values with tonal marks (discussed in Chapter 8) to establish the value pattern (Chapter 6). Your drawing starts to look more substantial and three dimensional when you add value. Check the value pattern in the drawing often to reveal more areas for correction. Figure 17-7b shows a drawing with the values added.

3. **Add the middle values and colors, working from general to specific to develop the drawing until it's complete.**

 We selected our colors in Figure 17-8 for value; our white door has green, pink, blue, and yellow in it, but it still looks white. You can develop the drawing with analogous colors or complementary colors.

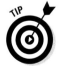

 Go for drama early in the drawing; you can always rein it in for a more conservative look later. Start with some strong colors and use more realistic colors to tone it down afterwards.

Figure 17-8:
The hall,
developed.

Project: A Village Scene

For outdoor scenes in a village, small town, or any place with two- or three-story buildings, the process is the same as for interiors. You make an underdrawing and then work out the angles with sighting or linear perspective. You just have objects of a bit larger scale. Do a bit of research before you start to find the best view and format for your project and follow these steps:

1. **Start with a camera and scout out your location.**

 Doing so helps you plan where you can work, what you need to bring with you, and troubleshoot any problems about the location before you start. (In other words, keep an eye out for vicious dogs, cranky property owners, and curious tourists.) Take lots of photos and try vertical and horizontal formats for your images. You may want to take notes about the scene, lighting, parking, and availability of nearby public facilities.

 Be sure to get permission if the site you want to use is private property.

2. **Go through your images back at home, choose your scene, and plan your outing.**

 In addition to looking for an interesting composition, consider which scene may look best rendered in pastels. After you choose the scene, think about what other materials you need, especially those specific to working outdoors and in your particular area.

 What paper are you going to use? Do you need an easel, chair, or other items? Try to think of anything to make your project successful. The process of working in town is the same as working in the country. Be sure to take along your sketchbook, your camera, and extra materials in case you want to use a different color paper or you want to start over if the first effort goes wrong. (Check out Chapter 16 for some general info for working outside.)

3. **Start the drawing with structure lines for your underdrawing.**

 Lay in structure lines with big arm motions to keep the lines straight as in Figure 17-9. Stop, check the drawing, and make corrections to get the perspective right.

Figure 17-9:
Structure line drawing of a village scene.

4. **Work out the angles in your scene by using linear perspective or sighting.**

 Find the vanishing points and converging lines to get a handle on the scene's deep space. You can also use the technique of following one edge to another.

5. **Lay in the basic values and then continue to develop the drawing like in Figure 17-10.**

 From this point on, you can use your own direction in the development of the project. If you're proficient in still lifes, use your experience modeling those objects to guide you in modeling and developing the forms in the scene. If not, Chapter 10 gives you the skinny on modeling.

Figure 17-10: Developing the exterior scene.

Chapter 18

Portraits: Capturing Realistic Head Shots

*P*ortraits can seem magical and elusive; an artist starts with a sheet of paper, and a few lines later someone you know is staring back at you. The truth is that drawing portraits is no different than drawing a still life or landscape. In fact, some of the techniques (such as blocking) that you use to start drawings of other kinds of subjects can help you create strong portraits. The problem that can arise with portraiture is that you may be inclined to draw what you *know* rather than what you *see* because viewing your subject as an object can be difficult. As we talk about working with pastels, we often focus on how you can use the medium to model a subject. If you don't have an adequate framework to hang the modeling on, no amount of fine modeling is going to give you a satisfying result.

Our advice is to try to focus on drawing what you see. With practice, you can improve your observational skills and make your likenesses more accurate. In the meantime, this chapter helps give you a foundation for tackling portraiture. Besides looking at ways to model the head, we show you a couple of different approaches to beginning your drawing and how to tackle those eyes, noses, and mouths.

The 4-1-1 on Blocking a Portrait

When starting on a portrait, you follow the system of working from *general to specific* to block in large shapes first and then slowly refine the figures until they come into full focus. Check out Chapter 6 for more detail on the general to specific method. The following sections give you an idea of how you can use the proportions of the head to block in a head using the general to specific method. You block in the overall shape of the head and neck and then begin dividing the areas up according to the placement of the features. We know you want to fashion the eyes first, but put them on the back burner for a bit.

Getting a handle on proportion

To make a drawing *proportionate* means to accurately portray how the drawing's elements relate to each other, particularly in size. Proportions are always a concern for artists, especially when working from observation. Although artists sometimes purposely exaggerate parts of the body to make a point (such as with the disproportionately large hands of Michelangelo's David), for the most part they try to be accurate in depicting the forms and have even developed sets of standards designed to help you organize and see the parts of the human form proportionately.

The standards that depict the proportions of the face are helpful, but they should not take priority over what you observe with the model in front of you. The standards assume that you're looking straight on at the model as opposed to looking up or down at the face, and they also fail to account for the multitude of ways humans can tilt their heads. Anytime the plane of the model's face is tilted away from your own, the spacing becomes *foreshortened* (appears short compared to the actual length or width), which skews the spacing of the features from the standard.

In the end, differences are what make individuals unique, so no set of standards can accurately apply to everybody. Use any standards we discuss as references to assist you, but rely more on what you definitely see than on what you think you know as you draw.

Using the relational method

When you use the *relational method,* you're looking at the relative positions of all the parts of the portrait. The parts relate to each other in specific ways, many of which are spelled out in the set of proportions you utilize. Some proportions, such as the vertical placements of the features, are true for the head regardless of whether the position is *frontal* (facing you), side, or ¾ (facing slightly away from you). The horizontal placements require a closer look because they can change as the head turns. In the following sections, you can see how the proportions apply to each type of view.

Blocking in a frontal portrait

When you're ready to block in a frontal portrait, the relational method shows you how to sight and apply these standards. Use the following standards and Figure 18-1 to check your drawing as you work.

- ✔ The eyes fall on a line halfway between the top of the skull and the chin. The hair adds extra height to the head, so don't consider it as part of your measurement here — it skews your proportions. This standard is the most important to remember because many beginners place the eyes too high on the head.

- ✔ The bottom of the nose hits between a third of the way and halfway between the eyes and the chin.

- ✔ If you divide the space between the bottom of the nose and the chin into three parts, the opening of the mouth falls on the mark for the top third.

✔ The space between the eyes is one eye's width. The width of the face at eye level is five eyes wide.

✔ The width of the nose fits between two vertical lines dropped from the inside corners of the eyes.

Be very careful about applying this standard. It doesn't apply for many people. We would drop it as a standard, but using it for observational purposes is helpful.

✔ The width of the mouth fits between two vertical lines dropped from the pupils of the eyes when looking straight ahead.

✔ The ears fit between the line for the eyes and the line for the mouth opening.

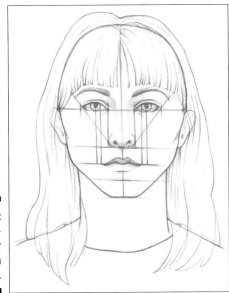

Figure 18-1:
The propor-
tions for
the head in
frontal view.

Blocking in a ¾-view portrait

When you do a portrait in ¾ view, the spacing of the features from the top of the head to the chin is the same as it is for frontal portraits (see the preceding section), but you must sight the widths of the features from observation. For example, the closest eye is larger than the farther eye. If you divide the mouth in half, the closer side of the mouth is larger than the far side of the mouth.

In ¾ view, the position of the ear is the same as for the frontal view: situated between the line for the eyes and the line that plots the opening of the mouth. After you've plotted the distance from eye to mouth opening, turn that vertical measurement horizontally and find the point the same distance from the eye. This point is where the back edge of the ear goes. After you know where the back of the ear is, you can block it in by observing the width and shape of the model's ear.

Looking from the side view

Even though the face is turned to the side, the proportions and spacing of the features from the top of the head to chin are the same as they are for a frontal portrait (see the earlier section). The tricky part is getting the spacing for the ear and back of the head. Use the ear-placing guidelines we give in the preceding section and then draw in the back of the head from observation. If hair covers the area, simply draw the shape of the hair as you see it. Check out Figure 18-2 to see how the proportions apply in a side view.

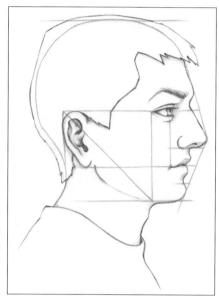

Figure 18-2:
Proportions
of the head
in side view.

The 1-2-3 of Blocking in Initial Portrait Drawings

When you work on an initial sketch for a portrait, use your *sighting stick* (see Chapter 3) throughout the drawing to determine angles and measure heights and widths. Getting the proportions and angles right in the initial drawing is critical because they are essential to capturing the likeness. If you wait until you're modeling the drawing to deal with them, you're too late. The following instructions break down step by step how you actually block the initial drawing for a frontal portrait. When you're ready to refine the forms, check out the next section, which discusses capturing the different facial features.

Getting the blocking-in steps right is critical. Take your time and don't rush. You can trace most portrait problems back to mistakes you made when you were laying down the first lines.

1. **Take a moment to study the overall shape of the head, neck, and shoulders and block in the basic exterior shapes with long, straight lines.**

Avoid any detail or refined shapes at this point. Keep the lines loose. You can see how we started in Figure 18-3a.

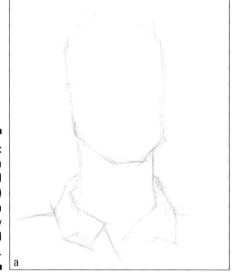 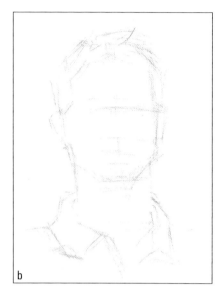

Figure 18-3: Block in the overall shapes (a) and then slightly more detail shapes (b).

2. **Keep using long, straight lines to block in and draw the basic shape of the hair.**

 Just focus on the hair's shape. Don't draw batches of lines for individual hairs; that strategy makes your subjects look like they have haystacks for hair!

3. **Continue blocking in the basic shapes of the face, neck, and shoulders.**

 You can draw the shape of the collar or neckline of the clothing as well. Our drawing is blocked in to this point in Figure 18-3b.

 Don't erase as you're blocking in your forms. The nice thing about this blocking in process is that you can keep *restating* your lines (drawing new lines over old lines) until you get your shapes right. Being accurate is important, but don't let it freeze you up. Work lightly and loosely, restating your lines and refining the forms until they're accurate.

4. **Use your sighting stick to block in the facial features by following these steps.**

 A. Start with the eyes.

 Find the angles of the line that the eyes fall on and a line that moves down the center of the face. Don't assume these lines are strictly horizontal and vertical — they change with the tilt and turn of your head. Figure 18-4 shows you how the eye lines and center lines change as the position of the head changes.

 Use your sighting stick to measure the proportions of the eyes across the eye line on the model. Is the face five eyes wide at that point? What proportion of the line is each of the eyes? Block them in.

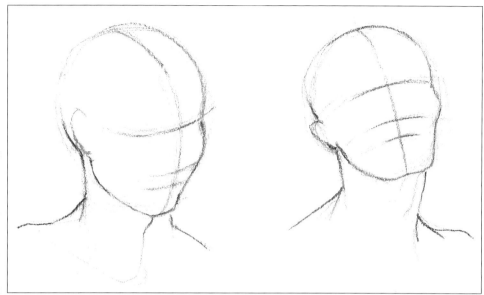

Figure 18-4:
The angles
of the eyes
and center
of the face
change with
the tilt of
the head.

B. Block in the nose.

Hold the sighting stick so that the end is on the eye line and your thumb marks the end of the chin. Look for the bottom (not the tip) of the model's nose. Mark where the bottom of the nose should be on the center line you located in Step 4A. Use the inside corners of the eyes to find the width of the nose and block in the nose.

C. Block in the mouth.

Mark the mouth's opening on the center line. Drop a couple of light reference lines down from the pupils of the eyes to mark common mouth placement; check that against your model by holding your sighting stick vertically in line with the model's pupil to find the corner of the mouth, which falls between the pupil and the edge of the iris closest to the nose. When you find the width, block in the mouth.

D. Block in the ears if you can see them.

The model's hair may hide the ears. If you do see them, they may fit between the eye and mouth lines, but check with your sighting stick to be sure.

Figure 18-5 shows a fully blocked-in face; see "Blocking in a frontal portrait" earlier in this chapter for guidance on finding the placement of these features.

You use a similar process for blocking in portraits in ¾ and side views. If you look at Figure 18-6a and b, you can see blocked in drawings for both of these points of view.

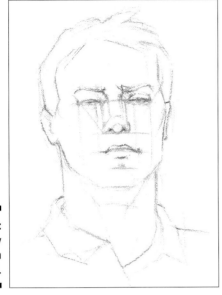

Figure 18-5:
A fully blocked in head.

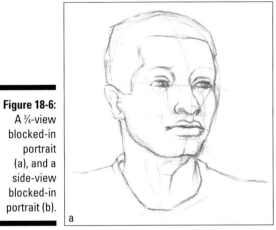 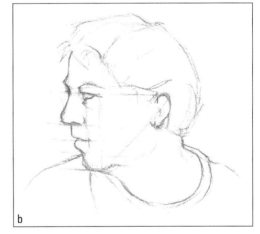

Figure 18-6:
A ¾-view blocked-in portrait (a), and a side-view blocked-in portrait (b).

Capturing Features: The Drawing and Modeling How-To

Blocking in the positions of the features in the portrait is often easier than modeling them. Practicing features in your sketchbook without putting them into a portrait can help you nail down your forms without worrying about how they relate to the entire portrait. Then when you do work on a full portrait, your portrait work is more effortless.

The following sections focus on specific facial features and hair and give you hints and pointers for drawing them. Sit down with your sketchbook and practice drawing each feature; the more practice you get, the better you get at drawing these features. When you are ready to model them, refer to Chapter 10 for information about modeling value patterns.

Looking at eyes

You probably already have a good idea of the parts of an eye: Your eye is a ball, set in a socket and covered by the upper and lower lids. You can bring this basic information to your drawing as you work on the eyes. When you're ready to draw your model's eyes, first observe how the lids wrap around the eyeball. Notice also that the lids have thickness. Beginners sometimes make the mistake of drawing the eyes with a single line for the top lid and another line for the bottom lid, but you need more than the width of a pencil line to depict the thickness of the lids. The overall structure of the eye affects the patterns of light and dark and how you model them. Figure 18-7 shows some basic structural elements.

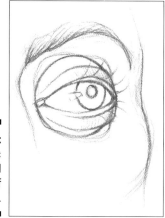

Figure 18-7:
The basic structural elements of the eye.

Stick to the following steps and check out Figure 18-8 as you practice drawing eyes in frontal and ¾ views in close-up. Remember that the smaller you draw the eye, the less detail you show.

1. **Use your sighting stick to find the angle of the eye from the inside corner to the outside corner and draw it lightly on your paper.**

 Most of the time, the amounts of eye showing above and below the angle you set are different.

2. **Draw the area near the tear duct like a *V* or *U* shape lying on its side and add the lids.**

 The lower lid curves the most near the outer corner of the eye and appears to tuck up under the upper lid. It curves less near the center and then a bit more near the tear duct. Deep-set eyes may have little upper lid showing, but protruding eyes may have a lot of lid exposed. Likewise, people may exhibit varying amounts of lower lids, depending

how their eye sits in the socket. Draw the shape of the folds you see for the upper and lower lids.

3. **Draw the iris and pupil.**

 The iris and pupil are circles, but if the eye is turned, they become slightly elliptical. Most of the time, the upper lid covers part of the top of the iris and just the edge of the bottom of the iris.

4. **Add a little hollow between the eye and nose under the brow.**

 As we mention earlier in this section, the eye sits in a socket and much of the time protrudes a bit from that socket. The nose, of course, protrudes more than the eye, so that creates a little hollow between the two features under the brow line. The hollow's shape is somewhat oval, so look for its exact position and shape and lightly draw it in. Adding it helps the eye and nose appear more three-dimensional.

5. **Move on to the eyelashes.**

 Don't draw individual eyelashes. Instead, darken the line for the upper lid and the outer third of the line you drew for the bottom lid. Fade the lines in and out by starting with less pressure and increasing the pressure as you move through the line. Lighten up the pressure at the end of the line. Doing this improves your line quality and makes the shapes look more three-dimensional.

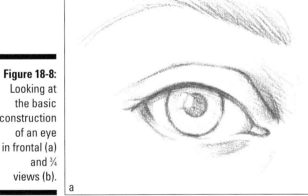 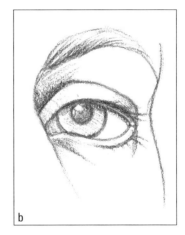

Figure 18-8: Looking at the basic construction of an eye in frontal (a) and ¾ views (b).

a

b

To block in a side view of an eye, stick to the preceding steps and consider these additional points while you refer to Figure 18-9.

✔ Using a *horizontal* reference line (rather than an angled one), measure the amount of eye and lid showing above and below the line.

✔ Remember that the lids have thickness, so draw the curve of the eyeball and then add the thickness of the lids to finish the curves of the upper and lower lids. The lines finish where the upper lid disappears into the brow line and where the lower lid folds into the cheek.

✔ Look carefully at how the curve of the lower lid tucks into the upper lid. Don't draw straight lines for the lids; the lids actually curve around the eyeball.

✔ You can draw the curl of the eyelashes, but don't go crazy with them!

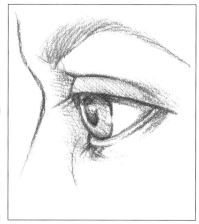

Figure 18-9:
The construction of the side view of an eye.

Now you can model the eyes with your pastels. The following list gives you some pointers, and Figure 18-10 shows a modeled eye.

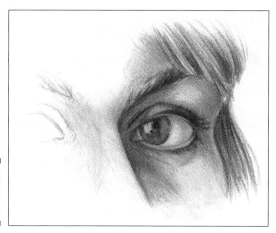

Figure 18-10:
Modeling an eye.

✔ The direction of the lighting is important, so as always, follow the patterns and use darker, cooler colors in the shaded areas and warmer, lighter colors in the lit areas. See "Depicting Skin Color" later in this chapter for more information on how to choose colors for skin tones.

✔ Use white sparingly. If you use pure white for the whites of the eyes, your model looks like she's put her finger in a light socket. The white of the eye isn't actually white, even in the highlights. Some people suggest using light blue for the white of the eye, but try using combinations of pale, muted orange tones at the corners lightened with a light, muted blue to make lighter areas. You can mark white into the soft blue to model the very lightest areas. Use blue-violets for the darker areas and shadows where the eyelashes and upper eyelid cast a shadow on the eyeball. At the corners, the colors can blend together.

✔ Look carefully to find the highlight in the iris or pupil. Look for the shape of the reflected light in the eye. Use a soft white pastel to mark its shape.

✔ Usually, you find a slightly lighter area on the edge of the lower eyelid just under the iris.

Sniffing out noses

Noses have a tendency to look flat in portraits, but understanding their underlying structure makes drawing them easier. Just remember that noses are shaped like a pup tent (but narrow on one end and wider on the bottom), with two flat planes on either side coming together to form the bridge of the nose. Sometimes you see rounded, soft shapes or a flat bridge, as if the ridge was shaved off, but the basic structure is the same. If you look at Figure 18-11, you can see how this structure can form a basis for the nose.

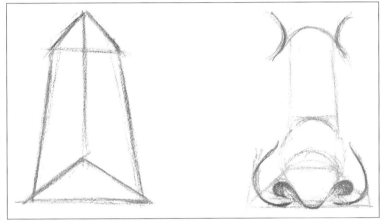

Figure 18-11: Building a nose from a tent shape.

To capture a nose's features, follow these general steps:

1. **Draw the nose's basic shape.**

 Think of the nose as a tent, with the ridge of the nose acting as the ridge of the tent. Observing your model's nose, you can see that the nose is narrower near the eyes than it is at the bottom. Lightly draw a line for the ridge, a triangle at the end, and two verticals for the sides. Each side of the nose is a flat plane.

2. **Focus on the end of the nose.**

 If you focus on the end of the nose, you can find a triangular shape plotted from the tip of the nose along the sides of the nostrils and across the bottom of the nose. If the nose is naturally turned up, the triangle is taller and wider, so you see more of the area of the nostrils. If your model's nose protrudes more directly out from the face, the triangle may seem short or flat and wide, and you see less of the nostrils. Refine the triangle you drew in Step 1 to more closely match your model's nose.

3. Draw the nostrils.

If you put your finger in your nose, you can see that a nostril isn't just a hole in your face; it's made of a flap of skin and cartilage that wraps around. (The key here is *your nose*; we don't recommend doing this to your model.) The opening of the nostril is shaped like a bean and forms a tunnel that you can see into and that has some interior form. Keeping an eye out for these nuances can help you draw more accurate noses.

When you draw the nose from a ¾ view, you can begin at the brow line of the far eye and draw the profile of the nose to the tip. At the bottom of the nose, build the nostrils and side of the nose out of the triangular shape (see Figure 18-12).

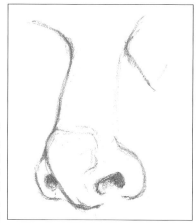

Figure 18-12:
Looking at the nose from a ¾ view.

Modeling the nose can be a little intimidating, but don't let it throw you; just remember to treat the nose as a set of flat planes, each describing a side of the nose. The modeled nose in Figure 18-13 and these tips can help you model a successful nose:

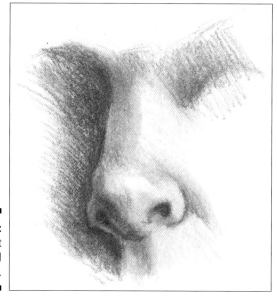

Figure 18-13:
Looking at a modeled nose.

✔ Every plane of the nose — top, sides, and bottom — has a different value of light or dark in most kinds of lighting, just like the planes of a box.

✔ Most of the time, the bottom triangular area of the nose is darker than the rest of the nose.

✔ Don't darken the openings of the nostrils evenly. Look for light areas in the lower part of the nostril where the opening is less shaded.

✔ After you find the basic value for each plane, find and add the nuances of the values within each.

Mastering mouths

The mouth is an important facial feature, and drawing it isn't overly difficult. To draw a realistic mouth, stick to these steps:

1. **Draw a line that defines the shape of the opening of the mouth.**

 Most of the time the center of the line is higher than the ends. Sometimes the center dips slightly, but even then it's still higher than the ends. Figure 18-14a shows you this kind of line.

2. **Draw the shape of the upper lip.**

 Look for the *V*-shape in the center of the mouth. Don't draw a random *V;* carefully observe its size and whether it's narrow or wide. Check out the *V* at the top of Figure 18-14a.

3. **Draw lines connecting your *V* with the corners of the mouth.**

 Make sure you use lines that curve slightly as shown in Figure 18-14a (because of the curve of the upper and lower jaws). Avoid using straight lines.

4. **For the bottom lip, compare the vertical sizes of the top and bottom lips, mark the lowest point of the lower lip, and then simply draw the shape of the lip.**

 The lower lip is often larger than the upper lip, so the distance from the opening of the mouth to the lowest point of the lip is greater than the distance from the opening of the mouth to the highest point of the upper lip. Figure 18-14b shows you the final stage of drawing the lips.

After you finish drawing the lips, you're ready to model them. Observe your lighting and how it affects the value pattern on the lips, and keep the following pointers in mind to ensure your mouth and lips are true to life.

✔ The upper lip is usually darker than the lower lip. The opening of the mouth is the darkest area of the mouth.

✔ The upper lip may also cast a shadow on the lower lip.

✔ Because the mouth curves around the face, one side of the lips may be darker than the other side.

✔ The center edge of the lower lip may be darker than the edges on either side of center.

In Figure 18-14b, you can see how to model the lips in steps.

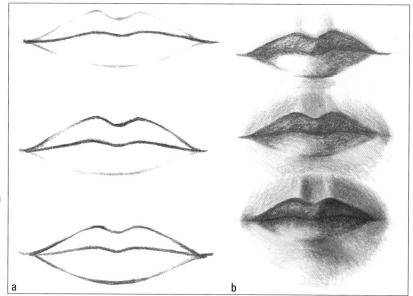

Figure 18-14:
Draw (a)
and model
(b) the lips
in steps.

a b

Exploring ears

Drawing ears can drive even more experienced artists crazy. The good news: You can often cover them up with hair. However sometimes you just have to break down and draw an ear. Don't let them intimidate you, though. They may appear complex, but you can break them down into three simple parts: a big *C*, a little *C*, and a *Y*. Here's an easy way to block them in. Follow along in Figure 18-15.

1. **Draw the basic shape of the ear, which is a big *C*.**

 Don't just draw a simple *C* shape, though. Draw it as you see it.

2. **Draw the little *C*-shaped piece of cartilage inside the opening of the big *C*, with the open part of the little *C* facing the cheek.**

3. **Start drawing the tail of the *Y* at the bottom of the little *C* and continue it around the bend of the big *C*, branching the top of the *Y* into the curl at the top of the big *C*.**

With those shapes blocked in, you can begin to model the ears. The *Y* shape represents the peak of the shape, so the dark areas fall on either side of the *Y*'s lines. You also find a dark area where the ear canal begins beneath the little *C* at the tail end of the *Y*. Use the color of the hair and the shadow cast on the neck to help define the outer edge of the ear. The last part of Figure 18-15 shows the modeled ear.

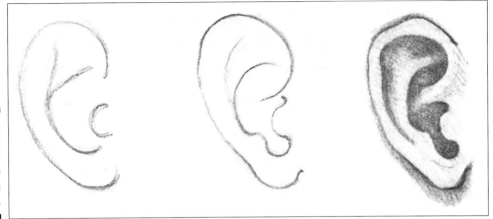

Figure 18-15:
Using
simple
shapes to
draw an
ear.

Brushing up on hair

Many people begin to draw hair by laying in a multitude of lines without looking at the patterns of movement and value in the hair. This technique generally makes the hair look like a flat straw cap or stylized wig. When you draw hair, these steps can help:

1. **Look at the basic shape of the hair on the head and then break down that shape into sections.**

 The basic shape may follow the silhouette of the head, but after that, look for areas of the hair that hold together as a section and then break those sections down into segments. For example, bangs are a section, but you can also see that bangs generally appear to divide further into segments.

2. **Look at the value pattern and how the shapes of the darks and lights break down the overall form of the hair.**

 Hair generally has an overall color with patterns of darker and lighter colors in various segments. Concentrating on those patterns is your primary tactic for capturing hair. Doing individual strands comes last, and then only sparingly. Look for the shapes of the light, medium, and dark colors and lightly draw them in. Then you can begin applying base colors for each of the areas, after which you break those areas into lighter and darker areas to refine the modeling. Flip to Chapter 10 for information about using patterns of value.

3. **Sparingly add wisps or separated strands of hair if you see them.**

 Not everyone has loose, wispy hair. If you see strands, add a few for interest, but don't overdo it. Simply draw fluid lines with a color slightly different from the color of the body of the hair.

TIP

A good strategy to follow is to make the face in focus — especially the eyes but also the features in general — and then let the rest of the head (particularly the hair) go slightly out of focus toward the edges. Use contrast and detail in the face and the areas that frame the face, but avoid creating a hard edge between the hair and the background. Let the edges soften and blur slightly by minimizing crisp details and eliminating the extreme darks and lights. You can see this technique very effectively in the early portrait works of Chuck Close, but in the meantime, you can look at our humble example in Figure 18-16.

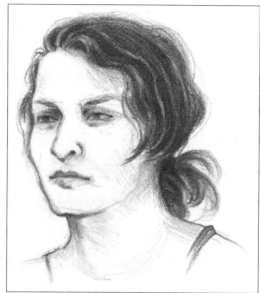

Figure 18-16:
Draw and model hair by focusing on the value patterns and blurring the edges slightly.

Depicting Skin Color

Adding skin color to a pastel work can be a challenging task for beginning artists. Talking about skin tones is always a touchy subject because no single flesh tone exists. Even among the same racial and ethnic groups, you can find as many variations in colors as you see people. Thus to make an interesting and realistic skin tone that matches your model, you need to observe the colors you see in your model's skin and find the right match. The following sections give you an important overview of portraying your model's skin color and tips for making your task a tad easier.

Identifying which colors work

When drawing a portrait, choosing the right colors to match your model's skin color is an important task. You can choose a main hue color for the skin

and then define the areas of dark and light by choosing colors of different hue, value, and intensity. Here are some principles that can help guide you:

- ✔ **Skin hues:** *Skin hue* (the actual color you see in the skin) is the most flexible decision you can make when doing portraits because you can choose to use realistic or *invented* (unrealistic) colors and still come out with a portrait that looks like the person you're portraying. You can read more about hue and invented color in Chapter 11.

 That said, skin colors are often hard to define if you're trying to work realistically, because they're varied and complex in the combination of hue, value, and intensity. Just remember that everyone's basic skin color, no matter how dark or light, is derived from some hue of orange, red-orange, or yellow-orange. The hues just appear muted in skin.

 Try analyzing skin colors by comparing them to wood colors and imagining what the wood colors would look like if they had more white in them. For example, the color of oak is derived from orange; a muted version creates a neutral skin tone, similar to the foundation you find at a cosmetics counter for "neutral" skin. Similarly, pine stems from a yellow-orange, which relates to the cosmetics designed for "warm" skin, and mahogany originates from a red-orange, which relates to the cosmetics designed for "cool" skin. "Cool" skin has more red in it, and "warm" skin has more yellow in it. You can use all of these hues when you model any skin, using some in shaded areas and others in highlighted areas. You can even use blues, greens, and violets in shadowed areas.

- ✔ **Skin values:** *Skin value* (how light or dark the color is) trumps everything when you're using color in a portrait, so the value must be right for the color to be right. Always try to stay true to the values that you see unless you have a reason for changing them. Cool, dark colors are best for shadowed areas. Generally, that means redder colors than the main skin color, but it can also mean violets, blues, and greens.

- ✔ **Skin intensities and temperatures:** The next most important consideration is intensity and temperature. Skin intensity refers to the skin's brightness; *skin temperature* tells you whether the hue is warm or cool. In general, shaded areas, such as those under the nose, use cooler colors, and lighted areas, such as the bridge of the nose, have warmer colors. Here are a couple of variations on this idea that you can try:

 - Use warm colors throughout the portrait, but concentrate warm yellow-oranges and oranges in the lighted areas, and cooler red-oranges and reds in the shaded areas.

 - Use warm colors throughout the portrait, but add cool colors in the shaded area.

For your first portraits, keep your colors simple and concentrate primarily on capturing the lights and darks in the portrait. When you're ready, expand your palette and experiment with more challenging color combinations. Don't feel frustrated if new colors don't work out the first time you try them. (Check out the next section if you're interested in experimenting with different color combos.)

Using unconventional colors

Applying realistic colors isn't the only way to employ color in a portrait. You can use brilliant color, as you may find in a Matisse or Toulouse-Lautrec portrait, or you can use muted colors as in works by Lucien Freud (Sigmund's grandson). Influential portrait artist Alice Neel is also known for employing extraordinary color. If you're adventurous, you can dive right in and start experimenting.

Here are a couple of suggestions for venturing into color palettes that are less realistic:

- ✔ **Try tying the values in a portrait to bright pure colors.** For example, make all light values pure yellow, middle values vibrant reds or oranges, and dark values tropical blues and blue-greens.

- ✔ **Put colored lights on your model and use the colors as you see them.** Don't be afraid to employ green or purple lights.

- ✔ **Think of a mood you want to portray and put together a palette that reflects that mood.** Use those colors in your portrait, even if they aren't realistic. Tie the colors to your value patterns.

If you're a little more conservative but want to shake up your palette, take a look at portraits by David Hockney. His work may offer you a bridge to doing some fascinating work with color. The drawings are sensitive and refined, but the colors are quite vibrant.

The following are some color combinations you should avoid if you want to maintain the form or create interesting color combinations:

- ✔ Stay away from using a duller color for a highlighted area, such as a cheekbone, next to a brighter color in a more shaded area, such as the lower cheek. It can kill the color and make the cheek look flat and dead.

- ✔ Don't limit your colors to a base color modified by marking over it with a white pastel and a dark pastel because the overall colors look flat and dead.

- ✔ Use black as stingily as possible, perhaps only as a lash line or for the line for the opening of the mouth, because your colors will look muddy and dead otherwise.

Project: A Step-By-Step Portrait

The earlier sections in this chapter give you all the information you need to create a portrait, so this section gives you a chance to do just that. Find a willing model (or set up a full-length mirror and sit for yourself) and position him so that you can easily see him without peering around your drawing board.

Don't use children as models. They can't sit still long enough, which can frustrate both you and the child. If you must draw children, do them a favor and work from photographs.

Ready to get started? The following steps and illustrations send you right down the path to portrait glory:

1. **Position your model so that you can see him clearly.**

 If you're modeling for yourself, set up your mirror in the general area the model would have occupied. Bring it in closer if it seems too far away.

2. **Light your model well.**

 Be sure to light your model in an interesting manner. Harsh light is dramatic, but may not be flattering to your model, so experiment to find lighting that interests you and reflects what you want to say in the portrait. Be sure you don't shine the light in his eyes. Head to Chapter 4 for basic lighting info. You can also check out Chapter 12 to see how lighting affects your subject matter.

3. **Establish a basic initial drawing.**

 Lightly block in the drawing of the head, face, and shoulders. Don't erase or labor over the drawing too much. See Figure 18-17 for our initial drawing, and check out "The 1-2-3 of Blocking in Initial Portrait Drawings" earlier in this chapter for guidance on the initial drawing.

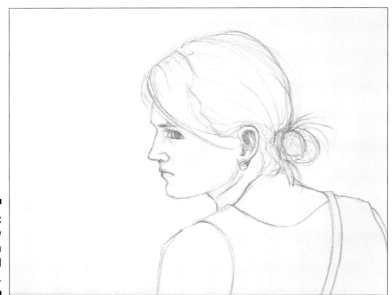

Figure 18-17: Start by laying in the initial drawing.

4. **Block in the basic colors.**

 Use warm colors for the lighter areas and lay them in with broad strokes with the side of your pastel. The preceding "Depicting Skin Color" section gives you the skinny (no pun intended) on working out skin color. These blocked-in colors are going to look a little rough, as they do in Figure 18-18, but don't let that scare you. As always, you build up the colors as you work through the project from general to specific.

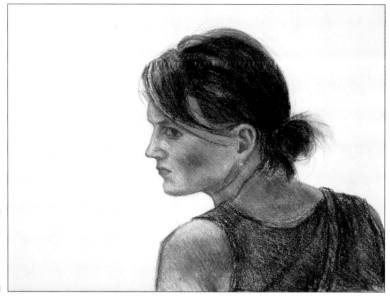

Figure 18-18:
Block in
the basic
colors.

5. **Activate the background by blocking in your basic background color and lightly blending it into the paper.**

In this step, you simply lay in color flatly. You may use different colors if the shapes behind the model break up the background. Many times, you can use the background to help define the side of the face or shape of the head. You can see the blended stage in Figure 18-19.

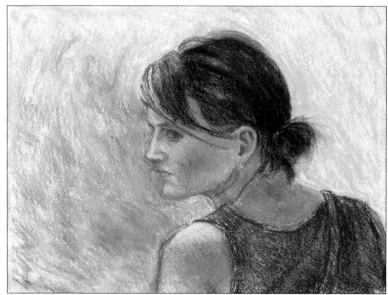

Figure 18-19:
Lay in some
color to
activate the
background.

6. Model the forms.

Begin modeling the face, head, and shoulders to build the basic patterns of light and dark values. You can continue to mass the color as you did to block the colors in, or you can begin hatching (see Chapter 9 for more on these marks). Feel free to blend areas to soften the strokes, but don't get bogged down by trying to create perfect transitions from one color area to another. Check out our partially completed portrait in Figure 18-20.

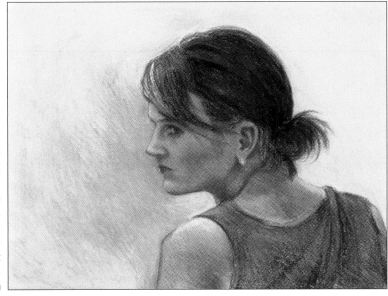

Figure 18-20: Model the portrait's forms focusing on the basic patterns of light and dark.

7. Refine the forms as in Figure 18-21.

Continue to model the portrait in layers, bringing the face into focus and allowing other areas, such as hair and shoulders, to appear softer.

8. Finish and save the small details, such as small strands of hair and highlights in the eyes, for last.

Make sure that the entire composition looks like you've given it adequate attention. You can see our finished portrait in Figure 18-21.

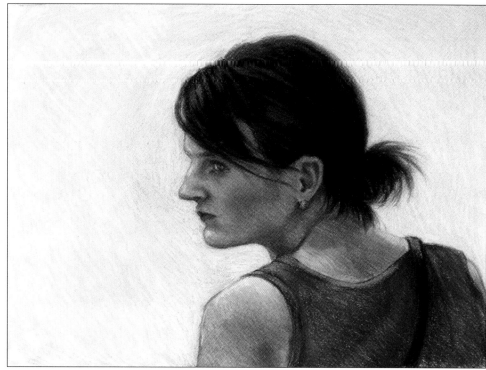

Figure 18-21:
Refine the
forms and
save the
details for
last to finish
the portrait.

Chapter 19

Adding People to the Picture

. .

In This Chapter

▷ Making gesture drawings of people and working with models

▷ Blocking in the figure proportionately

▷ Tackling those tricky hands and feet

▷ Reconciling your figures with their surroundings

▷ Drawing a seated portrait

. .

*1*n the days of the 18th- and 19th-century art academies, working from the human form was considered the highest form of art making. History painting, with its battle scenes packed with writhing bodies of humans and animals, was king. Art students worked from plaster casts until they were skilled enough to tackle the nude model, and women were out of luck because they weren't allowed to work from nude models at all, which was essential if you wanted to do history painting.

Fortunately, you don't have to endure the academy to begin to draw people today. This chapter helps you dive in and start drawing people right away. Be forewarned: It does take patience. Keep in mind that studying and drawing the human form is a life-long pursuit. Competency takes practice, but with a little work, you can find it very rewarding. If you find that you enjoy drawing people, picking up a copy of *Figure Drawing For Dummies* by Kensuke Okabayashi (Wiley) is a good next step in your education.

Making Quick Sketches of People

The best way to practice and improve your ability to draw people is to make lots of quick sketches called *gesture drawings* in which you quickly capture the movement and essence of the form without concentrating on the details. In fact, these drawings are also known as *action drawings* because they capture the figure's action. The more of these drawings you make, the faster you will improve; check out Chapter 5 for more on gesture drawing.

Drawing in an area where people congregate is a good way to practice. If you eat lunch in a busy area every day, you can spend a little time in your sketchbook and turn into a pro in no time. Otherwise, a shopping mall, zoo, or museum is perfect because you have a mix of people sitting, walking, and standing. You can start with easy positions, such as people standing still in line, and work up to more difficult poses and activities, such as people sitting or moving around.

Make people drawings approximately the size of your hand. Time yourself and work on each for less than five minutes — preferably around two minutes. Try to get something down for every part of the figure in the first ten seconds or so; the idea is to show the gist of what you're seeing, using fluid, continuous lines that move in and out of the form. Start by working from the inside of the figure and moving to the outside, almost like building from the skeleton out. If you're having trouble getting the entire figure into the drawing within two or three minutes, you're probably too concerned with the outside edges.

Having Someone Sit for You

Throughout this book, we say again and again that working from observation is best, which for people drawing means asking someone to sit and pose for you when you work on longer drawings. Friends and family are usually willing participants if they can watch television while you work, but if you don't provide entertainment, they may quickly tire of the process and jump up at the worst time to see how you're doing. The following sections highlight what you need to know about sighting your models and other important pointers you need to remember.

Sighting and measuring the body

Don't let the human form intimidate you. You sight and measure the body the same way you sight and measure a still life — by looking at the relationships of one part or object to another. (Refer to Chapter 12 for an overview of sighting a still life.) If the person is standing, you can easily use your *sighting stick* (a slim stick used to find angles and compare lengths; see Chapter 3) to measure sections of the body and check them against a standard set of proportions, such as you see in Figure 19-1. You don't impose those standards on the body you're drawing. You use them as guidelines to help you check the proportions.

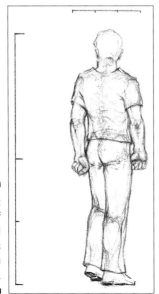

Figure 19-1:
A set of standard proportions for a human figure.

You sight and measure the figure by finding a section of the body that is easy to see, such as the upper arm or lower leg, and measuring everything else against that part. When you draw the line for that part on the paper, it becomes the known measurement that determines how long the lines for all the other parts are. Because the lengths of all of the other lines are drawn relative to that line, the length you draw that first part also determines how big the figure becomes on your paper.

For example, one proportion is that the distance from the head to the hipbone is equal to the distance from the hipbone to the floor. If someone has long legs, as ballet dancers often do, you don't reduce her leg length. You check the distance from the head to the hipbone and then ask yourself how much longer the legs are than that distance. In fact, keep that proportion in mind because making the legs too short is one of the most common beginner mistakes. The way you can apply this is to mark the height of the standing figure and then measure and mark where the hipbone should be. After you mark the hipbone, you can block out the rest of the figure. In Figure 19-2, you can see how a section of the body can be used to measure other areas.

Most of the time, however, your subjects don't conveniently stand for you so that you can plug them into a preconception of what they should look like. They sit, twist, and turn so that you can't possibly measure them against the standards. For example, how can you apply the standards in Figure 19-1 to someone curled up in the fetal position? You can't.

As you work, remember to pay attention to the angles and diagonals of the arms, legs, and other parts of the body. Accurate lengths don't do you much good if the angles are wrong. You can find out more about sighting and measuring angles in Chapter 5; treat the angles you find in arms and legs similarly to the angles you find in boxes.

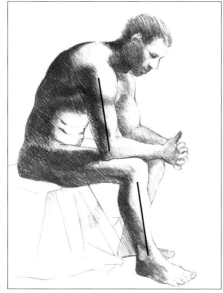

Figure 19-2:
Using a section of the body to measure other parts.

Eyeing general modeling tips

After you get your volunteer to model for you, keep the following hints in mind to help you set up and successfully work with your model.

✔ **Think about how the position of the figure fills the page.** Use your viewfinder to establish a compelling composition — flip to Chapter 5 for guidance on using a viewfinder to create a composition. Consider your *negative space,* the background in your scene. (Refer to Chapter 12 for info about considering negative spaces in the composition.) Avoid drawing a small figure floating on a large page; if you have trouble breaking that habit, try making a rule that the figure must touch two edges of the paper.

✔ **Be sure to light your drawing properly so that you can see to work.** Light your subjects in an interesting manner; consider unusual lighting, such as drawing from the light of the television or from candlelight. Using a spotlight may provide the lighting you want, but be considerate to your models and don't shine the light in their eyes! (Refer to Chapter 4 for more discussion on lighting basics.)

✔ **After you begin working, block in the initial sketch quickly.** Finish the entire initial sketch before allowing the model to move. Amateur models tire quickly, so you have about 20 minutes to lay in the drawing before you must give them a break. Use a timer so you don't get caught up and force them to stay longer than they're comfortable. (Check out Chapter 6 for blocking how-to.)

✔ **Before giving your models a break, mark the critical positions of their feet, back, legs, and so forth.** You can do so with strips of easy-release masking tape. Marking positions is important because you want to try to get the model back into position as closely as possible. Be aware that even professional models never return to exactly the same position.

Taking a figure drawing class

You can do yourself a big favor and progress much faster if you take a drawing class that incorporates working from a nude model. The better you understand the unadorned human form, the faster your work is going to progress — you can't observe and understand what you can't see. When our students occasionally ask us why we require them to work from a nude model, we tell them that learning to draw the figure from a clothed model is like trying to learn to draw hands from a model that wears gloves.

Having a friend pose in a bathing suit or leotard is okay in a pinch, but taking a class from a good instructor can shave years of frustration off your efforts. An instructor can let you know what you're doing right and help you identify and overcome the hurdles you face. You can find drawing classes at community art centers, university outreach programs, and through private instruction with a trained artist. Check the telephone book for programs, or ask an art teacher at your local high school for recommendations.

If you're worried about drawing someone who has no clothes on, we understand. *Everyone* worries about it before they do it. After about ten minutes, though, you'll be more worried about your drawing than what you're drawing from! After that, it's nothing. You will join the ranks of our students who leave their first drawing session with the model saying, "That wasn't nearly as bad as I thought it would be!"

✔ **Don't force friends or family members to pose for long sessions.** Try to keep sessions no longer than 2½ to 3 hours. Your models may never come back if they remember your sessions as being interminable. Work in 20-minute segments and give lots of breaks. Before finishing, take some photos with your digital camera of the model in position so that you can continue working while the model is gone.

Fitting Your Model on the Page

If you have ever drawn people before, you know how hard it can be to control how they fit on the page. They're always too big, too little, or cropped in strange ways. You can manage how they work into the composition, however, and in the process conquer drawing difficult positions of the body. The following sections explain how to do so.

Working from the inside out

When you build the figure from the inside out, you immediately establish the position and size of the body so that it fits wherever you want it to fit. Here is the process for blocking in the body from the inside out; after you use these steps to establish the initial drawing, you can begin to model the forms with your pastels. Follow along in our example in Figure 19-3.

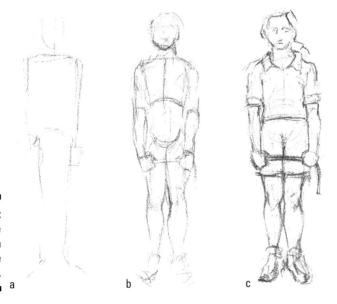

Figure 19-3: Building the figure from the inside out.

a b c

1. **Find the directional lines.**

 Take a second before you start and look for the major directions of the body. For example, if a person stands and reaches for the sky, the major directions may look like a *Y.* Draw lightly and try to establish the directions

of the body in five lines or less. These lines provide the foundation for the rest of the drawing. They determine the position of the body, its height, and the angles of the parts of the body.

The lines should be fluid and describe the movement; the drawing shouldn't look like a stick figure.

2. **Block in the basic shapes.**

 Think of blocking in the body mass as adding bone and muscle structure. If you go straight to adding clothing, the fabric may not appear to hang on the figure right. Examine and refine the lengths and the positions of the body parts. Add ribcage and pelvic areas very simply, as you see in the second step of Figure 19-3 — simple *U* shapes are fine. Then establish major muscle groups, such as the buttocks and thighs. After you have had a little practice and understand the figure well, you can move through this blocking step more quickly or eliminate it if the model is clothed.

3. **Add clothing and refine the figure's forms.**

 Now that you have something for the clothes to hang on, you can add them and develop the nuances of the forms. Be thoughtful in your choices of areas to develop, however. If the focus of the figure is the head, as in a portrait, develop the face, but if the focus is on the figure, keep the face and head simple. Leave details such as hands and feet simple, as well, so that they don't attract undue attention. If you fuss over them, the only things your viewer sees are gnarly-looking hands or awkward feet, because they look different from the rest of the drawing. It's better to block them in and leave them relatively simple. Head to "Drawing Realistic Hands and Feet" later in this chapter for more on tackling these extremities.

Drawing foreshortened body parts

Anytime anything points toward you or away from you, its length appears to shorten. If you ask a friend to raise an arm straight out from his side, level with the shoulder, you see no change in the arm's length. However, if you then ask him to slowly turn his arm toward you until he can point his finger at you, you notice that the length of the arm shortens until it almost disappears behind his finger and hand. This change is *foreshortening,* and it helps you get the correct proportions for your figure.

You can conquer foreshortening in the figure (and everything else) by doing three things:

1. **Look very hard.**

 Go beyond being observant to study and analyze what you see. If you assume too much, everything can go awry. Use your sighting stick to make good comparisons.

2. **When you draw your directional lines, pay attention to the lengths of the lines that represent the various parts of the body and how the lines relate to each other.**

 Don't automatically draw the upper and lower arms the same length, for example. Looking for intersections can help you map the body. For example, finding a hand on a knee, crossed ankles, or a chin resting on a hand can help you get all the parts in the right place.

3. **After you capture the lengths, block in the masses of different areas by finding sections that fit together like a jigsaw puzzle.**

 Study the area and ask yourself whether you can see any geometric shapes, such as spheres, cylinders, or cones in the form. Imagine and then draw how they're positioned together. Use anything else that helps you see the parts clearly to help you block them in. For example, dividing the body into sections that look like sliced ham helps for some people. Others stick with the shapes they see. Figure 19-4 shows you how to put these steps into action.

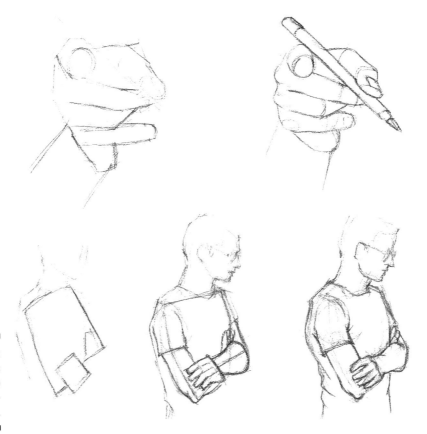

Figure 19-4: Use this strategy to tackle foreshortening.

Drawing Realistic Hands and Feet

Most artists, beginners and veterans, agonize at some time or another about drawing hands and feet. Along with the face, they can be some of the most complex parts of the body, but we suggest you don't get too worked up about drawing them. Most of the time, they become problems because some artists fuss over them too much in the composition. Unless they're important to the focus of the composition, keep them fairly simple. Understanding hand and foot forms well enough to elegantly depict them with a few simple lines takes a little practice, but you can do it. In the following sections, we give you strategies for tackling them, and with practice, we believe you can conquer hands and feet and draw them with the best of artists.

Getting a grip on hands

You can block hands easily if you remember two words: mittens and planes. The mittens help you find the overall shapes of the hands, and *planes* help you understand the positions and shapes of the fingers and rest of the hand. Stick to the following method to tackle drawing hands. You can follow along in Figure 19-5.

1. **Study the shape of the hand and draw it as a mitten shape.**

 Make sure the shape you draw is the mitten shape you see, not a standard shape for a mitten. You can find the shape of the mitten by following the shape the tips of the fingers make if you draw a line from tip to tip.

2. **Carve the negative spaces between the fingers away from the mitten shape.**

 They look like pie slices and can help you find the positions of the fingers.

3. **Divide the hand into planes.**

 Look at how the knuckles for the joints of the fingers line up with each other. You can see that the planes of the hand change at every joint. Mark the changes in the planes lightly on the mitten shape. Playing dot to dot with the joints may help.

4. **Make sure the hand has thickness and draw the fingers simply in line to finish blocking in the hand.**

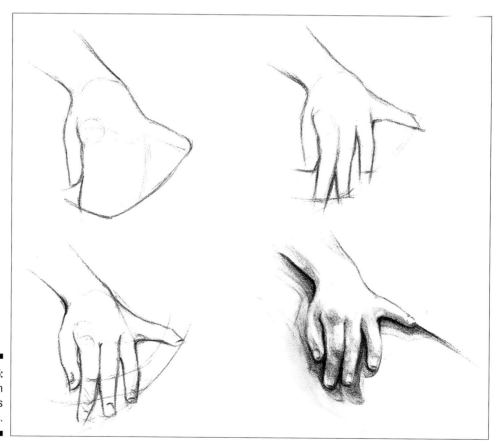

Figure 19-5:
Blocking in
the shapes
of hands.

When you model the hands, you can approach modeling them similarly to the way you would model a set of boxes. Every plane has a different value and the boxes cast shadows upon each other.

Jumping into feet

Drawing feet is a little more complicated because you must use different strategies depending on the position of the feet. The good news: You can always count on using a system of straight lines and prominent triangle shapes to block out the shape of a foot in any position. All you have to do is slightly change the method depending on the foot's position.

In general, follow these steps to draw feet:

1. **Draw the lines for the lower leg.**

 As you draw them, move these two lines closer to each other as they approach the foot. Avoid making gingerbread man legs.

2. **Block in a major triangle from which you can build the rest of the foot.**

 If you're looking at the front of the foot, the triangle will be rounded off where the top of the foot meets the ankle and at the toes where the curve comes forward at the big toe and then follows the positions of the rest of the toes. If you're looking at the back of the foot, look for the triangle that the Achilles tendon and heel form. When looking at either the inside or outside of the foot, the triangle runs from the point where the top of the foot meets the leg and then to the heel and finally to the toes.

3. **Build the rest of the foot.**

 Add the shapes that the triangle doesn't consider. For the front of the foot, add angles in the proper place on either side to represent ankles. Do the same for the back of the foot, but you must also add any part of the front of the foot that you see on either side of the heel. Block in those shapes simply as you see them. They change a lot from one position of the foot to another. When you place the angles for the ankles, notice that the inside ankle is always higher than the outside ankle. For the sides of the feet, you must add the heel as another triangle, and tuck in the ankle as a lightly drawn *"J"* shape.

4. **Refine the forms.**

 Break down the geometric forms to give the rest of the foot definition. For the front of the foot, start with the toes. Find the big toe first and then break down the rest of the area into the shapes of the rest of the toes. For the inside or back of the foot, if you see the arch of the foot, lay in the shape of an arch. On the outside of the foot, look for three ovals along the edge where the foot touches the floor: one at the middle of the foot, one at the pad for the little toe, and one for the shape of the little toe. After you have refined the basic shapes, you can draw lines that find the nuances of the forms. Overall, the advice for feet is the same as for hands: Keep them really simple!

Figures 19-6a, 19-6b, and 19-7 show you how to block feet from the front, back, and side. Look at how the triangular shapes establish the shapes of the feet in a general way before the forms are refined.

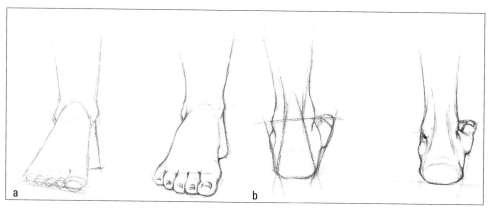

Figure 19-6:
Building the
form of the
foot in the
front view
(a) and
the rear
view (b).

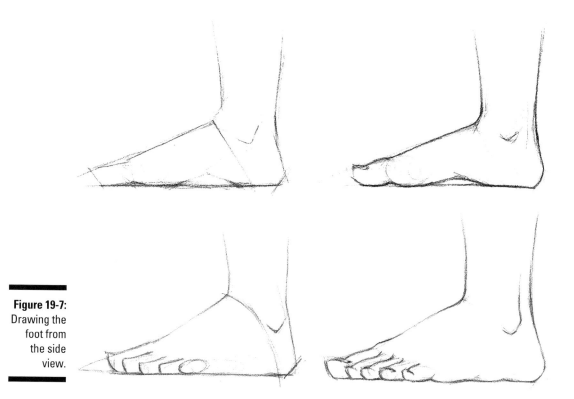

Figure 19-7:
Drawing the
foot from
the side
view.

Project: Creating a Seated Portrait

When you do a seated portrait, you incorporate skills from lots of different categories of genre painting, including still life (Chapter 12) and portrait (Chapter 18) of course. If you're working outdoors or by a window, even landscape (refer to Chapter 16) becomes a part of it. Familiarity with the forms is a big help, and that comes with practice, but ultimately, you're using the same process as you do for other pastel drawings that we discuss

throughout this book. For the entire project, no matter whether you're working on the face, a chair, or the objects on a side table, you build the drawing using the same process.

The background is more forgiving than the likeness of your model, but if you can treat the entire project objectively, you may find success comes more easily. Don't get tied up fussing over whether the likeness of the model is right; if you can mentally back up from the project and relax, you can find it easier to see the forms and get the likeness.

After you gather your materials and round up a model, you can follow along with the illustrations as you work. For this project you need pastel pencils and hard and soft pastels; a sighting stick and viewfinder; Rives BFK paper, torn to 16 x 20 inches or your choice of paper and size; a drawing board or easel; and paper towels or tortillions for blending.

Capturing a likeness can be tough, so you may want to set your goals a little lower for your first attempts — like just trying to make it look human! Your next goal may be making it look the right age and gender and then striving to capture the accurate likeness.

1. **Set up your model and work area.**

 If you're working outside your usual space, you still need to set up your easel and workspace as you would under normal circumstances. If you're setting up in someone's living space, you may want to consider putting down a tarp to catch pastel dust that falls to the floor.

2. **Find an interesting composition.**

 Be sure to take the time to set up your model and the surroundings (including lighting) in an interesting way — you don't have to incorporate the model's entire body. Use your viewfinder to try out various possibilities for compositions and come up with a compelling balance of figure to background.

3. **Make a few rough sketches in your sketchbook.**

 Take a second to try out your composition before you begin on your good paper. That way you can work the kinks out of the composition without tearing down the tooth of your paper. Remember to use a format for your sketches that is the same proportions as your paper. Draw an outline for a frame for your format; don't allow the image to float in white space. Check out Chapter 6 for guidance on creating rough sketches.

4. **Lay in your initial drawing with a pastel pencil.**

 We've done ours in blue, but you can choose a color close to your paper or colors similar to the overall color of your portrait. Try to complete the initial drawing in 20 minutes so that your model doesn't sit too long. You may be tempted just to work on the model and leave the background until break time, but all the parts are relative in the scene, so you need to work on the entire composition at once. Lay the drawing in lightly and don't be afraid to *restate* (redraw lines over the old ones) as needed; you want to avoid erasing as much as possible. In Figure 19-8a, you can see our initial drawing, complete with restated lines.

5. Block in your colors for the entire composition.

Concentrate on finding the patterns of light and dark both in the figure and the background. This *value pattern* can show you the direction the finished work may take. Keep in mind, however, that these patterns can change — darkening as you lay them in, lightening as you rub them into the paper, and so forth — so keep an open mind about your direction. Make sure that every part of your background looks like you have given it attention. You can see our composition with the colors blocked in Figure 19-8b.

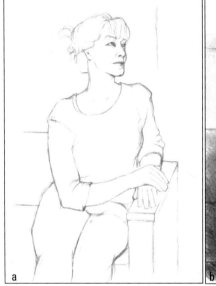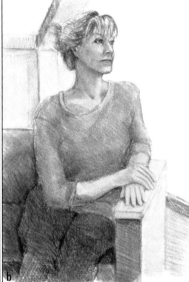

Figure 19-8:
Make an initial drawing (a), and block in the colors (b).

a b

Contrasting light and dark brings your figure forward. Using brighter colors for the figure and duller colors in the background also brings the figure forward.

This step is dangerous, because you may be tempted to complete the face before you block in the rest of the composition. Resist the temptation! If that's a problem for you, try blocking in all of the colors in the composition first and block the face last.

6. Begin refining the forms.

Remember to work from *general to specific* here, bringing the drawing up in layers; don't concentrate on the face first. Think of this part as a process of slowly bringing the drawing into focus. Go through the entire drawing and refine the forms a little more as you begin to develop the value patterns. Continue to refine the forms and the nuances of the value patterns with each new layer. You can see our in-progress drawing in Figure 19-9.

Even though you want to give the background attention, you don't want to give it as much attention and development as the figure — it's in the background for a reason. Make the values in the background similar to those in the figure and drop the lightest lights and darkest darks, blur the edges, and avoid detail when possible.

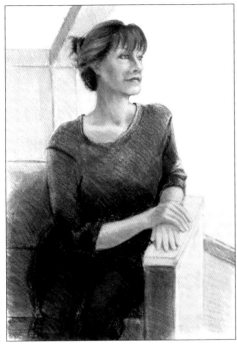

Figure 19-9:
Refine the forms as you build layers of drawing.

7. **Finish up the face.**

 Because you're drawing a portrait, the major focus of the drawing is the face, so that is the area where you do the most refining. The face is probably the most complex area of your composition; the shapes are smaller and the value pattern is more intricate than the rest of the composition.

 You do have some choice in how refined you want the face to be, especially if you avoided working on the face too much earlier in the drawing process. If you want a more mysterious figure, or an expressive portrait, you may want to leave the face loose and similar to other areas of the composition. You can check out our finished portrait in Figure 19-10.

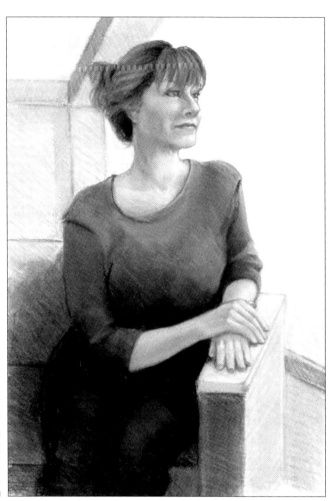

Figure 19-10:
A finished
seated
portrait.

Part V
The Part of Tens

The 5th Wave — By Rich Tennant

NAOMI CHANNELS HER EATING DISORDER THROUGH PASTELS

"I'm working from the spicy side of the color wheel, blending ketchup red and cheddar cheese yellow to get the orange sorbet highlights on the hot-dog-colored barn."

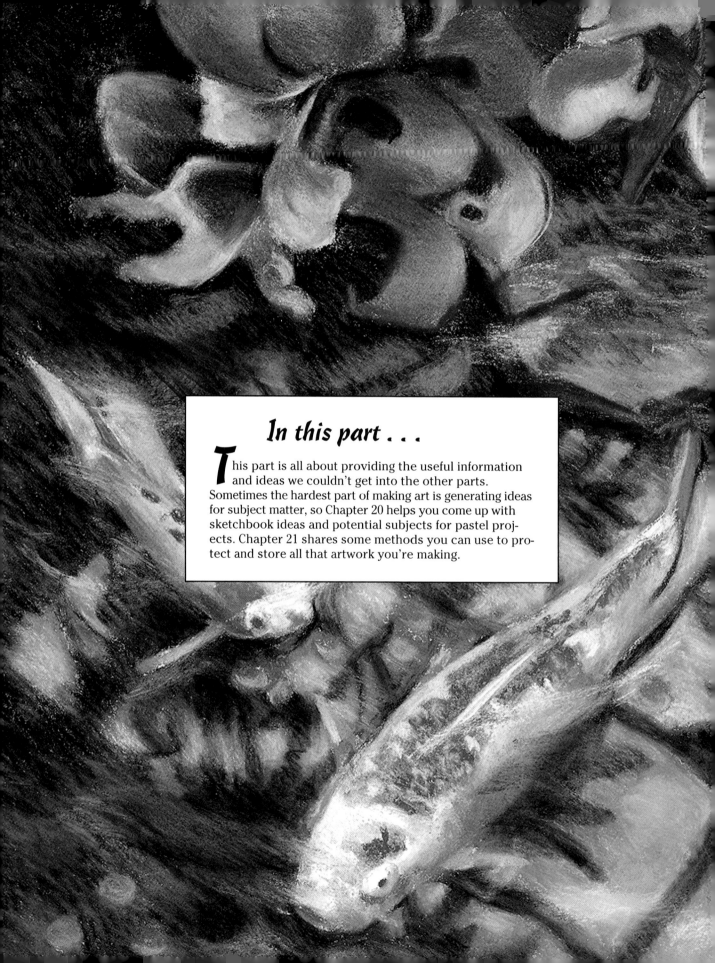

In this part . . .

This part is all about providing the useful information and ideas we couldn't get into the other parts. Sometimes the hardest part of making art is generating ideas for subject matter, so Chapter 20 helps you come up with sketchbook ideas and potential subjects for pastel projects. Chapter 21 shares some methods you can use to protect and store all that artwork you're making.

Chapter 20

Ten Great Subjects for Pastel

In This Chapter

▷ Drawing everyday subjects in interesting ways

▷ Heading outside to capture cool objects

*W*hat constitutes a proper pastel subject? You can use pastel for any-thing you put your mind to — with the freedom of the modern age, nothing is off limits. The possible subjects for pastel are as bountiful as your imagination, but sometimes having too many choices can be overwhelming.

Working with pastel has some challenges. Very large artworks are labor inten-sive, and images with minute detail can be difficult to achieve with pastel sticks or even pencils. So as you're figuring out what subject to draw, don't bite off more than you can chew. This chapter can help you come up with some easy and new ideas.

A Collection of Potted Plants

If you like natural forms and have a desire to make images of landscapes or other living environments, potted plants make a good subject. Using plants works well, especially if the plants have large leaves and a variety of green colors and are contained in attractive pots. Plants that work well include philodendrons, snake plants, jade plants, and umbrella plants (*schefflera*). All have leaves that should be easy to draw, and they're easy to grow if you want to raise your own subject. If you want to work from flowers, go for simple shapes like lilies or orchids.

After you have your plants, set them in *dappled* (spotty) light on a back-ground of contrasting color to make the leaves really stand out. Draw them close-up so they fill and even run off the page. Use *positive* and *negative shapes* (meaning the leaves and the small spaces you see between the leaves) to draw the leaves and use as many colors as you can to produce the variety of green colors.

Donuts or Slices of Pies and Cakes

If you have a sweet tooth, what better subject to draw than your favorite des-sert? Drawing tasty treats is certainly fun, and it comes with a sense of humor built in. Find some desserts with brilliant color or texture and put them on a

bright plate to show off all their gooey qualities (see Figure 20-1). This subject is tailor made for exaggerated color and unconventional marks, so be daring with color and try drawing the subject from different points of view, in single servings or in pairs, and in larger than-life size to achieve the texture of the frosting. Bright red cherry filling is easy, but try to jazz up the piecrust as well — use pinks, pale blues, and yellows to mimic the value of the color without relying too much on the boring tans and browns. When you're done drawing, wash your hands and dig in.

Figure 20-1:
Practice drawing something sweet.

A Grocery Store Vegetable Display

Whether it's your local vegetable stand in daylight or a market display indoors, the beautifully stacked fruits and vegetables are just waiting for you. The market has set up the produce to look its very best, so you've already got an ideal scene. You can try to work from observation, but a store display can be a busy place — the bustle of shoppers and shopkeepers makes working from photos a better solution. Plus, a photo means you don't have to worry about your centerpiece being purchased out from under you.

An Abandoned Building

Whether it's an old barn, a tumbled-down shed, or an urban industrial building, the patina of age, use, and history makes any of these a compelling subject. A scene that shows evidence of human use suggests a narrative, so as you draw, think of the story behind the scene and the people who lived and worked in the building and try to communicate this narrative in your work. The color may look drab, but you can make lovely browns and grays by layering these colors with a combination of blues, greens, and violets.

If the building is remote or in an unfamiliar area, remember to be safe. Take someone with you on your excursion and take photos of the scene to work from in your home or studio. Also, remember to respect private property and ask permission to be there. Working from observation is preferable if

location, weather conditions, and your schedule permit, but taking photos and sketches of the area is still a useful way to help you complete the piece later in the studio as the light changes or the rain starts.

Your Backyard

Explore your own turf for an easy view of nature. Head out the back door with your viewfinder (see Chapter 3) and see what's out there close to home. Your options are endless: You can make a portrait of a tree, a picture of a row of vegetables in your garden, or a study of a border of flowers, taking some photos first to try out different compositions. And the outdoor subjects aren't just for summertime. Spring and autumn provide great colors, and a snowy scene drawn through a window can be just as compelling as a summer piece.

The advantage of working in your own backyard is that it's outdoors but not out in the wild. You're close to a bathroom, shelter from rain, your sunhat, and any supplies you forget to bring with you. Working in your yard is like a practice run for *really* heading out to the wild, like the park down the street.

A Friend at the Beach or Pool

Summer at the beach or pool offers a low impact way to practice figure drawing in natural light. The setting is gorgeous, you can document your vacation, and it's a lovely way to enjoy the out of doors. Take your sketchbook and make some preliminary sketches first to work out the proportions. Then you're ready to try a portrait or work from the entire body to make a study of anatomy. Remember to take your camera and shoot some photos to finish your artwork later — the sun is going to change position, and your subject may want to take a swim.

Make sure your subject is someone known to you and that he knows you're planning to draw him. Even a friend may be a little self-conscious.

A Still Life of Your Art Materials

Documenting the tools of your trade is an easy way to start drawing without even having to leave your workspace. Art supplies come in attractive boxes and have interesting colors and shapes. Consider your pastels and papers, but be sure to include easels, tools, and your favorite jar that holds your pencils, too. You can even throw in non-pastel materials like paint tubes, utility knives, and any non-arty still life items you like.

Make several arrangements and sketches to test your composition, and remember to include the shadows of the objects as well. Get in close to capture the fine details of small objects.

A Self-Portrait in a Rearview Mirror

Any self-portrait is a useful means to study the human face. Self portraits have been a tradition for many centuries now — van Gogh did over 200 (often in pastel) in the ten short years of his artistic career.

For this self-portrait, take a modern approach and find an unconventional mirror. Maybe it's a bathroom mirror, a makeup mirror, or the rearview mirror in your car. Aim for a quirky, odd effect and look at yourself from an unusual angle. (This technique also makes you less self-conscious about drawing yourself.) Try this project in your sketchbook first to work out any problems in the composition.

Eggs on a Windowsill

Simple, perfect eggs make a great subject in their quiet, unfussy shells. Set two or three eggs in a row on a sill and focus on how the light influences the values on the eggshells. The window casts a backlight on the eggs, creating a halo effect around the edges. Try placing white eggs on a solid colored surface, such as a piece of paper or cloth, to add color to the reflected light on their shells. You may also see objects behind the eggs in the window; you can include them or blur the focus to let the eggs take center stage. The egg project in Chapter 8 may help you get a handle on drawing eggs.

Strange as this may sound, brown eggs are great for practicing the color of skin — their range of tan and brown shades resembles many skin tones, and their shell texture mimics skin's texture.

Glasses of Water

Drawing a glass of water can be a real test of your abilities. If you look closely, you can see two or three free-form shapes in the glass and the water. Nailing those shapes is the secret to capturing all those reflections. Make several studies in your sketchbook for practice, working from general to specific by adding two or three big shapes of value and then adding some highlights and dark spots to see how quickly the glass takes shape.

Keep the position of your head steady as you work; a fixed point of view keeps the shapes stable so you can draw them. Work in life size to allow you to catch all the bits and pieces of light and dark, and don't overblend — the crisp edges between one form and another are what achieves the reflections in the glass and water. Check out Chapter 13 for more tips on drawing glass.

Chapter 21

Ten (or So) Ways to Protect and Store Your Art

In This Chapter

▶ Storing your work in the right manner and with the right materials

▶ Handling your pastel work with care

Pastel works are more delicate than other artwork and require special handling to preserve the integrity of the paper and the drawing. Even though you may have only a few drawings at this point, it isn't too early to work on ways to conserve them. This chapter gives you some helpful pointers to protect and store your masterpieces.

Store Your Artwork Flat

Pastel pieces are unique because the pigment particles can actually fall off the paper's surface if you knock it on its edge, even if it's in a portfolio. Store your work flat until you frame it. *Flat files,* which are shallow, wide drawers, are best, but you can also store works flat in a sturdy, handmade portfolio (check out Chapter 3 for more info).

Handle Your Paper and Works Carefully

When you handle your paper and finished artwork, avoid *dinging* it (giving it one of those half-moon shapes created by breaking the paper's fibers, such as by bending). Dings show up as unintended lines in your drawing and lower your work's sale value. You can avoid damaging your paper by holding it flat on its diagonal corners or on its opposing edges and allowing the center to hang easily. If you must hold a sheet with one hand, hold it at the center of the short edge and let the entire sheet hang vertically, allowing it to float as you hold it.

Cover Your Work

You can easily damage the surface of your pastel work by moving anything across its surface. The ideal solution is to keep the work covered with *glassine paper,* which is quite slick and transparent. If you can, fold the glassine paper in half (like a folder) and place the artwork in it. You can also use a fine quality, slick tracing paper, which is available in pads. It's slightly less expensive than glassine paper but doesn't work quite as well.

Allow Art to Touch Only Archival Materials

Acidic materials, found in papers and boards made from wood products, cause the paper fibers to break down, yellow, and disintegrate over time, much like an old newspaper. Even though you use acid-free papers, acids in other papers, mat boards, and art materials can still cause your work damage, so ensure that only *archival,* or acid-free, materials touch your work.

Use Fixative When Appropriate

Fixative (which we discuss in Chapter 3) can reduce the amount of damage your work's surface encounters. If you use fixative judiciously in the lower layers of pastel, you can balance the need to protect the work with maintaining the aesthetics of the work. Spraying periodically in the lower layers helps stabilize the work, and then you can leave the top layers unsprayed to maintain the fresh look of the pastel marks.

Frame Your Work with Glass

Works on paper, such as pastel, watercolor, and drawings, can be damaged easily and must always be protected under glass to avoid that damage. Be sure to frame the work with a spacer or mat to hold the surface of the glass off the pastel; see the following section for more on keeping the glass off your piece.

Mat and Shrink-Wrap Your Work

Mat your work to separate the artwork from the glass. Condensation can form on the glass and cause *foxing,* or mildew, to develop on the paper. The glass can also lift pastel off the paper if it touches it. If you pull your work out regularly to show it, consider also having it shrink-wrapped to protect it from the wear and tear of handling before you frame it.

Avoid Using Regular Masking Tape

Absolutely never use masking tape for matting and framing. The residue from regular masking tape will yellow your paper in a few short years, even if it only touched the paper for a few minutes. See "Allow Art to Touch Only Archival Materials" earlier in this chapter for more on using archival, acid-free materials.

Attach Your Work Properly to Its Backing

Use archival paper tapes sparingly for attaching a work to its backing. A small piece folded in half and attached on the backside of each top corner of the artwork works for most pieces. If the art moves around at the bottom, add pieces in those corners only. Never tape around the perimeter of the artwork, and use the tape sparingly because it can cause your work to warp as normal humidity in the air causes the paper to enlarge and contract.

Index